Treasures of
Catherine the Great

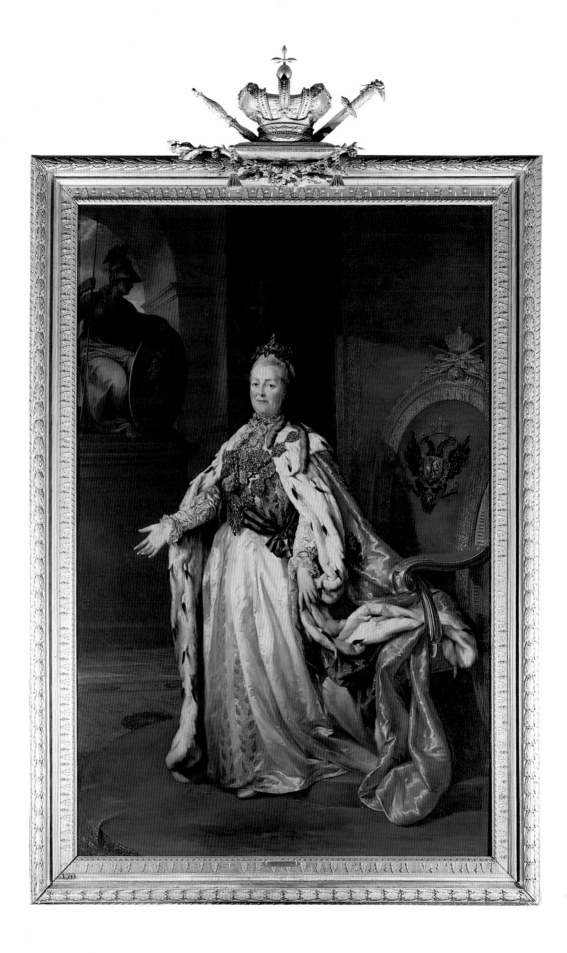

STATE HERMITAGE MUSEUM

HERMITAGE DEVELOPMENT TRUST

Treasures of Catherine the Great

EDITED BY PROFESSOR MIKHAIL B. PIOTROVSKI

HERMITAGE ROOMS
ГОСУДАРСТВЕННЫЙ
ЭРМИТАЖ
at SOMERSET HOUSE

Thames & Hudson

HARRY N. ABRAMS, INC.
PUBLISHERS

This publication has been produced to coincide with the exhibition
Treasures of Catherine the Great, which marks the opening of the Hermitage Rooms at Somerset House
by His Royal Highness, The Prince of Wales, on Tuesday 21 November 2000.

The exhibition is open to the public from 25 November 2000 to 23 September 2001.

EXHIBITION STEERING COMMITTEE
On behalf of the Hermitage Museum:
Prof. Mikhail Piotrovski *Director*
Dr Georgy Vilinbakhov *Deputy Director (Research)*
Dr Vladimir Matveyev *Deputy Director*
(Exhibitions and Development)
Dr Natalya Guseva *Deputy Head, Russian Department*
On behalf of the Hermitage Development Trust:
Lord Rothschild *Chairman of the Trustees*
Geraldine Norman *Executive Director*
Dr Timothy Clifford *Director, National Galleries of Scotland*

HERMITAGE WORKING GROUP
Dr Natalya Guseva *Exhibition Coordinator*
Vyacheslav Fyodorov *Head of the Russian Department*
Olga Ilmenkova *Head of Exhibition Documentation*
Dr Vladimir Matveyev *Deputy Director*
(Exhibitions and Development)
Klara Nikitina *Head of Restoration and Conservation*
Dr Tamara Rappe *Deputy Head, Western European Department*

HERMITAGE DEVELOPMENT TRUST
Geraldine Norman *Director*
Sam Oakley *Exhibition Organiser*
Joy Lowe, Aisha Jung *Assistants*
Sue Bond *PR Consultant*
Selina Fellows *Retail Consultant*

Objects have been restored specially for this exhibition
in the workshops of the State Hermitage Museum, under the
guidance of Alexey Bantikov, Konstantin Blagoveshchensky,
Rita Grunina, Vladimir Kashcheyev, Valentina Kozyreva
and Klara Nikitina.

Photography by Leonard Heifetz, Yury Molodkovets,
Svetlana Suyetova and Vladimir Terebenin

NB All measurements are given height × width in cm.
Due to the fragility of works on paper and ivory, a small
number of exhibits are on display for only part of the exhibition
period and will be replaced by other similar works. These items
are clearly marked in the catalogue text according to when they
will be in the exhibition:
25 November 2000 – 5 March 2001
6 March 2001 – 25 June 2001
26 June 2001 – 23 September 2001.

Gallery and exhibition design by Jasper Jacob of JJA
Marquetry floors by Khepri and Parfenon
Mount making and installation by Colin Bowles Ltd
Catalogue translated by Catherine Phillips and Aisha Jung
Catalogue edited by Natalya Guseva and Catherine Phillips,
with thanks to Prof. Isabel de Madariaga, FBA, FRHist Soc
Catalogue design by Roger Davies

Distributed throughout the world
excluding the United States and Canada by
Thames & Hudson Ltd, 181A High Holborn, London WC1V 7QX

www.thamesandhudson.com

British Library Cataloguing-in-Publication Data
A catalogue record for this book is available
from the British Library

ISBN 0-500-97597-3

Distributed in North America by
Harry N. Abrams, Incorporated, New York

Harry N. Abrams, Inc.,
100 Fifth Avenue
New York, N.Y. 10011
www.abramsbooks.com

ISBN 0-8109-6732-4

© 2000 State Hermitage Museum
© 2000 Hermitage Development Trust

Printed and bound in the United Kingdom

Front cover illustration
Cat. 10 *Equestrian Portrait of Catherine II, in the Uniform of*
an Officer of the Semyonovsky Regiment Vigilius Eriksen. 1722–82

Back cover and page 3
Monogram for a maid of honour

page 1
Eagle designed by Yevgeny Ukhnalov

Frontispiece
Full-length Portrait of Empress Catherine the Great
of Russia After Alexander Roslin
Collection of the Marquess of Cholmondeley,
Houghton Hall, Norfolk

CONTRIBUTORS TO THIS CATALOGUE
V.F. Vyacheslav Fyodorov
N.G. Natalya Guseva
N.I.G. Natalya Gritsay
A.K. Alexander Kruglov
G.K. Galina Komelova
I.K. Irina Kotelnikova
M.K. Maria Kosareva
M.F.K. Militsa Korshunova
O.K. Olga Kostyuk
T.K. Tamara Kudryavtseva
T.T.K. Tamara Korshunova
Y.K. Yulia Kagan
Y.I.K. Yelena Karchova
L.L. Lydia Liackhova
M.L. Marina Lopato
S.L. Sergey Letin
M.M. Maria Menshikova
N.M. Natalya Mavrodina
O.N. Oleg Neverov
G.P. Galina Printseva
Y.P. Yulia Plotnikova
E.R. Elizaveta Renne
T.R. Tamara Rappe
E.S. Elena Shlikevich
I.S. Ivan Sychov
I.A.S. Irina Sokolova
N.S. Natalya Serebryannaya
T.S. Tatyana Semyonova
V.S. Valery Shchevchenko
Y.S. Yevgeniya Shchukina
A.T. Anna Trofimova
E.T. Evelina Tarasova
J.V. Jan Vilensky
I.Y. Irina Yetoyeva
L.Y. Larisa Yakovleva
Y.Y. Yury Yefimov
Y.Z. Yuna Zek

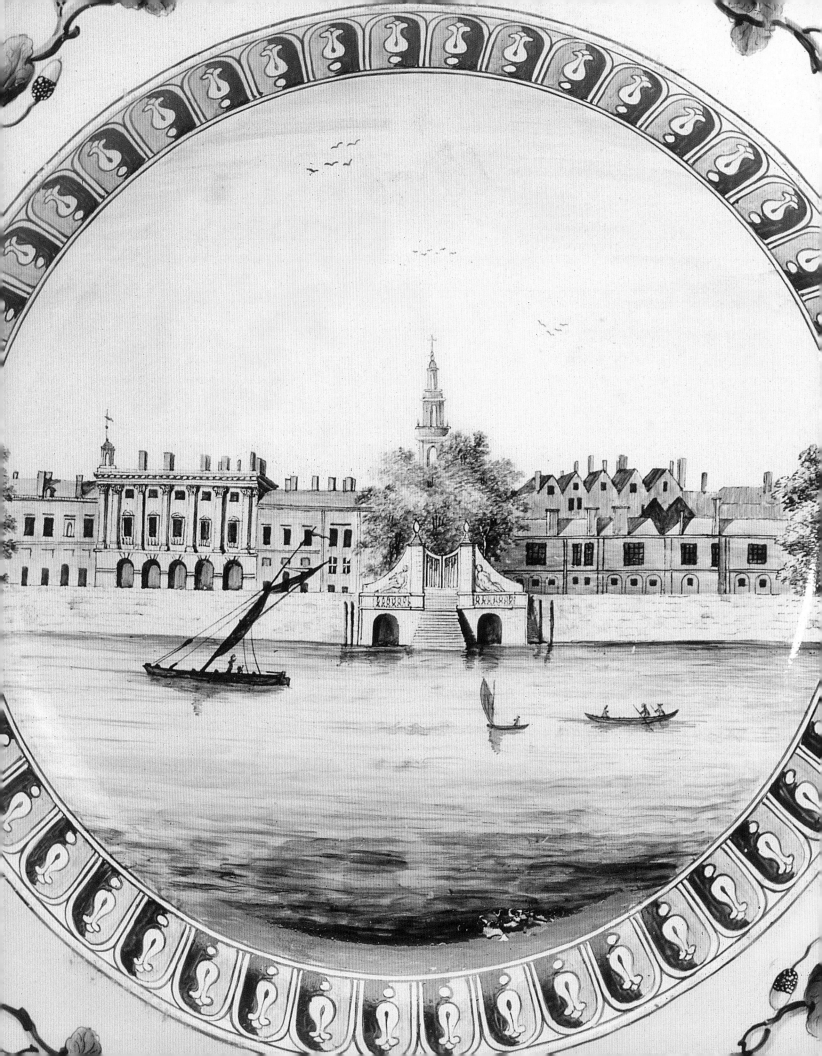

Contents

Left
Wedgwood Plate Decorated
with a View of Old Somerset House
[Cat. 270]

Foreword

BY PROF. MIKHAIL PIOTROVSKI

It was during a pleasant conversation with Lord Rothschild that the idea for these galleries was born, an idea which was quickly turned into concrete plans, and which has now become reality. The Hermitage will be sending regular exhibitions to the Hermitage Rooms at Somerset House, where information about the museum's history and about the Hermitage today will be accessible to all. Contact will be facilitated with the museum's employees, its archives, library and educational centre. With time there will be a library of books about the Hermitage and I very much hope the Rooms will be a regular meeting place for the British Friends of the Hermitage.

Such an innovative step, in keeping with the spirit of the new century, is nonetheless merely another manifestation of the Hermitage's age-old tradition of internationalism, a tradition set by Catherine the Great. Our museum captures the essence of Russian cultural politics in its openness to the world, seeing the main duty of such a vast museum as the provision of full access to its immense reserves, whether it be by extending available exhibition space, developing open storage areas, extensive use of electronic catalogues and the Internet, or shows at our own exhibition centres.

Which is what brings us to Somerset House. This magnificent architectural ensemble resembles the Hermitage's new wing in St Petersburg, the General Staff Building: a former ministerial office block becomes a vibrant cultural centre, in which the square or courtyard is an active element.

I hope that the Hermitage Rooms will become a centre for academic and cultural exchange between London and St Petersburg. We would never have embarked on such a plan without the preliminary approval of colleagues and friends in the London museum world. Today, however, we are certain that we can add a small but attractive detail to London's cultural life.

The Hermitage Rooms will, we hope, be like a "jewellery box": small outside, but packed with regularly changing objects which please the eye and stimulate the mind.

This will be very much in keeping with that spirit of artistic collection and admiration which drove the museum's founder, Catherine the Great. To her memory our first exhibition is dedicated. Catherine (and Russia) had the most varied links with Britain in the 18th century; many leading members of the Russian aristocracy modelled their way of life on Britain, buying works of art which have contributed significantly to the Hermitage's excellent collection of British art.

Inspired by the idea of enlightened monarchy, but shocked by the French Revolution, Catherine would seem to have found in Britain a rational combination of the principles of centralised power and care for the common weal. She bought in England not only Old Masters but also contemporary British art, from Wedgwood ceramics to paintings by Wright of Derby and Reynolds.

Our countries are tied by centuries of traditions which live still within those who took up realisation of the idea for the Hermitage Rooms at Somerset House with such enthusiasm. I would like to thank them all – in London, in St Petersburg and in Moscow – from the bottom of my heart.

I would also like to thank all those who visit the Hermitage on the Thames, and hope that it will be so much to their taste that they come and see the Hermitage on the Neva.

Foreword

BY LORD ROTHSCHILD

This is the first exhibition in the Hermitage Rooms at Somerset House – the first, I hope, of a very long series serving to deepen the mutual understanding between our two countries and to cement our friendship.

We have much to celebrate. This year has seen Somerset House, the great riverside palace, open to the public for the first time in 220 years of existence. Delivered from its role as a car park, the full glory of the great courtyard has been revealed – from time to time enhanced by the splashing of fountains. The terrace, with its magnificent views up and down the river, is now a convenient place to meet your friends, to relax, to eat and drink.

A new museum, the Gilbert Collection, came to life in May in the river elevation of the building, its first new cultural facility. It is now joined by a superlative attraction, the first foreign branch of the State Hermitage, Russia's premier museum and one of the world's four great encyclopaedic collections of art – with the British Museum, the Louvre, and the Metropolitan Museum, New York.

The idea of establishing a "baby Hermitage" in London first arose informally when the director of the museum, Professor Mikhail Piotrovski, came to my London office in early 1999. Those of us interested in the fate of Somerset House were, at the time, casting about for a new and exciting occupier who would add an extra cultural dimension to the site. I put forward the idea to Professor Piotrovski that his museum might like a London base and his reaction was so positive that we immediately set about preparing a formal proposal.

An agreement over the creation of "Hermitage Rooms" at Somerset House was reached in July 1999 and it is an extraordinary achievement by Professor Piotrovski, his colleagues, and our Director Mrs Geraldine Norman, that this complex international undertaking has been realised in little over a year. A suite of rooms in an 18th-century British office building has been transformed to recreate a wing of the Winter Palace in St Petersburg. The basic décor of the Hermitage Rooms, like the Hermitage itself, reflects the style of the Emperor Nicholas I (1825-55).

It was important to our friends who work at the Hermitage that visitors to the British exhibition space should understand the context from which the exhibits are drawn. Our introductory gallery does this in a number of technically innovative ways, from a plasma screen connected directly to a camera in Palace Square, St Petersburg, to a virtual tour of the whole Hermitage collection from a bank of computers, and a video tour of the Hermitage's magnificent interiors.

None of this could have been achieved without the commitment and dedication of the Trustees of this project, and the generous financial support of a group of private individuals and organisations that were quick to appreciate and endorse the potential of this visionary endeavour, including Morgan Stanley Dean Witter, our Corporate Founder Sponsor. They all deserve the heartfelt thanks not only of those of us directly involved with the project, but also of the British people and art lovers from all over the world whom we expect to welcome to the Hermitage Rooms in the years to come.

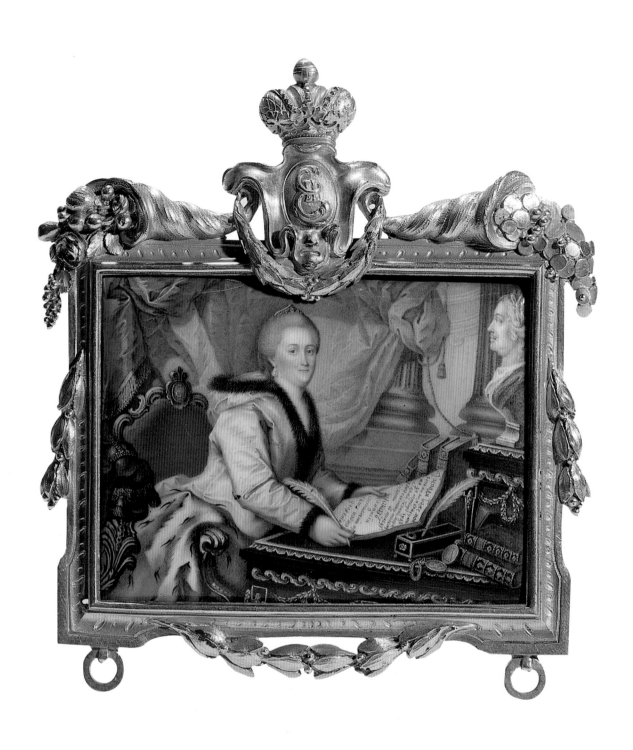

Catherine II Holding her 'Instruction' [Cat. 30]

Catherine II
Empress of All the Russias

PROF. MIKHAIL PIOTROVSKI
DIRECTOR OF THE
HERMITAGE MUSEUM

To historians she is Catherine the Great. To Russian nobles and commoners of her time she was the "beloved mother" of her people. With not a single drop of Russian blood in her veins, for her contemporaries and for successive generations this woman was the most Russian and most positive of all the Romanovs after Peter I.

Upon the monument she erected to Peter the Great in the heart of St Petersburg she wrote "To Peter the First – Catherine the Second"... It was she who put into effect those things of which Peter dreamed, for the sake of which he overturned centuries-old Russian traditions. During her reign, Russia became a truly great European state, a rich and powerful land. Its capital and its court amazed foreign visitors. Its army and its art collections were the object of envy.

Catherine was a true autocrat who conducted herself just as she saw fit. European rulers changed lovers without a second thought and Catherine did the same, as if demonstrating woman's right to equality with man in everything. She was forgiven her many faults by the Russian people, right down to the overthrow of her husband and her seizure of the throne, for all were perceived as being eventually for the good of Russia.

She had a talent for identifying outstanding people and supporting them by matching them with tasks at which they could excel. Thanks to her skilful selection of loyal and enterprising assistants her reign was marked by numerous military and political victories and Russia's voice rang out across the world.

Catherine was an enlightened monarch, admired (at a distance) by the French Encyclopédistes. Initially much taken by the novelty of their ideas, Catherine lost her taste for abstract ideals after the French Revolution revealed the possible results of excessive intellectual freedom. "Russia above all" was her credo.

Not only was Catherine able to satisfy the interests of the Russian nobility and the country as a whole, she also resolved the need for a new means of national self-identification: she gave the Russian people a reason to be proud of themselves. Thus it is that none of the scabrous tales or caricatures of Catherine which have run the world round can deprive her of the sobriquet "the Great".

Catherine loved the theatre. Not only did she write and direct plays, but she played many brilliant and inspired roles in life. The world she organised around herself was one vast theatrical performance, with its own symbolism and conventions, its own exaggerations and references. Her whole life was a theatre, and she was the director.

Part of this whole performance were Catherine's "Hermitages". Her predecessors had already used the word "Hermitage" to describe rooms or pavilions where a monarch

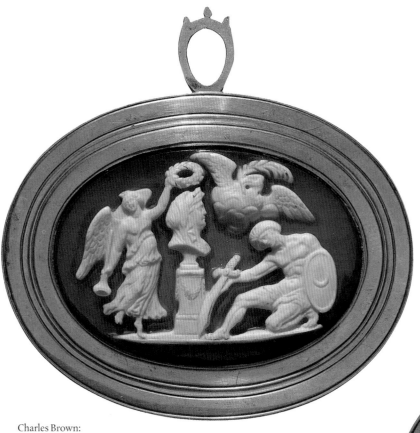

Charles Brown:
Cameo: Allegory of the Victory over the Turkish Fleet
[Cat. 184]

William Brown:
Cameo: Catherine II Instructing her Grandsons
[Cat. 185]

William & Charles Brown:
Cameo: Catherine II Crowning Prince
Potemkin with Laurels
[Cat. 186]

14

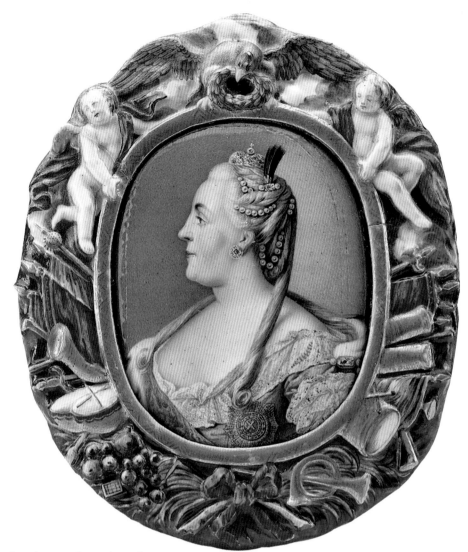

Andrey Chorny: *Catherine II* [Cat. 32]

could escape formality and behave like a private individual; Catherine applied the word not only to the place where she held informal gatherings and where she kept her art collections, but to a whole complex of events – receptions, performances, meals, visits to her collections, and games of cards. The Empress played cards not solely for entertainment – behind the jokes and card games important affairs and human fates were decided.

Humour and mockery were an essential part of court life and were often very serious matters. Catherine's famous rules of conduct for her Hermitage (see page 15) can be perceived as a mere joke, but we can also read in them a witty satire on the lax behaviour of Peter's reign. The apocryphal story of Prince Potemkin conducting Catherine on a tour of the Crimea with cardboard villages set up along the river banks to create the impression of real – prosperous – settlements has given rise to the phrase "Potemkin villages". The Empress was clearly not so simple as to be deceived by pictures of prosperous villagers and happy peasants displayed along the river banks.

This story is surely part of the whole theatrical approach visible throughout the whole of Catherine's reign.

Catherine's theatre was so successful because it incorporated both skill and a considerable proportion of sincerity. This is particularly clear in her collecting activities. The Empress understood perfectly the demonstrative effect of a court museum and she was quite conscious of the fact that – in the eyes of Europe – a great collection was as important as a great army. She learned this from the example of Frederick the Great of Prussia – whom she then outdid at his own game.

Collecting was also a true passion, however. She loved to look over her engraved gems and her albums of prints and engravings. She watched new deliveries of paintings being unpacked in her private apartments with eagerness. It is today incredible to note the uniformly high level of the Hermitage collections dating from Catherine's time, for paintings were acquired en masse, and the Empress saw them only after they had been delivered to St Petersburg. Catherine's spirit and taste pervade the collections just as they make themselves felt in the buildings, the Winter Palace, the Small and Large Hermitages, despite the fact that they have each been rebuilt and reworked many times since her death. What better proof of her power and authority? Hence her portraits are to be found scattered all over the museum.

As was to be expected of a monarch, and particularly of a female monarch, it all started with precious objects and jewels. The crown jewels were kept in the Empress's own private apartments, in her Diamond Room, where she often gathered people of an evening to play at cards. This was the forerunner of the "Hermitage", a name initially used to describe the mezzanine apartments where Catherine received her friends surrounded by engraved gems and precious jewels, where guests could pass through a series of rooms each decorated in a different Oriental style, moving as it were from China to Turkey to Persia. From here the "imperial museum" grew and spread. First came a Hanging Garden with a pavilion housing mechanical dining tables which could be raised and lowered by servants from below, avoiding the necessity of servants eavesdropping on private conversations – this was the Hermitage itself; then came the Large Hermitage, the Hermitage Theatre, the Raphael Loggias. As Catherine's collections grew, they became active participants in Hermitage "happenings"... Today these objects serve to remind us of the brilliance of that life.

Modest private rooms and a sumptuous museum: these two elements symbolise the two sides of Catherine's character. Her way of life was well regulated. She rose at six and conducted affairs of state while she performed her toilet. For breakfast she drank only strong coffee (often made by herself), dining at around one o'clock in what was an important ceremony at which she gathered her closest courtiers and then officially removing to her library to read and write and to receive guests. In the evening, guests gathered in her apartments or in her Hermitage for conversation and cards. The Empress did not usually take supper, and was often in bed by eleven.

A simple way of life, to all appearances. But then again, she liked to play cards for diamonds, which lay in heaps in special boxes on the tables. The courtiers' rich attire was dazzling. Dinner services employed for imperial receptions are today considered

ПРАВИЛА
ПО КОТОРЫМЪ ПОСТУПАТЬ ВСѢМЪ ВХОДЯЩИМЪ ВЪ СІИ ДВЕРИ.

1.
Оставить всѣ чины внѣ дверей равномѣрно какъ и шляпы, а наипаче шпаги.

2.
Мѣстничество и спесь, или тому что либо подобное, когда бы то случилось, оставить у дверей.

3.
Быть веселымъ, однако ничего не портить, и не ломать, и ничего не грызть.

4.
Садиться, стоять, ходить, какъ кто за благо разсудитъ, не смотря ни на кого.

5.
Говорить умѣренно, и не очень громко, дабы у прочихъ тамо находящихся уши или голова не заболѣла.

6.
Спорить безъ сердца, и безъ горячности.

7.
Не вздыхать, и не зѣвать, и ни кому скуки или тягости не наносить.

8.
Во всякихъ невинныхъ забавахъ что одинъ вздумаетъ, другимъ къ тому приставать.

9.
Кушать сладко и вкусно, а пить съ умѣренностію, дабы всякій всегда могъ найти свои ноги, вы ходя изо дверей.

10.
Ссоры изъ избы не выносить; а что войдешъ въ одно ухо, то бы вышло въ другое прежде нежели выступитъ изо дверей.

Если кто противу вышесказаннаго проступится, то по доказательству двухъ свидѣтелей за всякое преступленіе каждый проступившійся долженъ выпить стаканъ холодной воды, не изключая изъ того и дамъ, и прочесть страницу Тилемахиды громко.

А кто противу трехъ статей въ одинъ вечеръ проступится, тотъ повиненъ вы учить шесть строкъ изъ Тилемахиды на изусть.

А если кто противу десятой статьи проступится, того болѣе не впускать.

Catherine's Rules for Behaviour in her Hermitage

Right
Translation of the Rules

RULES
FOR THE BEHAVIOUR OF ALL THOSE
ENTERING THESE DOORS

1. All ranks shall be left outside the doors, similarly hats, and particularly swords.

2. Orders of precedence and haughtiness, and anything of such like which might result from them, shall be left at the doors.

3. Be merry, but neither spoil nor break anything, nor indeed gnaw at anything.

4. Be seated, stand or walk as it best pleases you, regardless of others.

5. Speak with moderation and not too loudly, so that others present have not an earache or headache.

6. Argue without anger or passion.

7. Do not sigh or yawn, neither bore nor fatigue others.

8. Agree to partake of any innocent entertainment suggested by others.

9. Eat well of good things, but drink with moderation so that each should be able always to find his legs on leaving these doors.

10. All disputes must stay behind closed doors; and what goes in one ear should go out the other before departing through the doors.

If any shall infringe the above, on the evidence of two witnesses, for any crime each guilty party shall drink a glass of cold water, ladies not excepted, and read a page from the Telemachida* out loud.

Who infringes three points on one evening, shall be sentenced to learn three lines from the Telemachida by heart.

If any shall infringe the tenth point, he shall no longer be permitted entry.

* A poem of 1766 by Vasily Trediakovsky, relating the adventures of Telemachus, son of Odysseus. Over-long, old-fashioned and heavy, the poem was perceived by contemporaries as the very model of bad poetry.

English Heliotrope Table Nécessaire in a Gold Frame
[Cat. 125]

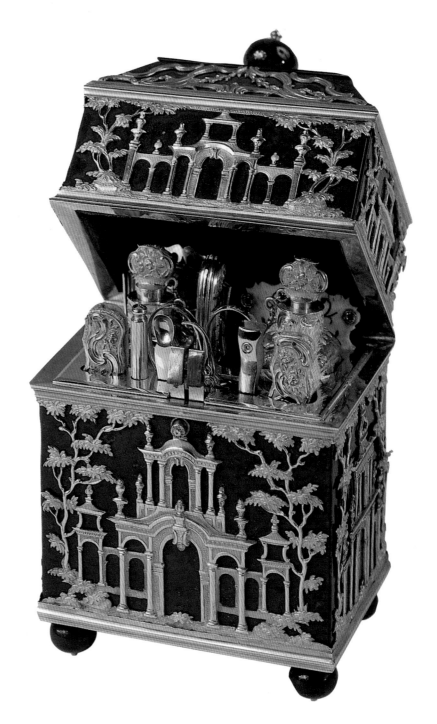

masterpieces of applied art. Grandiose and luxurious celebrations and masquerades were as much a part of life at Catherine's court as were romantic liaisons, both open and secret.

Catherine left her adopted country and her adopted people a rich inheritance. Any mention of the Hermitage and its incredible collections today inevitably leads on to talk of her. She not only herself acquired a veritable sea of masterpieces, she left to her heirs a tradition of collecting as an important element in state affairs. She created a museum which was a symbol of Russia's openness to the world, a paradigm of Russian cultural history, in which national pride co-exists happily with internationalism.

Visiting Masterpieces

1

Nicolas Poussin. 1594–1665
Moses Striking the Rock

Book of Exodus xvii: 5-6
Oil on canvas. 122.5 × 191
Inv. No. GE 1177
Provenance: 1779, acquired from George, 3rd Lord Orford, as part of the Walpole
Collection from Houghton Hall; acquired by Sir Robert Walpole before 1736; inherited by
M.A. Malandier from her aunt, Claudine Bouzonnet-Stella, who inherited it from her
uncle, the artist Jacques Stella; painted for Jacques Stella.

Poussin's iconographical source for this painting was probably
Josephus Flavius's *Judaean Antiquities*, which describes precisely
those details seen in the Hermitage canvas. Josephus makes
particular reference to the cliff split in two and the stream of
water which appeared: "Moses struck the rock with his staff; at
that instant it was rent in two and from it flowed in great
abundance water of extreme clarity" (Book III, Chapter I).

The attribution and the dating to 1649 have never been open to
doubt and are based on the evidence of the 17th-century authors
Félibien, Bellori and Baldinucci.

There are preparatory drawings in the Hermitage (Inv. Nos
OR 13549, OR 18548), the Louvre, Paris (Inv. No. 843) and in the
National Museum, Stockholm, and a variation of the
composition is in the collection of the Duke of Sutherland (on
loan to The National Gallery of Scotland, Edinburgh).

The painting was copied and engraved on numerous occasions.
Blunt (1966) listed 9 copies.

EXHIBITIONS:

Exposition Nicolas Poussin, Louvre, Paris, 1960, No. 88

Nicolas Poussin, Grand Palais, Paris, 1994, No. 185

Nicolas Poussin, Royal Academy of Arts, London, 1995, No. 185

LITERATURE:

A. Blunt: *The Paintings of Nicolas Poussin. A Critical Catalogue*, London, 1966, No. 23

W. Friedländer: *Nicolas Poussin. A New Approach*, London, 1966, pp. 53, 61

C. P. Landon: *Vie et oeuvre complète de Nicolas Poussin*, Paris, 1814, No. xx

E. Magne: *Nicolas Poussin, premier peintre du Roi*, Brussels – Paris, 1914, p. 155, No. 149

J. Thuillier: *Toute l'oeuvre peinte de Poussin*, Paris, 1974, No. 161

E. K. Waterhouse: "Poussin et l'Angleterre jusqu'en 1744", *Nicolas Poussin (Actes du Colloque
International, Paris, 19-21 Septembre 1958)*, 2 vols, Paris, 1960, vol. 1, p. 290

W. Wild: *Nicolas Poussin*, 2 vols, Zurich, 1980, Bd. 1, S. 148-9; Bd. 2, No. 151

Y. Zolotov, N. Serebriannaia, N. Petroussevitch, M. Maiskaia, I. Kouznetsova:
Nicolas Poussin dans les musées de l'Union Sovietique. Peintures. Dessins, Leningrad, 1990, No. 33

N.S.

Catherine enraged British public opinion with her acquisition in
1779 of the paintings from Houghton Hall, collected by Britain's
first Prime Minister, Sir Robert Walpole, 1st Lord Orford.
Recognised by contemporaries as one of the most outstanding
collections in England, rumours of its sale by the 3rd Lord Orford
provoked a speech in Parliament. Protests were to no avail,
however, and Catherine successfully acquired 204 works from
Orford, including large groups of paintings by Rubens, Van Dyck
and Carlo Maratti, excellent pieces by Murillo, Snyders and Guido
Reni, and two works each by Claude Lorrain and Poussin.

The sale was to be recalled bitterly for years to come both in the
press and in the memoirs of British tourists to Russia. In February
1782, for instance, *The European Magazine* stated tragically that:
"The removal of the Houghton Collection of Pictures to Russia is,
perhaps, one of the most striking instances that can be produced
of the decline of the empire of Great Britain, and the advancement
of that of our powerful ally in the north…"

The portrait of Catherine the Great which hangs in Gallery 1 is
thought to have been a gift to George, 3rd Lord Orford, from
Catherine herself, a mark of her gratitude upon purchase of this
magnificent collection.

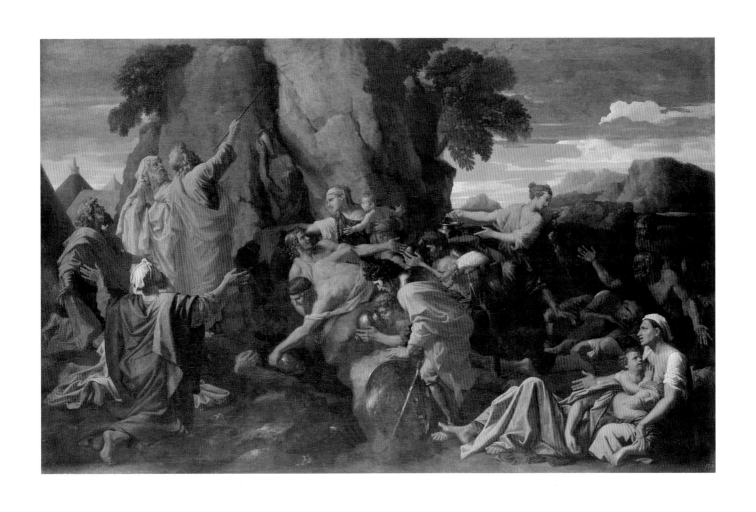

2

Jacob Jordaens. 1593-1678
Allegorical Family Portrait

Oil on canvas. 178.4 × 152.3
Inv. No. GE 485
Provenance: 1764, acquired with the collection of Johann Gotzkowski, Berlin; 1734, passed at auction of Jacob Jordaens, The Hague, 22 March (No. 100).

In this allegorical painting (an unusual genre for Jordaens), none of the figures have been identified. Nevertheless, the figure of Cupid aiming an arrow at the young woman's breast and other symbolical details indicate that it should be understood as a depiction of an engagement or marriage (1968 Ottawa, No. 106; De Jongh 1986).

Carnations (in the background to left) are an ancient symbol of marriage; the fountain with its Cupid on a dolphin hints at love's source; flowering branches are a sign of purity and chastity; the winding vine (background right) represents conjugal affection; the parrot (on the bride's arm) indicates conjugal fidelity. Judging by her facial features, the woman to the viewer's right may be the bride's sister.

The fountain with a Cupid would appear to derive from works by Rubens (compare, for instance, the engraving by Christoffel Jegher, 1596-1652/3, after Rubens's *Susanna and the Elders*). A similar fountain stood in the garden of Rubens's house in Antwerp and is shown in Rubens's *The Walk (Rubens and Hélène Fourment in the Garden of Their House)* (Alte Pinakothek, Munich).

Family Portrait is dated to the 1650s on the basis of the costumes and similarities in style of execution with other works by Jordaens from that period.

Jordaens is not known to have produced any other portraits of this type, but in 1969 Jaffé (1969) published a drawing which is a copy from Jordaens's group – a variant on the Hermitage composition.

EXHIBITIONS:

Jacob Jordaens (1593-1678), catalogue by Michael Jaffé, National Gallery of Canada, Ottawa, 1968, No. 106

Yakob Iordans (1593-1678). Zhivopis. Risunok. Katalog vystavki k 300-letiyu so dnya smerti Ya. Iordansa [Jacob Jordaens (1593-1678). Paintings. Drawings. Catalogue of an Exhibition on the 300th Anniversary of the Death of J. Jordaens], State Hermitage, Leningrad, 1979, No. 8

Jacob Jordaens (1593-1678). Paintings and Tapestries. Drawings and Engravings, Koninklijk Museum voor Schone Kunsten, Antwerp, 1993, No. A80

Catherine the Great & Gustav III, Nationalmuseum, Stockholm, 1999, No. 386

LITERATURE:

H. Fierens-Gevaert: *Jordaens*, Paris, 1906, p. 107

N. Gritsay: "Portrety Yakoba Iordansa v Ermitazhe" [Portraits by Jacob Jordaens in the Hermitage", *Trudy Gosudarstvennogo Ermitazha* [Papers of the State Hermitage], issue XVIII, 1977, pp. 91-3

G. Hoet: *Catalogus of naamlyst van schildereyen, met derzelver pryzen, zedert een langen reeks van jaaren zoo in Holland als op andere plaatzen in het openbaar verkogt ... ,* 's-Gravenhage, 1752, vol. I, blz. 405, lot 100

R.-A. d'Hulst: *Jacob Jordaens*, Stuttgart, 1982, p. 291

M. Jaffé: "Reflections on the Jordaens Exhibition", *Bulletin of the National Gallery of Canada, Ottawa*, No. 13, 1969, p. 16, No. 106

E. De Jongh: *Portretten van echt en trouw. Huwelijk en gezin in de Nederlandse Kunst van de zeventiende eeuw*, exh. cat., Frans Halsmuseum, Haarlem, 1986, blz. 32-3

N.I.G.

Just a year after coming to the throne in 1762, Catherine embarked on a series of wholesale purchases of magnificent collections, her motivation not solely a love of art. Her first such acquisition, in early 1764, was of 225 canvases from Johann Gotzkowski, including this work and Hals's *Portrait of a Young Man with a Glove* (Cat. 3). Gotzkowski was a Berlin merchant who had amassed the paintings for Frederick II of Prussia. Financial difficulties resulting from the Seven Years' War meant that Frederick was unable to pay for the paintings, and Catherine would seem to have been inspired by a desire to prove herself not only as cultured as other European rulers, but also richer.

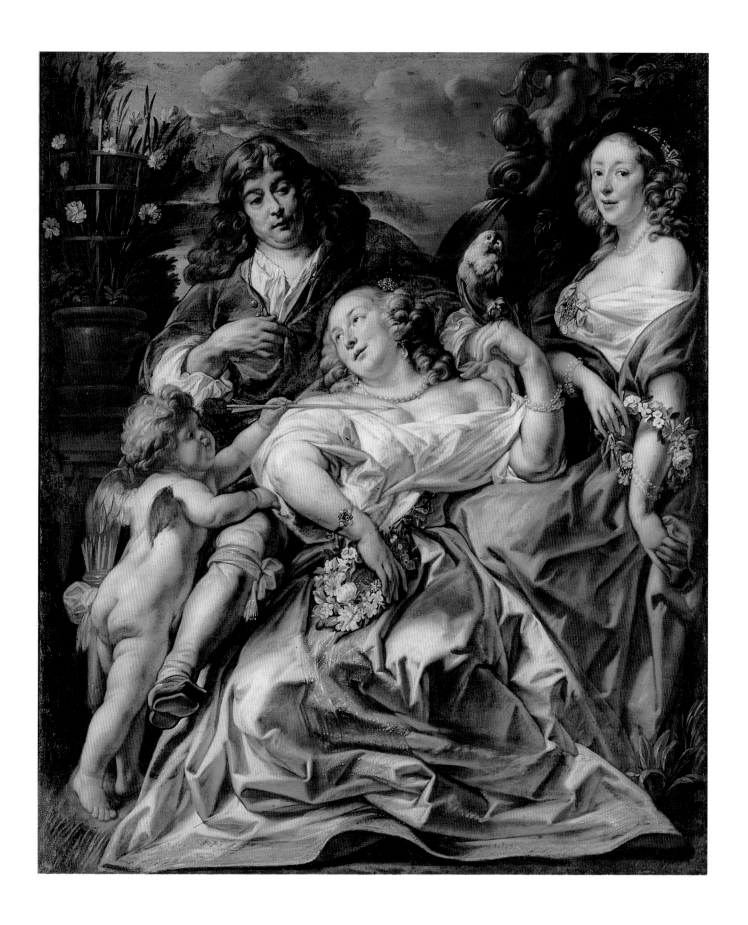

3

Frans Hals. 1582/3-1666

Portrait of a Young Man with a Glove

Oil on canvas. 80 × 66.5 (with additions at top and along both sides)
Inv. No. GE 982
Monogram to right: *FH*; traces of another monogram visible below
Provenance: 1764, acquired with the collection of Johann Gotzkowski, Berlin; c. 1670 in a collection in England.

The unidentified elegant young man wears a wide-brimmed hat and is shown three-quarter face, a compositional scheme often found in Hals's mature works. He looks down at the viewer and together with the gesture of the right hand resting on his chest this gives him a proud appearance. Light falling on the face and ground around the sitter's head accentuates the expressive silhouette. The man's attire plays an important role in the overall colour scheme, but particular stress is placed on the white collar and ochre-brown gloves. Hals has a rich, painterly style, manifested in free brushstrokes and the rich variety of shades of black in the costume.

In the 1670s this portrait was engraved (in reverse) by Edward Le Davis (?1640-84?), on the same sheet as a figure from another, earlier painting by Hals, the so-called *Mulatto* (Museum der bildenden Kunste, Leipzig). This engraving, published in London, bears the inscription "The Mountebanck Doctor and His Merry Andrew". Seymour Slive emphasised that such a free interpretation and transformation of two works by Hals may have been the idea of the engraver himself. Le Davis's composition is evidence that both canvases were in England at this time.

R. E. Hutchinson, Keeper of the Scottish Portrait Gallery, was the first to note that the Hermitage portrait might be identified with "an exceeding fine portrait of a physician by Francis Halls" listed under No. 99 in the sale catalogue for the collection of Colonel Charteris sometime around 1732. The portrait was purchased by a Mr Stewart.

Slive also drew attention to a reference in the notebooks of George Vertue for c. 1750 to "a picture 3/4 painted of a Doctor by Frans Hals" then in his possession.

When the portrait arrived in St Petersburg in August 1764, it was listed in the inventory as "a good portrait of an officer… two hundred and fifty reichsthalers, with a seal [i.e. monogram – I.A.S.], painted by master Frans Hals". A printed catalogue of the Hermitage Picture Gallery produced in 1774, however, says simply "Portrait of a man in black attire and flat collar", a less specific identification of the sitter which is echoed in all later Hermitage catalogues.

Most scholars agree in dating the painting to around 1640, when Hals's work underwent some changes: the excessive jollity of the heroes in his earlier works, their rich costumes and bright colouring, are replaced by a more restrained, monochrome treatment.

EXHIBITIONS

Master Paintings from the Hermitage Museum, Leningrad, National Museum of Western Art, Tokyo; Kyoto Municipal Museum of Art; Tokyo, 1977, No. 19

Works by Western European Masters from the Hermitage Collection, Hokkaido Museum of Modern Art, Sapporo, 1985 [In Japanese with some Russian], No. 32

Dutch and Flemish Paintings from the Hermitage, The Metropolitan Museum of Art, New York; Art Institute of Chicago; New York, 1988

L'Age d'or flamand et hollandais. Collections de Catherine II. Musée de l'Ermitage, Saint-Pétersbourg, Musée des Beaux-Arts de Dijon, 1993, No. 11

Catharina, de keizerin en de kunsten. Uit de schatkamers van de Hermitage/ Catherine, the Empress and the Arts, Treasures from the Hermitage, De Nieuwe Kerk, Amsterdam, 1996, No. 80

LITERATURE:

W. von Bode, M. J. Binder: *Frans Hals, sein Leben und seine Werke,* 2 vols, Berlin, 1914, Abb. 123A

C. Grimm: *Frans Hals. Entwicklung, Werkanalyse, Gesamtkatalog,* Berlin, 1972, S. 106, No. 129

C. Grimm: *Frans Hals. The Complete Work,* New York, 1990, No. 161

C. Hofstede de Groot: *Beschreibendes und kritisches Verzeichnis der Werke der hervorragendsten holländischen Maler des XVII. Jahrhunderts,* Paris-Erlingen, 1907-28, Bd 3, No. 308

E. W. Moes: *Frans Hals, sa vie et son oeuvre,* traduit par J. de Bosschere, Brussels, 1909, p. 181

E. C. Montagni: *L'opera completa di Frans Hals,* Milan 1974, No. 161

S. Slive: *Frans Hals,* 3 vols, London – New York, 1970-4, vol. I, p. 97; vol. II, p. 214

S. Slive: *Frans Hals,* exh. cat., ed. Seymour Slive, National Gallery of Art, Washington; Royal Academy of Arts, London; Frans Halsmuseum, Haarlem; 1989-90, p. 223, note 3

N. Trivas: *The Paintings of Frans Hals,* London – New York, 1941, p. 76

W. R. Valentiner: *Frans Hals,* Stuttgart – Berlin – Leipzig (*Klassiker der Kunst*), 1923, S. 197

Zapiski Yakoba Shtelin ob izyashchnykh iskusstvakh v Rossii [The Notes of Jacob Stählin on the Fine Arts in Russia], 2 vols, Moscow, 1990, vol. II, p. 99

I.A.S.

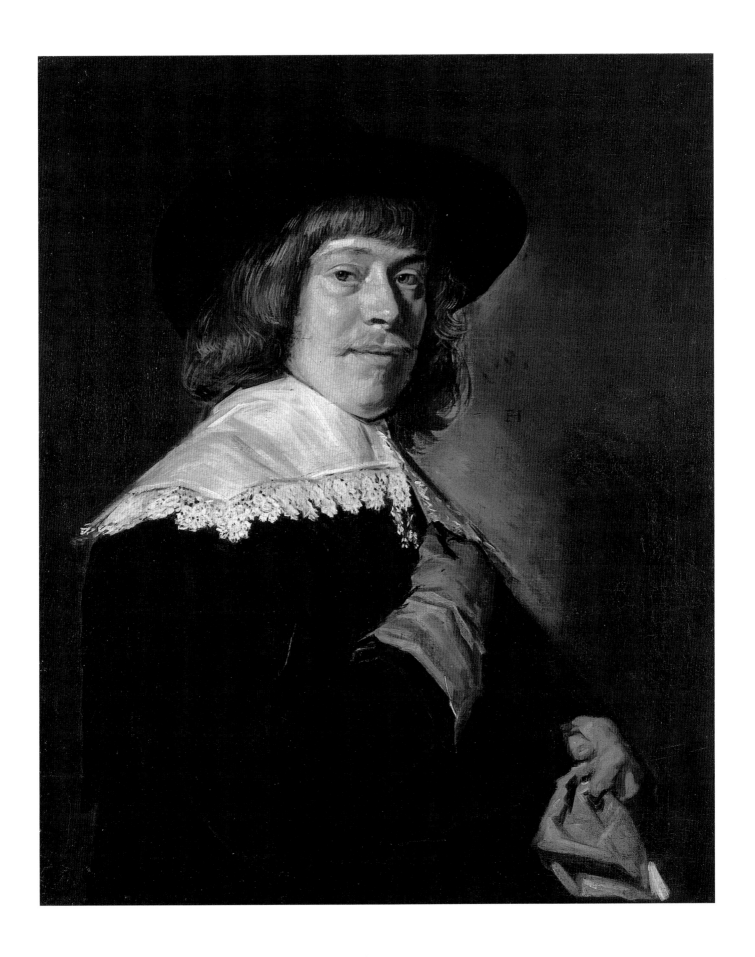

Short Reference Guide

Russia adopted the Gregorian calendar only in 1918. In the 18th century there were 12 days difference between the Julian calendar in use in Russia and the Gregorian calendar used in Europe (i.e. 1 February in St Petersburg was actually 13 February in London). Dates used in this exhibition refer to the Julian calendar (Old Style, or OS) unless otherwise stated.

BUILDINGS OF THE HERMITAGE

Winter Palace – 1754-62
architect Bartolomeo Rastrelli

Small Hermitage – 1764-7
architect Jean-Baptiste Vallin de la Mothe

Large (Old) Hermitage – 1771-87
architect Yury Velten

New Hermitage – 1839-52
architect Leo von Klenze

Hermitage Theatre – 1783-7
architect Giacomo Quarenghi

Until 1917 the **Winter Palace** was an imperial residence and the Hermitage an imperial museum, housed in a separate wing of the palace, although it opened to the public in 1852. All imperial property, including the Hermitage, was nationalised after the February Revolution in 1917, and the Winter Palace was gradually transferred to the museum's control over the next decades.

The Hermitage was predated by the **Kunstkammer, St Petersburg,** the oldest museum in Russia, opened to the public in 1719 by Peter the Great, with the aim of improving and educating his subjects. It incorporated minerals, scientific specimens, skeletons and examples of anatomical anomalies (preserved in jars), found objects, unusual jewels and works of applied art. It became part of the Academy of Sciences in 1724. After the monarch's death in 1725, his personal collection of curiosities was added to the Kunstkammer.

HISTORICAL OUTLINE

1703 Foundation of St Petersburg by Peter the Great

1712 St Petersburg becomes official capital of the Russian Empire

1724 Peter the Great issues decree founding the Academy of Sciences (opens 1725)

1729 Birth of Sophia Frederika Augusta of Anhalt-Zerbst, later Catherine II

1744 Sophia arrives in St Petersburg and adopts the Russian Orthodox religion, taking the name Catherine (Yekaterina Alexeyevna)

1745 Catherine marries Grand Duke Peter, heir to the Russian throne

1754 Birth of Catherine's son Paul

1756 Start of the Seven Years' War

1757 Russia joins the Seven Years' War against Prussia. Foundation of the Academy of Arts

1761 Death of Empress Elizabeth. Grand Duke Peter succeeds to the throne as Peter III

1762 End of the Seven Years' War, Peace of Paris. Birth of Alexey Bobrinsky, Catherine's illegitimate son by her lover Grigory Orlov

1762 Peace declared between Russia and Prussia. Overthrow and assassination of Peter III after a reign of just six months. Catherine seizes the throne and is crowned almost immediately. Liberation of the Russian nobility from compulsory service to the state

1764 Stanislas Poniatowski, a former lover of Catherine's, is elected King of Poland

1767 Catherine issues her "Instruction", a philosophical and legal treatise presented to a Legislative Commission set up to compile a new Code of Laws

1768-74 War with Turkey

1770 Defeat of the Turkish fleet at Chesme

1773 Grand Duke Paul marries Wilhelmina, Princess of Hesse-Darmstadt, who takes the Russian Orthodox name Natalya Alexeyevna

1774 Treaty of Kuchuk-Kaynardzhi, by which Turkey cedes the Crimea to Russia

1776 Death of Natalya Alexeyevna: Grand Duke Paul marries Sophia Dorothea, Princess of Württemburg, who takes the Russian Orthodox name Maria Fyodorovna

1777 Birth of Alexander, Catherine's first grandson, later Alexander I

1779 Birth of Constantine, Catherine's second grandson

1782 Unveiling in St Petersburg of the Bronze Horseman, Etienne Falconet's equestrian monument to Peter the Great

1783 Final annexation of the Crimea by Grigory Potemkin. Death of Grigory Orlov

1784 Death of Catherine's favourite Alexey Lanskoy

1786 Foundation of Loktev (later Kolyvan) lapidary works

1787 Catherine visits the Crimea, accompanied by Joseph II of Austria.

1787-91 War with Turkey, the Russian forces commanded by Grigory Potemkin

1791 Death of Grigory Potemkin

1796 Death of Catherine the Great. Her son, Paul I, becomes emperor

THE ROMANOV DYNASTY FROM PETER THE GREAT

Peter I	1682-1725
Catherine I	1725-7
Peter II	1727-30
Anna Ioannovna	1730-40
Ivan VI	1740-1
Elizabeth	1741-61
Peter III	1761-2
Catherine II	1762-96
Paul I	1796-1801
Alexander I	1801-25
Nicholas I	1825-55
Alexander II	1855-81
Alexander III	1881-94
Nicholas II	1894-1917

Biography of an Empress

Catherine's Life

GERALDINE NORMAN

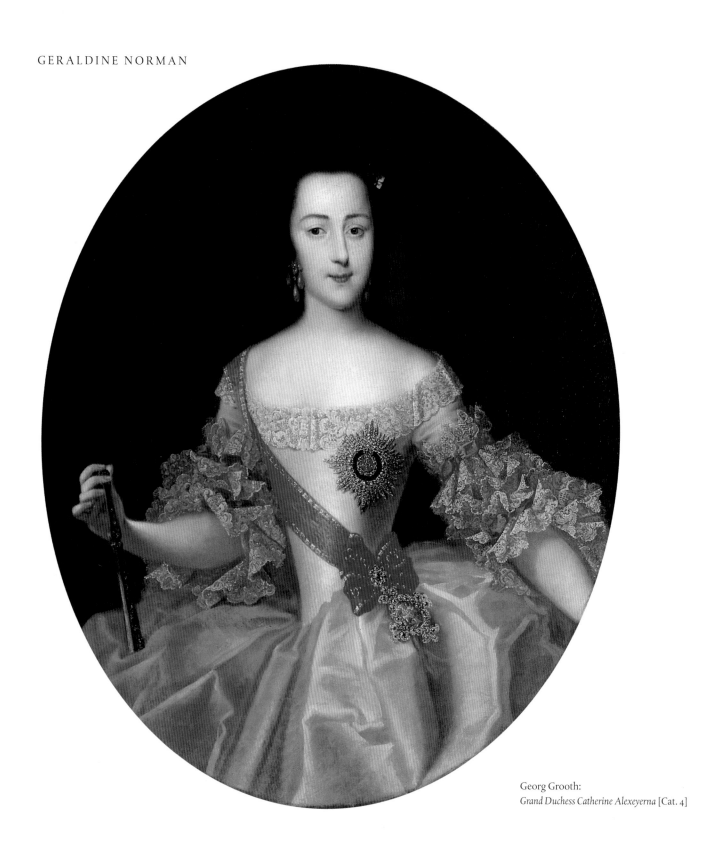

Georg Grooth:
Grand Duchess Catherine Alexeyerna [Cat. 4]

Catherine was one of the greatest art collectors of all time in both the scale and quality of her purchases. In 1790, six years before her death, she explained in a letter to her friend and agent Melchior Grimm how her collection surpassed those of all other monarchs of her day: "Besides the paintings and the Raphael loggia", she wrote, referring to her 4,000 Old Masters and copies of Raphael's Vatican frescoes, "my museum in the Hermitage contains 38,000 books; there are four rooms filled with books and prints, 10,000 engraved gems, roughly 10,000 drawings and a natural history collection that fills two large galleries." She did not mention the superb examples of the decorative arts she had commissioned or her 16,000 coins and medals.

She tended to buy in bulk, her purchases frequently serving as tools of statesmanship. Her first major purchase, in 1764, of 225 magnificent Old Masters that a Berlin dealer had gathered for Frederick of Prussia – who could not afford to pay for them – was a humiliation for a monarch with whom Russia had recently been at war. Buying the collection formed by Sir Robert Walpole, Britain's first Prime Minister, in 1779 had the additional attraction of demonstrating the superior purchasing power of the Russian Empire over the British. Poussin's *Moses Striking the Rock*, which returns to Britain for this exhibition, was one of the masterpieces of Walpole's collection.

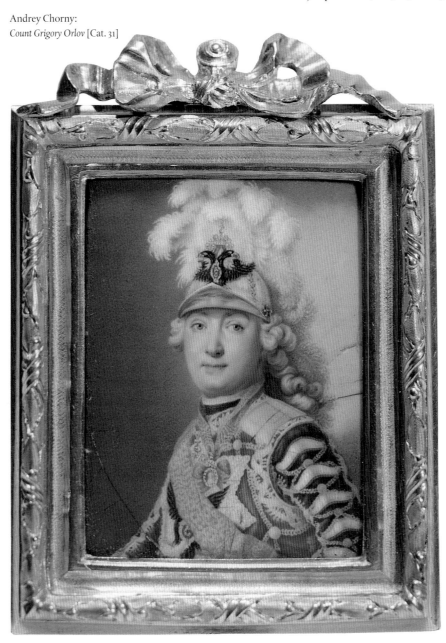

Andrey Chorny:
Count Grigory Orlov [Cat. 31]

Catherine was born on 29 April 1729, the daughter of Prince Christian August of Anhalt-Zerbst and his wife Johanna, Princess of Holstein Gottorp, whose brother became King of Sweden in 1751. She was baptised Sophia Frederika Augusta according to the Lutheran rite. Selected at the age of 14 as a suitable bride for her second cousin Karl Peter Ulrich of Holstein Gottorp, heir of the childless Empress Elizabeth of Russia, Sophia set off for St Petersburg with her mother. She converted to the Russian Orthodox religion in Moscow at the age of 15, taking the name Catherine Alexeyevna, and was married to Peter on 21 August 1745, shortly after her sixteenth birthday.

She had no legitimate claim to the Russian throne, yet just six months after her husband's accession as Peter III she ousted him to rule in her own right. Within days of

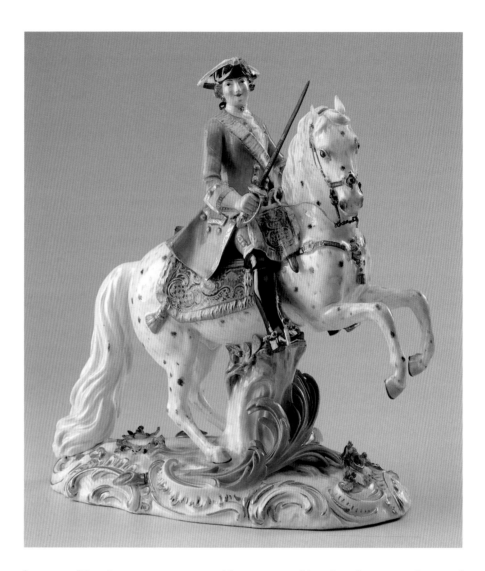

her coup d'état Peter was assassinated by a group of her friends. No one knows if Catherine was party to the plot but she certainly condoned it, issuing a statement that he had died of one of "his habitual haemorrhoidal attacks together with a violent colic".

Catherine went on to make St Petersburg one of Europe's most glittering and civilised capitals. It was for her statesmanship, however, that she was to become known as "the Great". She extended Russia's frontiers to the Black Sea in the south, annexing the Crimea in 1783, and swallowed up much of Poland to the West. She rationalised Russia's local government structure, revised Russia's antiquated legal system and sought to introduce the Spirit of the Enlightenment into Russia. She summoned a Legislative Commission in 1767, elected by the various free orders of society, to prepare a new Code of Laws based on the "Instruction" she had drafted, drawing on authors such as Montesquieu and Beccaria. No Code resulted, but the Commission, which sat until 1774, produced much material in which Catherine was to draw extensively in her later reforms.

Grooth's portrait of Catherine at the time of her marriage, the earliest included here, depicts a strong-minded, dark haired girl in an elegant, lace-trimmed dress, her new station accentuated by the diamond Great Cross and sash of the order of St Catherine

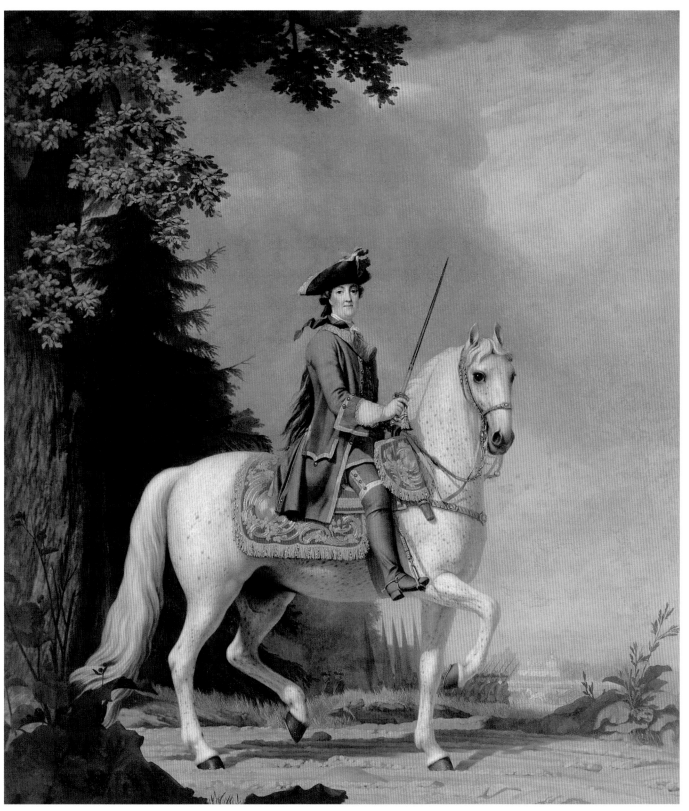

Vigilius Eriksen:
Equestrian Portrait of Catherine II [Cat. 10]

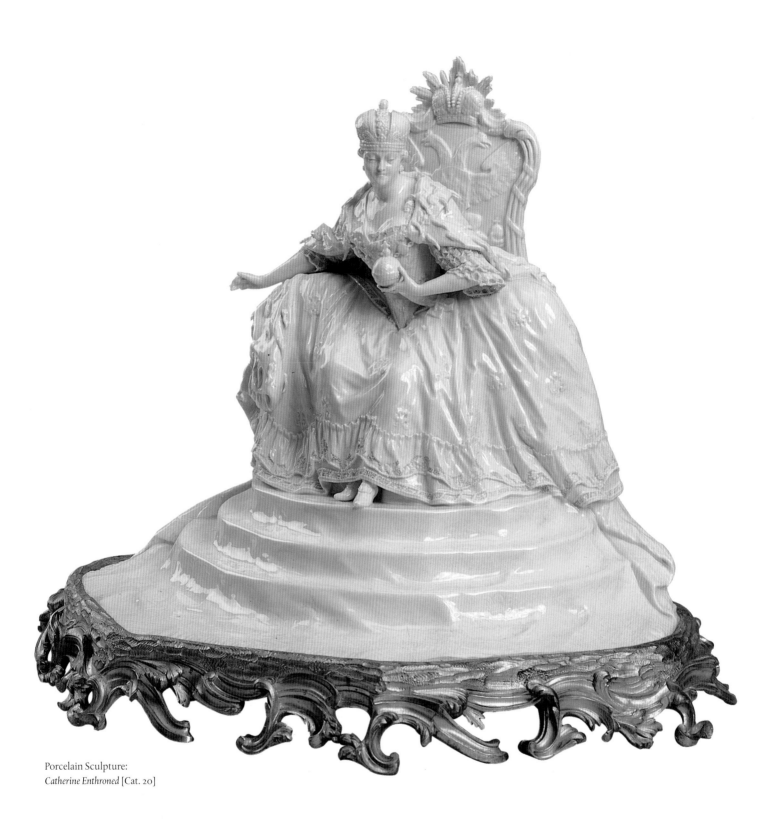

Porcelain Sculpture:
Catherine Enthroned [Cat. 20]

conferred on her by Elizabeth. Despite the conventional flattery required of a court painter, the engravings of Peter and Catherine, executed a few years later, cannot obscure the weakness of character in Peter's face.

Peter, who was only one year older than Catherine, was mentally and emotionally immature and dominated by a childish passion for playing soldiers. Catherine's initial attempts to please or appease him were a failure and her marriage was followed, she said, by "18 years of boredom and loneliness [which] forced her to read many books." A passionate admirer of Voltaire, Diderot and the Encyclopédistes, she was very well read and considered a bluestocking by her contemporaries.

It has been suggested that Peter was infertile. If so, Catherine's son and successor, Paul I, was most probably fathered by a handsome courtier called Sergey Saltykov, the first of her succession of lovers. Empress Elizabeth was present at the birth and immediately took the child back to her own room. Catherine tells us in her memoirs that she comforted herself by reading Tacitus's *Annals*, Voltaire's *Essay on the Customs and Spirit of Nations* and Montesquieu's *Spirit of the Laws*. Elizabeth brought Paul up – Catherine was rarely allowed to see him. She was to do the same herself with Paul's two eldest sons, Alexander and Constantine, whom she educated and clearly adored.

When Elizabeth died in 1761 Catherine was in love with a Guards officer, Grigory Orlov, the eldest of five enterprising brothers. While her husband, newly proclaimed Peter III, alienated the nation by insulting the Orthodox Church and making an abject peace with Frederick the Great of Prussia, Catherine, concealing her pregnancy under her wide mourning robes, gave birth to a son by Grigory Orlov. Carl Christineck's charming portrait of the child, Alexey Bobrinsky, born on 11 April 1762, outshines contemporary images of Paul, the legitimate heir.

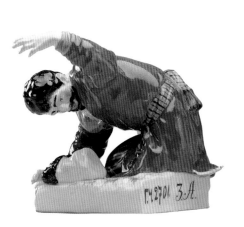 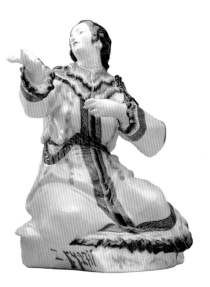

Porcelain Figure:
Kneeling Russian Peasant [Cat. 21]

Porcelain Figure:
Woman in National Costume [Cat. 22]

Shortly afterwards, those who were planning to replace Peter III with his wife, fearing betrayal, acted precipitously. Catherine was spending a few days at the seaside palace of Peterhof when Alexey Orlov arrived in a hurry on 28 June 1762 to fetch her back to St Petersburg, where she was proclaimed Empress in her own right. The five brothers and their friends had worked hard to win the support of the army and the Church, both of which institutions recognised Catherine as Empress.

It appears to have been a genuinely popular move, despite some initial divergence over whether she should reign in her own right or merely as regent for her son Paul. Catherine herself was in no doubt and was careful, throughout her long reign, to distance Paul from affairs of state in case his supporters should seek to oust her.

Catherine was admired for her good looks, her cheerful disposition, her intelligence and her optimism. She was "pretty rather than beautiful", according to the Prince de Ligne, friend of Emperor Joseph II. "Her eyes and her agreeable smile made her large forehead seem smaller. But this forehead still told all… it betokened genius, justice, precision, boldness, depth, equanimity, tenderness, serenity, tenacity, and its width all testified to her well developed memory and imagination. It was clear that there was room for everything in this forehead."

Grigory Orlov remained her lover during the first decade of her reign. The miniature of Orlov in a plumed helmet suggests a handsome and dressy young officer, capable of breaking many hearts. Catherine was clearly deeply attached to him and their relationship lasted for 12 years until his flagrant infidelities led to his dismissal as favourite in 1772.

During these years Catherine was absorbed with applying the ideas of the Enlightenment to governance. Another miniature shows Catherine holding her famous "Instruction". This document, comprising 20 chapters and 526 articles, described her vision of how Russia was and should be governed. The dominant influences on her thought at this time were still the Encyclopédistes, Montesquieu and Beccaria, the Italian jurist. She also became an ardent admirer of the English jurist Sir William Blackstone, the French translation of whose *Commentaries on the Laws of England* became her bedside book for many years and the inspiration of some of her reforms.

Catherine's 18 years of solitary reading bore fruit after she became Empress. She bought Diderot's library in 1766 when he was in financial difficulties, leaving it in his Paris home and paying him a salary to work as its "librarian". She corresponded regularly with Voltaire from 1763 to his death in 1778, when she bought his books as well. She shipped them back to St Petersburg and built a special library in the Winter Palace to accommodate the 7,000 red morocco-bound volumes. A view of the library with Houdon's marble portrait of the seated Voltaire, also commissioned by Catherine, in the distance, shows the splendour of the environment she felt Voltaire's books deserved.

With its ornamental obelisk, arched ceiling and marble columns, the library reflects Catherine's definite Neoclassical preferences. After the riot of Baroque ornament favoured by Elizabeth, Catherine's taste seems restrained, almost severe. This is apparent from her jewels, jewelled boxes, jewelled watches and chatelaines, which become simpler in design as her reign progresses, deriving their visual impact increasingly from classical balance of form rather than rich encrustation with precious stones. Catherine was not,

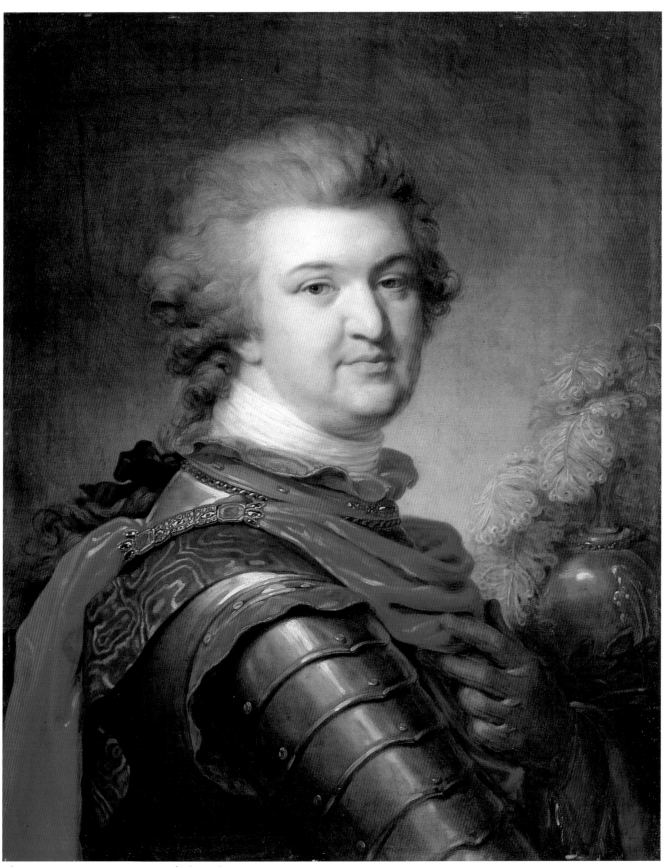

Johann-Baptist Lampi: *Prince Grigory Potemkin* [Cat. 14]

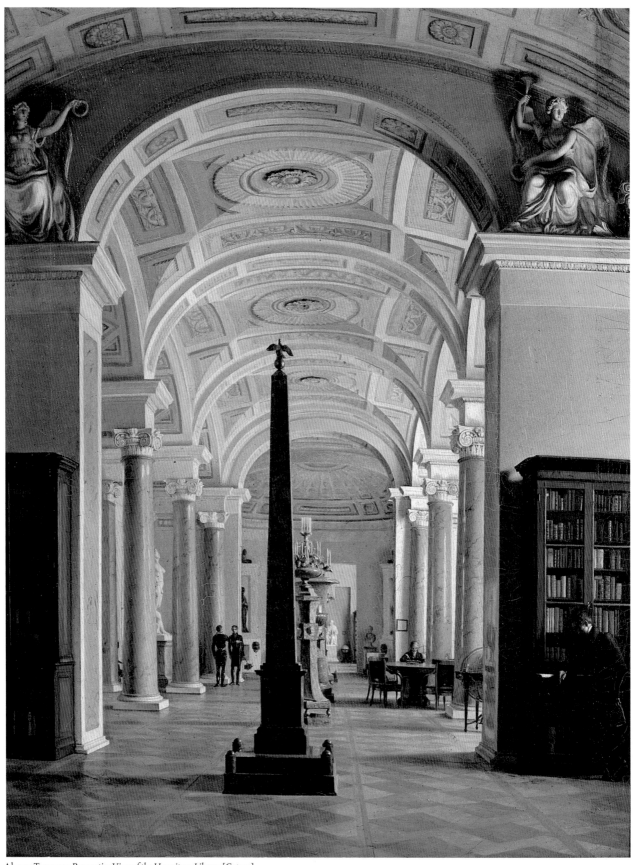

Alexey Tyranov: *Perspective View of the Hermitage Library* [Cat. 15]

however, opposed to opulence. She understood the necessity of pomp and circumstance to give radiance to her court and to attract the allegiance of the people.

Her study of history generated a fascination with Antique coins and medals and she commissioned sumptuous gold medals to commemorate the great events of her own reign, including her own coronation, the inauguration of the Academy of Fine Arts, the annexation of the Crimea and the introduction of smallpox vaccination. The latter reflects the remarkable courage of both Catherine and the British doctor, Thomas Dimsdale, who inoculated her with great public pomp in 1768, as an example to the rest of the country. If anything had gone wrong Dimsdale would surely have lost every shred of reputation – but it was successful and Catherine raised him to the rank of Baron.

There are medals to commemorate events in the lives of many of Catherine's lovers, but above all the glorious achievements of Grigory Potemkin, whom she was to appoint Governor of southern Russia and Prince of Tauris after the annexation of the Crimea (the Tauris of Antiquity).

Potemkin was ten years Catherine's junior and first came to her attention during the coup of 1762. He went on to distinguish himself in the Turkish war of 1768-74, although it was not until 1774 that he became her lover and then only for two years. He remained, however, in some sense her consort, the statesman who directed the country at her side and fought her wars. It is said that they were secretly married. Their intimacy was one of intellectual equals and passionate friends – they wrote to each other every day when parted. Contemporary sources depict Potemkin as brilliant, moody and theatrical.

Frederick the Great's gift of a Berlin porcelain service to Potemkin in 1778 underlines the recognition of his status throughout Europe as Catherine's favourite. The Hermitage has over 200 pieces from this service, decorated with scenes of Potemkin's victories and with views of southern Russia. In these early days of European porcelain production, factories were almost private fiefdoms of the sovereign and a useful source of diplomatic gifts. Frederick had given Catherine a Berlin dessert service in 1772 which included a spectacular surtout-de-table comprising figures of the Empress enthroned surrounded by representatives of all the provinces of Russia in national dress – there are still 470 pieces in the Hermitage, including the three we show here.

She had many lovers after Potemkin but only Zavadovsky, future Minister of Education, Lanskoy, who died in 1784, and Mamonov were sufficiently cultured to become intimate friends. Prince Shcherbatov, in an essay on the laxity of Russian morals in the 1780s, denounced Catherine: "though she is in her declining years, though grey hair covers her head and time has marked her brow with the indelible signs of age, yet her licentiousness does not decline." The rest of Europe observed her behaviour in this department with disapproving interest. Such conduct was indeed permitted to men at the time, but not to women.

Yet, Catherine was popular with most ranks of society. Cheerful, accomplished, idealistic and hard working, she was adored by her servants. "Should we compare all the known epochs of Russian history," wrote the great Russian historian Nikolay Karamzin in 1811, "virtually all would agree that the happiest for Russian citizens was that of Catherine; virtually all would prefer to have lived then than at any other time."

4

Grand Duchess Catherine Alexeyevna.
Mid-1740s

Georg Christoph Grooth (Kleine Grooth).
1716-49

Oil on canvas. 105 × 85 (oval)

Inv. No. ERZh 2474

Provenance: 1958, from Pavlovsk Palace; formerly at
Gatchina Palace.

(Illus. see p.28)

Summoned to Russia in 1744 by Empress
Elizabeth as a bride for the heir to the Russian
throne, Grand Duke Peter, the young Princess
Sophia Frederika Augusta of Anhalt-Zerbst took
the Russian Orthodox name Yekaterina
(Catherine) Alexeyevna. On her arrival in
Moscow on 10 February 1744, the Princess and
her mother, Princess Johanna Elisabeth, received
the Great Cross of the Order of St Catherine,
shown in Grooth's portrait.

In a letter to Melchior Grimm, Catherine gave
herself the following joking epitaph: "Here lies
Catherine II, born in Stettin 21 April 1729. She
moved to Russia in 1744 in order to marry
Peter III. At the age of 14 she set herself a triple
task: to be loved by her husband, Elizabeth and
the nation. She omitted nothing which could
achieve this. 18 years of boredom and loneliness
forced her to read many books. Coming to the
Russian throne, she sought for good and tried to
bring her subjects happiness, freedom and
property…" Several copies of this portrait were
produced by Grooth and his pupils. I.K.

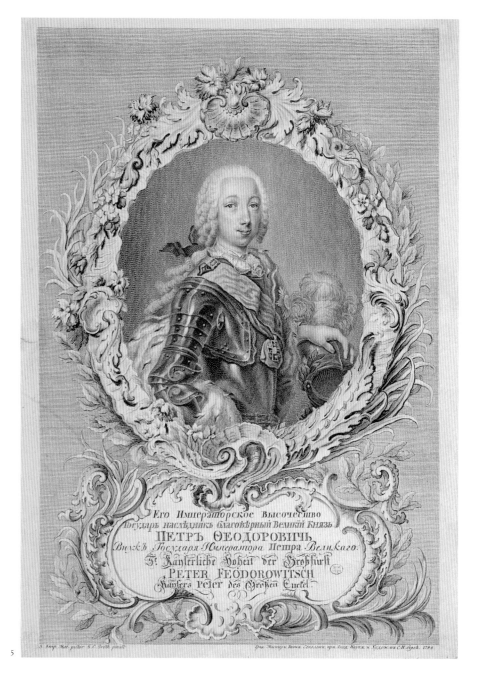

5

5

Grand Duke Peter Fyodorovich. 1748
Ivan Alexandrovich Sokolov. c. 1717-57

Below beneath the oval: *S.Imp.Mai. Pictor G. Grooth pinxit*
– *Грыдоровалъ Мастеръ Иванъ Соколовъ при*
Академіи Наукъ и Худож. В С.П.бурхъ. 1748 [His
Imperial Majesty. Painter G. Grooth. Engraved by
Master Ivan Sokolov at the Academies of Arts and
Sciences. In St Petersburg. 1748]

Etching. 45 × 31.2

Inv. No. ERG 15278

Provenance: Main Hermitage Collection.

6

Grand Duchess Catherine Alexeyevna.
1740s, 1761

Ivan Alexandrovich Sokolov. c. 1717-57
Yefim Grigoryevich Vinogradov. 1725/8-69

Bottom right: *Вырѣзывалъ Ефимъ Виноградовъ при*
Императорской Академіи въ С.Петербургъ 1761
[Carved by Yefim Vinogradov at the Imperial Academy
in St Petersburg 1761]

Etching. 44.5 × 30.5

Inv. No. ERG 13352

Provenance: Main Hermitage Collection.

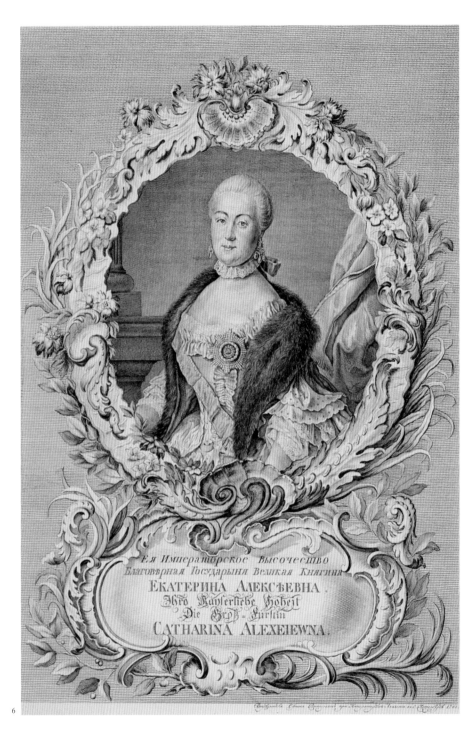

6

Paul I (1754-1801; reigned 1796-1801), was the son of Catherine the Great, with whom his relations were uncomfortable. He married first Princess Wilhelmina of Hesse-Darmstadt, who died in childbirth in 1776. His second wife, Sophia Dorothea, Princess of Württemburg, took the Russian Orthodox name Maria Fyodorovna. Their two eldest sons, Alexander and Constantine, were largely brought up by Catherine, who adored them and made herself personally responsible for their education. Paul was murdered in his newly built Mikhail Fortress after just four years on the throne.

Rachette spent the last 30 years of his life in St Petersburg, initially employed as a modeller at the Imperial Porcelain Manufactory. He took charge of production of a series of vast ceramic ensembles, amongst them the manufactory's most famous works, such as the Arabesque Service and a series of porcelain statues of different national types in Russia. His most famous monumental sculptures in St Petersburg are the tomb of Prince Alexander Bezborodko in the Church of the Annunciation, Alexander Nevsky Monastery (1801), fountain statues for the Grand Cascade at Peterhof Palace (1806-9) and relief compositions for the Kazan Cathedral (1806-9). Enjoying a reputation as a talented portraitist, Rachette produced this bust of Emperor Paul I in a variety of materials – bronze, marble, plaster, papier-mâché and porcelain. E.T.

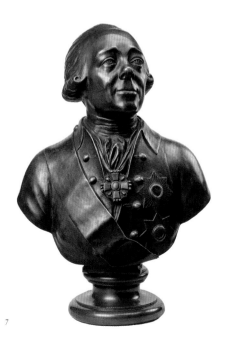

7

Grand Duke Peter (1728-62; 1761-2 Peter III) and his wife, the future Catherine II, both wear the sash and star of the Order of St Andrew. The portrait of Peter comes from a painting by Georg Christoph Grooth but Sokolov never completed the engraving of Catherine, also from a work by Grooth. In 1760-1, Vinogradov took up the old plate and cleaned it, setting an engraving from a portrait by Pietro Rotari within Sokolov's decorative frame. G.K.

7
Paul I
Jacques Dominique Rachette. 1744-1809
Bronze. Height 73
Inv. No. ERSk 13
Provenance: 1946, from the Military Engineering Museum, Leningrad.

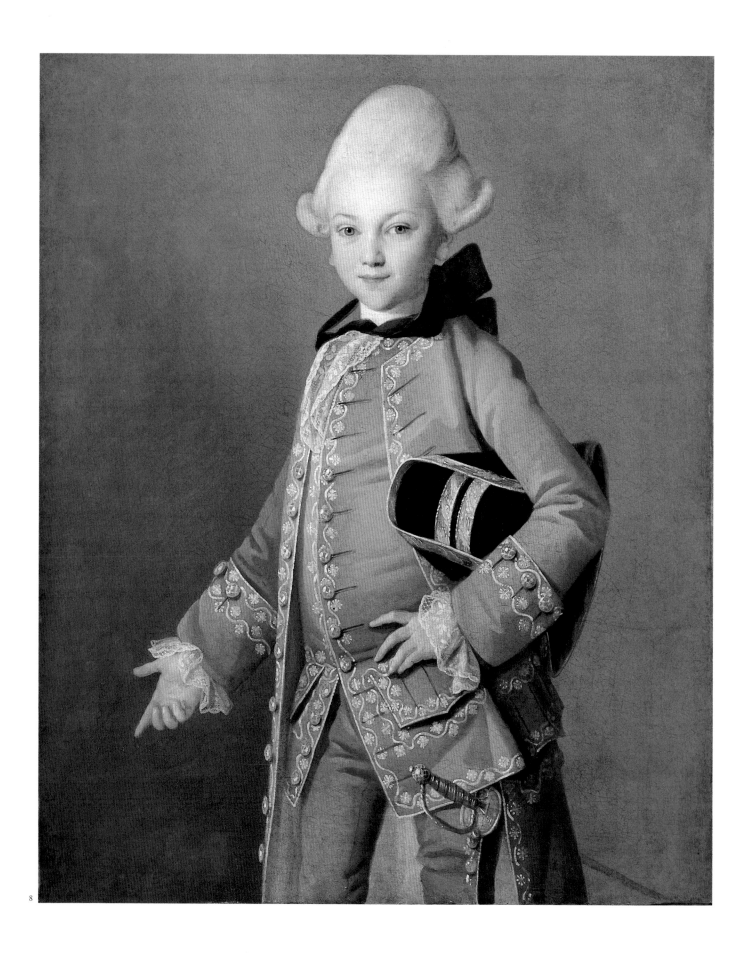

8

8

Count Alexey Bobrinsky. 1769
Carl Ludwig Christineck. 1732/3 – no later
than 1794

On the back: *C.L. Christinek. D. Pinx.* 1769

Oil on canvas. 90 × 73.5

Inv. No. ERZh 1407

Provenance: 1941, from the Museum of Ethnography;
formerly collection of A. A. Bobrinsky, St Petersburg.

Alexey Grigoryevich Bobrinsky (1762-1813), was
the illegitimate son of Catherine II and Grigory
Orlov. His surname was taken from the village of
Bobriki, Epiphany District, in Tula Province,
which was bought for him on the orders of the
Empress. He was initially brought up in the
family of a footman, Shkurin, then from 1775 by
Ivan Betskoy, President of the Academy of Arts,
graduating in 1782 from the Nobles' Land Corps.
In 1785-7 he lived in Paris, under the care of
Friedrich Melchior Grimm, returning to Russia
in 1788, first to Revel (now Tallinn, Estonia), and
later to Bogoroditsa, Tula Province, where he
busied himself with the study of agriculture,
mineralogy and astronomy.

The portrait was clearly commissioned by the
Empress herself for the child's seventh birthday.
Christineck was a pupil of Lucas Conrad
Pfandzelt, who produced many works for the
court and was curator of Catherine's collection
of paintings. I.K.

9

Catherine II in Travelling Costume
Unknown Artist. After 1787

Oil on canvas. 52.2 × 65.8

Inv. No. ERZh 2702

Provenance: 1974, from Leningrad Museums Fund.

(Illus. see p.27)

This portrait was taken from an original by
Russian artist Mikhail Shibanov (Russian
Museum, St Petersburg), painted during
Catherine's journey to the Crimea in 1787.

Catherine is shown wearing a red travelling
overcoat with stars of the Orders of St Andrew,
St George (1st class) and St Vladimir (1st class)
and a fur hat. She was exceedingly pleased with
Shibanov's portrait and it was repeated on
numerous occasions in paintings, prints and
miniatures. I.K.

10

Equestrian Portrait of Catherine II
Vigilius Eriksen. 1722-82

Signed below centre: *V Erik…pinx*

Oil on canvas. 195 × 178.3

Inv. No. GE 1312

Provenance: 1918, from the Romanov Gallery in the
Winter Palace.

(Illus. see p.31)

The painting is a reduced copy from an original
produced for the audience chamber at Peterhof,
probably shortly after the coup d'état which
brought Catherine to power in June 1762. One of
Eriksen's most important works in Russia, it was
repeatedly copied both by Eriksen himself and
by other artists.

Catherine II wears the uniform of a Life Guards
officer of the Semyonovsky Regiment (some
authors have mistakenly identified it as that of the
Preobrazhensky Regiment – for the basis of the
correct identification see "K perevorotu 28 iyunya
1762 goda" [On the Coup of 28 June 1762],
*Iz proshlogo. Istoricheskiye materialy leyb-gvardii
Semyonovskogo polka* [From the Past. Historical
Materials for the Semyonovsky Life Guards
Regiment], St Petersburg, 1911). The light blue
sash is that of the Order of St Andrew. Catherine
is shown riding her horse, *Brilliant* [Diamond], on
the day of the coup (her monogram and the date
28 June are on the tree), when she set out from St
Petersburg at the head of a number of regiments.
Catherine travelled to Peterhof, where her
husband Peter III had arrived the day before and on
29 June, confronted by a total lack of support, the
Emperor signed his abdication. Catherine returned
to the capital where she had already been
proclaimed Sovereign with the support of the
Guards and the people.

It is difficult to date the portrait precisely
because of the large number of replicas. S. A.
Poroshin, mentor and mathematics tutor to
Grand Duke Paul, makes mention twice in 1765
of a portrait "where her Highness is depicted on
a horse in male attire", but this is just one
example of many different references by
contemporaries which contribute to difficulties
in dating the picture. One of the copies,
Equestrian Portrait of Catherine on Brilliant, larger
than this example, hung in the Hermitage
Gallery alongside the Carousel portraits of the
Orlov brothers who helped bring Catherine to

the throne. Eriksen painted equestrian portraits
of Grigory Orlov in Roman costume and Alexey
Orlov in Turkish costume after the famous
Carousel or masquerade tournament of 1766 and
together the works must have formed a highly
distinctive triptych.

The most important copies of the work are in
the State Museum of Art, Copenhagen, with two
at Chartres Museum, one in the Russian Museum,
St Petersburg, one in the Chinese Palace at
Oranienbaum, another in the Hermitage
Museum (376 x 348) and numerous replicas
which often show only head and shoulders. E.R.

11

Equestrian Figure of Catherine II

Meissen. Model by Johann Joachim Kändler. 1770

Mark: crossed swords with a dot

Porcelain, overglaze painting. Height 25.5

Provenance: 1918, formerly collection of Prince A. L.
Dolgorukov.

(Illus. see p. 30)

Kändler was the leading sculptor at Meissen
Porcelain Factory in Germany. His book of
models records that he worked on an equestrian
portrait of the Russian Empress in the summer
of 1770. Kändler's model derives from Eriksen's
famous equestrian portrait of 1762. Catherine
wears the uniform of the Semyonovsky
Regiment, with the blue sash and star of the
Order of St Andrew. K. Berling's hypothesis, put
forward in 1911, that the figure was
commissioned by Catherine herself to form a
pair to an existing equestrian figure of Empress
Elizabeth (produced by Kändler in 1748) is
generally accepted. L.L.

12, 13

*Pieces from the Potemkin Dinner and Dessert
Service.* 1778

Royal Porcelain Manufactory, Berlin

Additional pieces made at the Imperial Porcelain
Manufactory, St Petersburg, 1797-1801

Porcelain, overglaze painting, gilding

Provenance: 1941, from the Museum of Ethnography;
1920s–1941, Russian Museum; 1917, Archaeological
Commission; formerly in the collection of the Counts
Bobrinsky.

This large ceremonial service was presented to Prince Grigory Potemkin. Although the client's name is not mentioned in the order, contemporary scholars have no doubt that it was the Prussian King Frederick II himself, desirous of the support of the Russian Empress's powerful favourite. Set in oval and round medallions on the dinner service are scenes from the Russo-Turkish War of 1768-74, landscapes with genre scenes, views of towns and harbours. The dessert service is decorated with grisaille episodes from Virgil's *Aeneid*, some of the compositions copied from engraved illustrations to a French edition of Virgil, *Les oeuvres de Virgile traduites en français. Figures ornées en taille douce avec des remarques par l'Abbé des Fontaines*, Paris, 1743.

Johann Balthasar Borman, author of the paintings on the Berlin Service Frederick gave Catherine, may have painted this service, although to judge by the subject matter and manner of painting the river banks, harbours and ports, these were by Carl Wilhelm Böhme.

After Potemkin's death the service passed to his nephew, Count Alexander Samoylov, who was probably responsible for ordering additions to the service from the Imperial Porcelain Factory. These were to replace broken or lost pieces and bear the mark of the factory during the reign of Paul I.

In 1821 the service formed part of the dowry of Countess S. A. Samoylova when she married Grigory Orlov's grandson, Count A. A. Bobrinsky, and it remained in the family until 1917. T.K.

12

Triangular Dish Showing a Harbour and Fortress, a Tower and a Church on the Bank

3.5 × 27.6 × 24.5

Marks in cobalt underglaze: a sceptre

Inv. No. ERF 611

13

Triangular Dish Showing a Landscape with a Shepherd in a Round Medallion

3.5 × 27.6 × 24.5

Marks in cobalt underglaze: a sceptre

Inv. No. ERF 613

12

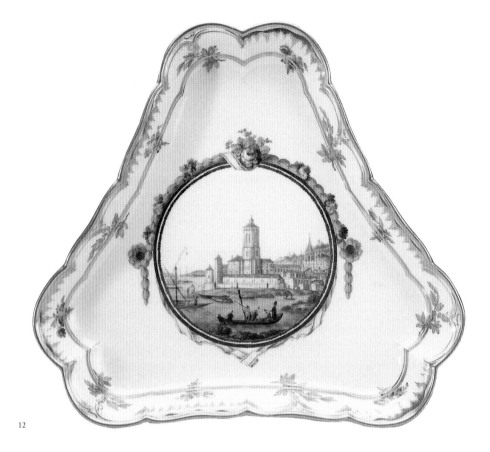

13

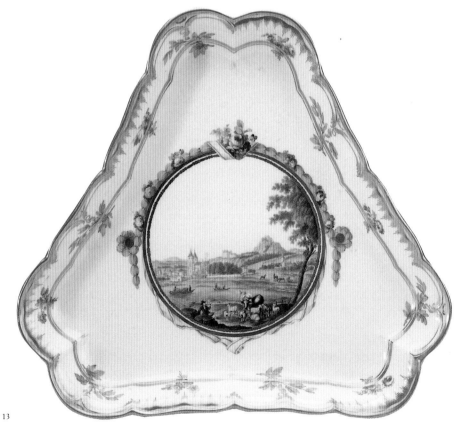

14

Prince Grigory Potemkin. c. 1791

Johann-Baptist Lampi the Elder. 1751-1830

On the back of the canvas an old paper sticker with the Russian text: *Portrait of Prince Potemkin of Tauride, inherited by Countess Sofia Alexandrovna Bobrinskaya from her Father, Count Alexander Nikolayevich Samoylov. This painting was kept at Smel in the Kiev Province in the old manor house (later burnt down) by the church and was brought to St Petersburg around 1854.*

Oil on canvas. 73.5 x 60.5

Inv. No. ERZh 1879

Provenance: 1941, from the Museum of Ethnography; formerly collection of A. A. Bobrinsky, St Petersburg.

(Illus. see p. 35)

Prince Grigory Alexandrovich Potemkin (1739-91) was an outstanding Russian statesman and military commander. He studied at Moscow University, and as a junior officer in the Horse Guards played an active role in the coup which brought Catherine to power – for which he received several awards and a promotion. He took part in the Russo-Turkish War of 1768-74, attaining the rank of Lieutenant-General. Summoned to the court in 1774, he became Catherine's favourite and was raised to the rank of General-in-Chief, Adjutant-General and then Vice President of the Military Collegium. In 1783, after his annexation of the Crimea for Russia, Potemkin became Commandant of the Horse Guards Corps, Fieldmarshal-General and Governor of the conquered lands and was promoted to President of the Military Collegium in 1784. In 1786 he received the honorary title "of Tauris" (the Greek name of the Crimea) and during the Russo-Turkish war of 1787-91 he was Commander-in-Chief of the Russian armed forces. Catherine II was much affected by his death: "My pupil, my friend, one might say my idol, Prince Potemkin of Tauris, has died… He combined with a warm heart an unusually right understanding of things and a rare mind… he was brave at heart, brave in thought, brave in soul…" she wrote to Grimm. "There is no one now to rely on", she said (Khrapovitsky Diaries 1990, p. 252).

Potemkin is shown in armour and a red mantle, with the sash of the Order of St Andrew across his shoulder. I.K.

15

Perspective View of the Hermitage Library. 1826

Alexey Vasilyevich Tyranov. 1808-59

Oil on canvas. 93.5 × 73

Inv. No. ERZh 2430

Provenance: 1956, from the Central Stores of the Suburban Palace Museums; formerly Imperial Hermitage, Tauride Palace, Catherine Palace at Tsarskoye Selo, Gatchina.

(Illus. see p. 36)

In the 1790s Catherine's library was housed in the gallery of the Oval Room in the Large Hermitage and was thus usually called "The Hermitage Library". In 1795-6 the ground floor of the Raphael Loggia block (1792, Giacomo Quarenghi) was rebuilt to house the library, the foreign books moving to the new rooms in 1796 to form "the foreign Hermitage Library". They were joined by the libraries of Diderot and Voltaire, which Catherine had acquired. Voltaire's library from his estate at Ferney was placed in a separate room, at the centre of which stood Jean-Dominique Houdon's sculpture of *Voltaire Seated*, commissioned by Catherine. The new library interiors were richly decorated with stucco, painting and coloured stones, with numerous sculptural groups, busts and scientific instruments. Tyranov's painting shows the main room of the library.

The Raphael Loggia itself survives, but the surrounding rooms have not: they were rebuilt when the New Hermitage was erected in the 1840s. V.F.

16

Marie-François Arouet de Voltaire. 1778-9

Jean-Dominique Houdon. 1741-1828 (workshop)

Marble. Height 48

Inv. No. ERSk 71

Provenance: 1941, from the Museum of Ethnography; formerly Fountain House of the Counts Sheremetev; 1779, brought from Paris by Count Nikolay Sheremetev.

Marie-François Arouet de Voltaire (1694-1778), French philosopher and Encyclopédist, was one of the leading figures of the Enlightenment. In his works he sharply criticised feudal relationships, despotic rule and clerical views. Much interested in Russian history and culture, he praised highly the progressive reforms of Peter I. Voltaire was admired and respected by all liberal thinkers and by the "enlightened" monarchs Frederick II and Catherine II, corresponding with the latter regularly from 1763 until his death.

In February 1778 Voltaire returned to Paris from 20 years of exile at Ferney, sitting for Houdon three times in the artist's studio. Houdon took a life-mask and worked at great speed, producing three versions of the bust: the first with bare shoulders and a wig, the second without the wig in Antique drapery, the third in a wig with modern attire. Voltaire was best pleased with the first version, from which this exhibit derives. Judging by the number of surviving busts by Houdon and his workshop, Voltaire was the most popular of all the sculptor's sitters. E.T.

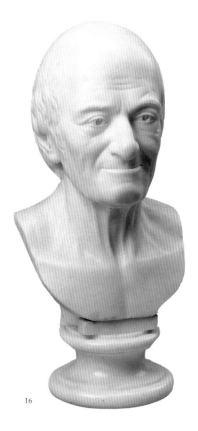

16

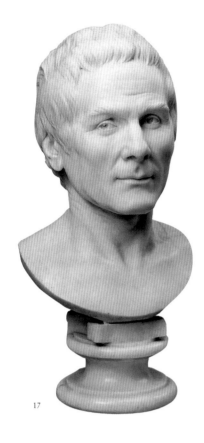

17

Jean-Jacques Rousseau. 1778-9
Jean-Dominique Houdon. 1741-1828
(workshop)

Marble. Height 50
Inv. No. ERSk 72
Provenance: 1941, from the Museum of Ethnography;
formerly Fountain House of the Counts Sheremetev;
1779, brought from Paris by Count Nikolay Sheremetev.

Jean-Jacques Rousseau (1712-78) was an
outstanding representative of French
sentimentalism, friend of Diderot and
contributor to the Encylopédie. He was greatly
critical of contemporary civilised society,
founded as it was on inequality and the cruel
exploitation of man by man. In his "lost paradise
of man's natural state", all men would be equal
and free of society's laws. His best known work
is *The Social Contract*. Unlike Voltaire, Rousseau
saw hope in religious feeling and the inner voice
of conscience.

Houdon's portrait busts of Rousseau, based
on a mask taken the day after his death on 2 July
1778, were second in popularity only to those of
Voltaire. Not merely excellent portraits, both

busts are idealised images of great philosophers.
They continued to be produced in Houdon's
workshop until his death, and many copies were
produced even later. Marble busts were sold to
clients such as Count Sheremetev, while plaster
and terracotta pieces were produced for the less
wealthy. E.T.

18

Denis Diderot. 1772
Marie-Anne Collot. 1748-1821

Signed and dated on the back: *par MA Collot 1772*
Marble. Height 57
Inv. No. NSk 2
Provenance: 1852, from the Tauride Palace; 1772,
commissioned by Catherine II for her Hermitage.

Denis Diderot (1713-84) was a friend of Collot
from the start of her career, praising her early
terracotta bust of him (1766) in his review of
the Salon of 1767, and thus helping bring her
fame as a portraitist.

18

When Falconet travelled to Russia to work on
his equestrian statue of Peter the Great – a
commission which he received through the
mediation of Diderot – Collot accompanied him.
Catherine's interest in Falconet was largely
prompted by her interest in Diderot, whom she
had invited to Russia but who was perpetually
putting off his journey. Impatient at the
philosopher's non-arrival, she commissioned
this marble bust from Collot, who had brought
the model or cast for it from Paris. Work on the
marble would seem to have begun no later than
October 1770 and certainly it had been
completed by 7 January 1773, when Falconet
wrote: "Since the real Diderot is unable to come
to render homage to Your Imperial Majesty, his
effigy awaits your orders for presentation to his
august protector… Mlle Collot has enjoined to
those verities which are offered by the model she
made more than six years ago, everything which
she has been able of the different features,
movements and impressions which make up the
physiognomy of the original. I believe the
portrait to be very like."

Falconet records that Collot intended to make
a portrait of d'Alembert as a pair to this bust, but
there is no confirmation that it was ever
produced. A plaster cast of the portrait of
Diderot was sent to Paris, arriving in March 1771
and arousing Diderot's warm admiration. I.Y.

19

Catherine II in a Kokoshnik. Mid-19th century
Unknown Artist. After Vigilius Eriksen

Oil on canvas. 70 × 60
Inv. No. GE 7276
Provenance: 1918, from the Romanov Gallery in the
Winter Palace.

Catherine here wears stylised Russian costume –
a kokoshnik head-dress and a sleeveless jacket
trimmed with fur sometimes described as
"Moldavian". In terms of iconography, this is the
most original portrait type of the Empress and
the unusual costume suggests that Eriksen was
commemorating some particular event. One
such occasion might have been the official
declaration of Catherine as "Mother of the
Fatherland" on 12 August 1767, a title offered her
by deputies of the Legislative Commission
gathered in Moscow to write the new Code of

Laws. Interestingly, Catherine refused two other titles: "the Great" (she said "I leave it to my descendants to judge my achievements impartially") and "Most Wise" ("In no way could I thus describe myself, for God alone is wise"). She justified her acceptance of the title "Mother of the Fatherland", however, by explaining that "to love the people entrusted to me by God I regard as the duty of my station; to be beloved by them is my wish".

This copy was probably produced specially for the Romanov Gallery in the Winter Palace, housing portraits of members of the royal house, in the mid-19th century. It would seem to have been taken not from Eriksen's original but from another copy, by Heinrich Buchholtz, as is clear from the very characteristic manner in which the eyes are painted. Jacob Stählin mentioned in his notes on artistic life in St Petersburg in the 18th-century a pastel portrait of the Empress in old Russian costume by Eriksen which was engraved by Christopher Melchior Roth.

19

Eriksen's original delicate pastel portrait appears not to have survived, but there are a number of known copies. In 1769, for instance, Catherine presented one to the English doctor, Thomas Dimsdale (collection of R. Dimsdale, Barkway, England), who had travelled to Russia to inoculate her and her grandchildren against smallpox. E.R.

20
Catherine II Enthroned
Berlin. Model by Friedrich Elias Meyer. 1770
Unpainted porcelain, gilded bronze. Height 38.5
Mark: sceptre
Inv. No. 19088
Provenance: 1886, from the Golitsyn Museum, Moscow.
(Illus. see p. 32)

In 1770 Frederick II of Prussia was presented with valuable furs by the Russian Empress. Seeking a worthy gift to make in return, upon investigation he learned that Catherine would be pleased with porcelain. Thus, in 1772, a magnificent dessert service with a grand centrepiece intended to eulogise the wise government and military victories of the Russian Empress (notably in the ongoing Russo-Turkish War) was delivered to Russia. Frederick himself developed the concept for the decoration: in the centre stood an unpainted porcelain figure of Catherine II enthroned beneath a baldacchino, surrounded by allegorical figures personifying her political virtues. Meyer, then leading sculptor at the Berlin Porcelain Manufactory, produced the model after a portrait by Vigilius Eriksen which Catherine had sent Frederick in 1769. The figure on show would seem to be – as was first suggested by Natalya Kazakevich – one of six trial copies which preceded the final figure (now on display in the Winter Palace) sent to Petersburg as part of the renowned service. L.L.

21, 22
Kneeling Russian Peasant Woman in National Costume
Berlin. Models by Wilhelm Christian Meyer. 1770
Porcelain, overglaze painting. Height 13.5cm; 20cm
Inv. Nos GCh 2701, GCh 2711
Mark: sceptre
Provenance: from 1910, Porcelain Gallery of the Hermitage; from 1885, Court Museum of the Winter Palace (Alexander III Museum of Porcelain and Silver Objects); from 1837 Great Palace, Peterhof; from 1772, service stores of the Winter Palace.
(Illus. see p. 33)

In addition to the figures of Catherine and allegories of virtue, the Berlin dessert service had, arranged around the throne, representations of people from different layers of society and the numerous peoples of Russia.

These figures were made after models by Friedrich Meyer's brother Wilhelm, based on drawings by the gifted Swiss mathematician Leonard Euler, then resident in St Petersburg. L.L.

23, 24
Pair of Urn-Shaped Vases with Lids. 1799
Yekaterinburg Lapidary Works
Dark green porphyry, bronze; carved, burnished, polished, cast, chased and gilded. 65 × 51
Inv. Nos E 2656, E 2657
Provenance: entered the Winter Palace before 1810.

The design for these vases was sent to the court on 8 August 1797 by the President of the Academy of Arts (also head of the Yekaterinburg Lapidary Works). The vases themselves appear in a list of objects sent to St Petersburg in 1799. They were valued at 1,441 roubles 16 kopecks.

A list of objects in the Hermitage completed in 1811 includes: "vases made at the Yekaterinburg factories and presented to the Sovereign Emperor Alexander I by Count Stroganov, Privy Councillor, High Chamberlain and knight of various orders, and were brought to the Hermitage from the Antechamber on 7 January 1810." N.M.

23, 24

25, 26

25, 26

Two Display Cases for Engraved Gems. 1851-2

Wilhelm Strom; Lindrus and Gize. St Petersburg.

To a design by Leo von Klenze

Mahogany veneer, alder and pine base; gilded bronze,
glass. Height (with pyramids) 149cm; table top 283 × 192

Inv. Nos E 143, E 148

Provenance: Main Hermitage Collection.

These two magnificent display cases have a
hexafoil table top resting on six bronze
gryphons and two carved piers, with six
revolving hexagonal covers made of gilded
bronze and glass.

Munich architect Leo von Klenze was
responsible for the design of the New Hermitage,
which opened as a public museum in 1852. All
the fixtures and fittings were discussed with
Emperor Nicholas I and the Hermitage keepers
and it was Florian Gille, keeper of the 1st
Department of the Hermitage, who suggested
the highly original form for these cases. Klenze
produced the drawings and the cases were made
in the workshop of Wilhelm Strom (bronze in

the workshops of Lindrus and Gize). Surviving
drawings bearing Klenze's signature reveal that
they were intended for the Cameo Room. T.S.

Miniatures

27

Family of Peter I. 1716-17

Grigory Semyonovich Musikiysky.

1670/1–c. 1739

Bottom left: *Санкт пітербургъ 1717 Григорій
Мусикіски* [St Petersburg 1717 Grigory Musikiysky]

Enamel on copper. 12 × 8.5

Inv. No. ERR 3798

Provenance: 1941, from the Museum of Ethnography;
formerly Russian Museum, Museum of Anthropology
and Ethnography of Peoples of the USSR; 1824-1910,
Imperial Hermitage; from the second half of the
18th century collection of Catherine II, Winter Palace.

The miniature shows Peter I and his wife
Catherine; to the right are Tsarevich Alexey,
Anna and Elizabeth with the small Pyotr
Petrovich.

Catherine, born Martha Skavronskaya,
became Empress Catherine I after the death of
her husband in 1725. Alexey, Crown Prince (1690-
1718), was Peter's eldest son, from his first
marriage to Yefrosiniya Lopukhina. Elizabeth
(1709-61) ruled Russia as Empress Elizabeth
Petrovna 1744-61. Anna (1708-28) married in 1725
Duke Carl Friedrich of Holstein Gottorp. Her son
Peter was declared heir to the throne by the
childless Empress Elizabeth and became Peter III,
husband of Catherine II. Pyotr Petrovich (1715-19)
was briefly heir to the throne.

Musikiysky produced the miniature from his
own drawing, commissioned by Alexander
Menshikov and presented to Peter I in October
1717, on the day the monarch returned from
extensive travels through Europe. G.K.

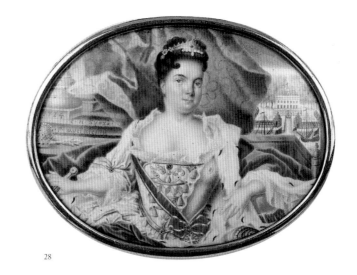

28

Catherine I with a View of Yekaterinhof. 1724
Grigory Semyonovich Musikiysky.
1670/1–c.1739

Left on the column base: 1724 *С. П. Бурхъ Г. Мусікіскй*
[1724 St Petersburg. G. Musikiysky]

Enamel on gold. 6.5 × 8.6 (oval)

Inv. No. ERR 3825

Provenance: 1941, from the Museum of Ethnography;
formerly Russian Museum, Museum of Anthropology
and Ethnography of Peoples of the USSR; 1824-1910,
Imperial Hermitage; from the second half of the 18th
century collection of Catherine II, Winter Palace.

In the background is the palace and park of
Yekaterinhof, built by Peter I in 1711 outside his
new city (now inside the bounds of St
Petersburg) and presented to his wife Catherine.
The palace was named in Catherine's honour.
 Catherine is shown wearing the star and sash
of the Order of St Catherine in this miniature,
taken from an original by Jean-Marc Nattier of
1717 and an engraving of Yekaterinhof by A. I.

Rostovtsev. It forms a pair with a portrait of Peter
against the background of the Peter and Paul
Fortress (not exhibited). G.K.

29

Peter I. 1725
Andrey Grigoryevich Ovsov. 1678/9-1740s

Right above the shoulder: A.O. 1725 *В П Б* [AO 1725 in
Petersburg]

Enamel on copper. 6.9 × 5.6 (oval)

Inv. No. ERR 3801

Provenance: 1941, from the Museum of Ethnography;
formerly Russian Museum, Museum of Anthropology
and Ethnography of Peoples of the USSR; 1824-1910,
Imperial Hermitage; from the second half of the 18th
century collection of Catherine II, Winter Palace.

This portrait is based on a combination of a
work in oil by Yan Kupetsky and an engraving by
Alexey Zubov of 1712. G.K.

30

Unknown Miniaturist
Catherine II Holding her "Instruction".
Late 1760s-1770s

Enamel on copper. 8 × 10.7

Inv. No. ERR 8014

Provenance: 1978, acquired for the Hermitage by the
USSR Ministry of Culture at auction in Zurich; 1930-78
collection of E. Loubovitch, France; formerly collection
of the Counts Orlov-Davydov, St Petersburg.
(Illus. see p. 12)

Catherine is shown seated at a table writing her
"Instruction", the philosophical and legal treatise
which she published in 1767 for the deputies of
the Legislative Commission compiling a new
Code of Laws. Voltaire wrote to Catherine on
25 February 1768: "I have read the draft
Instruction which you were pleased to send me.
Everything in it is clear, concise, just, full of

firmness and love for mankind. Lawmakers
occupy the foremost place in the temple of glory,
after them come the conquerors. Be assured that
none shall be spoken of so highly by posterity as
Your Majesty." G.K.

31
Count Grigory Orlov. Late 1760s-early 1770s
Andrey Ivanovich Chorny.
Died after 1780
Enamel on copper. 7.2 × 5.3
Inv. No. ERR 8013
Provenance: 1978, acquired for the Hermitage by the
USSR Ministry of Culture at auction in Zurich; 1930-78
collection of E. Loubovitch, France; formerly collection
of the Counts Orlov-Davydov, St Petersburg.
(Illus. see p. 29)

Grigory Grigoryevich Orlov (1734-83),
Catherine's favourite, played a key role in
bringing her to the throne. Chief of the Cavalry
Corps from 1765 to 1783, Grand Master of the
Artillery from 1765, President of the Free
Economic Society from 1765, he was raised to the
rank of Prince of the Holy Roman Empire in 1772.
Catherine described him in a letter to Voltaire of
1768: "General Master of the Ordnance Count
Orlov, Hero; this hero is like the Ancient
Romans, living and flourishing during the time
of the Republic, and is of just such bravery and
magnanimity".
 In this portrait, the face possibly based on an
equestrian portrait by Vigilius Eriksen of 1768,
Orlov is shown wearing the ceremonial uniform
of the Cavalry Corps with the sash of the Order
of St Andrew. G.K.

32
Catherine II. 1765
Andrey Ivanovich Chorny. Died after 1780
Inscriptions on the contrenamel: 1765; below: *A. Ч.*
[A. Ch.]
Enamel on copper: 9 × 7; 14.5 × 12 (with frame)
Inv. No. ERR 8330
Provenance: 1980, acquired for the Hermitage by the
USSR Ministry of Culture, from collection of Wehrlin,
Paris; 1930s, bought by Wehrlin in Moscow; formerly
collection of the Counts Orlov-Davydov, St Petersburg.

Grigory Orlov commissioned this miniature as a
gift for Catherine II, but a fault created during
firing (the bands across the image) meant that it

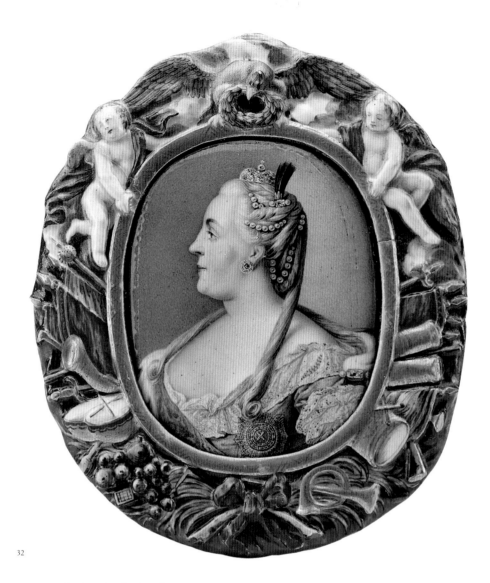

32

remained in the Orlov family collection. Its
original was a painting by Fyodor Rokotov
(Russian Museum, St Petersburg) of 1763. The
miniature is set into a porcelain frame, possibly
created by Chorny to a design by Gavriil Kozlov.
A similar miniature (without the frame) which
once belonged to Catherine II is now in the
Russian Museum. G.K.

33
Empress Yelizaveta Alexeyevna. Early 1800s
Unknown Artist (circle of Vladimir
Borovikovsky)
Oil on canvas, glued to card. 9.4 × 7.6 (oval)
Inv. No. ERR 5455
Provenance: 1950, from the Hermitage Exchange Fund.

Yelizaveta Alexeyevna (1779-1826), née Louisa-
Maria-Augusta of Baden Durlach, married in
1793 Grand Duke Alexander Pavlovich, from 1801
Alexander I. G.P.

33

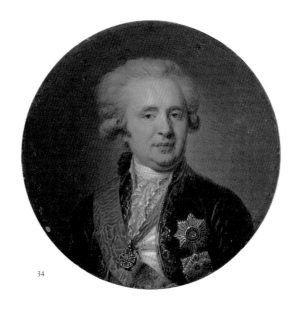

34

34

Count Alexander Bezborodko. Mid-1790s
Johann-Baptist Lampi the Elder. 1751-1830

On the back of the mount: *Графъ Александръ*
Андреевич Безбородко временъ Екатерины II род.
17го Мартъ 1747 г. скон. 16го Апр.1799 [Count
Alexander Andreyevich Bezborodko in the Time of
Catherine II Born 17 March 1747 Died 16 April 1799]
Oil on metal. Diameter 7.2
Inv. No. ORM OZEI 1678
Provenance: 1920s; formerly collection of Prince
A. A. Kurakin, St Petersburg.

Alexander Andreyevich Bezborodko (1747-99),
was a statesman and diplomat. From 1755 he was
Secretary, from 1784 de facto head of the
Collegium for Foreign Affairs. He became Chief
of the Court in 1794 and was raised to the rank of
Prince in 1797. He is shown with the sash and star
of the Order of St Andrew, the stars of St Vladimir
and St Alexander Nevsky (at the neck). G.K.

35

Count Alexander Stroganov. 1806-7
Dmitry Ivanovich Yevreinov. 1742-1814

Enamel on copper. 8.2×7 (oval)
Inv. No. ORM OZEI 1213
Below on the bronze plaque attached to the frame:
Графъ Александръ Сергеевичъ Строгановъ [Count
Alexander Sergeyevich Stroganov]
Provenance: 1928, from the Stroganov Palace Museum;
formerly Stroganov collection.

Alexander Sergeyevich Stroganov
(1738-1811), High Chamberlain and Senator, was
from 1800 to 1811 President of the Academy of
Arts, Director of the Imperial Libraries and
chairman of the Construction Commission for
the Kazan Cathedral in St Petersburg (depicted
on the print lying on the table). A man of
outstanding education, a patron of the arts, he
was the owner of an extensive and magnificent
gallery of paintings, collections of prints,
medals, coins and manuscripts, as well as a
superb library. He is shown in academic uniform
with a sash of the Order of St Andrew and the
Cross of St John of Jerusalem (Cross of Malta).
The painting derives from a portrait by Jean-
Louis Monnier of around 1806. G.K.

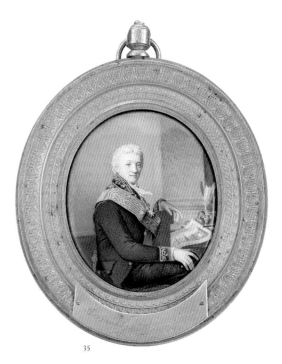

35

36

Ivan Shuvalov. 1780s

Unknown Artist

Gouache and varnish on ivory. 7.4 × 6.2 (oval)

Inv. No. ORM OZEI 1034

Provenance: 1911, from the collection of Grand Duke Sergey Alexandrovich.

Ivan Ivanovich Shuvalov (1727-97) was a statesman, High Chamberlain, Senator, Adjutant-General, and favourite of Empress Elizabeth. An active patron, he contributed to the foundation of Moscow University and the Academy of the Arts in St Petersburg, which he headed 1757-63. He was patron of many Russian artists. Between 1763 and 1777 he lived abroad, looking after students on grants from the Academy and assisting Russian artists.

He is shown in this miniature, based on a painting by Elizabeth Vigée-Lebrun of 1775, with the sashes and stars of the Orders of St Andrew and St Vladimir (1st class). G.K.

36

37

Count Alexey Orlov of Chesme. Late 1770s-early 1780s

Unknown Artist

Watercolour and gouache on ivory. Diameter 6

Inv. No. 225

Provenance: Main Hermitage Collection.

Count Alexey Grigoryevich Orlov (1735-1807), one of the five Orlov brothers, entered the Preobrazhensky Life Guards Regiment in 1749 and went on to help organise a conspiracy in support of Catherine, playing a central role in the 1762 coup which brought her to power. Together with Prince Fyodor Baryatinsky, he took part in the murder of Peter III, who was then imprisoned at Ropsha near St Petersburg. During the Russo-Turkish War of 1768-74 he commanded the Russian fleet in the Mediterranean. His famous victory over the Turkish fleet at Chesme in 1770 brought him the Order of St George (1st class), a diamond-studded sword and the honorary title "of Chesme". In December 1775 he retired, removed himself from the court and settled in Moscow, where he died.

Orlov is shown in admiral's uniform with the Orders of St Andrew, St George (1st class) and St Anne. G.K.

37

38

Count Valerian Zubov. 1794

Augustin Ritt. 1765-99

Watercolour and gouache on ivory. Diameter 5.3

Inv. No. ERR 5950

Provenance: 1958, via the Hermitage Purchasing Commission.

Valerian Alexandrovich Zubov (1771-1804), General-in-Chief, was the brother of Catherine's favourite Platon Zubov. A participant in the Russo-Turkish War of 1787-91, from 1800 he was Director of the Second Cadet Corps and Member of the State Council. He is shown here with the Order of St George (3rd class). G.P.

38

39

Grand Dukes Alexander and Constantine as Children. 1790

Heyde. fl. Russia 1780s-1790s

Below the helmet: *Heyde f. 1790*

Watercolour and gouache on ivory. 16 x 11.8

Inv. No. ORM OZEI 118

Provenance: Main Hermitage Collection.

This miniature depicts Catherine's beloved grandsons Grand Duke Alexander Pavlovich (1777-1825; Tsar Alexander I, 1801-25), and his brother Constantine (1779-1831), Chief of the Uhlan Life Guards, Commander of the Cadet Corps and Inspector General of the Cavalry, Commander in Chief of the Polish army from 1815 to 1831. Both boys wear the Order of St Andrew.

The miniature is based on Richard Brompton's portrait *Alexander Breaking the Gordian Knot* of the early 1780s (oil on canvas, Hermitage). G.K.

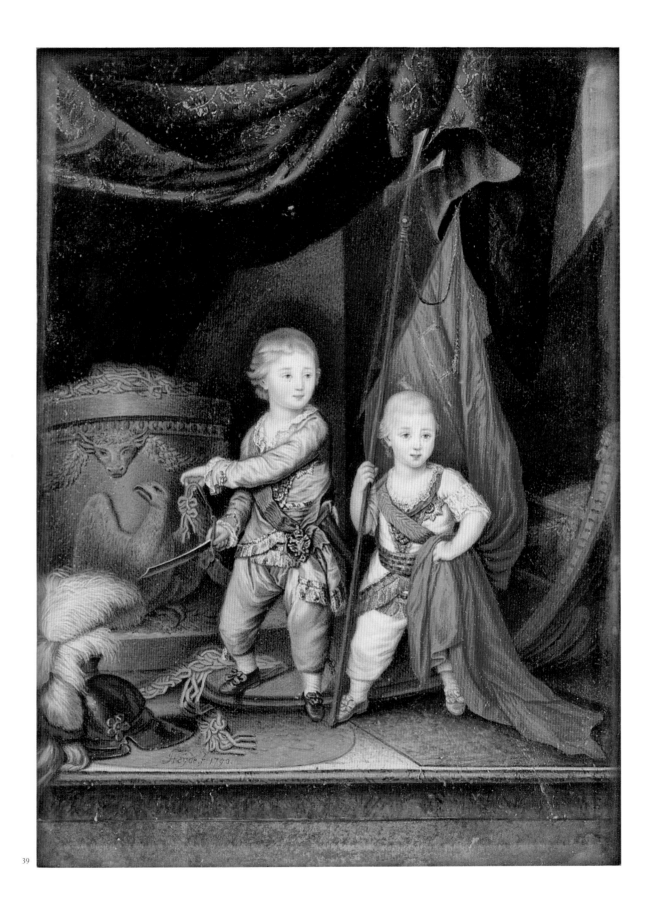

40

Grand Duchess Anna Fyodorovna.
1799-1800
Unknown Artist (circle of Vladimir Borovikovsky)

Watercolour and gouache on ivory. 16 × 12.5

Inv. No. ERR 8217

Provenance: 1981, via the Hermitage Purchasing Commission.

Grand Duchess Anna Fyodorovna (1781-1860), born Juliana-Henrietta-Ulrika, daughter of Franz-Friedrich-Anton, Duke of Saxe Zaalveld Coburg. In 1796 she married Grand Duke Constantine Pavlovich, but the marriage effectively collapsed in 1801 and she left Russia to live in Paris and Switzerland. In 1820 came a formal divorce, after which Anna Fyodorovna finally settled in Switzerland at the Villa Boissier near Geneva. She is shown with the star and sash of the Order of St Catherine. G.P.

40

Grand Duke Constantine at the Battle of Novi.
1799
Unknown Artist (circle of Vladimir Borovikovsky)

Watercolour and gouache on ivory. 16 × 12.5

Inv. No. ERR 8213

Provenance: 1981, via the Hermitage Purchasing Commission.

Constantine is shown wearing the uniform of a Cuirassier Life Guards officer with the sash of the Order of St Andrew and the Orders of St Anne (1st class) with diamonds, SS Maurus and Lazarus, and the Cross of St John of Jerusalem (Cross of Malta). G.P.

41

42

Alexander Naryshkin. 1794

Augustin Ritt. 1765-99

Watercolour and gouache on ivory. 8.7 × 7.1 (oval)

Inv. No. ORM OZEI 1807

Provenance: after 1924; formerly collection of V. L.
Naryshkin, St Petersburg.

Alexander Lvovich Naryshkin (1760-1826), was
High Chamberlain, Honorary Member of the
Academy of Arts and from 1799 to 1819 Director
of the Imperial Theatres. A man of great
erudition, patron of the arts, famous for his
untiring love of society, his wit, and his
perpetual – often merciless – jokes and puns.

The miniature was engraved in 1801 with
some small changes and in different attire, with
the inscription "Peint en Miniature par Ritt –
1801 – Gravé par J. Saunders". G.K.

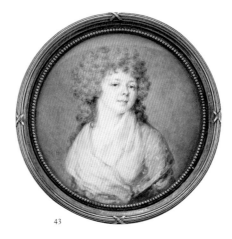

43

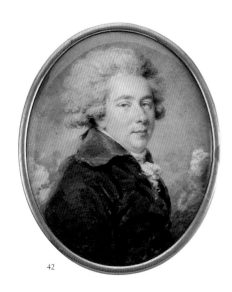

42

43

Princess Tatyana Yusupova. 1799

Augustin Ritt. 1765-99

Right by the shoulder: *RITT*

Watercolour and gouache on ivory. Diameter 6.8

Inv. No. ORM OZEI 1986

Provenance: 1925, from the collection of Ye. and
M. S. Oliv, Leningrad.

Tatyana Vasilyevna Yusupova (1769-1841), née
Engelhardt, was the niece of Grigory Potemkin.
From 1781 she was maid-of-honour to Catherine
II. Married first to M. S. Potemkin (1785-90), in
1793 she wed Prince Nikolay Borisovich Yusupov.
She was one of the most educated women of her
time, and her house was visited by Russia's
leading poets, Alexander Pushkin, Vasily
Zhukovsky and Gavriil Derzhavin. G.K.

44

Prince Ivan Baryatinsky (?). 1795 (?)

Augustin Ritt. 1765-99

Front right: *Ritt*; back of frame: *Il fait tout mon bonheur*

Watercolour and gouache on ivory. 8.5 × 6.8 (oval)

Inv. No. ORM OZEI 2064

Provenance: after 1924; formerly collection of the
jeweller Agapon Fabergé (son of Carl).

Prince Ivan Ivanovich Baryatinsky (1772-1825/30),
was adjutant to Grigory Potemkin and later
Master of Ceremonies at the court of Paul I.
He was an outstanding representative of
St Petersburg's "gilded youth" in the 1790s. G.K.

45

Stanislas Poniatowski, King of Poland. 1803

Karl Raczynski. fl. first half 19th century

Left along the oval: *K. Raczynski*; right: *1803*

Watercolour and gouache on ivory. 6.5 × 5.3 (oval)

Inv. No. ERR 4088

Provenance: 1941, from the Museum of Ethnography.

Stanislas August Poniatowski (1732-98), a Polish
magnate, was King of Poland between 1764 and
1795. After the Third Partition of Poland in 1795
he abdicated and spent his last years in Russia,
where he died.

Poniatowski is shown wearing the Orders
of the White Eagle and St John of Jerusalem
(Cross of Malta). The basis for this portrait was
Johann Lampi's oil on canvas painting of
around 1790. G.P.

44

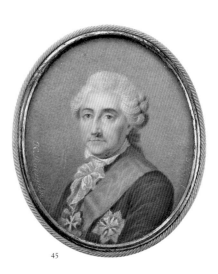

45

46
Portrait of Grand Duchess Maria Fyodorovna.
1780s
Unknown Artist

Watercolour on ivory. 8 x 5.5 (visible image); 14.5 × 11.8
(in wooden frame)

Inv. Nos ERR 33

Provenance: 1941, from the Museum of Ethnography.

Two of the children from Paul's second marriage,
to Maria Fyodorovna, were to go on to rule
Russia: Alexander I (1801-25) and Nicholas I
(1825-55). G.P.

47
Portrait of Grand Duke Paul. 1780s
Unknown Artist

Watercolour on ivory. 8 x 5.5 (visible image); 14.5 × 11.8
(in wooden frame)

Inv. Nos ERR 32

Provenance: 1941, from the Museum of Ethnography.

46

47

48

Grand Duchess Yelena Pavlovna. Early 1790s

Pyotr Gerasimovich Zharkov. 1742-1802

Watercolour and gouache on ivory. 6.4 × 5.2 (visible
image); 18 × 14.4 (in frame)

Inv. No. ERR 8652

Provenance: 1986, via the Expert Purchasing
Commission, from the collection of V. S. Popov,
Moscow.

Grand Duchess Yelena Pavlovna (1784-1803),
second daughter of Emperor Paul, in 1799
married Crown Prince Frederick Ludwig of
Mecklenburg-Schwerin. G.P.

49

Grand Duke Constantine Pavlovich. c. 1809

Peter Ernst Rockstuhl. 1764-1824

Watercolour and gouache on paper. 11.9 × 6.6
(top rounded)

Inv. No. ERR 7279

Provenance: 1965, from the collection of A. I. Dolivo-
Dobrovolsky.

Rockstuhl was a Russian miniaturist, maker of
enamels and silhouettes, painter on porcelain
and glass. He worked in Riga and Vilnius and at
the end of the century in St Petersburg and was
author of numerous miniature portraits,
including works on glass. G.P.

50

Alexander I. 1820s

Unknown Artist

Watercolour and gouache on ivory. 5.5 x 4 (visible image
in oval); 7 × 5.5 (in setting)

Inv. No. ERR 7739

Provenance: Main Hermitage Collection. G.P.

50

51

51

Empress Yelizaveta Alexeyevna. 1810s
Unknown Artist

Watercolour and gouache on ivory. 6.3 x 5.1 (visible
image in oval); 7.5 × 6.4 (in mount)
Inv. No. ERR 8676
Provenance: 1986, from the collection of V. S. Popov,
Moscow.

See Cat. 33. G.P.

52

Nikolay Novikov. 1790s
Dmitry Grigoryevich Levitsky (?). 1735-1822

Oil on metal. 8.2 x 6.5 (oval); 21.5 × 17 (in frame)
Inv. No. ERR 7748
Provenance: Main Hermitage Collection; until 1824,
Zurov collection.

Nikolay Ivanovich Novikov (1774-1818) was a
leading Russian cultural figure during the time
of Catherine II. A writer, journalist and publisher,
he was arrested in 1792 for expressing opposition
to serfdom in his writings, and spent four years
in the prison of the Peter and Paul Fortress.

Levitsky studied under Alexey Antropov and
worked in Moscow in the 1760s. In 1769 he was
appointed to the Academy of Arts, becoming
Academician in 1770. He was head of the portrait
class there between 1771 and 1787, after which he
retired, returning to the Academy Council in 1807.

This miniature was previously published as
the work of an unknown artist. G.P.

53

Prince Nikolay Yusupov. 1840
**Danila Grigoryevich Zhernovoy. 1809–
after 1840**

Right along the edge: *Д. Жерновой 1840 Астрахань,*
[D. Zhernovoy 1840 Astrakhan]
Watercolour and gouache on card. 17 × 14.7 (oval),
24 × 21.5 (in frame)
Inv. No. ERR 561
Provenance: 1941, from the Museum of Ethnography;
until 1913, collection of F. M. Plyushkin.

Nikolay Borisovich Yusupov (1750-1831), was a
senator and member of the State Council,
chamberlain and diplomat. A renowned courtier
in Catherine's time, he was commander of the
Moscow Expedition for Building of the Kremlin
and the Workshop of the Armoury; as well as
being a collector and patron. He was Director of
the Imperial Theatres, 1791-9, in charge of the
Imperial Hermitage 1796-9, and administrator of
the Imperial Porcelain and Glass Factories and
the Tapestry Manufactory 1792-1802.

Danila Zhernovoy was a serf artist to the
Yusupov Princes. He studied in the painting
studio on their estate at Arkhangelskoye near
Moscow but in 1832 was exiled with his family to
the Yusupovs' fishing industry on the Caspian
Sea. He continued to paint even after he was sent
as a soldier to Astrakhan. G.P.

Medals

54, 55
*Two Medals Commemorating Catherine II's
Accession to the Throne on 28 June 1762. 1767*
Johann Georg Wächter. 1726-1800
Front: *Б. М. ЕКАТЕРИНА. II. ИМПЕРАТ. И
САМОДЕРЖ. ВСЕРОСС.* [By the Grace of God
Catherine II Empress and Autocrat of All Russia];
beneath the portrait: *WAECHTER.F.* Reverse - above the
image: *СЕ СПАСЕНІЕ ТВОЕ* [This is Your
Salvation]; on the column base: *W* (medallist's
monogram); below: *ЮНІЯ 28 ДНЯ 1762 ГОДУ*
[28 June 1762]
54) Gold; struck. Diameter 6.7
Inv. No. Az 212
55) Silver; struck. Diameter 7.6
Inv. No. RM 1169
Provenance: Main Hermitage Collection.

Medals in honour of Catherine's accession to the
Russian throne were struck only on the fifth
anniversary of the event. Y.S.

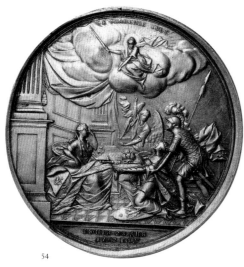

56

56
Great Coronation Medal of Catherine II. 1762
**Timofey Ivanovich Ivanov. 1729-1802/3
Johann Georg Wächter. 1726-1800**
Front: *Б. М. ЕКАТЕРИНА. II. ИМПЕРАТ. И
САМОДЕРЖ. ВСЕРОСС.* [By the Grace of God
Catherine II Empress and Autocrat of All Russia];
beneath the portrait: *тимофей Iвановъ,* [Timofey
Ivanov]. Reverse: *ЗА СПАСЕНІЕ ВѢРЫ И*

ОТЕЧЕСТВА [For the Salvation of Faith and
Fatherland]; left: *waechter;* below: *КОРОНОВАНА ВЪ
МОСКВѢ СЕНТЯБРЯ 22 ДНЯ 1762* [Crowned in
Moscow 22 September 1762]
Gold; struck. Diameter 6.35
Inv. No. Az 215
Provenance: 1917, from the collection of I. I. Tolstoy.

Gold and silver medals were struck in great haste
for Catherine's coronation, in six sizes, for
presentation according to the recipient's rank.
Dies for the front were all produced by Russian
medallist Timofey Ivanov. According to a
tradition established with the coronation of

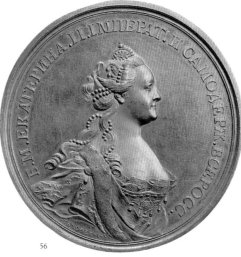

56

Catherine I in 1724, all celebrations took place in
Moscow, with the main ceremony held in the
Cathedral of the Dormition in the Kremlin. Y.S.

57
**Timofey Ivanovich Ivanov. 1729-1802/3
Johann Georg Wächter. 1726-1800**
*Medal Commemorating the Establishment of
the Foundling Hospital, Moscow. 1763*
Front: *Б. М. ЕКАТЕРИНА. II. ИМПЕРАТ. И
САМОДЕРЖ. ВСЕРОСС.* [By the Grace of God
Catherine II Empress and Autocrat of All Russia];
beneath the portrait: *тимофей Iвановъ,* [Timofey
Ivanov]. Reverse: *И ВЫ ЖИВИ БУДЕТЕ* [You Too
Shall Live]; left on column base: *I. G. Waechter f.*; below:
СЕНТЯБРЯ 1 ДНЯ 1763 ГОДА [1 September 1763]
Gold; struck. Diameter 5.1
Inv. No. Az 224
Provenance: 1922, from the Academy of Sciences.

Foundling Hospitals were set up for the care of

57

abandoned children on the initiative of Ivan
Betskoy (1703-95), first in Moscow and then in St
Petersburg. Y.S.

58
*Medal Commemorating the Ceremonial
Dedication of the St Petersburg Academy of
Arts on 18 June 1765*
**Johann Georg Wächter. 1726-1800
Pierre-Louis Vernier. Active in Russia 1764-8**
Front: *ЕКАТЕРИНА. II. ПОКРОВИТЕЛЬНИЦА*
[Catherine II Patron]; beneath the portrait: *WAECHTER.*
Reverse: *ТАКО ТВЕРДЫ ПРЕБУДЕТЕ*
[Be Always Thus Firm]; left: *L.VERNIER.F.*; below:
*СПЕТЕРБУРГС ИМПЕРАТ АКАДЕМ
ХУДОЖЕСТВЪ ТОРЖЕСТВЕН
ПОСВЯЩЕНА ІЮНІЯ 18 Д 1765 г.* [St Petersburg
Imperial Academy of Arts Ceremonially Dedicated
18 June 1765]
Gold; struck. Diameter 5.2
Inv. No. Az 228
Provenance: Main Hermitage Collection.

The Academy of Arts had been founded in 1757,
but on coming to power Catherine
commissioned a new building. Wächter used an
engraving by Jean-Louis Bonnet from a drawing
by Jean-Louis De Velly for the portrait of
Catherine II.

 Vernier ran the Academy of Arts class for
carving in steel and hardstones. Y.S.

58

59
Award Medal for a Graduate of the Academy of Arts. 1765
Johann Georg Wächter. 1726-1800
Pierre-Louis Vernier. Active in Russia 1764-8
Front: *ЕКАТЕРИНА. II. ПОКРОВИТЕЛЬНИЦА* [Catherine II Patron]; beneath the portrait: *WAECHTER.*
Reverse: *ДОСТОИНОМУ* [To One Who is Worthy]; *L.VERNIER*; below: *спб импер. Акад. Худож.*
17[] *іюнія 28.д.*
[St Petersburg Academy of Arts 17[] June 28]
Gold; struck. Diameter 5.2
Inv. No. Az 232
Provenance: 1922, from the Academy of Sciences. Y.S.

60
Medal in Honour of Ivan Betskoy. 1772
Johann Caspar Gottlieb Jäger. Active 1772-1790s
Johann Balthasar Gass. 1730-1813
Front: *ИВАНЪ ИВАНОВИЧЪ БЕЦКОЙ* [Ivan Ivanovich Betskoy]; beneath the portrait: *I.G. JAEGER.*
Reverse: *ЗА ЛЮБОВЬ К ОТЕЧЕСТВУ* [For Love for the Fatherland]; left: *I.B.G.F* [Johann Balthasar Gass Fecit]; below: *ОТЪ СЕНАТА* 20 *НОЯБРЯ* 1772 *ГОДА* [From the Senate 20 November 1772]
Gold; struck. Diameter 6.45
Inv. No. Az 877
Provenance: Main Hermitage Collection.

Ivan Ivanovich Betskoy (1703-95) made a great contribution to culture and education in Russia, from the establishment of Foundling Hospitals and the Institute for Young Ladies of the Nobility (the Smolny Institute) to his 30-year presidency of the Academy of Arts. On 20 November 1772, the Senate took the decision to commission a medal in his honour, but this was produced only several years later. Y.S.

61
Medal of the Free Economic Society. c. 1765
Johann Balthasar Gass. 1730-1813
Johann Georg Wächter. 1726-1800
Front: *Б. М. ЕКАТЕРИНА. II. ИМПЕРАТ. И САМОДЕР. ВСЕРОССIИСК.* [By the Grace of God Catherine II Empress and Autocrat of All Russia]; beneath the portrait: *I. B. GASS.* Reverse: *ЗА ТРУДЫ ВОЗДАЯНIЕ* [Recompense for Labour]:
below right: *W.*
Gold; struck. Diameter 6.6
Inv. No. Az 235
Provenance: Main Hermitage Collection.

Founded in 1765, the Free Economic Society initially sought only improvements in agriculture, but its sphere of activities broadened over the years. In 1796, for instance, it arranged a competition to compile a book for use in general literacy education, and it was particularly involved in the battle against smallpox. Y.S.

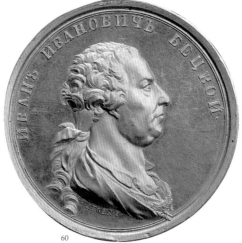
60

59

61

62, 63

Two Medals Commemorating the Introduction of the Tax-Free Import of Bread from Livonia and Estonia to St Petersburg. 1766
Timofey Ivanovich Ivanov. 1729-1802/3
Samoyla Yudich Yudin. 1730-1800

Front: *Б. М. ЕКАТЕРИНА. II. ИМПЕРАТ. И САМОДЕРЖ. ВСЕРОСС.* [By the Grace of God Catherine II Empress and Autocrat of All Russia; beneath the portrait: *тимофей Iвановъ* [Timofey Ivanov]. Reverse: *РЕВНОСТЬ СООТВЕТСТВУЕТ ПРОЗОРЛИВОСТИ* [Zeal is Wisdom]; right: *Ю.* [Yudin]

62) Gold; struck. Diameter 4.3
Inv. No. Az 253
Provenance: mid-19th century, from the Kunstkammer.
63) Gold; struck. Diameter 4.3
Inv. No. Az 252
Provenance: 1922, from the Academy of Sciences.

Due to a shortage of bread in St Petersburg, the decision was taken in 1766 to allow duty-free imports from the Baltic region. By Catherine's personal decree, those merchants who were the first to import grain in a particular month or who imported particularly large quantities were awarded gold medals designed by Jacob Stählin. In 1767 such medals were given "in addition to a certain sum of money to two merchants, one the Revel citizen Den, the other Jano of Riga, for bringing bread to St Petersburg at a time when it had been extremely expensive". Y.S.

64

Medal Commemorating the Introduction of Smallpox Vaccination to Russia in 1768. 1772
Timofey Ivanovich Ivanov. 1729-1802/3

Front: *Б. М. ЕКАТЕРИНА. II. ИМПЕРАТ. И САМОДЕРЖ. ВСЕРОСС.* [By the Grace of God Catherine II Empress and Autocrat of All Russia]; beneath the portrait: *тимофей iвановъ* [Timofey Ivanov]. Reverse: *СОБОЮ ПОДАЛА ПРИМЕРЪ* [She Herself Set the Example]; below: *октября 12 дня 1768 ГОДА* [12 October 1768]
Gold; struck. Diameter 6.4
Inv. No. Az 256
Provenance: Main Hermitage Collection.

Catherine was one of the first European rulers to be personally vaccinated against smallpox – along with the heir to the throne and several courtiers – as an example to her subjects. Scottish doctor Thomas Dimsdale was invited from Britain to carry out the vaccination. Dimsdale was made a Baron for his services, appointed body-physician to the Empress, and awarded a life pension of £500 p.a., while the boy who provided blood for use in the vaccination was raised to the nobility and given the surname Ospenny (from the Russian ospa meaning smallpox). Gold versions of the medal commemorating the event were presented to the Empress in 1772 during a visit to the Senate. Y.S.

65

Medal Commemorating the Court Carousel of 11 July 1766
Timofey Ivanovich Ivanov. 1729-1802/3
Johann Georg Wächter. 1726-1800

Front: *Б. М. ЕКАТЕРИНА ИМПЕРАТ. и САМОДЕРЖ. ВСЕРОСС.* [By the Grace of God Catherine Empress and Autocrat of All Russia]; beneath the portrait: *ТИМОФЕЙ IВАНОВЪ* [Timofey Ivanov]. Reverse: *СЪ АЛФЕЕВЫХЪ НА НЕВСКIЕ БРЕГА* [From the Banks of the Alfios to the Banks of the Neva]; below right: W; below: *ЮЛЯ 11 ДНЯ. 1766 году* [11 July 1766]
Silver; struck. Diameter 6.5
Inv. No. Az 240
Provenance: Main Hermitage Collection.

A Carousel or sporting competition was held on 11 July 1766 on the square in front of the Winter Palace. In a specially erected amphitheatre, four teams or court "quadrilles" attired in rich costume competed in riding, carriage driving, archery and javelin throwing. The inscription on the reverse of the medal likens the event to the Olympic Games, held in Antiquity on the banks of the River Alfios. Y.S.

65

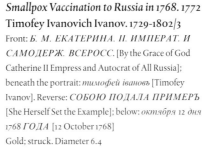

62

64

66

Prize Medal for the Court Carousel, Awarded to Count Grigory Orlov. 1766
Timofey Ivanovich Ivanov. 1729–1802/3
Front: *Б. М. ЕКАТЕРИНА ИМПЕРАТ. и САМОДЕРЖ. ВСЕРОСС.* [By the Grace of God Catherine Empress and Autocrat of All Russia]; beneath the portrait: *ТИМОФЕЙ ІВАНОВЪ* [Timofey Ivanov]. Reverse: *СЪ АЛФЕЕВЫХЪ НА НЕВСКІЕ БРЕГА* [From the Banks of the Alfios to the Banks of the Neva]; right: *m.i.* [Timofey Ivanov]; below: *ГРАФУ ГРИГОРЬЮ ОРЛОВУ ПЕРВ. ПРЕЙС ВТОР. МЕДАЛЬ ИЮЛЯ 11 Д. 1766 г.* [To Count Grigory Orlov First Prize Second Medal 11 July 1766]
Gold; struck. Diameter 5.1
Inv. No. Az 242
Provenance: Main Hermitage Collection.

Grigory Orlov was renowned for his great strength and love of sporting events (as were his brothers – a second medal was awarded to Alexey Orlov). Count Münich presented Orlov with the medal and a laurel wreath while the ladies present wove a garland from the flowers in their hair to crown the victor.　　　Y.S.

67

Prize Medal for the Court Carousel, Awarded to Countess Natalya Chernyshova. 1766
Timofey Ivanovich Ivanov. 1729–1802/3
Samoyla Yudich Yudin. 1730–1800
Front: *Б. М. ЕКАТЕРИНА ИМПЕРАТ. и САМОДЕРЖ. ВСЕРОСС.* [By the Grace of God Catherine Empress and Autocrat of All Russia]; beneath the portrait: *ТИМОФЕЙ ІВАНОВЪ* [Timofey Ivanov]. Reverse: *СЪ АЛФЕЕВЫХЪ НА НЕВСКІЕ БРЕГА* [From the Banks of the Alfios to the Banks of the Neva]; left: *С. Ю* [Samoyla Yudin]; below: *ГРАФИНЕ НАТАЛЬЕ ЧЕРНЫШЕВО. ПЕРВ. ПРЕЙС. ТРЕТИЯ МЕДА. ИЮЛЯ. 11. д. 1766. го* [To Countess Natalya Chernyshova. First Prize. Third Medal. 11 July 1766]
Gold; struck. Diameter 4.3
Inv. No. Az 245
Provenance: 1925, from the Stroganov collection.

Countess Natalya Petrovna Chernyshova (1741-1837) married Prince Vladimir Golitsyn (1731-98) in 1766. She spent most of her nearly one hundred years at court where she became a legendary figure: Chernyshova served as proto-type for the aged Countess in Alexander Pushkin's short story *The Queen of Spades* (1833).　　　Y.S.

68

Medal Commemorating the 50th Anniversary of the Academy of Sciences. 1776
Samoyla Yudich Yudin. 1730–1800
Johann Caspar Gottlieb Jäger. Active 1772–1790s
Front: *Б. М. ЕКАТЕРИНА ИМПЕРАТ. И САМОДЕРЖ. ВСЕРОССИИС.* [By the Grace of God Catherine Empress and Autocrat of All Russia]; beneath the portrait: *с.юдинъ* [S. Yudin]. Reverse: *ЕЮ ПРОЦВЕТУТЪ НАСАЖДЕНИЯ ПЕТРОВЫ* [Peter's Initiatives Flower in Her]; right: *I.C.I.* [Johann Caspar Jäger]; below: *юбилей. акад. наукъ. торжествованъ 1776* [Jubilee of the Academy of Sciences Celebrated 1776]
Gold; struck. Diameter 5.2
Inv. No. Az 274
Provenance: Main Hermitage Collection.

Jacob Stählin was responsible for designing the anniversary celebrations for the Academy of Sciences, as well as a medal and jeton, the inscriptions and images on which specifically emphasised Catherine's role as heir to and developer of the innovations of Peter the Great. The reverse of this medal shows the Kunstkammer, where the Academy was housed until Quarenghi's new building was erected.　Y.S.

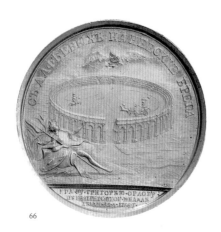

66

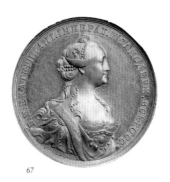

67

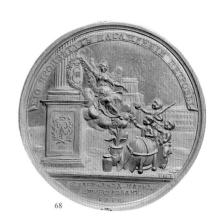

68

69

Jeton Commemorating the 50th Anniversary of the Academy of Sciences. 1776

Johann Caspar Gottlieb Jäger. Active 1772-1790s

Front: *ПЕТРЪ ВЕЛИКИЙ ИМПЕР. Основъ акад 1725* [Emperor Peter the Great. Founded the Academy 1725]. Reverse: *ЕКАТЕРИНА II. ИМП. ВСЕРОС. Покров. Акад. 1776* [Catherine II Empress of All Russia. Patron of the Academy. 1776]

Gold; struck. Diameter 2.7

Inv. No. Az 275

Provenance: Main Hermitage Collection. Y.S.

69

70

Medal Commemorating the Establishment of the Order of St George in 1769

Johann Balthasar Gass. 1730-1813

Front: *Б. М. ЕКАТЕРИНА II ІМПЕРАТ. И САМОДЕРЖ. ВСЕРОСС.* [By the Grace of God Catherine II Empress and Autocrat of All Russia]; beneath the portrait: *I.B.GASS.F.* Reverse: *ХРАБРОСТИ* [Bravery]; on the sash: *ЗА СЛУЖБУ И ХРАБРОСТЬ* [For Service and Bravery]; below: *1769 г.26. ноября* [26 November 1769]

Gold; struck. Diameter 7.8

Inv. No. Az 257

Provenance: Main Hermitage Collection.

Founded on 26 November 1769, the Order of St George was intended for the reward of military feats and had four classes. The medal was produced some years later, to a design of 1785 by Jacob Stählin. Y.S.

71

Medal Commemorating the First Marriage of Grand Duke Paul in 1773

Johann Caspar Gottlieb Jäger. Active 1772-1790s

Johann Balthasar Gass. 1730-1813

Front: *ВЕЛИКИЙ КНЯЗЬ ПАВЕЛЪ ПЕТРОВИЧЪ ВЕЛИКАЯ КНЯГИНЯ НАТАЛИЯ АЛЕКСЕЕВНА* [Grand Duke Pavel Petrovich Grand Duchess Natalia Alexeyevna]; bottom edge: *I. G. JAEGER. F.* Reverse: *БОЖИИМ ПРОВИДЪНIЕМЪ* [By the Providence of God], on the pedestal the monograms *PP NA въ въчность* [PP NA in Eternity]; below: *бракосочетание совершено сентября 29. дня. 1773 года* [Marriage Concluded 29 September 1773]

Gold; struck. Diameter 6.5

Inv. No. Az 266

Provenance: 1922, from the Academy of Sciences.

Catherine II's son (later Paul I) married Princess Wilhelmina of Hesse-Darmstadt, who took the Russian Orthodox name Natalya Alexeyevna. But the marriage was shortlived: the Grand Duchess died in childbirth in 1776, along with the infant. Y.S.

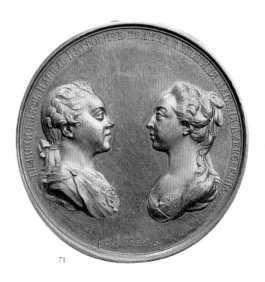

71

70

72

Medal Commemorating the Second Marriage of Grand Duke Paul in 1776
Johann Caspar Gottlieb Jäger. Active 1772–1790s
Johann Georg Wächter. 1726–1800
Front: *В: КН: ПАВЕЛЪ: В: КН: МАРІЯ ФЕОДОРОВНА* [Grand Duke Pavel Petrovich: Grand Duchess Maria Fyodorovna]; *I. C. JAEGER*. Reverse: *НОВАЯ НАДЕЖДА РОССІИ* [Russia's New Hope]; below: *бракъ совершенъ сентября 26 дня 1776 года* I. G.W.F. [Marriage Concluded 26 September 1776. Johann George Wächter Made This]
Gold; struck. Diameter 6.4
Inv. No. Az 271
Provenance: 1922, from the Academy of Sciences.

Less than a year after the death of his first wife, at his mother's insistence the heir to the throne married Sophia Dorothea, Princess of Württemburg, who took the Russian Orthodox name Maria Fyodorovna. Y.S.

73

Medal Commemorating the Birth of Grand Duke Alexander in 1777
Johann Balthasar Gass. 1730–1813
Johann Caspar Gottlieb Jäger. Active 1772–1790s
Front: *Б. М. ЕКАТЕРИНА II ИМПЕРАТ. И САМОДЕРЖ. ВСЕРОССІИС.* [By the Grace of God Catherine Empress II and Autocrat of All Russia]; beneath the portrait: I.B.GASS. Reverse: *НЕБЕСНЫЙ ДАРЪ* [Heavenly Gift]; right: I.G.I [Johann Gottlieb Jäger]; below: *вел. князь александръ павловичь родился. декабря. 12 дня. 1777 года* [Grand Duke Alexander Pavlovich Born 12 December 1777]
Gold; struck. Diameter 6.4
Inv. No. Az 276
Provenance: Main Hermitage Collection.

Catherine toyed with the idea of making her grandson Alexander heir to the throne in place of her son Paul, which led to many personal conflicts within the imperial family. Y.S.

foreground Faith, Hope and Charity hold the newborn child, while the Church of St Sophia in Constantinople (converted into a mosque – hence the minarets) is visible in the distance to the right. Y.S.

74

75

Medal Commemorating Transportation of the Stone Pedestal for the Monument to Peter I in St Petersburg in 1770
Johann Caspar Gottlieb Jäger. Active 1772–1790s
Front: *ЕКАТЕРИНА. II* [Catherine II]; beneath the portrait: I.G.I.F. [Johann Gottlieb Jäger fecit]. Reverse: *ДЕРЗНОВЕНІЮ ПОДОБНО* [Like Audacity]; I.G.I [Johann Gottlieb Jäger]; below: *генваря 20. 1770* [20 January 1770]
Gold; struck. Diameter 6.4
Inv. No. Az 258
Provenance: Main Hermitage Collection.

Etienne Falconet's equestrian statue of Peter I, the Bronze Horseman, was to be set on a vast stone which was found 12km from St Petersburg. Two years – from September 1768 to September 1770 – were required for the complex transportation of the stone, first across dry land then by water. Catherine and her suite came to watch the process in January 1770 and before her eyes 400 people moved it 200 sazhen [about 426 metres]. Although this medal is devoted to the event, it was produced several years later. Y.S.

72

74

Medal Commemorating the Birth of Grand Duke Constantine in 1779
Carl Alexandrovich Leberecht. 1755–1827
Johann Balthasar Gass. 1730–1813
Front: *Б. М. ЕКАТЕРИНА II ИМПЕРАТРИЦА И САМОДЕРЖЦА. ВСЕРОСС* [By the Grace of God Catherine II Empress and Autocrat of All Russia]; beneath the portrait: C. LEBERECHT F. Reverse: *С СИМИ* [With These]; below: *ВЕЛ. КН. КОНСТАНТИНЪ ПАВЛОВИЧЬ РОДИЛСЯ В ЦАРСКОМ СЕЛЪ АПРЕЛЯ 27 ДНЯ 1779 ГОДА* [Grand Duke Constantine Pavlovich Born at Tsarskoye Selo 27 April 1779]; right: GASS
Gold; struck. Diameter 6.4
Inv. No. Az 277
Provenance: Main Hermitage Collection.

Catherine had many far-reaching plans for her second grandson, enshrined in her "Greek project". He was named Constantine, his first wet-nurse was a Greek woman named Helen (after the Emperor Constantine's mother), and his tutor was also Greek. The Empress hoped to restore the ancient Greek empire on the ruins of "a barbarian state", granting it "total independence" by handing it over to the rule of the Grand Duke. On the reverse of the medal is a composition embodying these hopes: in the

72

75

76

Medal Commemorating the Unveiling of the Monument to Peter I in St Petersburg in 1782
Pud Ivanovich Bobrovshchikov. 1741-?
Johann Georg Wächter. 1726-1800

Front: *Екатерины II. Б.* [Catherine II. Bobrovshchikov]. Reverse, on the pedestal: *ПЕТРУ. I. ЕКАТЕРИНА. II.* [To Peter I. Catherine II]; below: *лѣта. 1782. августа. 6. Дня* [6 August 1782]; left: *W*
Gold; struck. Diameter 6.4
Inv. No. Az 282
Provenance: Main Hermitage Collection.

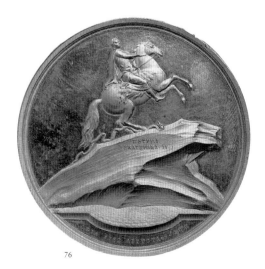

76

77

Medal Commemorating the Unveiling of the Monument to Peter I in St Petersburg in 1782
Pud Ivanovich Bobrovshchikov. 1741-?
Carl Ivanovich Leberecht. 1755-1827

Reverse, on the pedestal: *ПЕТРУ. I. ЕКАТЕРИНА. II.* [To Peter I. Catherine II]; below: *лѣта. 1782. августа. 6. Дня* [1782. 6 August]; left: *carl leberecht. f*
Gold; struck. Diameter 6.4
Inv. No. Az 283
Provenance: Main Hermitage Collection.

A handwritten note from the Empress herself dated 1 August 1782 gave orders for the preparation of medals to mark the unveiling of Falconet's monument to Peter I: "Large gold – 10, middle-sized – 50, lesser – 150. Great Silver – 200, middle-sized – 300, lesser – 500." Medals of all three sizes bore the date and the inscription which stands on the sculpture's pedestal, "To Peter I. Catherine II", implying that the Empress was direct heir to Peter and his policies. Catherine frequently presented these medals both to her own subjects and to foreigners for services to the throne. In July 1789, for instance, she ordered that a gold medal "of the middle kind" be presented to an English ship's master who had rescued four Russian sailors escaped from Swedish imprisonment. Y.S.

78

Medal Commemorating Reinforcement of the Russian Navy in 1782. 1790
Timofey Ivanovich Ivanov. 1729-1802/3

Front: *Б. М. ЕКАТЕРИНА II ИМПЕРАТ. И САМОДЕРЖ. ВСЕРОССIИС.* [By the Grace of God Catherine Empress and Autocrat of All Russia]; beneath the portrait: *выр. 1790. г. тимофей ивановъ* [Timofey Ivanov Carved 1790]. Reverse: *СИЛЫ ПОБЕДАМЪ СОРАЗМЕРНЫ* [Forces Equivalent to Victory]; below: *1782 года июля въ 28 день* [28 July 1782]
Gold; struck. Diameter 7.8
Inv. No. Az 280
Provenance: Main Hermitage Collection.

Additional ships were built for the navy on the Black Sea in the early 1780s. Evidence that the medal (designed in 1785 by Jacob Stählin) was struck later is provided by the date and signature of the medallist on the front. Y.S.

79

Medal Commemorating Russia's Annexation of the Crimea in 1783
Timofey Ivanovich Ivanov. 1729-1802/3
Johann Balthasar Gass. 1730-1813

Front: *Б. М. ЕКАТЕРИНА II ИМПЕРАТ. И САМОДЕРЖ. ВСЕРОССIИС.* [By the Grace of God Catherine Empress and Autocrat of All Russia]; beneath the portrait: *вырезы. 1784. г. тимофей ивановъ* [Timofey Ivanov Carved This in 1784]. Reverse: *СЛѢДСТВIЕ МИРА* [The Result of Peace]; on the map: *СТЕПЬ КРЫМСКАЯ* [Crimean Steppes] *перекопъ, сивашъ гнилое море* [Perekop, Sivash Decaying Sea] *АЗОВСКОЕ МОРЕ* [Sea of Azov] *КРЫМЪ* [Crimea], *КУБАНЬ* [Kuban], *таманъ* [Taman], *ЧЕРНОЕ МОРЕ* [Black Sea]; below: *присоединены къ российской империи безъ кровопролития апреля 8 дня 1783 года* [United with the Russian Empire Without Bloodshed 8 April 1783]
Gold; struck. Diameter 6.5
Inv. No. Az 287
Provenance: 1922, from the Academy of Sciences.

Russia annexed the Crimean Peninsula and the neighbouring shores of the Black Sea via peace treaties and when the design for the medal was presented to Catherine she herself added the inscription "The Result of Peace". Y.S.

78

79

80

Medal Commemorating the Affirmation of Property Rights in 1782

Timofey Ivanovich Ivanov. 1729-1802/3

Front: *Б. М. ЕКАТЕРИНА II ИМПЕРАТ. И САМОДЕРЖ. ВСЕРОССІИС.* [By the Grace of God Catherine Empress and Autocrat of All Russia]; beneath the portrait: *выр. 1790. г. тимофей ивановъ* [Timofey Ivanov Carved 1790]. Reverse: *ВЪ ПОЛЬЗУ ВСЕХЪ* [For the Good of All]; on the banner: *LIBERTAS*

Gold; struck. Diameter 7.8

Inv. No. Az 290

Provenance: Main Hermitage Collection.

The manifesto "On the extension of owners' property rights to all works of the earth, on its surface and contained within it" was published on 28 June 1782. Y.S.

80

81

Lesser Gold Medal of the Nobles' Land Corps, Awarded to Count Alexey Bobrinsky in 1782

Pierre Louis Vernier. Active in Russia 1764-8

Front: *ЕКАТЕРИНА. ВТОРАЯ* [Catherine the Second]; below: *VERNIER*.

Reverse: *УСПЪВАЮЩЕМУ* [To a Good Student]; below: *АЛЕКСЕЮ ГР. БОБРИНСКОМУ* 1782 [Alexey Gr. Bobrinsky 1782] (the name and last two figures engraved)

Gold; struck and engraved. Diameter 4.3

Inv. No. Az 273

Provenance: 1927, from the Museums Fund.

Alexey Grigoryevich Bobrinsky (1762-1813), illegitimate son of Catherine II and Grigory Orlov, graduated in 1782 from the Nobles' Land Corps with the title of lieutenant, receiving this Lesser Gold Medal. Y.S.

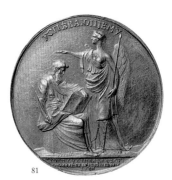

81

82, 83

Two Medals on the Death of Alexander Lanskoy in 1784

Johann Balthasar Gass. 1730-1813

Front: *АЛЕКСАНДРЪ ДМИТРИЕВИЧЪ ЛАНСКОЙ: ГЕН ПОР: И ГЕН АДЪЮТ* [Alexander Dmitriyevich Lanskoy. Lieutenant General and Adjutant General]; bottom edge: *I.B. GASS. F.*

Reverse: *ВЪ ПАМЯТЬ ДРУЖБЫ* [In Memory of Friendship]; below: *родился 1758. г. марта. 8. д. скончался 1784 г. июня 25 д.* [Born 8 March 1758 Died 25 June 1784]

82) Gold; struck. Diameter 4.4

Inv. No. Az 977

83) Silver; struck. Diameter 4.4

Inv. No. RM 7999

Provenance: Main Hermitage Collection.

Six months after the death of her favourite Alexander Lanskoy in 1784, Catherine commissioned a medal in his memory, herself introducing certain changes to the design, adding the inscription on the reverse, "In Memory of Friendship". Y.S.

82

84

Medal Commemorating Catherine II's Journey to the Crimea in 1787

Timofey Ivanovich Ivanov. 1729-1802/3

Front: *Б. М. ЕКАТЕРИНА II ИМПЕРАТ. И САМОДЕРЖ. ВСЕРОССІИС.* [By the Grace of God Catherine Empress and Autocrat of All Russia]; beneath the portrait: *выр. 1787. г. тимофей ивановъ* [Timofey Ivanov Carved this 1787]. Reverse: *ПУТЬ НА ПОЛЬЗУ* [A Useful Journey]; below: *въ 25 лѣто царствованія 1787 году* [In the 25th Year of Her Reign 1787]

Gold; struck. Diameter 6.5

Inv. No. Az 291

Provenance: 1922, from the Academy of Sciences.

To mark the 25th anniversary of her rule, in January 1787 Catherine II undertook a journey down the River Dnieper to see the southern lands which had recently been annexed to Russia. In addition to a vast suite of courtiers, the Empress was accompanied by foreign ambassadors and the Austrian Emperor, Joseph II, who travelled under the pseudonym Count Falkenstein. The journey was marked by magnificent celebrations and the launch of new naval ships, as well as demonstrations of the fleet's raid on Sebastopol, all intended to display Russia's military and economic might. On 15 March 1787 the Empress personally decreed the preparation of 100 gold and 500 silver medals "on the occasion of this Our present journey".

The dated signature is evidence that the medal was produced that same year.　　　Y.S.

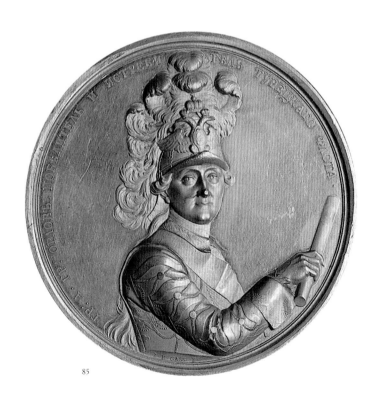

84

85
Medal in Honour of Count Alexey Orlov, Commemorating the Victory of the Russian Fleet at Chesme in 1770
Johann Balthasar Gass. 1730-1813
Front: *ГР. А. ГР. ОРЛОВЪ. ПОБѢДИТЕЛЬ И ИСТРЕБИТѢЛЬ ТУРЕЦКАГО ФЛОТА* [Count Alexey Grigoryevich Orlov. Victor and Destroyer of the Turkish Fleet]; beneath the portrait: *I. B. GASS.* Reverse: *И БЫСТЬ РОССІИ РАДОСТЬ И ВЕСЕЛІЕ* [Russia Shall Indeed Have Joy and Merriment]; below: *чесма іюня 24 и 26 въ благодарность побѣдителю отъ адм. колл.* [Chesme 24 and 26 June in Thanks to the Victor from the Admiralty Collegium]
Gold; struck. Diameter 9.1
Inv. No. Az 1009
Provenance: Main Hermitage Collection.

In June 1770, during the Russo-Turkish War of 1768-74, a Russian squadron commanded by Admiral Grigory Spiridov arrived in the Mediterranean, having travelled from Kronstadt (St Petersburg) avoiding the European mainland. On 24 and 26 June, the Turkish fleet was totally destroyed during a battle at Chesme. Commander of the united forces of Russia on land and sea was Alexey Grigoryevich Orlov, brother of Catherine's favourite Grigory Orlov. In 1771, on the anniversary of the Battle of Chesme, the Admiralty Collegium produced this medal in his honour. In a letter, Catherine recorded her involvement in composing the inscription on the reverse.　　　Y.S.

86, 87
Two Medals in Honour of Count Grigory Orlov. 1771
Georg Christian Wächter. 1729-98
Johann Georg Wächter. 1726-1800
Front: *ГРАФЪ ГРИГОРІЙ ГРИГОРІЕВИЧЪ ОРЛОВЪ РИМСКІЯ ИМПЕРІИ КНЯЗЬ* [Count Grigory Grigoryevich Orlov Prince of the Roman Empire]; beneath the portrait: *G. C. WÄCHTER.* Reverse: *РОССІЯ ТАКОВЫХЪ СЫНОВЪ ВЪ СЕБѢ ИМѢѢТЪ* [Russia Should Have Such Sons]; below: *за избавление москвы отъ язвы въ 1771 году* [For Saving Moscow from Danger in 1771]; right: *I.G.W.F.* [Johann Georg Wächter fecit]
86) Silver; struck. Diameter 9.2
Inv. No. DRM 8982
Provenance: 1928, from the Yusupov House Museum, formerly Yusupov collection.
87) Silver; struck. Diameter 9.2
Inv. No. RM 8231
Provenance: Main Hermitage Collection.

Catherine's favourite Count Grigory Orlov not only played a leading role in bringing her to the throne, but in 1771, at the Empress's command, he was sent to take control in Moscow after disorders during an epidemic of the plague. His successful efforts were marked by the issue of this medal, on the reverse of which the Count is shown as the Classical hero Marcus Curtius (who

85

threw himself into a chasm to save his country) against a panorama of Moscow. The French sculptor Etienne Falconet praised this example of the Russian medallist's art extremely highly.

Y.S.

88
Medal in Honour of Prince Grigory Potemkin. 1789
Carl Alexandrovich Leberecht. 1755-1827
Johann Georg Wächter. 1726-1800
Front: *КНЯЗЬ ГРИГОРІЙ АЛЕКСАНДРОВИЧЪ ПОТЕМКИНЪ ТАВРИЧЕСКОЙ ГЕНЕРАЛ ФЕЛЬДМАРШАЛЪ* [Prince Grigory Alexandrovich Potemkin of Tauride Fieldmarshal General]; beneath the portrait: *CARL LEBERECHT.* Reverse: *КРОТОСТІЮ СМИРЕНЪ ПРОТИВНИКЪ* [The Enemy Tamed by Gentleness]; *W. F.*; below: *присоединеніе къ Россіи крыма и тамана въ 1783 году* [The Annexation of the Crimea and Taman to Russia in 1783]
Gold; struck. Diameter 9.1
Inv. No. Az 1024
Provenance: 1922, from the Academy of Sciences.

Grigory Potemkin became Catherine's favourite in 1774 and remained her closest ally and adviser in matters of state until his death. She marked his

services in conquering the southern territories in 1789 with the simultaneous issue of three medals, each with the same portrait of Potemkin on the front. Leberecht produced this portrait from the life, as is proved by a wax sketch signed by the medallist (also Hermitage). On the reverse of these medals were dedications to Russia's annexation of the Crimea, the establishment of the Yekaterinoslavl Territory and the Tauride Region, and to Potemkin's military victories of 1788. Catherine herself composed the inscriptions on the back and in sending copies of the medals to Potemkin she wrote: "I have admired in them both your image and the deeds of a man in whom I have not been mistaken." Y.S.

89
Medal Commemorating the Death of Admiral Samuel Greig on 26 October 1788. 1791
Carl Alexandrovich Leberecht. 1755-1827
Front: *САМУИЛЪ КАРЛОВИЧЪ ГРЕЙГ РОССІЙСКОЙ АДМИРАЛЪ* [Samuil Karlovich Greig Russian Admiral]; beneath the portrait: *C.LEBERECHT.F.* Reverse, on the obelisk over the arms: *STRICE SURE* ["attack surely" – Greig's device]; in the centre: *ВЪ ПАМЯТЬ ТРУДОВЪ И СЛУЖБЫ* [In Memory of Labours and Service]; right: *inv. et fecit Carl Leberecht 1791*; below: *СКОНЧАЛСЯ ОКТЯБРЯ 15 ДНЯ 1788 ГОДА* [Died 15 October 1788]

Gold; struck. Diameter 7.8
Inv. No. Az 927
Provenance: Main Hermitage Collection.

Samuel Greig (1736-88) was a Scot who trained in the British Royal Navy and entered the Russian service as a Captain in 1764. He made his name in the Russo-Turkish wars, particularly at the Battle of Chesme in 1770. From 1775 Vice-Admiral and Commander of the Port of Kronstadt, from 1782 Admiral. During the war with Sweden, Greig headed the Russian fleet and led several victories but fell seriously ill and died on board ship on 15 August. In 1791 the Petersburg Mint struck medals in his honour showing a monument to the Admiral and his tomb in the Domkirche in Tallinn. Y.S.

90
Medal in Honour of Count Alexander Suvorov. 1790
Carl Alexandrovich Leberecht. 1755-1827
Johann Balthasar Gass. 1730-1813
Front: *ГРАФЪ АЛЕКСАНДРЪ ВАСИЛЬЕВИЧЪ СУВОРОВЪ РЫМНИКСКІЙ ГЕН: АНШЕФЪ* [Count Alexander Vasilyevich Suvorov of Rimnic, General-in-Chief]; beneath the portrait: *LEBERECHT.* Reverse, on the shield: *Рымникъ Измаилъ Кинбурнъ Фокшаны* [Rimnic, Ismail, Kinburn, Focşani]; right: *I. B. G.* [Johann Balthasar Gass]

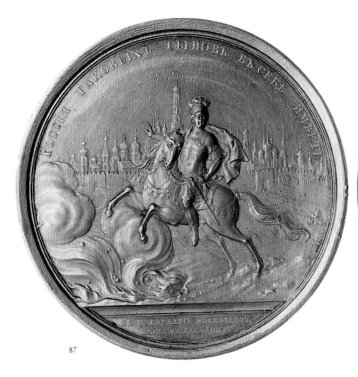

87

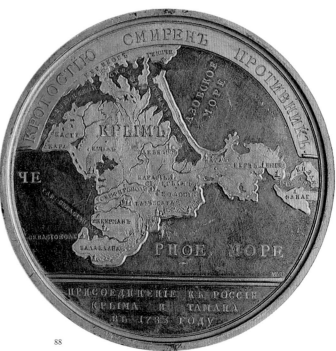

88

89

90

Gold; struck. Diameter 7.8

Inv. No. Az 1069

Provenance: Main Hermitage Collection.

Russian military commander Alexander
Vasilyevich Suvorov (1729-1800) was hero of a
number of victorious campaigns during
Catherine's reign. This medal marks his victories
of 1787, 1788 and 1790 in the Russo-Turkish war.
In a letter of 9 September 1793, Suvorov
expressed his thanks to Leberecht (who depicted
him as an Antique hero) and requested another
copy of the medal. Y.S.

91

Medal Commemorating the Birthday of Catherine II on 21 April 1793

Grand Duchess Maria Fyodorovna. 1759-1828

Front: monogram of Catherine II in a wreath. Reverse:
ЯКО ИМЯ ТАКО ЖИЗНЬ [As the Name so the
Life]; below: *МАРІЯ ВЫР* 1793 *года* [Maria Carved
1793]

Silver; struck. Diameter 3.9

Inv. No. RM 1803

Provenance: Main Hermitage Collection.

Maria Fyodorovna, wife of Grand Duke (later
Emperor) Paul, was a woman of some artistic
talent. Leberecht gave her lessons in wax
modelling, ivory carving, engraving in steel and
on hardstones. Her signature is found on three

Russian medals: this piece, a coronation medal
for Paul I of 1797, and a medal in honour of
Alexander I's victorious return to Russia from
Europe in 1814.

Maria Fyodorovna often presented her works
to her mother-in-law. Catherine gave this medal
to the Hermitage, as is recorded in Georgi's
description of St Petersburg of 1794. Y.S.

91

92

Medal Commemorating the Marriage of Alexander Pavlovich in 1793

Carl Alexandrovich Leberecht. 1755-1827

Front: *ВЕЛИКІЙ КНЯЗЬ АЛЕКСАНДРЪ
ПАВЛОВИЧЪ ВЕЛИКАЯ КНЯГИНЯ
ЕЛИСАВЕТА АЛЕКСЕЕВНА* [Grand Duke
Alexander Pavlovich Grand Duchess Yelizaveta
Alexeyevna]; below: *CARL. LEBERECHT. F.* Reverse:
БЛАГО ВОЗСІЯ МНОГО [Many Blessings Did
Shine]; on the shield: the monograms *AP EA*; right:
c.l. f. [Carl Leberecht fecit]; below: *сентября. 28. дня.
1793 года* [28 September 1793]

Gold; struck. Diameter 6.5

Inv. No. Az 305

Provenance: Main Hermitage Collection.

Catherine selected as the bride of her favourite
grandson, Alexander, Louisa-Maria-Augusta of
Baden Durlach, who took the Russian Orthodox
name Yelizaveta Alexeyevna. Both were so
handsome that at court they were nicknamed
"Cupid and Psyche". The medallist produced
their portraits *à l'antique*, in keeping with the
prevalent Neoclassical style. Y.S.

92

93

93

Medal Commemorating the Peace with Turkey of 1791

Carl Alexandrovich Leberecht. 1755-1827

Johann Georg Wächter. 1726-1800

Front: *Б. М. ЕКАТЕРИНА. II. ІМПЕРАТРИЦА И САМОДЕРЖИЦА ВСЕРОССІЙСКАЯ* [By the Grace of God Catherine II Empress and Autocrat of All Russia]; beneath the portrait: *CARL. LEBERECHT. F.*
Reverse: *ПОБѢДАМИ ПРИОБРѢТЕНЪ МИРЪ* [Peace Acquired Through Victories]; below right: *I.G.W.F.* [Johann Georg Wächter fecit]; below: *декабря 29 дня 1791 года* [29 December 1791]
Gold; struck. Diameter 8.3
Inv. No. Az 301
Provenance: Main Hermitage Collection.

The Treaty of Jassy which concluded the Russo-Turkish War of 1787-91 gave Russia territory between the South Bug and the Dnestr and confirmed Russia's annexation of the Crimea. By tradition, campaign participants were presented with gold and silver memorial medals in three sizes, according to rank, while soldiers received silver oval medals with the Empress's monogram on one side and the inscription "victors in peace" on the other. These memorial medals bear the last portrait of Catherine II taken during her lifetime.
Y.S.

94

Miniature Medal on the Death of Catherine II in 1796

Unknown Medallist

Gold; struck. Diameter 6 mm
Inv. No. Az 309
Provenance: 1856, from the collection of Yakov Reichel, St Petersburg.

This miniature medal, intended for setting into a ring, reproduces a carved portrait of Catherine II by Grand Duchess Maria Fyodorovna. Similar miniature medals bearing a portrait of Alexander I were made for this purpose after his death. Reichel thought that the medal was made on Matthew Boulton's lathe [see Cat. 95].
Y.S.

94

95

Medal with a Portrait of Catherine II and the Dates of her Life. c. 1803

Conrad Heinrich Küchler. Active Germany and England 1763-1821

Stamped inscriptions. Front: *Б. М. ЕКАТЕРИНА. II. ІМПЕРАТ. И САМОДЕРЖ. ВСЕРОСС* [By the Grace of God Catherine II Empress and Autocrat of All Russia]; *К.* Reverse: *NAT. 2 MAJ. MDCCXXIX* OBIIT 6/17 NOV. MDCCXCVI. ** [Born 2 May 1729* Died 6/17 November 1796]
Copper; struck and gilded. Diameter 3.0
Inv. No. IM 21536
Provenance: Main Hermitage Collection.

Struck as a trial piece on a lathe from the English manufacturer Matthew Boulton, who in the early 19th century supplied equipment to the St Petersburg Mint and stone vases to the court [see Cat. 315].
Y.S.

96

One-sided Proof Medal with a Portrait of Peter III. c. 1797

Carl Alexandrovich Leberecht . 1755-1827

Front: *Б. М. ПЕТРЪ III ИМПЕРАТОРЪ И САМОДЕРЖЕЦЪ ВСЕРОСС* [By the Grace of God Peter III Emperor and Autocrat of All Russia]; beneath the portrait: *C. LEBERECHT*

Silver; struck. Diameter 6.6

Inv. No. RM 1166

Provenance: 1925, from the Stroganov collection.

After Catherine's death in 1796, her son Paul revived the memory of his father, so long ignored and reviled, moving Peter's body from "exile" in the Alexander Nevsky Monastery to the Peter and Paul Fortress, where Russian rulers since Peter I were buried.

A second example of a rare version of this medal, in lead, was formerly in the collection of J. Iversen and is now also in the Hermitage. The die was not tempered and was thus deformed when struck. Y.S.

97

Ivory Vase with A Procession of Cupids and Tritons with Attributes of Mars. 1775

Johann Xavery

Monogram of Catherine II and the date: *1774 10 Juli;* signed below: *I. H. Xavery. 1775*

Ivory, bronze. Height 39.1

Inv. No. 2855

Provenance: 1775.

Little is know of Xavery, except that in 1766 one Johann Xavery applied for employment to the Administration for Construction, but was refused. Nonetheless, the Hermitage has two marble sculptures and two biscuit groups bearing his signature, all dated between 1765 and 1777. One of the marbles has the inscription "St. Petersburg", one biscuit group bears the name of the master at the Imperial Porcelain Manufactory who produced the porcelain mass. It thus seems almost certain that Xavery was employed at Manufactory. He was possibly a member of the famous Flemish Savery (Xavery) family of artists and sculptors.

This ivory vase also bears his signature. It was probably commissioned by Catherine to commemorate the triumph of Russia's land and sea forces after the conclusion of the Peace of

97

Kuchuk-Kaynardzhi of 1774 in the Russo-Turkish war. Along the body of the cup are allegorical scenes with children, while the lid is decorated with figures of two naked boys holding garlands of flowers. All of Savery's subjects are in some way linked with children, who even make their appearance in the most un-childlike scenes, such as a Triumph of Military Forces. E.S.

98
Wig. Second half of the 18th century
Western Europe
Silver thread, cloth. 38 × 38
Inv. No. E 2067
Provenance: by the early 20th century in the Gallery of Objets de Vertu; by 1789, in the Winter Palace.

The entry recording this wig in the Inventory (No. 420) in January 1833 reads simply "Wig of silver hair with a small chignon." In his guide to the Gallery of Objets de Vertu of 1902, however, Lieven noted "Wig of silver threads. By legend presented to Empress Catherine II by the Naryshkin family."

It seems likely that the wig came from the family of Count Semyon Kirillovich Naryshkin (1710-75), who was in 1740-1 Plenipotentiary Envoy to England, later Marshal to Grand Duke Peter (future Peter III) 1742-56, and finally Ober-Jägermeister.

Count Naryshkin was considered the leading dandy of his day and Catherine often visited his theatre when she was Grand Duchess. It is perhaps during one such visit that the Empress was given the wig. L.Y.

98

Objets de Vertu

Objets de Vertu at the Imperial Court

OLGA KOSTYUK

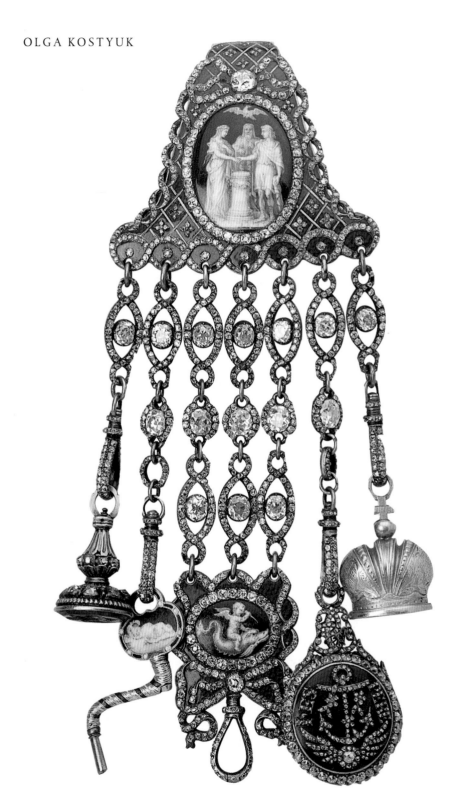

Jean Jack Duc: *Chatelaine with "Cameo" Decoration* [Cat. 129]

Desiring to create a city which would equal the capitals of Europe, Peter the Great invited masters from abroad and from all over Russia to take part in building and decorating the city he had founded in 1703. In 1711 he brought "the best masters of various arts" from Moscow[1] and in 1714, when St Petersburg was declared the Russian Empire's new capital, all official bodies were transferred there – including part of the rich Armoury collections. St Petersburg thus became home to a small but highly significant jewellery collection at the very start of the city's existence.

Russia's military and diplomatic successes and the court's orientation towards European artistic tastes led to an influx of foreign jewellers, who introduced the guild system: one for Russian craftsmen, the other for foreign masters (the latter existed unofficially from 1714 before being approved by Peter on 1 January 1721). To become a member of a guild, a craftsman had to have served an apprenticeship of at least three years and to have produced independent work.

Growing state expenditure on military needs and construction of the new capital, together with a lack of raw materials, led to stagnation in jewellery production at the start of the 18th century. Precious metals had to be imported, but Peter issued a decree on 24 August 1700, ordering a search for "gold, silver and other" mines. In 1704 the first silver factory opened near

Nerchinsk and from the 1730s Russian silver was available to jewellers; gold still came as ingots or coins from Western Europe – Holland, Germany and Italy – and Turkey. Sometimes jewellers were given by the court office "for new works, scrap items found not to be to modern taste".[2] The first Russian gold appeared with the opening of a mine in 1745 near Yekaterinburg in the Urals, which did much to improve the Russian economy in the last years of Empress Elizabeth's reign, and led to the appearance of rich jewellery at her court.

When Catherine came to the throne in 1762, Elizabeth's Baroque Winter Palace was already complete, but the Empress began to rework its interiors. In 1764 Catherine's Audience Chamber in the south eastern block became her "Diamond Chamber", "in place of the alcove, a glazed cupboard was placed here in which the imperial treasures were kept."[3] This room "can be considered the richest cabinet of precious items. The state regalia stands… on a table beneath a large crystal cover through which everything can be clearly observed… Along the walls of this room are set out several glazed cupboards housing many adornments of diamond and other precious stones, while others have a large number of Order medals, portraits of HER IMPERIAL HIGHNESS, snuffboxes, watches and chains, cases of drawing instruments, rings, ribbons, gold sword hilts and other precious items, from which the MONARCH chooses whatever SHE pleases for the presents SHE gives."[4]

It became the fashion for all those with the necessary means to collect precious jewellery, thus of course facilitating increased activity on the market,[5] as jewellers sought to satisfy a growing demand for luxury items. Not only was the city rich in gold- and silversmiths, there was an excellent diamond workshop under the command of Ivan Betskoy, who also had charge of the Peterhof Lapidary Mill and the sources of coloured stones from Siberia.[6] Catherine's friend and ally, Princess Dashkova, relates how Betskoy asked Catherine to whom she owed her throne. Catherine said: "to the Highest and to the election of my people". Betskoy protested: "I am the unhappiest of men… when you do not recognise me as the sole person who made ready the crown for you. Was it not I who raised up the Guard? Was it not I who showered money on the people?" Catherine replied: "since I owe you the crown, whom better can I entrust with readying it for the coronation? I rely in this on your efficiency and therefore do I give into your command all the diamond workers of my empire."[7]

In the words of Rev. William Coxe, who visited St Petersburg in 1779: "The richness and splendour of the Russian court surpasses all the ideas which the most elaborate descriptions can suggest. It retains many traces of its antient Asiatick pomp, blended with European refinement… Amid the several articles of sumptuousness which distinguish the Russian nobility, there is none perhaps more calculated to strike a foreigner than the profusion of diamonds and other precious stones, which sparkle in every part of their dress. In most other European countries these costly ornaments are … almost entirely appropriated to the ladies; but in this the men vie with the fair sex in the use of them. Many of the nobility were almost covered with diamonds; their buttons, buckles, hilts of swords, and epaulets, were composed of this valuable material; their hats were frequently embroidered, if I may use the expression, with several rows of them…"[8]

Johann Scharff: *Snuffbox "Lisetta"* [Cat. 104]

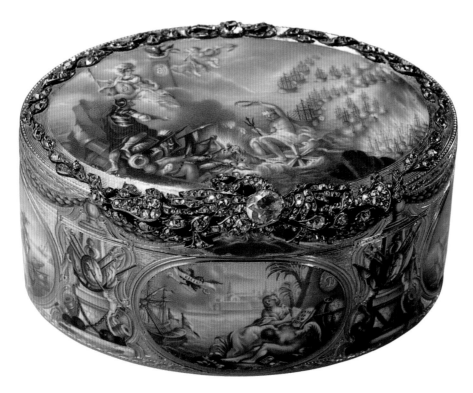

Jean-Pierre Ador *Snuffbox "Chesme"* [Cat. 102]

Jewellery production flourished in the second half of the 18th century, the period most fully represented in the Hermitage. Jean-Pierre Ador's snuffbox with a painted enamel symbolising the victory of the Russian fleet at Chesme is a perfect example of how great military feats were reflected in this apparently incompatible art form. Portrait miniatures were common decorative elements, and Catherine had not only a snuffbox bearing portraits of her grandsons Alexander and Constantine, but even one with her favourite dog, the greyhound Lisetta.

The greatest influx of jewellery items came in the 1770s and 1780s, and the objects most commonly mentioned in inventories are snuffboxes, often made as presents, perhaps including the donor's monogram, portrait or name, or a depiction of the event which inspired the gift. Although Catherine herself was very fond of snuff, she "never carried a snuffbox with her, for these latter lay about in her rooms, on all the tables and windowsills of her study". She used "only that tobacco which was sown for her in Tsarskoye Selo, she snuffed always with the left hand on the basis that she gave her right to her subjects to be kissed."[9] A large proportion of the Hermitage's snuffboxes date from Catherine's time. Rococo elements, still seen in the 1760s, come to be replaced by simpler and stricter forms; snuffboxes become plainer – rectangular, oval or round, only more rarely octagonal. Smooth surfaces, framed with precious stones or enamel, come increasingly into play and the decoration owes much to the fashion for Antiquity, typically incorporating laurel wreaths and strict

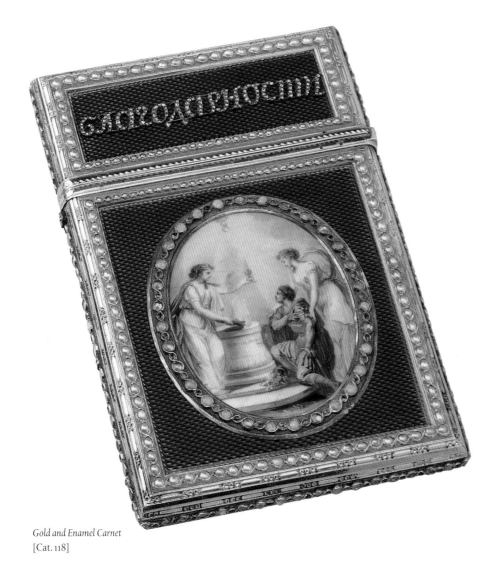

Gold and Enamel Carnet
[Cat. 118]

garlands, braids or ova, using coloured enamels or chased gold. Large diamonds, common in the middle of the century, were totally replaced by much smaller stones in the 1780s.

Neoclassicism, the style which dominated the late 18th century, led to increasing simplification and severity, and it became fashionable to decorate objects with monochrome minerals (usually diamonds and pearls), with cameos and intaglios or imitations of them, as on the chatelaine made for Catherine's favourite, Count Semyon Zorich, its painted miniatures imitating engraved gems. Such "simplicity" was favoured by Catherine, who in 1782 decreed a toning down of court dress, "with the aim of introducing greater simplicity and moderation for the preservation of one's own wealth for better and more useful things and to prevent ruinous luxury…"[10]

Although during Catherine's reign Russia firmly established itself as a gold-mining power, purchases of gold and silver continued. In 1788, for instance, imports included "18 pounds of gold in *yefimki* [coins] and ingots and also 382 poods and 18 pounds of silver", in 1789 of "248 poods and 18 pounds of silver, as well as 10 pounds of gold". Russia itself was producing annually "from 1200 to 1400 and more poods of silver, from 40 to 80 poods of gold".[11] Gold was brought to the Salt Office, which distributed it to different masters, while the quality of finished items of jewellery and the purity of the metal were determined by "the assay chamber for local gold masters and silversmiths. Here they are obliged to bring their work for inspection and stamping and can for a very moderate price give gold and silver of any purity and composition for ligature [by which base metal was added to harden precious metals] for gold and silver work."[12]

It was probably as part of her desire to put some order into her collection of objets de vertu and to control expenses that Catherine published a decree to the Cabinet on 16 July 1786, stating that "items for gifts shall henceforth be purchased for cash… and those

Jean-François Bouddé: *Bottle Stand* [Cat. 106]

which are too expensive should be returned to their makers"[13] Later a special book was compiled, of "objects kept in the cabinet and room of Her Imperial Highness for gifts". Earlier inventories formed the basis for an important manuscript compiled in 1789 (still in the Hermitage), which provides the first mention of works "composing the 'Armitazhe' of Her Majesty".[14] It is from this book that we know that Catherine owned the watches on chatelaines by contemporary European masters included in this exhibition, as well as the table nécessaires and other memorial items. New acquisitions were also listed in the 1789 inventory over the following years.

Amongst the snuffboxes and personal jewellery recorded in the inventory, there are objects used for the imperial table. Such pieces were often finely worked, for instance Bouddé's filigree bottle holder, although some bear no marks to identify the master, as with Catherine's gold travelling service.

After the construction of the Raphael Loggia in 1792, the Diamond Room was moved into the southern section of the new building. Contemporaries noted the luxury and brilliance of the pieces on show, "various rarities of filigree, mother-of-pearl, agate and jasper, [gathered] on the orders of Catherine from all the palace stores and from the Moscow Armoury."[15] There were "boxes and

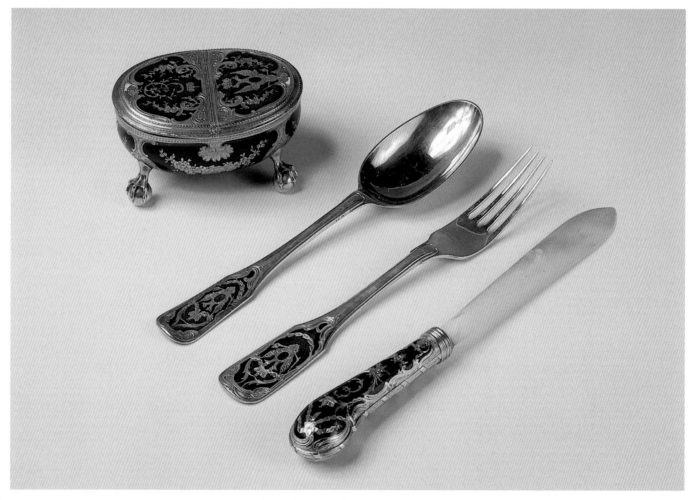

Items from Catherine's Travelling Service [Cats 107-10]

caskets of silver wire, marvellously woven, partly gilded, some laid with stones and pearls… also salt cellars of precious stones… various ewers… pocket watches of previous Sovereigns and their families… who collected snuffboxes also very different in time, size, appearance, material, others with precious stones and pearls…"[16]

Both old and new Diamond Rooms probably existed in parallel for a time, since the imperial regalia remained near Catherine's throne room. The new and much larger room served as a storage area for objets de vertu for over half a century. Its Russian Neoclassical interior was hung with paintings by Van Dyck, the showcases made by Russian masters Christian Meyer and Heinrich Gambs, and in the very centre stood James Cox's grandiose Peacock Clock. Cox's smaller works, often table decorations or nécessaires, were highly prized in St Petersburg and entered the most significant private collections, those of the Stroganov and Yusupov families.

Alongside the new Diamond Room were collections of cameos and corals, "selected works of nature, mainly from locations in the kingdom". Initially, Catherine followed Peter the Great's collecting tradition, concentrating on "the universal museum", but she later rejected this approach, handing over natural history collections to other museums, to the Kunstkammer and the Academy of Sciences. Only minerals remained at her palace, a reflection of a widespread fashion for collecting minerals towards the end of the

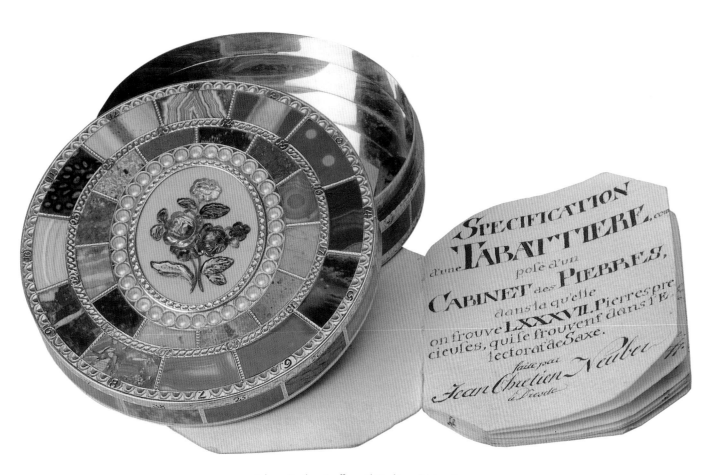

Johann Neuber: *Snuffbox with Hardstones* [Cat. 124]

century: mineral "museums" or "cabinets" were to be found in the palaces of many of Catherine's courtiers. One new phenomenon resulting from this was the appearance of "mineralogical" snuffboxes, such as the fine example by Saxon master Johann Christian Neuber on display here.

St Petersburg in the late 18th century was a melting pot for styles and approaches; it drew masters from Moscow and other towns with developed traditions of working with precious metals, from many corners of Europe. All brought with them the principles, technical achievements, habits and knowledge acquired at home, but all of them were in turn influenced by local traditions and the taste of their clients, and this it was which set St Petersburg apart from other European centres of jewellery production.

NOTES

1 M. M. Postnikova-Loseva, N. G. Platonova, B. L. Ulyanova: *Zolototye i serebryanoye delo XV - XX vv.* [Gold and Silver Work of the 15th to 20th Centuries], Moscow, 1983, p. 97.

2 A. E. Velkerzam [Felkersam]: "Inostrannyye mastera zolotogo i serebryanogo dela" [Foreign Masters in Gold and Silver], *Staryye gody* [Days of Yore], July-September 1911, p. 109.

3 V. I. Pilyavsky: *Istoriya i arkhitektura zdaniy* [The History and Architecture of the Buildings], Leningrad, 1974, p. 72.

4 Georgi 1794, 86-7.

5 Levinson-Lessing 1986, pp. 57-8.

6 S. P. Yaremich: "Vliyaniye vospitatelnykh idey na khudozhestvennuyu shkolu. Prezidenstvo I. I. Betskogo" [The Influence of Educational Ideas on the Art School. The Presidency of I. I. Betskoy], *Russkaya akademicheskaya shkola XVIII v.* [The Russian Academic School in the 18th Century], Leningrad – Moscow, 1934, p. 67.

7 *Zapiski Dashkovoy* [The Notes of Dashkova], London, 1859; reprinted Moscow, 1990, pp. 70-1; a slightly abbreviated version is available in English: *The Memoirs of Princess Dashkova*, translated and edited by Kyrill Fitzlyon, Durham and London, 1995, pp. 88-9.

8 Coxe 1784, vol. 1, pp. 491-2.

9 Pylyayev 1990, pp. 183-4.

10 Ya. K. Grot: *Yekaterina II v perepiske s Grimmom* [Catherine II in Correspondence with Grimm], St Petersburg, 1884, p. 409.

11 Georgi 1794, p. 183. A pood is equal to 16.38 kg.

12 *Ibid.*, p. 188.

13 Russian State History Archive, Fund 468, *Opis* 1, *chast* 2, *delo* 390/1, ff. 234-8.

14 Hermitage Archive, Fund 1, *opis* 6Z, *delo* 9.

15 Svin'in 1821, p. 278.

16 Georgi 1794, pp. 387, 388, 389.

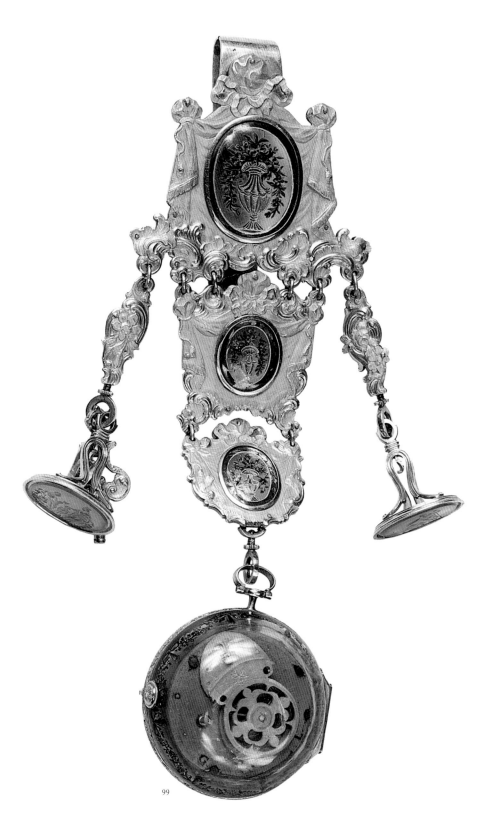

99

99

Watch with a Glass Body on a Gold Chatelaine with Two Pendants. 1760s

St Petersburg

On the back of the mechanism: *GL*

Gold, glass, wood, chalcedony, metal, enamel; carved, chased, pounced and painted. Diameter of watch 4.9; chatelaine 15.5 × 7.1

Inv. No. E 2055

Provenance: from the mid-19th century in the Gallery of Objets de Vertu; formerly in the Diamond Room.

This watch belonged to Catherine II and then to Paul I, who presented it to his secretary, Obrezkov; Obrezkov's widow later presented it to the Dowager Empress Maria Fyodorovna who in turn transferred it to the Diamond Room. In this rare piece the mechanism is made of wood and fastened with mechanical ties. On the back are a carved rosette and the letters GL, while the glass body is painted with garlands of flowers. The two pendants have chalcedony intaglios, one showing Minerva and Cupids, the other Themis and Minerva with a shield bearing the imperial arms. O.K.

100, 101

Bracelets with Portrait Miniatures. 1760s

St Petersburg

Gold, silver, diamonds, rock crystal, miniatures; polished and painted. 17 × 2.2

Inv. Nos E 4275, E 4795

Provenance: from the mid-19th century in the Gallery of Objets de Vertu; thought to have belonged to Catherine II.

Each of this pair of bracelets consists of six oval medallions beneath rock crystal, attached with hinges. These medallions have alternating portraits of men and women in gouache on ivory, with a setting of diamonds in silver.

G. Lieven identified the sitters as Crown Prince Peter Fyodorovich (Peter III) and Grand Duchess Catherine Alexeyevna (Catherine II) and their close relatives, although it was later suggested that they might be relatives of Empress Maria Fyodorovna. The first hypothesis seems most likely since the man with the orange sash of the Prussian Order of the Black Eagle derives from a portrait of Catherine's father, a work of A. Pen (?) of c. 1725 (Hermitage). O.K.

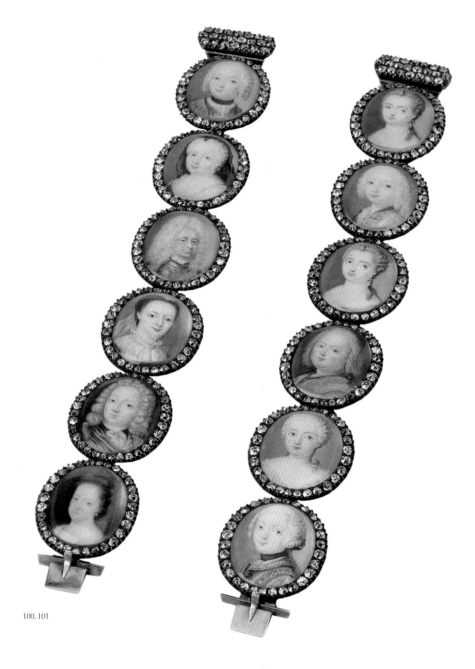

100, 101

by the obelisk with the inscription "Patrie", the sacrificial altar with the inscription "Monument éternel" – are part of the box's commemorative programme. On the bottom is an enamel miniature with allegorical images of the Turkish fleet pulled by Neptune and Nereids to the shore, where they are met by Mars. In the central miniature on the lid, surrounded with a garland of diamonds, Neptune leads the fleet, Minerva (with a spear) leans on a shield with the monogram AO for Alexey Orlov, whose armoured figure is shown below. The clasp has a diamond eagle holding a laurel branch in its beak: possibly not merely a symbol of peace but also an allegorical hint at the owner's name (Orlov comes from *oryol*, Russian for eagle). Typical of Ador's early works, this snuffbox has analogies in a piece in the Louvre showing Susanna and the Elders and a Chesme Snuffbox in the Philips collection, which are also dated to the early 1770s.

Ador arrived in Russia in the early 1760s and went on to become one of St Petersburg's most famous jewellers, although he was never a member of the guild. In his workshop he produced services, decorative vases, fans, clocks, medals and weapons, but his work is mostly represented today by snuffboxes. He often signed his works, using two marks: IA in a crown, or IA beneath a crown. O.K.

103

Snuffbox with a Portrait of Grand Duke Paul.
1774
Jean-Pierre Ador. 1724-84

St Petersburg

Maker's mark and signature: *Ador St Petersbourg;* on the miniature: *Boutellier*

Gold, silver, diamonds, enamel; chased and painted.

3.3 × 7.1 × 5.5

Inv. No. E 4498

Provenance: from the mid-19th century in the Gallery of Objets de Vertu; belonged to Catherine II.

Decorated with scaly *guilloche* pattern and covered with transparent turquoise enamel, this snuffbox has set into the lid a painted enamel medallion by Boutellier showing Catherine's son, Grand Duke Paul. The source for the portrait was a painting by Vigilius Eriksen, who produced a number of portraits of Paul. Only the Hermitage painting of 1766 and a similar piece in the David Collection, Copenhagen, provide

102

Snuffbox: Chesme. 1771
Jean-Pierre Ador. 1724-84

St Petersburg

Inscription: *ADOR – A – ST – PETERSBOURG*

Gold, silver, diamonds, rubies, enamel; chased and painted. 4.2 × 7.5 × 6.1

Inv. No. E 6239

Provenance: 1876, transferred to the Gallery of Objets de Vertu; 1854 presented by Empress Alexandra Fyodorovna to the Duke of Mecklenburg Strelitz, who bequeathed it to the Hermitage; sold to the Hermitage by the Yuryev Monastery, Novgorod; bequeathed to

Yuryev Monastery by Alexey Orlov's daughter; presented to Orlov by Catherine II.

(Illus. see p. 74)

Painted enamel compositions symbolise the victory of the Russian fleet (commanded by Alexey Orlov) over the Turks at Chesme on 24-26 June 1770. The figures of Chronos and History set into the central medallion on the edge record the date 24 June 1771, indicating that the snuffbox was made to celebrate the first anniversary of that victory. All the decorative elements – the laurel wreaths, Hercules with his club, Minerva

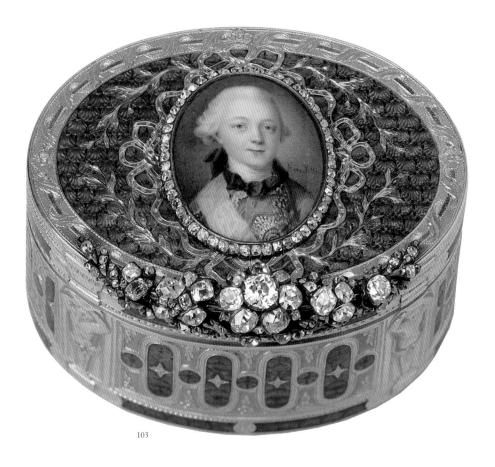

103

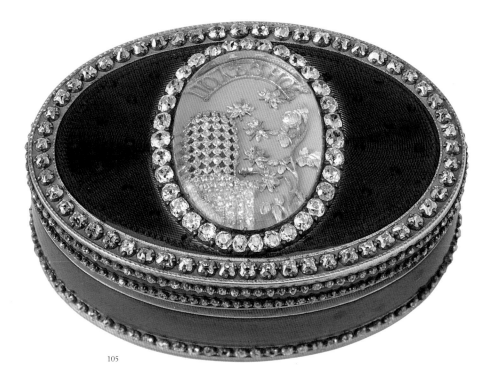

105

direct analogies for this miniature. Not long before the portrait was painted, in 1762, Paul was raised to the rank of Admiral, which explains the chased military trophies on the back of the snuffbox. The articulation of the edge with four chased caryatids derives from French jewellery of the previous decade. O.K.

104
Snuffbox: Lisetta. 1777
Johann Gottlieb Scharff

St Petersburg
Maker's mark, mark for St Petersburg 1777, hallmark (damaged)
Gold, enamel, diamonds, silver, emeralds, miniature; chased and painted. 2.2 × 7
Inv. No. E 4463
Provenance: from the mid-19th century in the Gallery of Objets de Vertu.
(Illus. see p. 74)

The removable lid bears a painted enamel miniature showing Catherine's favourite pet dog, the greyhound Lisetta. In style, the work is typical of the 1770s, when Scharff repeated both the form and size on numerous occasions. Unlike his contemporaries Jean-Pierre Ador and Jean-François Bouddé, Scharff made much use of coloured minerals. Here the colour scheme is based on a combination of diamonds and emeralds set into a brown enamel ground.

A goldsmith and jeweller, Scharff arrived in St Petersburg with his parents from Moscow in 1767 as an apprentice. He became a master in 1772, then in 1788 alderman of the foreign guild of jewellers. Famed for his work with tiny diamonds, his mark is IGS. O.K.

105
Snuffbox: Useful. 1780
Johann Gottlieb Scharff

St Petersburg
On the lid: *Полезное* [Useful]
Gold, silver, diamonds, rock crystal, enamel; chased and painted. 2.2 × 4.9 × 6.9
Inv. No. E 4692
Provenance: 1885, transferred to the Gallery of Objets de Vertu from the Cabinet of State Diamonds; belonged to Catherine II.

Covered with dark-blue enamel over a guilloche ground, around the edges of the lid, base and border this snuffbox has diamonds in silver

settings. In a medallion on the lid, beneath a plaque of rock crystal, is a composition with a beehive, bees and a rose bush (Catherine's device, elements of which were used in many Petersburg works in the 1780s) in tiny uncut diamonds, with above it the gold inscription: "Useful". The snuffbox was probably specially commissioned. O.K.

106
Bottle Stand with Filigree Gold Decoration. 1780
Jean-François Bouddé. Active in St Petersburg 1765-85
St Petersburg
Marks: master, gold letter *K*
Gold; filigree, polished, chased. 3.7 × 6.3
Inv. No. E 5146
Provenance: 1882, transferred from the Main Palace Administration, kept in the Gallery of Objects de Vertu.
(Illus. see p. 76)

Decorated with applied gold filigree decoration: rocaille motifs, branches, rosettes and flowers. In the border is a medallion with Catherine's monogram beneath the imperial crown. The Hermitage has two such stands, similarly decorated, which possibly formed part of a palace service. For a long time they were attributed to some unknown French master, "F. X. B.", but were later attributed to Bouddé. The pair to this piece also has a mark for St Petersburg for 1780. O.K.

107-10
Items from Catherine's Travelling Service (Salt Cellar, Knife, Fork, Spoon). 1770s
St Petersburg
Gold, enamel, mother-of-pearl; engraved. Salt cellar: 4.5 × 6.7 × 9; spoon: 4.2 × 19.4; fork 19.4; knife 21.7
Inv. Nos E 4259, E 4613, E 4264, E 4262.
Provenance: from the mid-19th century in the Gallery of Objets de Vertu.
(Illus.see p. 76)

Archive documents and the memoirs of contemporaries inform us that the imperial court moved frequently from one palace to another, between winter and summer residences. The court was accompanied not only by servants but also by much of the imperial wardrobe and many everyday items.

These items formed part of a travelling service belonging to Catherine II. They are decorated

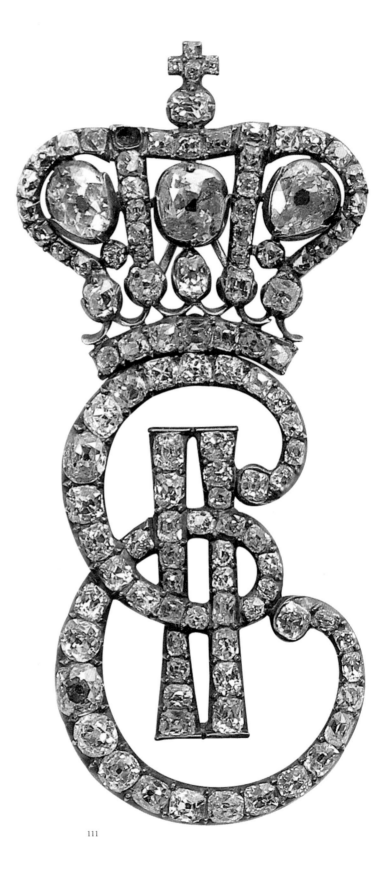

111

with blue enamel through which shows the *guilloche* gold surface, engraved flowers and Catherine's monogram "E II" beneath the imperial crown and the two-headed eagle. These elements are repeated on all the pieces in the service. O.K.

111

Lady-in-Waiting's Badge in the Form of Catherine II's Monogram. 1770s-1780s

St Petersburg

Silver, gold, diamonds; chased. 7.3 × 3.3

Inv. No. E 289

Provenance: 1908, transferred to the Gallery of Objets de Vertu from the collection of Grand Duke Alexey Alexandrovich.

Such badges were worn by ladies-in-waiting at the court of Catherine II, many of whom are shown wearing a similar piece in surviving portraits. At the present time the Hermitage and other Russian museums contain a number of differently decorated badges bearing the Empress's monogram, "E II", beneath an imperial crown. This gold badge is totally covered with diamonds set in silver and has a loop for a ribbon on the back. O.K.

112

Watch on a Chatelaine Decorated with Diamonds over Coloured Foil. 1760s

Geneva

On the mechanism: *Ls Dunant A Geneve*; *LzFR*; on the face: *Ls Dunant A Geneve*

Gold, silver, diamonds, enamel, rose diamonds, metal alloys; chased, engraved and painted. 4.6 × 17.4

Inv. No. E 4307

Provenance: from the mid-19th century in the Gallery of Objets de Vertu; from the 18th century in the Winter Palace.

Turnip-shaped watch in a removable case, the lid decorated with green enamel over an engraved ground with a diamond arrangement in the centre in the form of a vase of flowers. The gold chatelaine is chased and engraved and decorated with diamonds. Coloured foil was laid beneath each large diamond to intensify the colour and create a greater sense of richness, a device used by many jewellers in the middle of the 18th century. The side chains of the chatelaine end in two screw attachments, one of which has a key to wind the watch. O.K.

112

113

Snuffbox: Monument to Peter I. 1780s

Switzerland

Marks: maker and year *ii K*; charge décharge

Gold, enamel, miniature, glass, hair; chased and
painted. 2.3 × 7.5

Inv. No. E 4025

Provenance: from the mid-19th century in the
Gallery of Objets de Vertu; from the 18th century in the
Winter Palace.

Like many 18th-century pieces, this snuffbox is
completely covered with grisaille enamel
imitating a cameo. The image is based on a
medal by Johann Balthasar Gass and Johann
Georg Wächter on the unveiling of Etienne
Falconet's famous Bronze Horseman. Images of
this equestrian statue of Peter the Great appeared
on numerous items, including a snuffbox in the
Gilbert Collection (London) by Jean-François
Bouddé, and on medals.

 Swiss marks like those on this snuffbox
imitate contemporary Paris marks, with the
result that many Swiss snuffboxes have been
erroneously attributed to Parisian masters. O.K.

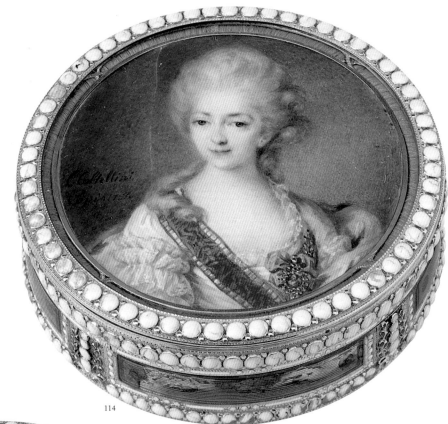

114

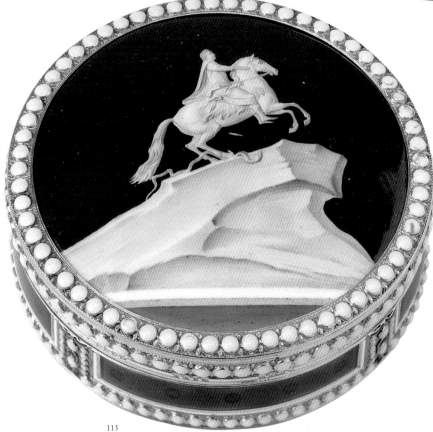

113

114

**Snuffbox with a Portrait of Princess
Yekaterina Orlova-Zinovyeva. 1780s
Master LFT; miniature by C. Coltellini**

Switzerland

Marks: maker, year *K*; inscription on the miniature:
C. Coltellini Copio 17.

Gold, enamel; chased and painted. 2.3 × 7.5

Inv. No. E 4882

Provenance: 1908, from the collection of Grand
Duchess Yelizaveta Fyodorovna.

Yekaterina Alexandrovna Orlova, née Zinovyeva
(1758-81), was maid-of-honour to Catherine
from 1775. In 1777 she married the Empress's
former favourite, Grigory Orlov, and became
lady-in-waiting.

 The snuffbox entered the Hermitage as the
work of a Parisian master, and was dated to 1773
(the miniature to 1751): like the previous item, it
has a Swiss year mark very like a Parisian one.
Later, a date of 1781 was suggested, as Orlova was
the only young lady-in-waiting to have received
the Order of St Catherine (1st class) which the
sitter wears. A confirmation for such a date is the

hair around the medallion which, like the enamel frame imitating opal (Orlova's preferred stone), was a characteristic memorial symbol: in 1781 Orlova died at Lausanne, where she was being treated for consumption. The portrait is a free copy from one of two portraits made during the Princess's lifetime (Dmitry Levitsky, Russian Museum, St Petersburg; Fyodor Rokotov, Tretyakov Gallery, Moscow). O. K.

115
Gold Nécessaire on a Chatelaine with Etuis.
Mid-18th century
France
Gold, mother-of-pearl, uncut diamond; polished, chased. Height 9.8; chatelaine 10.5 × 5.4
Inv. No. E 2671
Provenance: from the mid-19th century in the Gallery of Objets de Vertu; from the 18th century in the Winter Palace.

The use of such portable nécessaires was part of court etiquette. Like watches (with which they often formed a pair), they were worn to accord with different attire. The chatelaine (chain) was used with a hook to attach the nécessaire to the waist. Carved mother-of-pearl and applied rocaille chased gold ornament form the main decorative elements here. O.K.

116
Snuffbox with Miniatures and a Portrait of Peter III Inside. 1761
Jean George. Active 1752-63
Paris
Inscriptions: *George A Paris*; on the miniature on the lid: *V.Blarenberghe 1761*; on the miniature inside: Blarenberghe
Marks: Paris 1760-1, master Jean George (rubbed), charge décharge Eloy Brichard for 1756-62
Gold, rock crystal, miniatures; chased, painted.
4 × 7.2 × 5.5
Inv. No. E 4042
Provenance: from the mid-19th century in the Gallery of Objets de Vertu; listed in the inventory of Catherine's personal collection; thought to have belonged to Peter III.

Gouache miniatures on paper set beneath rock crystal show scenes in the life of Peter III's Holstein Guards Regiment (bottom, lid and sides) and an equestrian portrait of Peter wearing the Orders of SS Andrew and Anne with a group of soldiers (inside the lid). These miniatures relate to the Seven Years' War, and the snuffbox was probably commissioned by Peter himself. On the basis of the year mark for Paris and the signatures on the painting the box has been dated to 1760-1.

Louis-Nicolas van Blarenberghe (1716-94), author of the miniatures, was often employed by jewellers: similar decoration is found on snuffboxes in many other collections. The James A. de Rothschild collection (Waddesdon Manor) has a large number of works by Blarenberghe, among them three pieces with miniatures mounted into snuffboxes by George. Like the Hermitage piece, the central decorative feature of all of them is painting covering the whole of the surface, set into fine gold mounts with lightly engraved ornament. O.K.

115

116

117
Gold Watch on a Chatelaine with a Seal in the Form of a Vase. 1770s

Paris

Marks: Paris for 1777-8; charge décharge Jean Fouache for 1774-80

On the mechanism: 839, 8440 and the signature *Mallet A Paris*

Gold, silver, diamonds, enamel, rose diamonds, pearls, rock crystal, cornelian, metal alloys; chased and painted. 3.5 × 21.5

Inv. No. 4291

Provenance: from the mid-19th century in the Gallery of Objets de Vertu; formerly in the Diamond Room.

According to legend this watch belonged to Catherine II. It is decorated with enamel imitating moss agate-dendrite, a device characteristic of jewellery in the 1770s and 1780s. All the diamonds on the watch are in silver grips, while the white enamel face has Arabic numerals marking the hours and minutes. The chatelaine is made of ribbons with two medallion clasps decorated like the lid of the watch. On the end are four attachments with two brushes, a key and a seal in the form of a cornelian vase.

Louis Mallet, whose signature is on the watch mechanism, was a famous Paris clockmaker who produced pieces for the Duke of Orléans and the Paris aristocracy. His works are to be found in many museums and private collections. O.K.

118
Carnet of Gold and Enamel with Diamond Inscription. 1770s

Paris

Marks: Paris 177? (rubbed)

Inscriptions: *НАПОМИНАНИЕ* [Reminder]; *БЛАГОДАРНОСТЬ* [Gratitude]; *тобою восхожу* [Through Thee I Rise]

Gold, silver, enamel, diamonds, rose diamonds, pearls, emeralds, opals; chased, guilloche, painted.

8.5 × 5.7 × 0.9

Inv. No. E 4453

Provenance: from the mid-19th century in the Gallery of Objets de Vertu; from the late 18th century in the Winter Palace.

(Illus. see p. 75)

The gold carnet is covered with blue enamel over a *guilloche* ground with decoration of split pearls, opals and emeralds and has diamond inscriptions on both sides: "REMINDER" and "GRATITUDE". It was presented to Catherine II by Prince Potemkin. On the front and back of the case are allegorical enamel medallions, one showing Minerva crowning with laurels a portrait of Catherine II supported by the kneeling Chronos, while the muse of History holds an open book, and the other a soldier and a genius before an altar with the inscription "Through Thee I Rise". These were probably intended to symbolise Potemkin's military successes and his gratitude to the Empress. O.K.

117

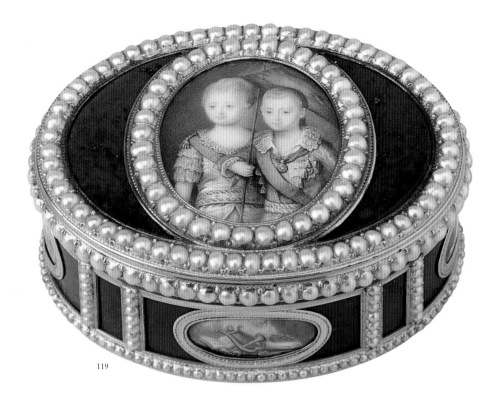

119

119

Snuffbox with Portraits of Grand Dukes Alexander and Constantine. 1781-2
Louis Cousin. Active 1766-81

Paris

Marks: Paris – S – 1781-2; master Louis Cousin, charge décharge Henry Clavel for 1780-9

Inscription: *FECONDITE* [Abundance]

Gold, lazurite, rock crystal, enamel, pearls; chased and painted. 2.2 × 6.8 × 5.2

Inv. No. E 4490

Provenance: from the mid-19th century in the Gallery of Objets de Vertu.

Plaques of lazurite are attached to a gold body, and set into the base is a painted enamel medallion showing the goddess Flora in a wreath, burning a bouquet of roses on an altar with the inscription "FECONDITE". The edges are decorated with frames of pearls and split pearls, while arranged along the border are four painted enamel medallions with allegorical attributes of the arts and sciences. In the centre of the lid is a gouache miniature on ivory beneath a plaque of rock crystal with childhood portraits of Grand Dukes Alexander and Constantine, Catherine's grandsons, wearing sashes of the Order of St Andrew.

Probably commissioned by the royal court, this snuffbox has many analogies for its decoration in the works of both French and Russian contemporaries. The unsigned miniature derives from portraits of the Grand Dukes by Richard Brompton (c.1734-83), a British portrait painter working in St Petersburg 1778-83. Constantine is shown with the banner of Constantinople, an echo of Catherine's plans to make him ruler of Greece. Judging by the age of the sitters, the miniature was produced not before the early 1780s.

It is possible that the portrait was set into a Paris-made snuffbox by Louis Cousin after it arrived in St Petersburg. O.K.

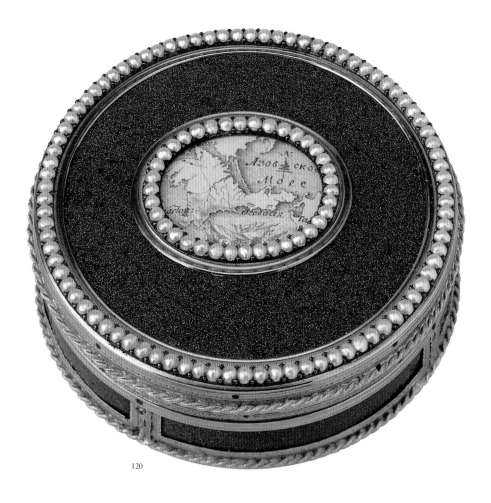

120

120

Snuffbox of Aventurine Glass, with a Map of the Crimea in a Medallion. 1784
Claude-Pierre Pottier

Paris

Marks: Paris 1784-5, charge décharge LL for 1783-9, master P C P

Gold, glass, pearls, aventurine glass, paper; chased, polished and painted. 2.2 × 6.4

Inv. No. E 4107

Provenance: from the mid-19th century in the Gallery of Objets de Vertu; from the late 18th century in the Diamond Room.

Entered in the inventory of Catherine's own jewels in the 18th century, this piece formed part of "Her Majesty's Armitazhe". The chased garlands along a punched ground, the applied braid and the use of glass imitating aventurine were all typical of late 18th-century jewellery. The miniature was probably set into the lid after the box arrived in St Petersburg and would have been intended to commemorate events in the Russo-Turkish war and the annexation of the Crimea. The map is on paper and is entitled "Map of Tauris" (Tauris being the name for the Crimea), with inscriptions in Russian showing the Azov Sea, Feodosia and Tauris. O.K.

121

Ring with a Watch. Late 18th century

Paris

On the mechanism: *Delouse & Comp. A. Paris*

Gold, silver, diamonds, rock crystal, enamel, metal alloys; chased. 2 × 2.5 × 2.1

Inv. No. E 4353

Provenance: from the mid-19th century in the Gallery of Objets de Vertu; from the 18th century in the Winter Palace.

Amongst the watches dating from the time of Catherine the Great are a number of pieces set into rings, where the mechanism is covered with rock crystal surrounded with diamonds. The white enamel face has the hours in Roman numerals and minutes in Arabic numerals. Along the edge of the watch lid and on the band are branches of diamonds in silver grips. O.K.

121

122

Ring with Portrait Miniatures.
Mid-18th century

Germany

Gold, silver, diamonds, quartz, miniature; chased and
painted. 1.6 × 1.9

Inv. No. E 4363

Provenance: from the mid-19th century in the
Gallery of Objets de Vertu; from the 18th century in the
Winter Palace.

This gold signet ring belonged to Peter III. In the
centre are painted miniatures beneath quartz
which revolve on their axis: one shows Georg-
Ludwig, Duke of Holstein Gottorp, uncle of
Emperor Peter III, wearing a wig and a green
uniform, with the Order of St Anne around his
neck; the other shows his wife. The medallions
are edged with diamonds. Such memorial rings
were common throughout Europe, and were to
be found in the private collections of monarchs
and many courtiers. O.K.

122

123

Memorial Ring with Heart-shaped Diamond.
Second half of the 18th century

Germany

Inscription: *UN SEUI ME SUFFIT*

Gold, diamond, hair; chased. Diameter 1.9

Inv. No. E 4654

Provenance: 1861, to the Gallery of Objets de Vertu,
earlier bequeathed by Maria Fyodorovna.

Against the background is gold text "UN SEUI
ME SUFFIT" (i.e. one heart is enough for me)
with a large heart-shaped diamond in the centre.
It is thought that the ring belonged to Frederika
of Württemberg, mother of the Russian Empress
Maria Fyodorovna. O.K.

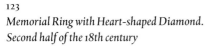

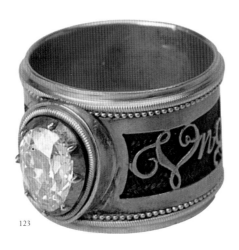

123

124

Snuffbox with Stones from Saxony. 1780
Johann Christian Neuber. 1736-1808

Germany

Gold, decorative stones; chased, polished; paper,
fabric. 2.2 × 7.5

Inv. No. E 4184

Provenance: from the mid-19th century in the
Gallery of Objets de Vertu; from the 18th century in the
Winter Palace.

(Illus. see p. 77)

Many of Catherine's courtiers kept "cabinets of
minerals" in the late 18th century, a fashionable
pastime reflected in a new means of decorating
jewellery, using small samples of different
precious and semi-precious stones. Like this
box, which arrived in the Hermitage very soon
after it was made, the earliest such items came
from Saxony. Engraved on the gold mount by
each stone is a number and inside the snuffbox
is a little book, "Specification d'une Tabatière
composé d'une Cabinet des Pierres dans laquelle
on trouve LXXXVI pierres précieuses qui se
trouvent dans l'Electorat de Saxe, faite par Jean
Chrétien Neuber à Dresde", with a list of the
minerals used in the decoration. O.K.

125

Heliotrope Table Nécessaire in a Gold Frame, with 12 Items. c. 1760

England

Gold, silver, mother-of-pearl, glass, steel, heliotrope, leather; polished and chased.

6.8 × 4.9 × 12.4

Inv. No. E 1811

Provenance: from the mid-19th century in the Gallery of Objets de Vertu; from the 18th century in the Winter Palace.

(Illus. see p. 18)

The Hermitage has a large collection of portable and table nécessaires, very common items in the 18th century. Inside this nécessaire are tweezers and a file, a needle, scissors, a pencil, mirror, brushes and bottles. It is decorated like a stylised summer house, with gold rocaille bands along a heliotrope ground in a manner typical of English Rococo masters.

An inscription inside reads: "I congratulate the most High Merciful Mother Sovereign on her name day. Almighty God, multiply the many prosperous years of the great Imperial Mercy to the least of her slaves. Both God and Your Highness are most merciful." The nécessaire was presented to Catherine on her name day. O.K.

126

Table Nécessaire Crowned with an Eagle. 1760s

England

Gold, silver, diamonds, rubies, emeralds, agate, cornelian, lazurite, mother-of-pearl, glass, steel; chased and polished. 13.3 × 6.7 × 5

Inv. No. E 1861

Provenance: from the mid-19th century in the Gallery of Objets de Vertu; from the 18th century in the Winter Palace.

The body of this nécessaire is formed of plaques of agate, lazurite and cornelian arranged alternately, the surface of the stone decorated with chased gold plaques bearing typical English Rococo ornament. The vaulted roof bears an eagle covered with diamonds, rubies and emeralds in silver settings. Inside the nécessaire are tweezers and file, a knife, scissors, pencil, mirror, brush and bottles. O.K.

127

Table Clock on Rhinoceros Legs with a Nécessaire and Musical Mechanism. 1772
James Cox. fl. 1749-91

London

Engraved on the key: *J. Cox. London. 1772*; on the clockface: *Ja.s Cox 1772*

Agate, gold, silver, coloured glass, pearls, crystal, metal; carved and polished. 36.9 × 17.5 × 14.5

Inv. No. E 2003

Provenance: from the mid-19th century in the Gallery of Objets de Vertu; in the 18th century in the Winter Palace.

Many such works, decorated in the style typical of English masters of the 1770s, were to be found in private collections in St Petersburg. The upper part of the watch is decorated with bouquets and insects attached to a movable hinge, thus increasing the play of light and reflections over the minerals. Cox's works were particularly popular after Potemkin acquired the famous Peacock Clock which he presented to Catherine II and which is to this day displayed in the Hermitage. There are similar works by Cox in museums in Europe and America. O.K.

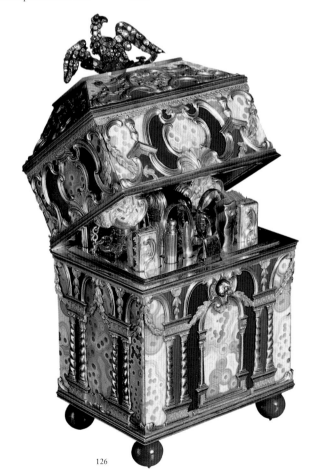

126

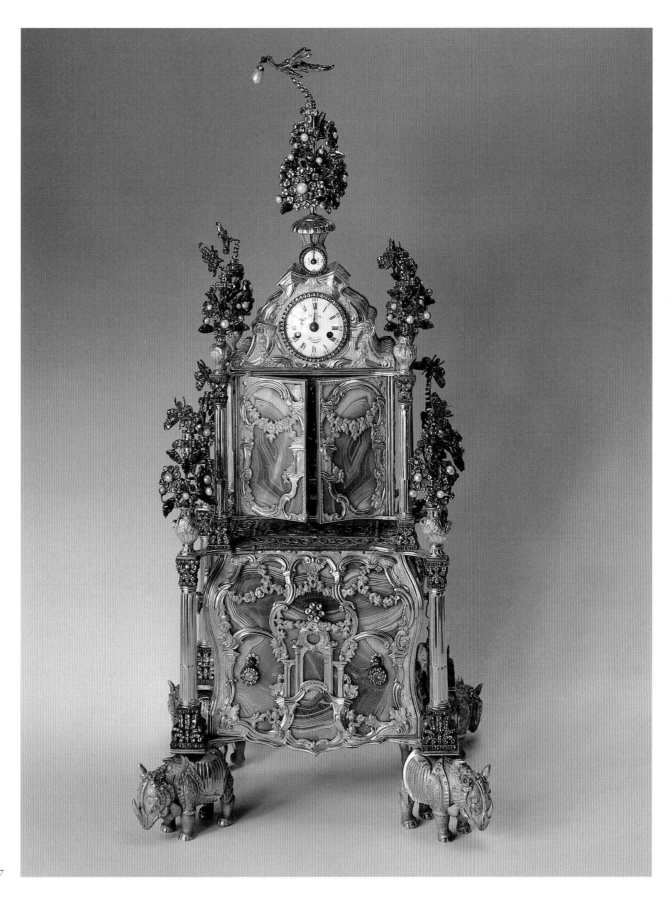

127

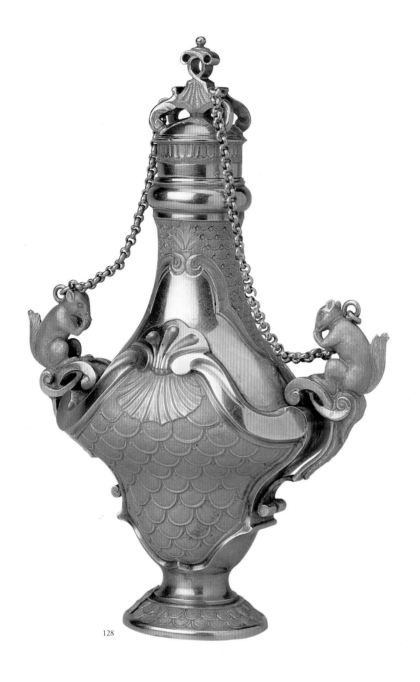

128

129
Chatelaine with "Cameo" Decoration. 1777
Jean Jack Duc. Active in St Petersburg
1770–85

England, Russia
Marks: London, assay, letter S for 1773–4, master John
Eaton; on the case of the magnifying glass: *Duc 1777*
Inscriptions: *PAR TOI* on one case; *J'espère* on the other;
inside the lid *pour Soritch*
Gold, silver, diamonds, rose diamonds, emeralds,
amethyst, enamel, glass; chased. 15.1 × 5.7
Inv. No. E. 4294
Provenance: from the mid-19th century in the
Gallery of Objets de Vertu; belonged to Catherine II,
kept in her Diamond Room.
(Illus. see p. 72)

Grisaille medallions imitating cameos decorate
the chain, along with small diamonds in silver
settings. This piece was made for Semyon
Zorich, one of Catherine's favourites. Attached
to the main piece is a little chain for a watch
(lost), an amethyst seal with the imperial two-
headed eagle and a gold seal in the form of a
crown with the engraved monogram "EA II" and
a magnifying glass. The winding key is also
decorated with grisaille painting. On one of the
cases of the magnifying glass is a sun, an obelisk
and the inscription "PAR TOI", on the other an
anchor, sun, flowers and the inscription
"J'espère". Inside the lid is scratched on one side
"pour Soritch" on the other "pour M. Soritsch".

Duc used a body by a London master, which
explains the London marks on the back of the
chatelaine. The geometric composition and the
use of grisaille are both characteristic of the
Neoclassical style, although the painter's
identity is unknown.

Duc was born in Frankfurt-am-Main but
moved to St Petersburg, where in 1770 he was
accepted as master of the foreign guild,
becoming elder 1778–85. One of St Petersburg's
leading jewellers, he marked his works with his
engraved signature and the letters J.D. O.K.

128
Perfume Bottle with Handles. 1760s

England
Gold; chased, engraved. 16.6 × 7.5
Inv. No. E 3028
Provenance: from the mid-19th century in the
Gallery of Objets de Vertu; in the 18th century in the
Winter Palace.

Long attributed to French masters, this little gold
vase-shaped bottle, with a stopper on a chain, is

in fact English work of the 1760s, as we can tell
from the "scaly" chasing, the combination of
several kinds of engraved ornament, and the
handles in the form of squirrels. Such bottles
may have been used for scent or other sweet-
smelling essences. Portable bottles were usually
flatter and smaller, and items such as this
probably stood on dressing tables, where they
would have had a flat stand or platter. O.K.

Cameo Fever

"An Imperial Affair"

YULIA KAGAN,
OLEG NEVEROV

Lorenz Natter: *Portrait of Philip von Stosch*
[Cat. 168]

Thus Catherine described a pastime enjoyed by many European monarchs, the collecting of cameos and intaglios. Personal dactylothèques – collections of engraved gems – were established in the 18th century by the kings of France, England, Prussia and Austria, by religious and secular rulers in Italy; their courts were flourishing centres for the creation of new works in precious and semi-precious coloured stones. Only the Russian Empress, however, was to indulge in this fashionable occupation on a truly grand scale.

Before Catherine came to the throne, there were about 150 engraved gems in St Petersburg's Kunstkammer, not including Peter the Great's precious "cameo cup" – its enamelled gold body and lid set with some 200 European cameos – presented to him by the Danish King Frederick IV in 1716. During Peter's reign, the Kunstkammer also gained a small set of casts from gems belonging to the French King. By the time of Catherine's death, however, her private collection consisted of 10,000 engraved gems, with 34,000 casts and pastes; she described it as "a bottomless pit" and her passion for engraved gems as "gluttony" or "cameo fever": "gluttony of this kind is as infectious as gall" she wrote.[1]

She made her first acquisition in 1763, the second year of her reign, for her son Paul: a small collection of gems left after the death in Russia of the renowned Lorenz Natter (most of his famous collection had been sold shortly before in Amsterdam). Unfortunately these gems have been swamped in a mass of later purchases and are today almost impossible to identify. They would, however, seem to have included three works by Natter himself, one a magnificent portrait of Baron Philip von Stosch in emerald.

Catherine's agents abroad, envoys and diplomats, travellers and aristocrats, antiquaries and artists, were to assist her in accumulating her engraved gems. In her correspondence with the sculptor Etienne Falconet, for instance, mention was made of an intaglio portrait of Madame de Pompadour by Jacques Guay, court engraver to Louix XV. The Empress was to pay the considerable sum of 100 louis d'or to acquire it, but this was just one of a few sporadic acquisitions: it was only later that Catherine's thoughts and actions came to be obsessed by engraved gems.

It is Catherine's correspondence with Melchior Grimm from the late 1770s which allows us to trace her growing passion, her letters – almost like diary entries – providing us with hundreds of little details. Usually they describe the acquisition of whole collections, but sometimes particular attention is paid to individual gems. In the summer of 1779, for instance, on the death of the painter Anton Raphael Mengs, Catherine's Rome agent, Johann Friedrich Reifenstein, acquired an ancient cameo of Perseus and Andromeda. Mengs had bought the cameo in Spain (the Spanish king had thought it too expensive) and Winckelmann, whose opinion was cited by Reifenstein in recommending the purchase, was lavish in his praises of the piece. Catherine eagerly awaited as the cameo was sent first to Grimm in Paris and thence to St Petersburg. At last, on 23 September 1780, she wrote: "The cameo with Perseus and Andromeda has been

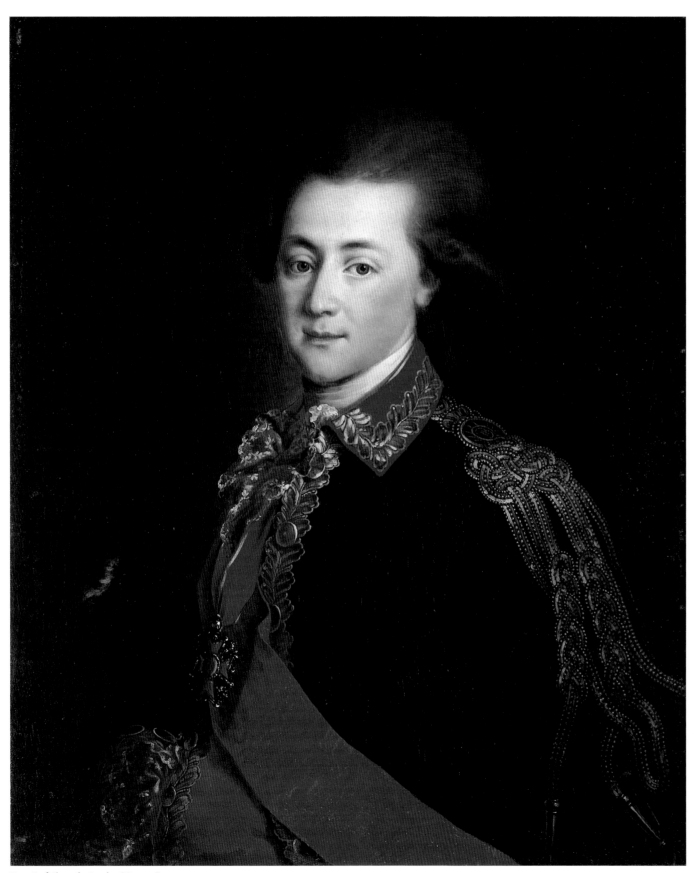

Portrait of Alexander Lanskoy [Cat. 212]

solemnly placed in the museum on the imperial mezzanine... When I saw the Andromeda I said: See what poor works arouse the enthusiasm of amateurs; let us look a little closer, give me my spectacles and a magnifying glass. This examination was to the benefit of the cameo, for in reality it is most perfect..."[2]

Catherine was apparently ready to buy everything available, but much remained beyond her reach. She found, however, the means of tearing down the walls of European cabinets: in 1781, through the court bookseller Johann Jacob Weitbrecht, Catherine discovered a small London manufactory producing casts of engraved gems. Founded 15 years earlier by the Scot James Tassie, it had a repertoire of 3,000 casts, no more than similar European workshops, but Catherine's grandiose commission for casts and copies opened the doors of dactylothèques previously closed to Tassie, who was thus able to expand his production to encompass all the European collections. In just a few years, Tassie's series of casts from ancient and modern gems grew to include 16,000 items.

Catherine's "Tassies", as they are now known, arrived in four lots between 1783 and 1788. They enabled Catherine both to find her way in the extensive European art market and to learn something of contemporary gem-engraving (flourishing in Europe and then experiencing a renaissance in England) so that she could select masters to create new pieces according to her own taste.

Two stages have been noted in Catherine's collecting of engraved gems, closely linked with her favourites Alexander Lanskoy and Alexander Dmitriyev-Mamonov.[3] After the appearance of Lanskoy in 1779, Catherine could no longer write to Grimm of her gems in the Winter Palace, as she had on 10 January 1778: "There the mice and I can admire it all".[4] Now she had someone who was driven by the same collector's passion. In 1782 alone, Catherine acquired in Rome the collection of the artist James Byrs, in Paris those of Count Baudouin and the Baron de Bréteuil, in Rochester the gems of Thomas Slade. Catherine wrote gleefully to Grimm in April 1785: "My little collection of engraved stones is such that yesterday four men had difficulty in carrying it in two baskets filled with drawers containing roughly half of the collection; so that you should have no doubts, you should know that these baskets were those used here in the winter to carry wood to the rooms..."[5] She was referring to the removal of her gems to a new pavilion, the Small Hermitage. It was Lanskoy who prompted Catherine to use native stones from the

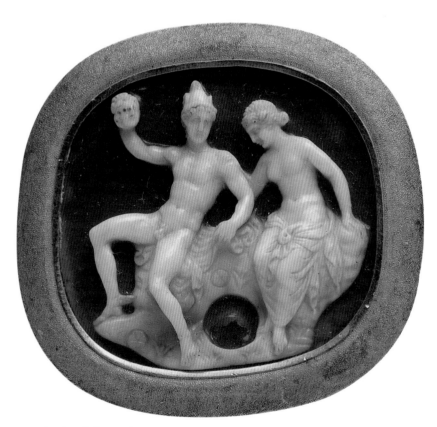

Perseus and Andromeda [Cat. 140]

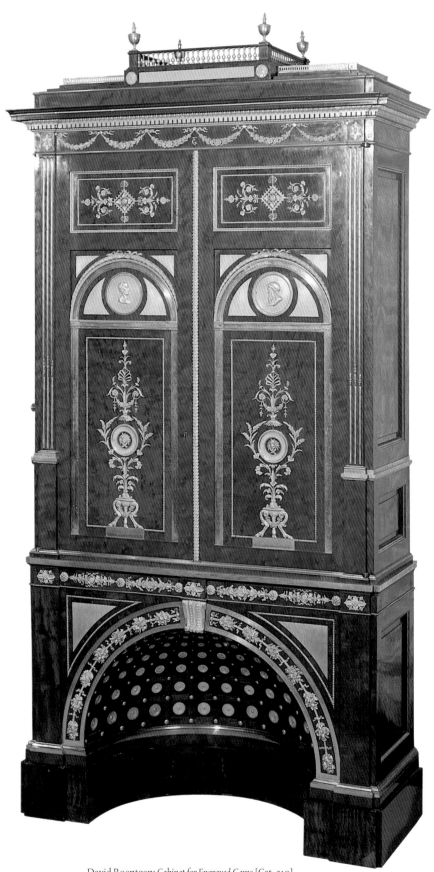

David Roentgen: *Cabinet for Engraved Gems* [Cat. 210]

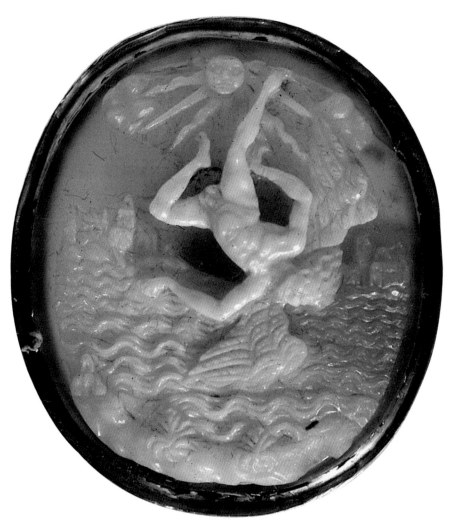

The Fall of Icarus [Cat. 156]

Urals and Siberia for new gems. A special decree was issued to search for sources of many-layered stones – during Catherine's lifetime this led to the appearance of the Yekaterinburg and Kolyvan Lapidary (or Grinding) Works "for cameo arts". Lanskoy himself did not live to see this: he died in 1784 at just 26 years old.

The death of her favourite cooled Catherine's passion for some time, but a year later it broke out with renewed force and she acquired Lanskoy's collection from his heirs, including his gems and casts.

In 1785, through the efforts of Princess Yekaterina Dashkova, President of the Academy of Sciences, Catherine exchanged the mineralogical cabinet of Professor E. Lachsmann for a large part of the Kunstkammer gems, including Peter the Great's "cameo cup". Despite her reverence for Peter's memory, the Empress ordered that the cup be broken up, the cameos removed, and added to her rapidly growing collection – an apparently barbaric step which simply reflected the increasing interest in gems as independent works of art. Dashkova also presented Catherine with her own collection, accumulated during her years in Italy, France and England. The Empress wrote to Grimm that the imperial collection was now "made up of stones alone the number of which probably exceeds 4,000, not counting the pastes... God knows how much pleasure there is in touching all this every day; they contain an endless source of all kinds of knowledge."[6]

The diary entries of Catherine's secretary Alexander Khrapovitsky, which repeatedly mention engraved gems, make it clear that the Empress even took them to her summer residence at Tsarskoye Selo.[7] She usually spent three hours after lunch on her "antiques", and one of her favourite pastimes was the making of casts from engraved gems in papier-mâché. Catherine also did much to encourage cameo engraving in her close circle. Carl Leberecht, the court engraver, taught Paul's talented wife Maria Fyodorovna, who created portrait cameos of Catherine, Paul and their sons. Maria's daughters too studied the art. Another of Leberecht's pupils was the Empress's new favourite, Count Dmitriyev-Mamonov, who himself produced a cameo portrait of her.

In the second half of the 1780s and early 1790s, Catherine's collecting of engraved

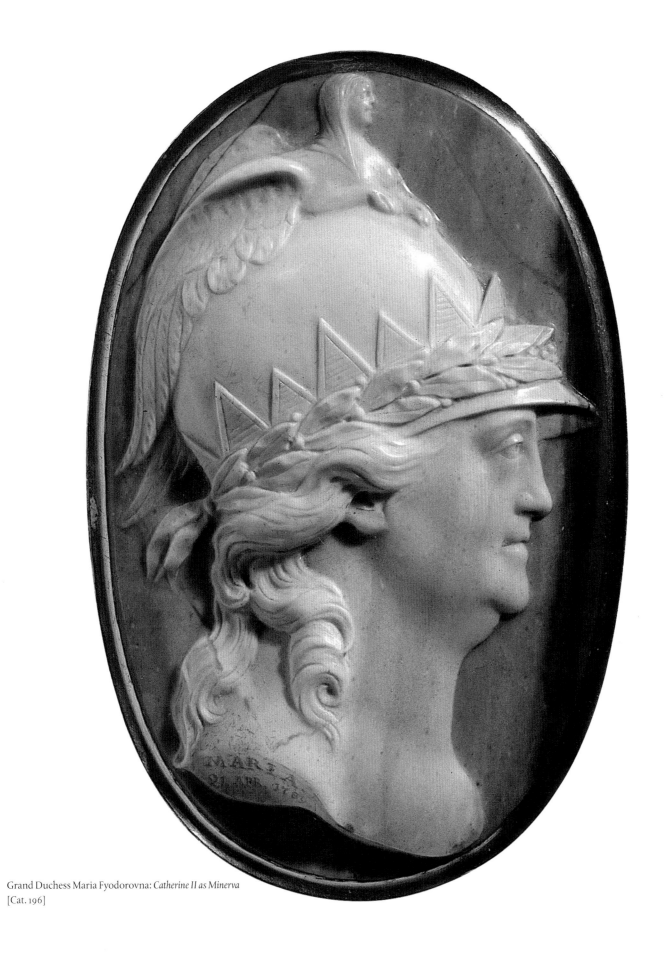

Grand Duchess Maria Fyodorovna: *Catherine II as Minerva*
[Cat. 196]

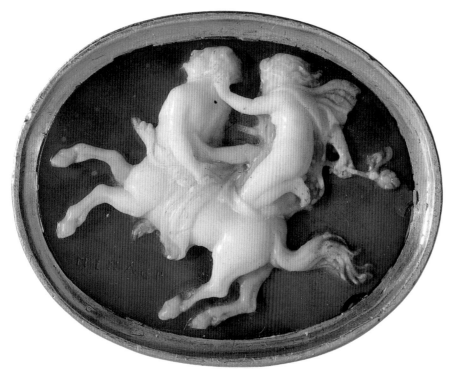

Giovanni Pichler: *Centaur and Bacchante*
[Cat. 172]

gems reached its heights. In 1786, Grimm sent to St Petersburg the collection of a most learned connoisseur of engraved gems, d'Ennery (called "the oracle" in their letters). Soon after this, from Alnwick Castle in England came part of the collection of Lord Algernon Percy: here Catherine found herself faced with an unpleasant reality – comparison with Tassie's casts revealed that the owner had kept back "many of the best engraved stones".[8]

Then, in the autumn of 1787, one and a half thousand engraved gems assembled by several generations of the house of Orléans poured into Catherine's collection. Amongst them were pieces which had once belonged to Princess Elizabeth-Charlotte of the Palatinate and others from Pierre Crozat's renowned collection. Negotiations continued for two years, accompanied by a voluminous correspondence, by indecision, hesitation and stout battle with rival purchasers, until finally, under pressure from Dmitriyev-Mamonov, the deal was completed for 46,093 roubles. This coincided with the removal of the whole collection from the Small Hermitage into the new Large Hermitage and David Roentgen, a regular supplier to the Russian court, was commissioned to provide five large identical mahogany cabinets richly decorated with bronze, each with 100 sliding drawers, to house the engraved gems.

Roentgen's cabinets filled up with incredible speed: not a year later Catherine acquired a collection even larger than that of the Orléans family: 2,337 gems from Joseph France, chief keeper of the Cabinet of Antiquities in Vienna.

Catherine may have been frightened at the consequences of the French Revolution, but it enriched her dactylothèque thanks to the dispersal of collections belonging to French noble families. The emigré antiquarian Alphonse Miliotti brought to St Petersburg gems from the collections of Saint Morys (Conseiller of the French Parliament), the Prince de Conti, Dazencours, Madame Baudeville and others. In 1792, Catherine received the collection of Jean-Baptiste Casanova, Director of the Dresden Academy of Arts. With justifiable pride, the Empress wrote on 25 May 1795 to Grimm, then in exile: "All the cabinets of Europe are but child's play compared to ours!"[9] Her will stated that she bequeathed her "antiques" to her "dear grandson Alexander".[10]

Catherine did much to encourage contemporary engraving in hardstones, which became a separate discipline in the medallists' class at the Academy of Arts, arranged on the model of the French Académie, with classes by Pierre-Louis Vernier. He was replaced by Johann Caspar Jäger, one of a large group of (largely German) court masters. These artists engraved numerous portraits of Catherine, often in extremely hard stones such as

Johann Weder: *Peter I* [Cat. 171]

aquamarine, sapphire and emerald, both allegorical images and gems glorifying her reign.

The Empress gave commissions to leading famous European engravers, to Giovanni Pichler, Johann Weder, Alessandro Cades, Angelo Amastini in Rome, the Abrahams (father and son) in Vienna, and to Gottfried Benjamin Tettelbach in Dresden. Between 1786 and 1796 she totally monopolised two London masters, the brothers William and Charles Brown, who exhibited not a single work in London during these years. The Browns are little known in their native land, although their gems are firmly within the British artistic tradition: an emphasis on portraiture, animalist works and the specifically English "sporting genre". Working individually and in collaboration, they also produced important allegorical works to reflect events from Russian history.

Such rapid and extensive acquisitions could not but smack of gluttony, and indeed weaken to a certain degree the influence of the collector's individual taste. In the 1780s, she entrusted the classification and description of the collection to Alexander Luzhkov, keeper and librarian, whose acceptance into the Academy of Sciences Catherine had arranged "for his care in sorting the antiques and medals". By 1794, Luzhkov had arranged her "bottomless pit" in orderly sections and subsections.[11] Catherine wrote on 25 May 1795: "All this is arranged systematically commencing with the Egyptians and passing through all the mythologies and stories both legendary and non-legendary, right up to the present day."[12] This "new – enlightened – understanding of the subject"[13] serves to provide convincing evidence of the Russian Empress's unique personality.

William & Charles Brown: *Allegory of Marriage*
[Cat. 188]

Charles Brown: *A Horse Frightened by a Lion*
[Cat. 182]

NOTES

1 SbRIO vol. XXIII 1878, p. 214.

2 SbRIO vol. XXIII 1878, pp. 189, 191.

3 M. I. Maximova: "Imperatritsa Yekaterina Vtoraya i sobraniye reznykh kamney Ermitazha" [Empress Catherine the Second and the Hermitage Collection of Engraved Gems], *Sbornik Gosudarstvennogo Ermitazha* [Anthology of the State Hermitage], issue 1, Petrograd, 1921, p. 44.

4 SbRIO vol. XXIII 1878, p. 77.

5 *Ibid.*, p. 341.

6 *Ibid.*, pp. 328-9.

7 *Dnevnik A. V. Khrapovitskogo* [A. V. Khrapovitsky Diaries], St Petersburg, 1901, pp. 12, 26.

8 *Ibid.*, Appendix, p. 365.

9 SbRIO vol. XXIII 1878, p. 638.

10 *Reznyye kamni XVIII i XIX vekov* [Engraved Gems of the 18th and 19th Centuries], exh. cat., Leningrad , 1926, p. 6.

11 Invaluable assistance in reconstructing Catherine's collection is provided by a set of glass pastes by Georg König and Karl Leberecht, reproducing all the gems she acquired, numbered using Luzhkov's inventory.

12 SbRIO vol. XXIII 1878, p. 638.

13 D. Prozorovsky: *Svod svedeniy, otnosyashchikhsya do tekhniki i istorii medalyernogo iskusstva* [Collection of Material Relating to the Technique and History of the Medallist's Art], St Petersburg, 1884, p. 158.

Engraved gems divide into two categories – cameos (convex relief carvings) and intaglios (concave carvings, often used as seals). Intaglio images are usually in reverse (notably visible in inscriptions).

Classical Engraved Gems

130
Scarab Intaglio: Young Horse-jumper (Apobate), Dog and Panther Mask.
6th century BC
Greece
Cornelian. 1.5 × 1
Inv. No. Zh 557
Provenance: 1787, from the collection of the Duke of Orléans, Paris.

An apobate had to leap from a horse, then run after it and leap onto its back again, all fully armed. O.N.

130

131
Scarab Intaglio: Hercules and the Winged Monster. 5th century BC
Etruria
Cornelian. 1.4 × 1.1
Inv. No. Zh 682
Provenance: 1788, from the collection of Joseph France, Vienna; before 1700, Capello collection, Venice.

Here the Etruscan engraver would seem to have turned to myths of the distant Northern Black Sea area, and that of Hercules and Echidna. O.N.

131

132
Intaglio Ring: Squatting Bather.
4th century BC
Greece
Cornelian. 2.1 × 1.3
Inv. No. Zh 575
Provenance: late 18th century.

In this rare piece, the signet ring is made entirely of cornelian and shows a beautiful bather admiring herself in a mirror. O.N.

133

133
Intaglio: Nike Driving a Quadriga.
4th century BC
Greece
Cornelian. 3 × 2.2
Inv. No. Zh 604
Provenance: 1792, from the collection of Jean-Baptiste Casanova, Dresden.

Nike, goddess of Victory, was an extremely popular subject for engraved gems during the Hellenic period, a time of lightning changes in the political map of the Ancient world thanks to the victorious campaigns of Alexander the Great and his successors. O.N.

134
Intaglio: Head of Medusa. 2nd-1st century BC
Asia Minor (?)
Cornelian. 2.1 × 1.7
Inv. No. Zh 623
Provenance: 1792, from the collection of Saint Morys, Paris.

There is some basis for attributing this gem to the engraver Solon, who worked at the court of King Mithridates VI of Pontus. O.N.

134

135

Intaglio: Venus and Eagle. 1st century BC

Rome

Cornelian, gold. 3.9 × 3.3

Inv. No. Zh 1225

Provenance: 1792, from the collection of Saint Morys, Paris.

Imperial Rome eagerly adopted the Hellenistic doctrine that a ruler's power was blessed by the gods. Here Venus, "mother of the Aeneids", caresses Jupiter disguised as an eagle, behind whom is a horn of plenty, symbol of the state's prosperity. O.N.

136

Intaglio: Nero as Jupiter. 1st century

Skylax

Rome

Cornelian, gold. 2 × 1.3

Inv. No. Zh 1444

Provenance: 1786, from the collection of Lord Algernon Percy, Alnwick Castle, England.

Obvious parallels between this portrait and images of Alexander the Great as Zeus indicate that Rome took from the Hellenic world not only the idea of a ruler's apotheosis after death but also the way that this was depicted in art. O.N.

137

Intaglio: Head of Helios (Nero as Sun God). 1st century

Rome

Rock crystal. 4 × 3.3

Inv. No. Zh 1433

Provenance: late 18th century.

Frequent depictions of Helios in 1st-century glyptics reflect the fact that the Sun God was perceived as the incarnation of Emperor Nero.

O.N.

137

136

138

Intaglio: Commodus as Jupiter. 2nd century

Rome

Amethyst. 2.1 × 1.7

Inv. No. Zh 1446

Provenance: 1792, from the collection of Saint Morys, Paris.

Each ruling Roman emperor was seen as an earthly embodiment of a higher deity, Jupiter Capitolinus. Here Commodus wears over his shoulders the aegis which is an attribute of Jupiter. O.N.

135

138

139

Intaglio: Portrait of Septimus Severus, Caracalla and Geta. 2nd-3rd century

Rome

Cornelian, gold. 3.2 × 2

Inv. No. Zh 1456

Provenance: 1788, from the collection of Joseph France, Vienna.

Such large intaglios showing members of a single family would seem to have adorned wreaths worn by priests serving the cult of Concordia Augustorum (Accord of the Augusti).

O.N.

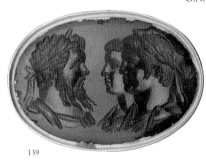

139

140

Cameo: Perseus and Andromeda. 1st century

Rome

Sardonyx. 2.8 × 3.1

Inv. No. Zh 298

Provenance: 1780, from the collection of Anton Raphael Mengs, Rome.

(Illus. see p. 96)

The composition of this cameo undoubtedly derives from some lost painting. It is found repeatedly on gems, lamps and frescoes.

O.N.

141

Cameo: Head of the Beardless Hercules (Antinous as Hercules?). 2nd century

Rome

Sardonyx. 6.2 × 4.9

Inv. No. Zh 307

Provenance: late 18th century; first half of the 18th century in the collection of A. Borioni.

While in the Borioni collection, this cameo was identified as an image of Iola, but in the Hermitage it has for many years been described as showing Omphale. It seems more likely, however, that the cameo relates to the cult of

Antinous, favourite of Emperor Hadrian, which arose after his early death.

A similar cameo from the collection of the Duke of Marlborough is in the Museum of Fine Arts, Boston.

O.N.

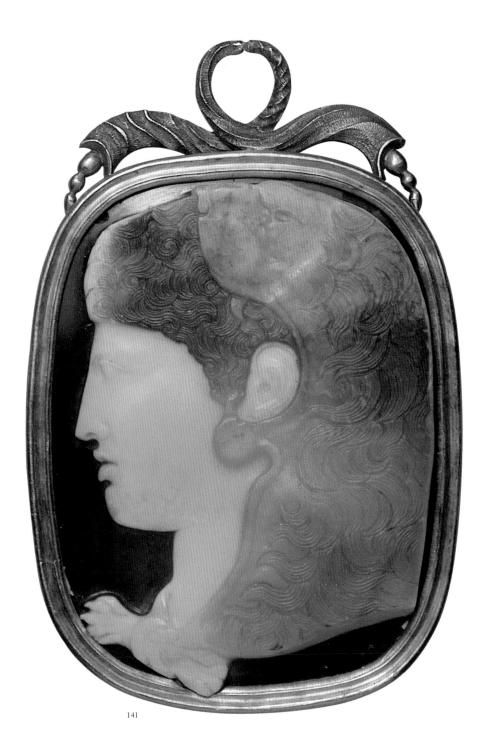

141

Post-Classical
Engraved Gems

142

Cameo: The Brazen Serpent. 13th century

Venice

Inscription in Ancient Hebrew: *He that looketh upon it shall be saved* (Book of Numbers, xxi: 8)

Sardonyx, gold. 2.8 × 3.4

Inv. No. K 5632

Provenance: before 1794.

In this cameo we see reflected the influence of various styles. From Byzantine art the master borrowed the depiction of the crowd, and some figures reveal similarities with a Byzantine ivory plaque showing the 40 martyrs. The placing of Moses before the serpent seated like a basilisk on a column7 recalls a miniature in an early Italian psalter, while the small angular folds of drapery and the rhythmic composition echo the reliefs of Giovanni Pisano. Not surprisingly, the cameo has been variously dated between the 10th and 15th centuries. At the present time the accepted dating – as with a number of other cameos with Hebraic inscriptions – is to the 13th century, with reference to the Byzantinising style typical of Venetian art at this date. Y.K.

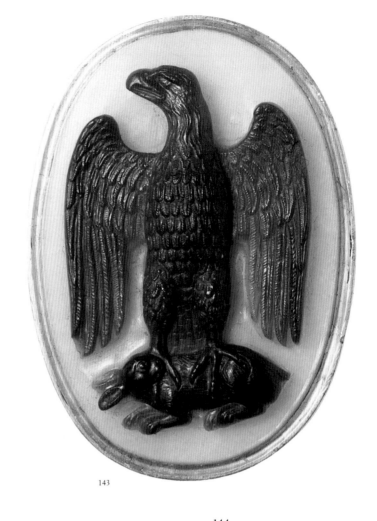

143

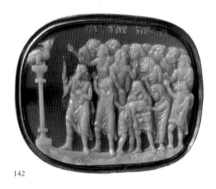

142

143

Cameo: Eagle with a Hare in its Talons. 1240–60

Southern Italy

Sardonyx, gold. 3.9 × 2.9

Inv. No. K 2141

Provenance: 1792, from the collection of Jean-Baptiste Casanova, Dresden.

An outstanding example of the skill of engravers working at the court of Frederick II von Hohenstaufen. The eagle (part of the Staufen state arms) bears a hare in its claws and thus symbolises strength and power – in its use of symmetry and the graphic depiction of feathers this image seems almost heraldic.

Such cameos were free interpretations of Ancient Roman works, a typical feature of art at the Sicilian court: in his efforts to build a great empire, Frederick sought all possible means to identify himself with the Roman emperors. Y.K.

144

Cameo: Lion. First half of the 13th century

Southern Italy

Sardonyx, gold. 3.5 × 2.2

Inv. No. K 2953

Provenance: 1792, from the collection of Jean-Baptiste Casanova, Dresden.

The lion formed part of the Hohenstaufen family arms and like the eagle, appeared not only on cameos but also in mosaics, on capitals, locks and other works of art produced in their circle. Y.K.

144

145

Cameo: Peacock. First half of the 14th century

France (?)

Inscription on the reverse, probably later: *DIVA FAUSTINA* [the Divinity Faustina]

Sardonyx, gold. 2.9 × 3.9

Inv. No. K 1189

Provenance: 1792, from the collection of Jean-Baptiste Casanova, Dresden.

The peacock was the symbol of Juno and was associated with Roman Empress Faustina, who was seen as being the goddess's earthly incarnation. In its heraldic nature, the bird should be dated to the medieval period, but it reveals a clear departure from the schematic and graphic approach employed in cameos produced around the Hohenstaufens. Recent information suggests that after the death of Frederick II many of his engravers abandoned Sicily and moved to France, where court traditions were enriched with features of French Gothic art. Y.K.

145

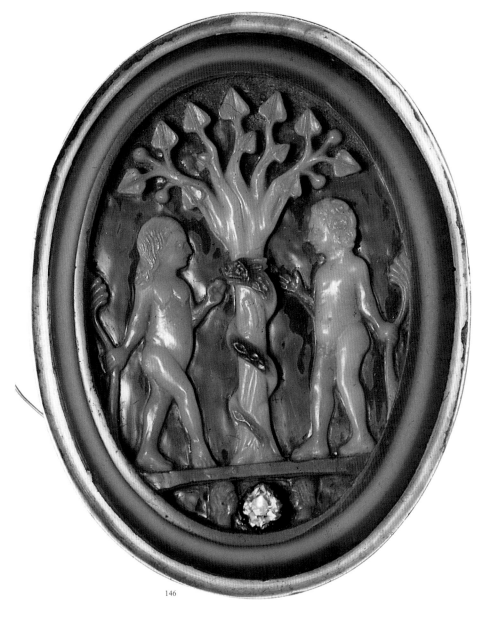

146

146

Cameo: Adam and Eve. Mid-14th century

Italy

Sardonyx, gold, diamond. 3.2 × 2.9

Inv. No. K 5631

Provenance: before 1794.

Employing the accepted iconography of depictions of the Fall, two naked figures stand half turned towards the Tree of Life. Their outstretched hands are shorter and in lower relief than those holding the vine, a timid attempt to convey perspective which became more widespread only in the 15th century. Making skilful use of the three different layers of the stone, the engraver plays the upper level in two gradations, increasing his "palette" to four shades. The two busts below, separated by a diamond (inserted later), are clearly portraits of his clients. Their hairstyles were fashionable in mid-14th-century Italy. Y.K.

147

Cameo: Portrait of Charles V (the Wise). 1370s

France

Sardonyx, gold. 3.4 × 2.9

Inv. No. K 988

Provenance: before 1794; in the early 17th century in the collection of Louis Chaduc (Paris, Rion).

From the form of the crown, the mantle decorated with lilies and the regalia (sceptre and "hand of Justice"), there is no doubt that this cameo shows a king of France. His precise identity is revealed by similarities with images of Charles in miniatures and tomb sculpture. Y.K.

147

148

Commesso: Portrait of Charles VII. Late 1420s

France

Milk chalcedony, garnet, emerald, gold, enamel. 3.1 × 2.9

Inv. No. K 990

Provenance: before 1795.

The "commesso" technique combines semi-precious and precious stones, gold and enamel. Only a few examples survive from before the 16th century, but this piece can be dated quite precisely to the 1420s on the basis of the form of the crown and the shaved temples and nape of the neck: it is thus one of the earliest known portraits of Charles VII, possibly created for his coronation, which took place at Rheims in 1429 and was attended by Joan of Arc.

The emerald was set no earlier than the late 16th century, replacing a lost stone.　Y.K.

149

Cameo: Angel with a Vernicle. Late 15th century

Netherlands

Mother-of-pearl, gold. 4.4 × 4.8

Inv. No. K 1638

Provenance: before 1794

A Vernicle is a depiction of a cloth with an image of Christ, named after St Veronica, who wiped Christ's face as he carried the Cross on the road to Calvary.

Mother-of-pearl engravings were common in 15th-century Germany and the Netherlands. Small mother-of-pearl reliefs were used as portable icons and images, as clasps and fasteners on clothes and headwear. Openwork pieces were particularly prized and were used to decorate a variety of objects, or could be placed like a rose window in a Gothic cathedral on

silver tower-like reliquaries. Judging by the folds of the cloth, this medallion has its visual source in 15th-century Netherlandish woodcuts.　Y.K.

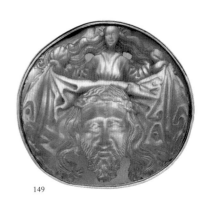

149

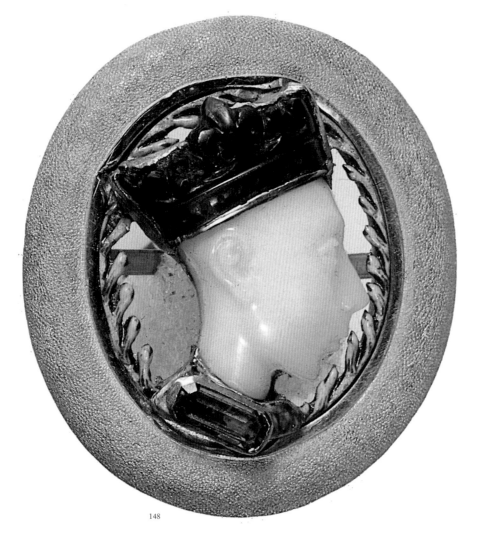

148

150

Intaglio: Portrait of Lodovico Moro. Between 1494 and 1499

Cristoforo Caradosso Foppa. c. 1452-1526/7

Milan

Inscription around the edge: *LVDOVICUS.M. SF. ANGLVS. DUX. M* [Lodovico Moro Sforza Angelus Duke of Milan]

Sapphirine-chalcedony, gold. 3.8 × 3.2

Inv. No. 3630

Provenance: before 1794.

Carved portraits provide us with outstanding proof of the flowering of Italian glyptics during the Renaissance. Portrait cameos and intaglios engraved in hard-wearing materials not subject to the destructive effects of time reflected a desire to immortalise the individual. Lodovico Moro would seem to have used this intaglio as his official seal, as is indicated by the official nature of the portrait and the inscription recording his full titles. This highly polished piece also served as a form for the casting of lead plaques used as diplomatic gifts. The attribution to Caradosso is based on similarities with medals he produced in honour of Lodovico Moro and is thus the renowned master's sole authenticated work in stone.　Y.K.

150

152

Cameo: Head of Christ. 16th century

Italy

Lazurite, gold. 4.2 × 3.5

Inv. No. K 675

Provenance: before 1794.

A common Renaissance depiction of Christ, deriving from a medal and plaques by Antonio Abondio, a medallist, sculptor and painter who worked in Milan, Vienna, Prague and Munich. In Renaissance glyptics this type was most frequently found in cameos engraved into blood jasper. Y.K.

152

151

Cameo: The Nativity. c. 1500

Northern Italy

Chalcedonyx, gold. 3.8 × 4.4

Inv. No. K 685

Provenance: before 1794.

Making use of fine nuances within the colour of the stone itself, the engraver created a cameo in grisaille. The transparent lower layer of the stone contributes to the sense of depth as the master builds his composition on two planes, with a third - the brick wall, the city of Bethlehem in the distance, the clouds behind the angels' heads – merely indicated by engraving on the background. This Gospel subject is treated like a genre scene, in a manner typical of late 15th-century North Italian reliefs. Y.K.

151

153

Cameo: Portrait of Charles V. Late 1530s-1540s
Giovanni Antonio dei Rossi. 1517-after 1575
Italy
Onyx, black agate, gold. 3.7 × 2.8
Inv. No. K 1180
Provenance: 1787, from the collection of the Duke of
Orléans, Paris.

In the sale catalogue of the Cabinet of engraved
gems of the Duke of Orléans, this cameo figures
as a portrait of Frederick Barbarossa, an error
repeated in the Hermitage inventory of engraved
gems. The current identification of the portrait
and its attribution were put forward by
V. Stegmann, on the basis of similarities with
engraved portraits of Charles V in the Hermitage
and other museums and particularly with a
cameo from a Florentine collection also
attributed to Giovanni Antonio de Rossi. We
should note the undoubted parallels for
treatment of the image of Charles V in reliefs by
Leone Leoni.

Rossi worked as both medallist and engraver,
and the carving of mainly single colour stones is
a distinctive feature of his style. The technique
used here, whereby the pale stone relief, with its
extremely finely modelled profile, is attached to
highly polished black agate, was extremely rare
for this date and is another confirmation of the
attribution. Y.K.

153

154

*Intaglio: Night Giving Morpheus a Bunch of
Poppies. 16th century*
Italy
Sard, gold. 2.9 × 3.5
Inv. No. I 5370
Provenance: 1795, from the collection of Thomas
Martin, London.

An almost literal reproduction of an engraved
heliotrope from the Medal Cabinet of the
Bibliothèque National in Paris, attributed to one
of the leading engravers of the High Renaissance,
Valerio Belli, called Vicentino. Even during
Vicentino's lifetime the original intaglio was
reproduced in quantity in plaques and was taken
up by other masters. In the Hermitage alone we
find two more 16th-century replicas and an
18th-century repetition. Some scholars have
identified this scene as "Ceres Teaching
Agriculture". Y.K.

154

155

Cameo: Eos on a Chariot. 16th century
Italy
Sardonyx, gold. 3.4 × 3.5
Inv. No. K 441
Provenance: late 18th century.

Rising up from the ocean bed is the goddess of
the dawn in a chariot drawn by four horses, a
motif found in Hellenistic and Roman glyptics,
in medieval and particularly in Renaissance
cameos. This piece, almost round in format, is
outstanding in its use of a mineral with no less
than seven layers of stone of different hues. Y.K.

156

*Cameo: The Fall of Icarus.
Late 16th - early 17th century*
Italy
Chalcedonyx, gold. 2.7 × 2.4
Inv. No. K 2189
Provenance: 1785, from the Kunstkammer, as part of the
Cameo Cup.
(Illus. see p. 98)

An expressive example of Mannerist engraving,
this cameo had its visual source in a print after a
drawing by Perino del Vaga. The cameo was one
of many decorating the famous Cameo Cup or
Peter's Cup, dismantled on Catherine's orders,
and it is visible (although the artist showed only
the wing and part of the hand of Icarus) in a
watercolour sketch of the cup by Ottomar Elliger,
made when it was in the Kunstkammer. Y.K.

157

*Cameo: Orpheus and the Beasts.
Late 16th century*
Alessandro Masnago (or studio). Active last
third of the 16th century
Milan
Variegated agate, gold. Diameter 4.6
Inv. No. K 1931
Provenance: 1792, from the collection of Jean-Baptiste
Casanova, Dresden.

Works by Alessandro Masnago and engravers of
his circle are easily recognised, for instead of
using stone with parallel layers (as was
traditional in the making of cameos), they
engraved in variegated agate or jasper mass with
coloured flecks and veins, creating a deceptive
"painted" appearance. Their characteristic high
relief engraving fills the whole of the stone's
surface to form a dynamic composition.
Masnago did not leave his native Milan but
produced many commissions for Emperor
Rudolph II; therefore the greater part of his
works are now in the Kunsthistorisches Museum
in Vienna. Y.K.

155

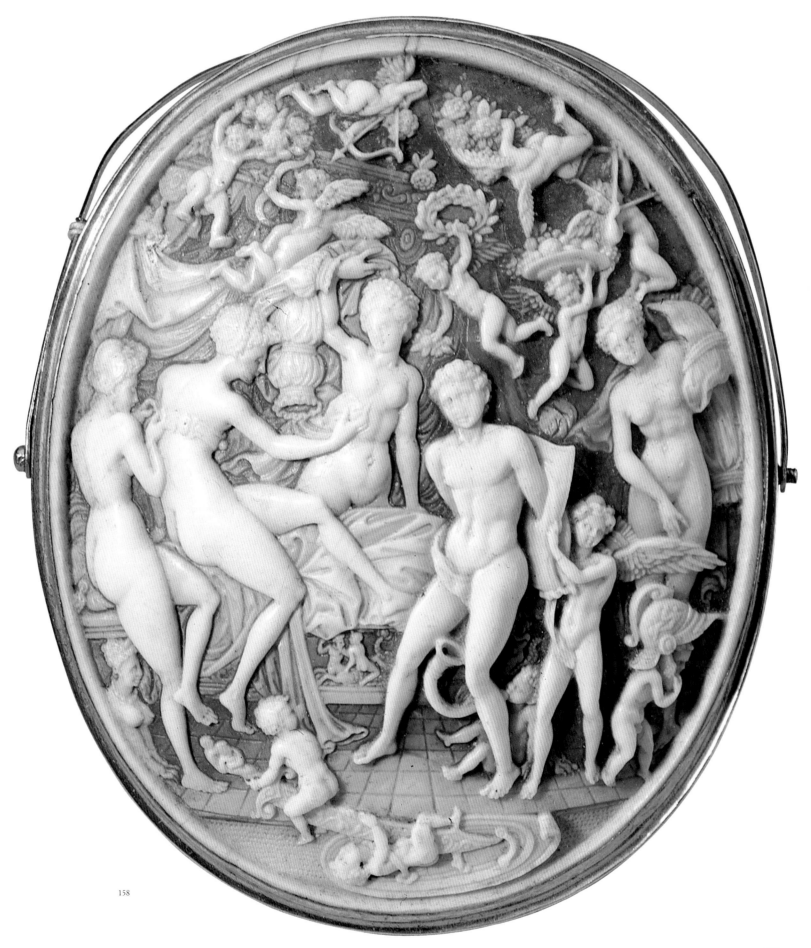

158

157

159

158

Cameo: The Toilet of Venus. c. 1530

France

Shell, black mastic, gold. 7.8 × 6.5

Inv. No. K 3369a

Provenance: late 18th century.

(Illus. see previous page)

This tightly-packed composition reproduces a drawing by Rosso Fiorentino, *Mars and Venus Served by Nymphs and Cupids* (Louvre, Paris). In adapting the rectangular drawing to his oval composition, however, the engraver introduced changes in some details. The drawing, an allegory of the marriage of Francis I and Eleanor of Austria, was produced in Florence in 1530, not long before Rosso moved to France to take part in the decoration of the palace at Fontainbleau.

The cameo can be dated to the years of Rosso's stay at the French court, which coincided with the "golden age" of engraving in shell in France. The appearance of two colours in the white shell is created by a layer of dark mastic applied to the reverse, which shows through the lower level. Y.K.

159

Cameo: Lot and his Daughters. 1540-5

Peter Flötner. c. 1485-1546

Nuremberg

Chalcedonyx, gold. 4.1 × 5.3

Inv. No. K 699

Provenance: 1794, acquired through the merchant Livio.

The composition is almost identical to a miniature box-tree relief in the British Museum, carved by the engraver and sculptor Peter Flötner, one of the leading representatives of the Northern Renaissance, as a model for the casting

of plaques (a rare example of such a plaque is in the Württembergisches Landesmuseum). The virtuoso skill revealed in the Hermitage cameo suggests the same author, although there are no other known hardstone works by him. Y.K.

160

Cameo: Portrait of Henry IV. 1597

France

Inscription along the edge, from shoulder to shoulder: *HENRICVS. IIII. FRANCOR. ET NAVAE. REX. 1597.* [Henry IV King of France and Navarre. 1597]

Mother-of-pearl. 3.6 × 2.9

Inv. No. K 641

Provenance: late 18th century.

One of four known and accepted portraits of Henry IV in mother-of-pearl, all clearly from the same hand. Like two of the others, this piece bears the precise date of its execution. The inscription with the sitter's full title on the cameos relate them closely to medals and in their iconography all derive from the medals and engraved gems of Guillaume Dupré. Y.K.

160

161

Cameo: Portrait of Elizabeth I. 1582/5

Julien de Fontenay. fl. 1590-1611 (attributed)

England

Sardonyx, gold. 3.1 × 2.9

Inv. No. K 827

Provenance: 1787, from the collection of the Duke of Orléans, Paris; until 1741 in the collection of Pierre Crozat, Paris.

There are dozens of portrait cameos of Elizabeth I, scattered across museums and private collections throughout the world. Before the appearance of orders and medals these were used as rewards for merit and for particular services to the throne. Elizabeth gave them to

her courtiers and Knights of the Order of the Garter could attach them to the insignia of the Order during great ceremonies and processions. We see them depicted in single and group portraits of the Elizabethan era. Although the majority of the cameos follow a specific stereotype, they are not copies, and nuances are visible even in the face, despite its mask-like appearance.

There is an undocumented but persistent suggestion that Henry IV, King of France, sent to Elizabeth's court his favourite gem-engraver, Julien de Fontenay, but there are other hypotheses regarding authorship of this cameo. Certainly it is clear that such mass production of Elizabethan engraved portraits could only have been carried out by a whole workshop, regardless of who stood at its head. Y.K.

162

Cameo: Portrait of Rudolph II. 1600-10
Ottavio Miseroni. 1567-1624

Bohemia

Sardonyx, gold. 6.7 × 3.3

Inv. No. K 963

Provenance: before 1794.

Ottavio Miseroni belonged to a famous Milan family of engravers of gems and vessels from rock crystal and coloured stones. He studied under his father, Girolamo Miseroni, and his uncle, Gasparo. In 1588, together with other members of his family, he travelled at the invitation of Rudolph II to the court at Prague, near which they founded a grinding mill, working mainly with local kinds of stone. This piece differs from the many engraved portraits of Rudolph II in that its lower part is occupied by the eagle's spread wing, giving it an allegorical tone. Y.K.

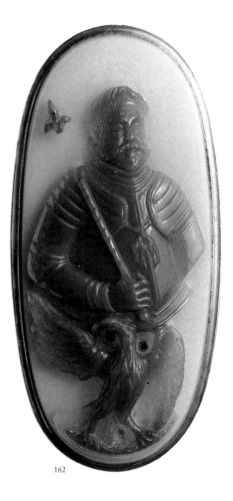

162

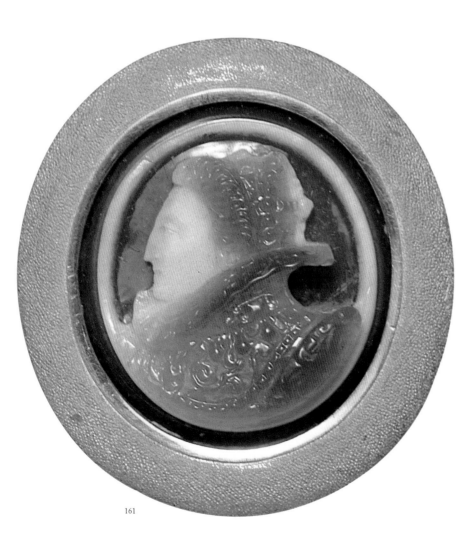

161

163

Cameo: Portrait of Ferdinand II. Second quarter of the 17th century

Southern Germany

Two-layered shell, gold. 2.6 × 2.2

Inv. No. K 817

Provenance: before 1794.

Iconographically, the portrait derives from the front of a medal of 1620 in honour of the battle at the White Hill, near Prague. It is engraved into an extremely thin upper layer of shell, such that the darker lilac-brown ground shows through, creating an interesting play of light and shade. Shell is much softer than stone and was often used to produce whole series of works. This piece possibly formed part of a series of portraits of rulers of the Holy Roman Empire. Y.K.

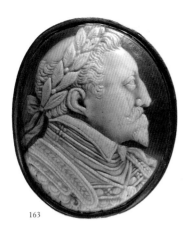

163

164

Cameo: Portrait of Christian IV. c. 1645

Northern Europe

On the back the monogram C 4 and the inscription:
REGINA FIRMA PIETAS [Firm royal piety]

White shell, gold. 3 × 2.4

Inv. No. K 1010

Provenance: before 1794.

The lively, expressive face was probably taken
from an engraving after a painted portrait by
Carel van Mander, even though the texture of the
camisole and the fine lace collar is rather dry. The
use of the Arabic (not Roman) numeral "4" is
specific to his monogram, set beneath the
Danish crown and edged with two palm leaves.

Y.K.

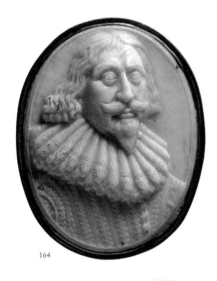

164

165

*Cameo (set in the form of a pendant):
Portrait of Herman Boerhaave. Late 17th –
early 18th century*

Holland

Tinted shell, gold, white and green enamel (pendant
setting – early 18th century). 3.6 × 2.3

Inv. No. K 979

Provenance: 1792, from the collection of Saint
Morys, Paris.

Entered in Catherine's inventory of engraved
gems in her Hermitage as a portrait of Herman
Boerhaave (1668-1738), a Leiden doctor,
anatomist, botanist, chemist, and author of a
handbook on chemistry. The miniature certainly
does not contradict the accepted iconography
for Boerhaave, a scholar well known in Russia in
the 18th century. The St Petersburg Military
Medical Academy has one of his manuscripts,
brought in 1740 by his nephew Herman Kaau-
Boerhaave, who became director of the medical
chancellery and physician-in-ordinary to
Empress Elizabeth in 1748.

Y.K.

165

166

*Intaglio: Soldier and Prisoners at a Triumphal
Gate. First half of the 18th century*

Germany (?)

Sardonyx, gold. 5.6 × 4.7

Inv. No. I 4382

Provenance: before 1784.

This rare subject may perhaps represent Theseus
taking the Amazons prisoner. The Baroque and
somewhat archaic nature of the figures, clothing
and architectural background, combined with
the unusually large stone, suggests that the gem

was created in Germany. There the transition
from the Baroque to Neoclassicism was more
drawn out, with Baroque reminiscences visible
later than in Italian art.

Y.K.

166

167

*Intaglio: Bust of Alexander the Great.
First third of the 18th century*
Johann Christoph Dorsch. 1676-1732

Nuremberg

Gold, sard. 3.4 × 2.9

Inv. No. I 4286

Provenance: 1788, from the collection of Joseph
France, Vienna.

Engraved portraits of Alexander's commanders,
Ptolemy, Seleucus, Antigonus and Cassander, are
carved in micro-technique in the corners while
to the sides are multi-figure scenes of
Alexander's victorious battles, after paintings
from *The Story of Alexander* by Charles Lebrun. In
the older literature this gem was described as
being engraved in garnet, and it became widely
known thanks to an engraving by S. Kleiner. It has
also been suggested that the true author was not
Johann Dorsch, but one of his daughters.

Y.K.

167

168

Intaglio: Portrait of Philipp von Stosch. 1739
Lorenz Natter. 1705-63

Italy

Signed to right: ΝΑΤΤΕΡ ΕΠΟΙΕΙ

Emerald (25.37 carat), gold. 2.6 × 2.1

Inv. No. I 3631

Provenance: 1764; until 1763 in the possession of
Lorenz Natter.

(Illus. see p. 94)

Few private individuals can have been the
subject of such a vast number of surviving
portraits, including hardstone engravings, as
Baron Philipp von Stosch, adventurer, patron,
man of learning, connoisseur of antiquities and a
passionate collector. Engraved gems were
Stosch's main interest and a description of his
collection was the work which first brought
Johann Winckelmann fame as a scholar. Stosch's
house in Florence, where he spent the last 26
years of his life, was a centre for the study of
ancient gems and for the patronage of new
engraving, then undergoing a revival after a long
period of stagnation. Engravers of Stosch's circle
created many portraits of him.

This portrait was influenced by a marble bust
of Stosch by Edmé Bouchardon and also reveals
Natter's acquaintance with medals produced in
honour of Stosch by François Marteau and
Johann-Karl Hedlinger.

Stosch gave Natter his start in what was to be a
brilliant career as a medallist, engraver and
theoretician. In 1739, on Stosch's
recommendation, Natter moved to England.
Although he travelled abroad on numerous
occasions to produce commissions at other
North European courts, Natter spent over 17
years in London, publishing there in 1754 a
treatise on methods of engraving in stone. The
unpublished second part of his treatise, the
Museum Britannicum (manuscript in the
Hermitage Archive), was intended to provide a
broad picture of the collecting of glyptics in
England in the middle of the 18th century. Y.K.

169

*Intaglio: Portrait of Oliver Cromwell. Middle
of the 18th century*

England

Cornelian, gold. 2.2 × 2

Inv. No. I 3636

Provenance: early 1790s, from the collection of Princess
Yekaterina Dashkova, St Petersburg.

Oliver Cromwell, from 1653 Lord Protector of
England, is depicted in profile as a Roman
commander. A cloak is thrown over his armour
and he wears a laurel wreath upon his head.
Princess Dashkova, in the inventory of her
collection (Hermitage Archive) published by
Oleg Neverov, says of this gem: "The Cromwell
was a present, I do not know its price."
Suggesting that the present may have been from
one of her numerous English friends, Neverov
noted that this portrait of the leader of Britain's
"Glorious Revolution" was an extremely fitting
element in the collection of a woman who saw
herself as a key figure in Catherine's coup of 1762,

also known in 18th-century Russia as a "glorious
revolution" due to its lack of bloodshed and the
broad social support it enjoyed. This portrait of
Cromwell, which Dashkova presented to
Catherine, served as a memorial of that coup.

Y.K.

170

*Intaglio: Portrait of Isaac Newton. First half of
the 18th century*

England.

Cornelian, gold. 2.1 × 1.8

Inv. No. I 4042

Provenance: 1763, from the collection of Lorenz Natter.

Images of Shakespeare, Milton and Newton
made their appearance in English glyptics from
the late 17th century and were widespread in the
18th century, when the subjects were particularly
in keeping with the mood of English society of
the Age of Enlightenment. This profile portrait
of Isaac Newton, without a wig and with a tailed
comet in the background (as in an intaglio in the

169

British Museum), is one of an early group of such gems. Small and not overly fine in execution, they are characteristic products of the transition from the Baroque to Neoclassicism. To both gem-engravers and consumers, the subject was more important than the execution. Y.K.

171
Cameo: Portrait of Peter I. 1780s
Johann Weder. 1742-1808

Rome
Signed on the shoulder: *WEDER F*
Sardonyx, gold, blue enamel. 4.9 × 4.2
Inv. No. K 1088
Provenance: before 1794.
(Illus. see p. 101)

Weder was part of the numerous colony of German artists who spent many years living and working in Rome. He enjoyed European-wide fame for his cameos (intaglios are almost unknown in his work) but it was his friendship with Catherine's agent, Johann Reiffenstein, which would seem to explain the large number of his works in the Hermitage (15 signed works alone). In this portrait of Peter I, Weder enlivened his conscientious but somewhat unexpressive and passionless manner by using precise contour and high relief, and making Peter's gaze tense and direct. Y.K.

172
Cameo: Centaur and Bacchante. Last quarter of the 18th century
Giovanni Pichler. 1764-91

Italy
Signed bottom left: *ПIХЛЕР* [Pichler]
Sardonyx, gold. 2.2 × 2.8
Inv. No. K 1813
Provenance: before 1794, from the collection of James Boyd, London.
(Illus. see p. 100)

The composition is borrowed from a wall painting at Pompeii, the group amazingly naturally set into the closed, oval space, preserving all the original's expression – not a common feature in Pichler's work. Ancient monuments, sculptures and frescoes rather than gems inspired the majority of Pichler's pieces. Recognised head of European glyptics during its last flowering in the second half of the 18th century, he was so taken by the spirit of Classical art that Winckelmann himself was said to have taken one of his works for an authentic Ancient piece. His style was nonetheless very individual: soft but precise relief, harmonious composition, great clarity and elegance of line. Pichler was never interested in extreme polish, and his works allow us to trace the light and confident movements of his tools. Y.K.

173
Intaglio: Centaur abducting a Maenad. 1770s-1780s
Alessandro Cades. 1734-c. 1813

Rome
Cornelian, gold. 2.7 × 2.1
Inv. No. I 9322
Provenance: 1792, from the collection of Saint Morys, Paris.

Cades worked in Rome in the manner of Giovanni Pichler. His younger brother, Tommaso Cades, also a gem-engraver, was famous for his workshop producing casts of engraved gems, where the "new" glyptics included 50 gems by Alessandro. Of this intaglio his series descriptions say that it repeats an Antique glass paste in turn derived from a fresco at Herculaneum (paste in Museum of Fine Arts, Boston).

Cades's intaglio was brought to St Petersburg during the French Revolution by the famous Paris antiquarian Alphonse Miliotti together with collections of engraved gems belonging to aristocratic families. Y.K.

174
Intaglio: Sacrifice to Minerva. 1769
Edward Burch. 1730-1814

London
Signed on the pedestal: *BURCH F.*
Chalcedony, gold. 2.5 × 2.2
Inv. No. I 3956
Provenance: before 1794.

In the catalogue of casts of 100 selected gems of his own work produced by Burch in 1795, the author indicated that this piece, after a drawing by Angelica Kauffmann, belonged to the Russian Empress. There must have also been another version for there is a cast, framed like a brooch, from a rectangular gem with rounded corners, in an English private collection. In 1769 Burch exhibited the Hermitage piece at The Society of Artists of Great Britain. Y.K.

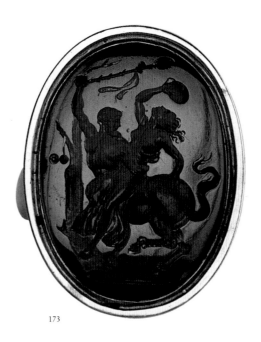

173

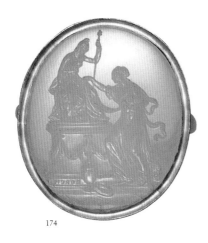

174

175
Intaglio: Dionysian Bull. 1782
Edward Burch. 1730-1814

London

Signed: *BURCH*

Cornelian, gold. 1.9 × 4

Inv. No. I 3957

Provenance: before 1794.

Copy from an Antique gem by master Hyllos in the collection of the French king (now Medal Cabinet, Bibliothèque National, Paris), well known in the 18th century from numerous casts and prints. Burch returned to this motif at least three more times. Y.K.

175

176
Intaglio: Head of Sappho. 1786
Edward Burch. 1730-1814

London

Signed: *BURCH*

Sard. 2.3 × 2

Inv. No. I 3958

Provenance: before 1794; formerly perhaps in the collection of Stanislas Poniatowski, King of Poland.

Copy of a gem by Giovanni Pichler which derives from a famous Antique bust in the Vatican. The Hermitage also has an author's copy of this intaglio in cornelian. After Burch, similar gems were made in England by William and Charles Brown, William Barnett, twice by William Lane, and by Edward Burch the Younger. Closest to this interpretation is an intaglio by Burch's pupil Nathaniel Marchant. All the different versions were cast by James Tassie. Y.K.

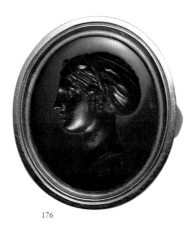

176

177
Intaglio: Head of Alexander the Great. Before 1772, or early 1780s
Nathaniel Marchant. ?1739-1816

London or Rome

Signed right: *MARCHANT*

Sard, gold. 3 × 2.5

Inv. No. I 3981

Provenance: 1786, from the collection of Lord Algernon Percy, Alnwick Castle, England.

Traditionally thought in the Hermitage to show the head of Antinous, in fact this intaglio has nothing in common with two portraits of Antinous by Marchant known from casts (one inspired by a bust at the Villa Mondragone near Frascati, now Louvre, Paris; the other by a bas-relief from the Villa Albani/Villa Torlonia, Rome).

Marchant included the Hermitage version in a series of 100 chosen works from his own oeuvre as "Head of Alexander", saying that he engraved it for the gem collector Lord Algernon Percy (Lord Beverley) from a cornelian fragment in the latter's collection. The small surviving part of the face did not allow identification of the original sitter, nor even the sex, and the catalogue compiled when the collection (known as The Beverley Gems), although still at Alnwick Castle, belonged to the Duke of Northumberland, described the fragment as "Profile of a Greek Youth or Goddess". It is hard to say if the engraver himself saw Alexander here or whether the owner suggested such a reconstruction, but certainly Marchant himself filled in the missing areas. The description of a series of casts by Tommaso Cades entitles the work "Head of Alexander the Great, copy from a Greek medal".

Gertrud Seidmann, author of the only monograph on Marchant and cataloguer of his works, dates the Hermitage gem to "before 1789", i.e. immediately after the engraver's return to London after 16 years in Rome. But in fact it formed part of that section of Algernon Percy's collection acquired by Catherine II in 1786 and should probably be dated either to the first London period of Marchant's work, or to the early 1780s, when the client himself was in Rome. It is very possible that it was during his stay there that Percy acquired the Ancient fragment.

In Rome, Marchant also engraved another two heads of Alexander after sculptures. The Hermitage version in its turn was repeated by his contemporary, the English engraver William Harris, who put his name on the diadem. Y.K.

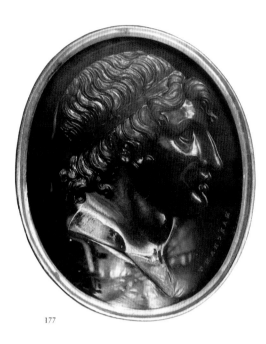

177

178
Intaglio: Bacchus and Ariadne. c. 1783
Nathaniel Marchant. 1739-1816

Rome

Sardonyx. Diameter 2.8

Inv. No. I 9333

Provenance: before 1794.

Undoubtedly the work of Marchant himself, despite the lack of a signature, this is a replica of an oval intaglio of the same title and size, a cast of which Marchant sent to London from Rome in 1783 for exhibition at the Royal Academy.

The composition derives from a severely damaged bas-relief from Herculaneum, then in the Palazzo Farnese (now Museo Nazionale, Naples). From the surviving parts of the thyrsus (staff entwined with ivy) and hand holding the vessel, Marchant built up the figure of the standing nymph (or Ariadne), although it is now thought that she looked somewhat different in the relief. The original gem belonged (according to the engraver) to G. H. Foot and was cast by James Tassie. It entered the British Museum in 1799 as part of the Cracherode collection. Raspe, whilst paying homage to the excellent engraving, reproved Marchant for his distinctly elongated proportions.

The Hermitage gem differs from the other pieces in its configuration, in some details and in the more precise drawing. Y.K.

179
Intaglio: The Rape of Europa. c. 1783
William Brown. 1748-1825

England

Signed left: *BROWN INV t*

Cornelian, gold. 2.6 × 3.5

Inv. No. I 3731

Provenance: before September 1786.

One of the earliest pieces by the Brown brothers in the Hermitage, this intaglio still reveals the Baroque features characteristic of their works in the early 1780s. Note, for instance, the choice of a

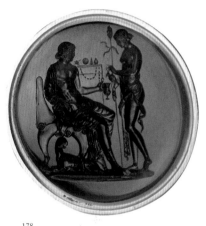

178

white-veined stone creating the effect of sea spray and foaming waves, over which Jupiter (disguised as a bull and accompanied by Cupid) bears Europa. Exhibited at the Royal Academy in 1783, the intaglio does not appear in bills (Hermitage Archive) presented to the Cabinet of Her Imperial Highness by the engravers themselves or by the court typographer and bookseller Johann Jacob Weitbrecht (their representative and commissioner). Raspe, however, including it in the third part of his manuscript catalogue of Tassie casts, compiled before 1786, indicates that it was then in the collection of Catherine II. The printed version of the catalogue (1791), includes the intaglio in a list of joint works by the brothers. On both occasions it is described as an outstanding modern work. The Browns returned to the subject in 1794 in a modest little octagonal intaglio on blood jasper (Hermitage): at the very moment of abduction Europa turns and holds out her hand in supplication to her friends on the bank. Y.K.

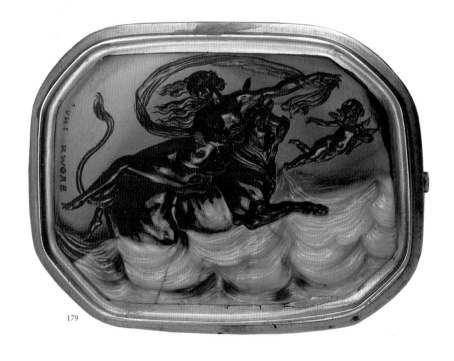

179

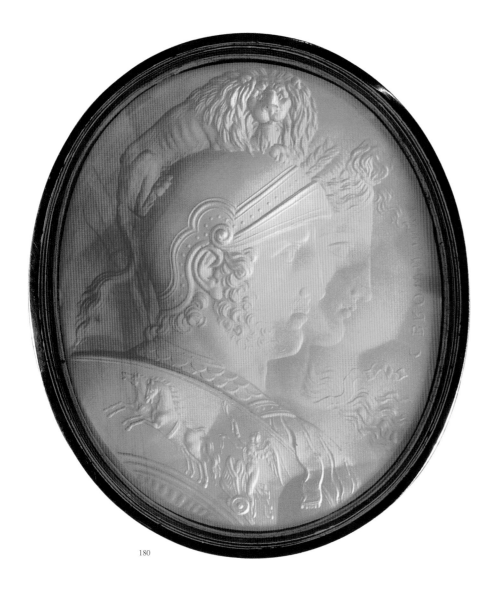

180

181
Intaglio: Bust of Hygieia. c. 1785
William Brown. 1748-1825
London
Signed at the bottom: *W. BROWN INV t*
Cornelian, gold. 3 × 2.7
Inv. No. I 3698
Provenance: October 1787.

William Brown exhibited intaglios showing the goddess of Health at the Royal Academy in London in 1778 and 1785. The Neoclassical style of this piece would seem to suggest the later date, as is confirmed by its arrival in the Hermitage shortly after. From a bill presented by Weitbrecht in October 1787 we know that it arrived from England in a gold setting decorated with a diamond, which was soon replaced by a simple smooth gold setting, as was usual for intaglios in Catherine's collection. A decade later, the engraver repeated the head (but without the staff wound round with a snake) in a cameo also in the Hermitage. Y.K.

180
Intaglio: Mars and Bellona. 1784
Charles Brown. 1749-95
London
Signed right: *C. BROWN. INV*
Cornelian, gold. 4 × 3.5
Inv. No. I 3946
Provenance: October 1787.

Exhibited at the Royal Academy in 1784 as "Mars and Venus", a title attached by Raspe to a similar second version belonging to the Prince of Wales and to this piece in the first Hermitage inventories. Later scholars (Dalton, Forrer, Maximova) retained the title, but the bill Weitbrecht drew up on the basis of an invoice from the Browns themselves gives the intaglio as "Mars and Bellona".

The *capita jugata* or double profile has its sources in the Hellenic period and was often found on coins, engraved gems and medals. Taking Antique examples as his guide, the engraver nonetheless sought his own interpretation of the subject, and thus he added the word "INVENIT" – invented – to the signature. Brown's gem has a packed composition, full of abundant details; he switches easily from deep counter-relief to the finest engraving, creating a rich play of light and shade and making this one of the best examples of English Neoclassical glyptics. It became well known from Tassie's casts and the composition was repeated by other engravers in stone and shell. Y.K.

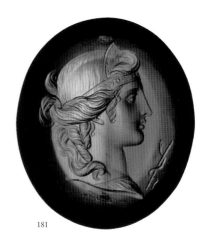

181

182

Intaglio: A Horse Frightened by a Lion. 1774
Charles Brown. 1749-95

London
Signed at the bottom: *C.BROWN F*
Cornelian, gold. 2.9 × 3.5
Inv. No. I 3953
Provenance: January 1791.
(Illus. see p. 102)

Based on George Stubbs' painting *White Horse Frightened by a Lion* (1770; Walker Art Gallery, Liverpool). Stubbs, the leading representative of the English sporting genre, produced his composition in two versions. It was reproduced in many different art forms, gaining fame through a large number of prints. The artist himself made a model of it for the production of ceramic plaques by Wedgwood.

Edward Burch, an older contemporary of Brown, was the first English gem-engraver to turn to Stubbs's work but Charles Brown, who himself had a taste for animalist works, repeated the subject at least twice (the first was an intaglio shown at the Royal Academy in 1774). Although the Hermitage gem is smaller, it is sharper and more expressive. A cast from it formed part of a small additional set of Tassie casts which arrived in the Hermitage in 1793 rather than the main Cabinet which arrived earlier.

Raspe suggested that Charles Brown made use of a print by William Woollett, and this was repeated in later publications but is not confirmed by recent study of the prints reproducing Stubbs's work. Greater analogies are to be found in a mezzotint by George Townley Stubbs, the painter's son. Y.K.

183

Intaglio: The Death of Socrates. 1791
William Brown. 1748-1825

London
Signed at the bottom: *BROWN*
Sapphirine-chalcedony. 2.3 × 3.1
Inv. No. I 4072
Provenance: March or November 1791.

Part of a triptych by the Brown brothers, the two others being *The Death of Seneca* and *The Murder of Archimedes* (both Hermitage). The choice of subjects and treatment are typical of their work in the late 1780s and early 1790s, as they moved increasingly towards Neoclassicism. *The Death of Socrates* was undoubtedly influenced by the paintings of Jean-François-Pierre Peyron and Jacques-Louis David, both exhibited at the Salon in Paris in 1787. William Brown may have seen the canvases during a stay in Paris in 1788 or perhaps later used printed reproductions. From David's composition come the figure of Socrates with that famous gesture in which the left hand holds the chalice containing hemlock, and the hand of Criton on his knee; the foreshortened bed recall's Peyron's painting. The engravers turned to Socrates again in 1794 for their intaglio *Socrates and Alcibiades* (Hermitage). Y.K.

184

Cameo: Allegory of the Victory over the Turkish Fleet. 1791
Charles Brown. 1749-95

London
Signed at the bottom: *C.BROWN F*
Sardonyx, gold. 5.3 × 6.8
Inv. No. K 1104
Provenance: January 1791.
(Illus. see p. 14)

Produced to commemorate Russia's victory in the war with Turkey of 1787-91, this allegorical cameo forms a pair with *Catherine II Instructing her Grandsons* (Cat. 185). A kneeling Turk lays down his arms before a pedestal bearing a bust of Catherine crowned by Glory with a laurel wreath; an eagle carries in its beak a palm, symbol of peace.

Watercolour sketches (Russian State Archive of Ancient Acts) for both cameos signed by William Brown were sent to Catherine II at the end of 1789. A letter from Weitbrecht to Catherine's secretary Khrapovitsky of 15 [OS] January 1790 makes it clear that work had already begun on the cameos, and that he had received another two drawings for pieces which "could be produced if the first are to our liking". He noted that, to simplify work on the image of Catherine, he had sent the Browns her portrait in wax, created by Carl Leberecht. The Browns told Weitbrecht with satisfaction that they had been able to achieve, thanks to the wax, an undoubted likeness. Work on the cameo was completed as planned by the end of 1790. Its price was set at £200. Y.K.

185

Cameo: Catherine II Instructing her Grandsons. c. 1791
William Brown. 1748-1825

London
Signed at right: *BROWN*
Agate-onyx, gold. 5.4 × 6.6
Inv. No. K 1124
Provenance: November 1791.
(Illus. see p. 14)

183

Catherine placed great emphasis on the education of her grandsons, Alexander and Constantine, herself developing their study programmes and writing literary and historical compositions for them. Here the Browns gave allegorical form to this aspect of her life. The Empress is shown as Minerva, seated before her grandsons (Constantine stands closest to her), with an open book in her hands; by her feet are various attributes of learning – a globe, quadrant and telescope – while the Grand Dukes are sheltered beneath the wing of an eagle. Although the sketch was sent to Russia in early 1790, work dragged on and it was finished only in the autumn of 1791. The cameo was priced at £200. Y.K.

186
Cameo: Catherine II Crowning Prince Potemkin with Laurels. 1792
William Brown. 1748-1825
Charles Brown. 1749-95
London
Signed at the bottom: *BROWN*; on the shield: *OCZAKOW*
Sardonyx, gold. 2.7 × 2.8 (without medallion),
5.7 × 5.8 (with medallion)
Inv. No. K 1125
Provenance: August 1792.
(Illus. see p. 14)

Produced to commemorate the taking on 6 December 1788 of the fortress of Ochakov by Russian troops under the command of Fieldmarshal Potemkin, during the 1787-91 war with Turkey. Work on the cameo would seem to have begun soon after the event, but it was completed only in 1792, after Potemkin's death. It was given its frame in the Hermitage and set in a glazed gold medallion. We do not know its price since it formed part of a single bill for seven cameos, of which two were related to this piece: one showed Catherine standing, holding a shield with the inscription "Russia", a curved sabre and sickle at her feet, while another had a winged Nike recording the victory at Ochakov on a shield. Y.K.

187
Cameo: Allegory of the Death of Potemkin.
1792
William Brown. 1748-1825
Charles Brown. 1749-95
London
Signed below on the urn: *BROWN*; along the edge:
PRINCE. POTEMKIN. OB. 16 A. D. 1791. AETAT. 52
Whitish-green onyx, gold. 3.8 × 3.1
Inv. No. K 1789
Provenance: August 1792.

A snake biting its own tail – symbol of eternity – surrounds Potemkin's initial on the body of the burial urn. The cameo was made and sent to St Petersburg for presentation to Catherine on the first anniversary of Potemkin's death.

Catherine's secretary Khrapovitsky noted in his diary: "Presented engraved stones from England sent by the Browns. Well received; they were admired, and the urn with the emblem on the death of Prince Potemkin of Tauris engraved on the stone was taken 'sans aucune sensation'."
 Y.K.

188
Intaglio: Allegory of Marriage. 1793
William Brown. 1748-1825
Charles Brown. 1749-95
London
Signed below: *BROWN*; on the temple: *VMHN*
Cornelian. 4.8 × 4.2
Inv. No. I 3628
Provenance: August 1793.
(Illus. see p. 101)

Produced in honour of the marriage of Grand Duke Alexander Pavlovich on 28 September 1793, this utterly Neoclassical gem has a symmetrical composition in which the young couple wear Classical attire. Facing each other, they join hands as a winged Glory rises above the entrance to the temple of Hymenaeus, illuminating their path with a burning torch. The laurel wreath over Alexander's head symbolises future victories. Y.K.

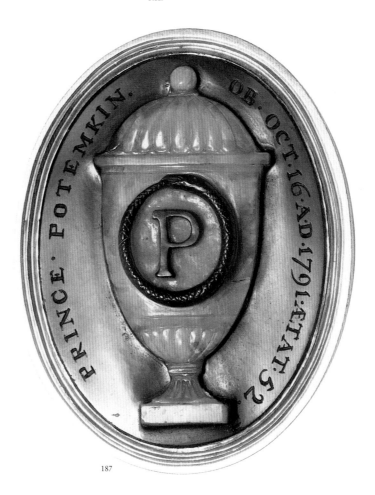

187

121

189

Intaglio: Hunting Dog. 1793

Charles Brown. 1749-95

London

Cornelian, gold. 2 × 2.8

Inv. No. I 3726

Provenance: November 1793.

Derives from an engraving by William Wollett after a painting by George Stubbs, *The Spanish Pointer.* Tassie's Cabinet includes two more repetitions of this gem, one of them in reverse bearing the signature of Charles Brown. Y.K.

189

190

Cameo: Lion and Lioness. c. 1793

Charles Brown. 1749-95 (attributed)

London

Cornelian-onyx, gold. 2.5 × 3.1

Inv. No. K 1841

Provenance: November 1793.

Although it is unsigned, this cameo was included in a bill from Weitbrecht dated 5 November 1793, "Group of lions, cornelian-onyx", and the work has long been attributed to the Brown brothers. Its subject and execution allow us to allocate it to the circle of the younger brother, Charles, who was particularly talented in animalist compositions. Like the previous intaglio, this cameo was strongly influenced by the work of George Stubbs. Y.K.

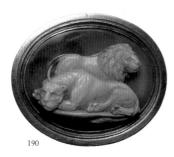
190

191

Cameo: Tiger. c. 1796

William Brown. 1748-1825

Charles Brown. 1749-95

(or William Brown)

London

Signed below: *BROWN*

Variegated agate, gold. 2 × 2.5

Inv. No. K 1785

Provenance: June 1796.

At this late period, the Browns sent their gems to St Petersburg as soon as they were completed. Since Charles died in 1795 we can be sure that even if this cameo was begun by him it must have been completed by William. Curiously, Weitbrecht's bill of 6 June 1796 includes the cameo in a group of gems after Antique models. Comparison with a contemporary print by James Murphy after a painting by James Northcote reveals, however, that this was the direct source for the image. Without seeking to create a naturalistic effect in the tiger's coat, the engravers managed to convey an effect of changing colour. Y.K.

192

Intaglio: Marius at Minturnae. c. 1796

William Brown. 1748-1825

London

Signed below: *BROWN*

Cornelian, gold. 3.7 × 4.4

Inv. No. I 3940

Provenance: June 1796.

In a bill from Weitbrecht for gems by the Browns, presented 6 June 1796, this intaglio is valued at £120. The bill also provides a free retelling of an excerpt from Plutarch's *Lives:*

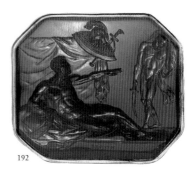
192

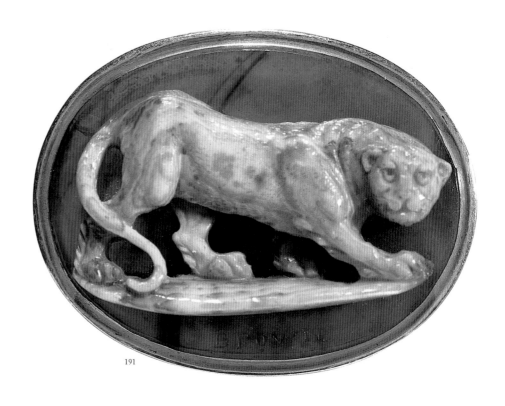
191

"Gaius Marius at the moment when a soldier is to kill him on the orders of Sulla; he is intimidated by the imposing air of the hero, who asks him – Do you known Marius?" In its Neoclassical composition, this intaglio clearly reveals the influence of French history painting of the 1780s, which the engraver may have seen in Paris during his short stay there in 1788. Y.K.

193
Cameo: Portrait of Prince Grigory Potemkin. 1787
George Heinrich König. Middle of the 18th century – after 1824

St Petersburg

Onyx-agate, gold. 2.8 × 2.4

Inv. No. K 5454

Provenance: 1787.

König trained in Vienna and arrived in St Petersburg in 1770. Although he travelled to London twice, spending several years there, he did his best work in the Russian capital. For Prince Potemkin he drew up plans for buildings, including the Tauride Palace, and worked at the glass manufactory; he taught "steel work" to Tula masters. Goldsmith, jeweller, sculptor, mosaicist, modeller in wax, he also proved to be an excellent engraver in metal and stone. At the court of Catherine II he acted as a chemist, developing different coloured glass pastes, enamels and smalts; together with Carl Leberecht he reproduced in glass paste all the engraved gems which the Russian Empress acquired. Although the literature usually states that König died in 1800, he was in fact still alive as late as 1824.

König made portraits of Potemkin in wax, marble, granite and cornelian and these were much prized by the Empress. The Prince is shown without a laurel wreath, repeating a full-size white marble relief presented by König to the Empress in November 1787, soon after her return from her journey to the Crimea. Portraits created after Potemkin's victory at Ochakov in 1788 show him wearing a laurel wreath. Y.K.

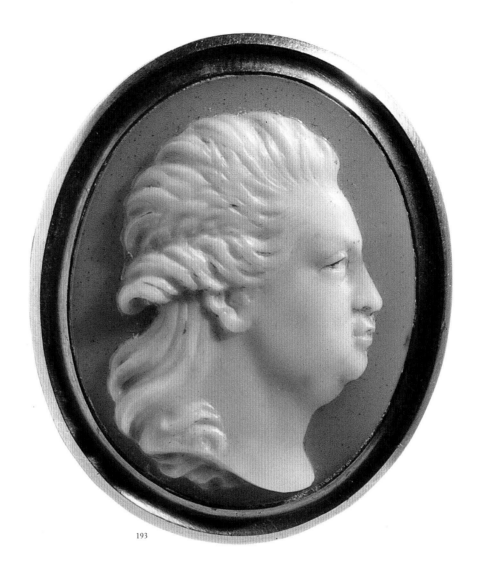

193

194
Cameo: Portrait of Alexander Lanskoy. 1785
Carl Leberecht. 1755-1827

St Petersburg

Signed: C.L.F.

Jasper, gold. 4 × 3.5

Inv. No. K 1807

Provenance: 1785.

Lanskoy became Catherine's favourite towards the end of 1779. She greatly valued his interest in history, literature and the fine arts, while they shared a burning passion for engraved gems. After Lanskoy's early death in 1784, Carl Leberecht was commissioned to produce a cameo portrait of him from a medal by Johann Balthasar Gass [Cats 82, 83]. It is engraved not in layered stone as it would appear: the pink jasper relief is applied to a darker jasper plaque. Y.K.

195
Cameo: Cupid with a Shield. c. 1787
Carl Leberecht. 1755-1827

St Petersburg

Signed bottom right: *ЛЕБЕРЕХТ* [Leberecht]

Chalcedonyx, gold. 2.7 × 3.8

Inv. No. K 1805

Provenance: 1787.

Cupid crouches down to look curiously at a depiction of the Gorgon Medusa on a shield lying on the ground. This shield belongs to Rinaldo, leader of the Crusaders, who has been overtaken by the witch Armida as he sleeps, and the scene is a precise reproduction of a fragment in the left part of Nicolas Poussin's *Rinaldo and Armida*. Like its pair, *Tancred and Erminia*, the canvas took its subject from Torquato Tasso's *Liberation of Jerusalem*, and was purchased by

Catherine in 1766 for her Hermitage (in 1930 *Rinaldo and Armida* was transferred to the Pushkin Museum of Fine Arts, Moscow).

In the Russian State History Archive is a document of 1787 recording the payment to Carl Leberecht of 800 gold roubles for this cameo. Leberecht was made a member of the St Petersburg Academy of Arts in 1794 and from 1800 he headed the engraving class in steel and hardstones. He was also an honorary member of the Berlin and Stockholm Academies. Y.K.

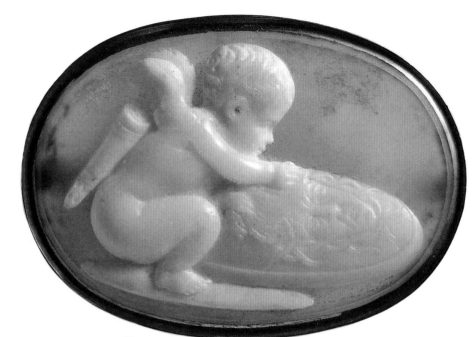

195

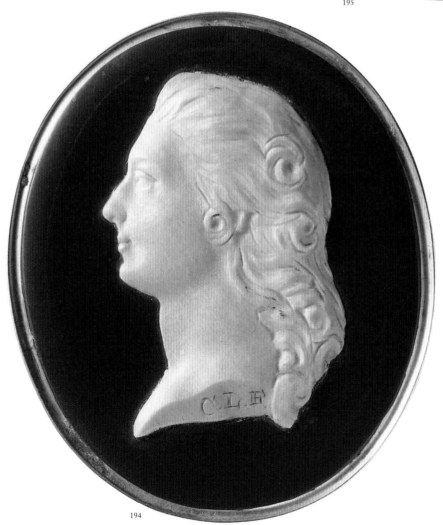

194

196

Cameo: Catherine II as Minerva. 1789
Grand Duchess Maria Fyodorovna.
1759-1828
St Petersburg
Signed and dated bottom: *MARIA F. 21 APR. 1789*
Jasper, gold. 6.7 × 4
Inv. No. K 1077
Provenance: 1789, presented by Maria Fyodorovna to Catherine.
(Illus. see p. 99)

Catherine's passed on her infectious love of engraved gems to those around her: "the learned and the ignorant – all have turned into antiquarians", she wrote to Prince Yusupov in 1788. Catherine encouraged her entourage in the engraving of gems, and this was one of the many artistic pastimes of Grand Duchess Maria Fyodorovna. Assisted in her studies by Carl Leberecht, she nonetheless, according to contemporaries, created her own gems (mostly cameos), independently.

This is the best of her works, engraved in 1789 in pinkish grey Siberian jasper. It shows Catherine wearing Minerva's helmet decorated with a winged sphinx and laurel wreath, and was produced for Catherine's name day. Immediately copies were made in biscuit porcelain, smalt glass, paste, plaster, as well as prints. The British engraver James Walker printed his version on

paper and satin in brown, red and black ink with a blue ground around the oval. Outside Russia, the work was mass produced by Wedgwood as cameo-like medallions in jasper ware and in the London workshop of James Tassie as medallions of white opaque glass.

The Grand Duchess also engraved cameo portraits of her husband, Grand Duke Paul (future Paul I) and their children. Y.K.

197
Pastes and Casts of Engraved Gems. 1780s
Workshop of James Tassie. London
Coloured and white glass, paper
Provenance: 1780s, purchased from James Tassie.

The manufactory of James Tassie (1735-99) produced portrait medallions as well as pastes and casts of engraved gems using a new technology invented by Tassie himself. Founded in London in 1766, its first printed catalogue, published in 1775, offered 3,106 different casts of gems from famous collections, no more than was usual for European workshops.

In 1781, however, Catherine learned of Tassie's manufactory and gave him a huge order for pastes. Thanks to her financial support, Tassie was able to expand his repertoire several times over and each of the works he made is now represented in the Hermitage in two modifications: as a paste in coloured glass, imitating the engraved gem itself, and as a white enamel-like cast.

The "Tassies" arrived in Russia between 1783 and 1788 in four lots, in special satinwood marquetry cabinets created for them by James Roach [Cat. 211]. Inside, the casts were arranged by subject and the whole was accompanied by a five-volume manuscript catalogue compiled by the German writer, learned numismatist and archaeologist Rudolf Erich Raspe – most famous as author of The Adventures of Baron Munchausen – then resident in England. This manuscript catalogue, the first two volumes in the hand of Raspe himself, is now in the Hermitage Archive. Later a full catalogue of the Tassie casts was published, with parallel English and French texts (R. E. Raspe: A Descriptive Catalogue of a General Collection of Ancient and Modern Engraved Gems, Cameos as well Intaglios, Taken from the Most Celebrated Cabinets in Europe; and Cast in Coloured Pastes, White Enamel, and Sulphur, by James Tassie, Modeller, London, 1791).

Of the 16,000 items (with pastes and casts of each item - 32,000 pieces in all) in the Hermitage's Tassie Cabinet, we are displaying a selection of 42 pastes and casts (in pairs), made from 21 cameos and intaglios. In a number of cases we can trace the present location of the original gems: Head of Serapis – Hermitage; Venus with an Eagle – Koninklijk Penningkabinet, Leiden; Alexander Placing Homer's 'Iliad' in a Casket – Medal Cabinet, Bibliothèque National, Paris; The Marriage of Cupid and Psyche by Tryphon – Museum of Fine Arts, Boston; Neptune on a Hippocampus – British Museum, London.

Raspe's catalogue has two numbers: the first (on the paper mounts) accords with the manuscript catalogue, the second with the more accessible publication of 1791. Y.K.

Reference for images overleaf

1. *Falcon Seated on a Solar Disk*
 Coloured paste. 3.9 x 3.3
 White paste. 4.1 x 3.4
 Raspe-Tassie 7/169

2. *Cylinder Seal with Hieroglyphics*
 Coloured paste. 4 x 2.6
 White paste. 3.9 x 2.4
 Raspe-Tassie 150/651

3. *Head of Isis*
 Coloured paste. 2.7 x 2.4
 White paste. 2.6 x 2.3
 Raspe-Tassie 45/258

4. *Atlanta with an Apple*
 Coloured paste. 4.3 x 3.1
 White paste. 3.8 x 2.7
 Raspe-Tassie 7713/8836

5. *Head of Jupiter*
 Coloured paste. 3.6 x 3.3
 White paste. 3.6 x 3.3
 Raspe-Tassie 239/902

6. *Head of Medusa*
 Coloured paste. 5.7 x 5
 White paste. 5.7 x 4.7
 Raspe-Tassie 3336/8989

7. *Head of Serapis*
 Coloured paste. 5.1 x 4.3
 White paste. 5 x 4
 Raspe-Tassie 416/1892

8. *Bust of Livia*
 Coloured paste. 4.7 x 4
 White paste. 4.6 x 3.9
 Raspe-Tassie 8130/11142

9. *Bust of Didius Julianus (?)*
 Coloured paste. 4.7 x 4.1
 White paste. 4.7 x 4.2
 Raspe-Tassie 12103/11963

10. *Venus with an Eagle*
 Coloured paste. 3.6 x 2.9
 White paste. 3.7 x 3.1
 Raspe-Tassie 358/1310

11. *Head of Medusa en face*
 Coloured paste. 7.6 x 9.2
 White paste. 7.8 x 9.2
 Raspe-Tassie 3296/8897

12. *Flora With a Basket of Flowers on her Head*
 Coloured paste. 4.4 x 3.1
 White paste. 4.3 x 4
 Raspe-Tassie 609/2017

13. *Alexander Putting Homer's Iliad in a Casket*
 Coloured paste. 4.7 x 4
 White paste. 4.6 x 4
 Raspe-Tassie 3663/9227

14. *Marriage of Cupid and Psyche*
 Coloured paste. 3.8 x 4.4
 White paste. 3.6 x 4.3
 Raspe-Tassie 11128/7199

15. *Victory in a Chariot*
 Coloured paste. 3.6 x 4
 White paste. 3.5 x 3.9
 Raspe-Tassie 7512/7796

16. *The Feat of Marcus Curtius*
 Coloured paste. 3.7 x 4.5
 White paste. 3.6 x 4.5
 Raspe-Tassie 4097/10621

17. *Neptune on a Hippocampus*
 Coloured paste. 5.1 x 4.1
 White paste. 4.9 x 3.9
 Raspe-Tassie 817/2570

18. *Portrait of an Unknown Man*
 Coloured paste. 3.4 x 3.1
 White paste. 2.8 x 2.4
 Raspe-Tassie 5892

19. *Bust of Athena en face*
 Coloured paste. 4.6 x 3.7
 White paste. 4.3 x 3.4
 Raspe-Tassie 462/1525

20. *Portrait of Mr MacDowal*
 Coloured paste. 2.8 x 2.4
 White paste. 3.1 x 2.5
 Raspe-Tassie 5747/14271

21. *Walking Bacchus*
 Coloured paste. 4.8 x 4
 White paste. 4.6 x 3.7
 Raspe-Tassie 13410/4292

4

5

8

9

12

15

16

20

21

Cameo Service.
1778-9

Sèvres Porcelain Manufactory
Soft porcelain, overglaze painting, gilding
Provenance: 1910, from the Winter Palace; 1782,
transferred from the Tauride Palace, residence
of Prince Potemkin; 1779, commissioned by
Catherine for Potemkin.

In the summer of 1778 Catherine wrote to Baron
Melchior Grimm of an angora cat which she had
been given by Prince Potemkin. "The cat of all cats",
as she described him, was a response in turn to
Catherine's commissioning of a service for
Potemkin at the Sèvres Manufactory. We do not
know the cost of the cat, but the service for 60
persons – 744 pieces made over two years – which
arrived in the summer of 1779 cost the Russian
Treasury 328,188 livres. The final payment of 81,000
livres was made in 1793, and saved the
manufacturers from ruin.

Nearly all the Sèvres employees were involved in
manufacturing this one service, with its rich
colouring of the kind possible only on soft
porcelain paste (porcelain without kaolin). Set
against the turquoise background are wine-
coloured cartouches, Catherine's monogram and
thick but restrained gilding. Although by the 1770s
Sèvres had achieved great success with soft paste,
the extensive use of new forms and rich decoration
in this service required numerous costly
experiments at all stages of its complicated
production.

Surviving drawings and sketches prove just how
much planning lay behind the decoration of this
dinner, dessert and coffee service, for which the
majority of forms were invented specially.

Increasing interest in Greek and Roman art in
general, and Catherine's own passion for engraved
gems in particular, led to the choice of the principal
decorative motif – imitation cameos, copied from
Antique originals. Taking the form of oval
cartouches or round medallions, they show scenes
from Greek and Roman history and mythology,
applied with stencils in a technique not previously
used at Sèvres. For large objects such as the wine-
coolers these "cameos" were produced separately,
using polished biscuit imitating agate or onyx, and
then set into hollows. With some 2,100 images on
the plates alone, the Cameo Service represents an
encyclopaedia of Antique art. A number of motifs
were taken from the decoration of the Theatre of
Marcellus in Rome, including the design for the
gilded frieze on each item.

In its combination of Neoclassical style and the
outgoing Rococo, of severe form and splendid
decoration, with its rich finish and details and its
grandiose surtout-de-table (executed in biscuit to a
design by Louis-Simon Boizot, it consisted of 38
groups arranged around a central "Russian Parnas"
with a bust of Catherine as Minerva), the Cameo
Service is one of the most unique and complete
porcelain ensembles ever produced.

During the fire which raged through the Winter
Palace in 1837, 160 of the 744 pieces were stolen, and
in 1856 the French Embassy in St Petersburg
reported finding over 100 pieces of Catherine II's
renowned service at Webb's in London. On the
orders of Alexander II, these were purchased and
returned to the Winter Palace, although six of the
best pieces were acquired by Lord Hertford and are
now in the Wallace Collection, London. Today the
Hermitage has 688 items from the service. J.V

198, 199
Two Flat Plates
Diameter 26; 26.2
Inv. Nos GCh 264, GCh 49

200, 201
Two Soup Plates
Diameter 26.3; 26.2
Inv. Nos GCh 337, 316

202
Four Part Dish
22.3 × 20
Inv. No. GCh 373

203
Oval Dish
27 × 21.3
Inv. No. GCh 357

204
Round Fruit Bowl
Diameter 21.1
Inv. No. GCh 368

205
Round Fruit Bowl
Diameter 21
Inv. No. GCh 370

206
Square Dish
25 × 25
Inv. No. GCh 361

207, 208
Two Wine Coolers
20 × 25; 20 × 25.6
Inv. Nos GCh 619, GCh 621

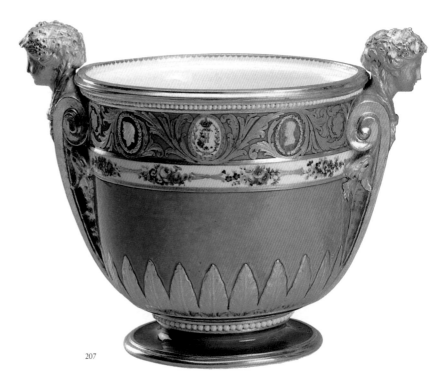

207

209

*Plaque: "Catherine II Rewarding Art and
Protecting Commerce"*

Wedgwood, England. Model attributed to John
Flaxman. c. 1785
Jasper ware. 41.8 × 31.6
Mark: *WEDGWOOD*
Inv. No. 23320
Provenance: 1926, from the Museum of the Stieglitz
School of Technical Drawing; previously collection of
Baron A. L. Steiglitz.

Catherine II was often portrayed – on a variety of
objects and in a variety of materials – as a
Russian Minerva (the Roman goddess
responsible for learning and intellectual
activity). Wedgwood took up the theme and
medallions with portraits of the Russian
Empress as Minerva are not uncommon (the
model entered the firm's repertoire in 1789). This
Hermitage jasper ware plaque, however, is
unique. Only one other version of the
composition *Catherine II Rewarding Art and
Protecting Commerce* is known, a rectangular black

basalt plaque in the Art Institute of Detroit
which has the title stamped on the back. In
publishing the Detroit plaque, the Wedgwood
scholars V. Harriman, R. Reilly and G. Savage
have attributed the model to the English sculptor
John Flaxman. Confirmation of such an
attribution is found in iconographical
similarities between the figure of Catherine as
Minerva in the Wedgwood plaques and Minerva
herself in drawings such as *Athena Throwing
Nausicae's Ball into the Sea* from the illustrations to
Homer's *Odyssey*, and *Minerva and the Winds* in
The Art Institute of Chicago.

The two-layer jasper ware technique used in
the Hermitage plaque, with white relief on a pale
blue ground, magnificently brings out both the
purity and complexity of the expressive
silhouette, capturing the refinement and
elegance of Classical gems. Architects and
designers employed Wedgwood plaques
inventively in many highly fashionable
Neoclassical interiors, making the image of the
Classical gem the keynote to artistic harmony.
Catherine II had a large ensemble of Wedgwood

plaques decorating her bedroom (designed by
Charles Cameron) in her summer palace at
Tsarskoye Selo, but this sadly perished during
the Second World War. L.L.

210

Cabinet for Engraved Gems. 1788-9

Neuwied, Germany. Workshop of David Roentgen
Oak and mahogany frame, mahogany veneer, with
gilded bronze and brass. 245 × 127 × 50
Inv. No. E 150
Provenance: 1789, purchased from David Roentgen,
Neuwied.
(Illus. see p. 97)

One of five cabinets specially made by the
renowned German cabinet-maker David
Roentgen (1743-1807) to store Catherine's
collection of engraved gems. Inside, all the
cabinets have four columns of flat drawers, 25 in
each column. Catherine mentioned two of the
cabinets in a letter to Grimm of December 1787,
and we know that the first pieces were

209

commissioned from Roentgen during his second visit to St Petersburg in 1786. Three similar cabinets were made under a contract of 11 February 1788, although it was thought for many years that they were imitations produced by a Russian master, Christian Meyer.

Their unusual appearance sets these cabinets apart from most of the master's work. Of particular interest is the lower part, a half-cupola decorated with cassone with round rosettes which finds no analogy in the remainder of Roentgen's furniture, and the device was clearly invented specifically for his work for the Russian Empress. The cabinet is richly decorated with bronze: arabesque ornaments on the doors,

profile medallions in the upper part and a bronze garland along the frieze. Documents published by C. Baulez (1996) allow us to suggest that the bronze decoration was by the French master Remond, and the models by Matin and Bureau, leading modellers and designers of arabesque ornament. Medallions showing Plato, Cicero, Socrates and Antiochus produced by Remond to decorate various bureaux (such as a bureau with Plato in the Hermitage) were also used to decorate the gem cabinets. We see profiles of Plato and Cicero in semi-circular niches in the upper part of the doors; similar medallions adorn the remaining four cabinets.

T.R.

211

Cabinet for Engraved Gems. 1783-90

London. Attributed to J. Roach

Oak, pine and fir frame, marquetry veneer with engraving of satinwood, maple, ebony and rosewood, bronze, white paste medallions imitating porcelain.

128 × 117 × 41

Inv. No. E 342

Provenance: no later than 1788, commissioned by Catherine II.

When Catherine ordered casts of engraved gems from James Tassie [Cat. 197] in 1781, the commission stated that "the collection must be placed in suitable cabinet-cupboards."

211

Both collection and cabinets arrived in several lots between 1783 and 1788. Raspe, author of the catalogue of the collection, tells us that they were made to designs by the English architect James Wyatt, who worked in the style of Robert Adam, applying Neoclassical principles to architecture and interior design. J. M. Robinson, author of a major study of Wyatt, cites information that Catherine II ordered the Russian ambassador in London to offer Wyatt any fee he wished to agree to be her court architect in St Petersburg. Wyatt never came to St Petersburg, but he did design these cabinets for Catherine.

One of the Hermitage cabinets (Inv. No. E 58) bears a plaque with the text "Cabinet Maker Roach", on the basis of which all are attributed to this master, of whom, unfortunately, almost nothing is known. Roach is mentioned by English scholars only as the author of these cabinets for Catherine II.

Thirteen cupboards of varying form and dimensions are directly linked to Catherine's own commission. The cabinet on display here does not form part of this series, differing in its more elegant proportions and the marquetry ornament on the doors, but great similarities in construction and the use of white oval medallions after Tassie casts strongly indicate a link with Roach and Wyatt. Yulia Kagan suggests that the cupboard was commissioned by Catherine when she placed an order for a second, smaller set of Tassies for presentation to Alexander Lanskoy. It would then have returned along with his other property to the Empress. T.R.

212

Portrait of Alexander Lanskoy. Late 1783 – early 1784
Unknown Artist

Oil on canvas. 84 × 66.5
Inv. No. ERZh 92
Provenance: 1941, from the Museum of Ethnography; until 1924 (or 1927) in the Department for the Protection of Art and Antiquities, Petrograd.
(Illus. see p. 95)

Alexander Dmitriyevich Lanskoy (1758-84), favourite of the Empress Catherine, was the son of a poor Smolensk landowner and Commander of Polotsk. He joined the army in 1772, moving to the Horse Guards in 1776. It was

in 1779, whilst serving as adjutant to Prince Grigory Potemkin, that he was presented at court and appointed Catherine's aide-de-camp, becoming her favourite. From 1780 he was Chamberlain and Major-General, from 1784 Lieutenant-General, then Adjutant-General and Lieutenant of the Horse Guards' Corps. Shortly before he died in June 1784 from "a malevolent fever" he returned to the state treasury all property presented to him by the Empress.

To contemporaries he was "an angel on earth, for he did not seek to bring harm to others" and indeed Lanskoy rejected court intrigues in favour of such pastimes as studying literature and history under the guidance of the Empress, and collecting works of art. "He was my pupil," wrote Catherine to Grimm on 2 July 1784, "grateful, mild and diligent, sharing my disappointments when they came, and joyful in my joys". Catherine was much affected by his death and ordered the erection of a Church dedicated to the Virgin of Kazan over his tomb.

Lanskoy is shown wearing the uniform of a major-general of the cavalry, with the aiguillette of an aide-de-camp on his right shoulder, and the Orders of Alexander Nevsky and St Anne (both awarded to him in 1783). In its iconography, this portrait recalls Dmitry Levitsky's painting of 1782 (Russian Museum, St Petersburg) but judging by the uniform and the Orders the sitter wears it was painted no earlier than 1783, and no later than February 1784. I.K., S.L.

213

Charles James Fox. 1791
Joseph Nollekens. 1737–1823

On the back: *Nollekens F.t London 1791*
Marble. Height 56
Inv. No. N.Sk. 13
Provenance: 1791, acquired for the Hermitage at Catherine II's request.

Charles James Fox (1749–1806), British Member of Parliament from 1768, statesman and renowned orator. Member and subsequently leader of the Whig Party.

During the second Russo-Turkish War, Russia occupied the Black Sea coast from the Dnieper to the Danube as well as the strategically important Ochakov Fortress. England and Prussia, worried by Russia's successes, demanded that all Russian conquests be

returned to the Ottoman Empire, threatening Russia with war if she refused, and the British fleet made ready to depart for the Baltic Sea. It was Fox's speeches in Parliament, coupled with active Russian propaganda in Britain, which forced the government to rethink the planned armed intervention.

In recognition of Fox's assistance in this crisis, Catherine II ordered the acquisition of his portrait in London. Nollekens had only recently completed this marble bust, originally intended for Earl Fitzwilliam, but on learning of the Empress's passionate desire to possess a portrait of Fox immediately, the Earl agreed to forego his own version. It was delivered to St Petersburg in early September 1791 and placed in the Hermitage. Catherine II caused a bronze copy of it to be made, and this was set amidst the busts of eminent people of antiquity in the colonnade of her beloved Cameron Gallery at Tsarskoye Selo. Catherine's acquisition of the portrait of Fox caused something of a stir in British political circles, which was reflected in a large number of caricatures in the early 1790s.

Fox, however, fell in the Empress's estimation when he supported the French Revolution: the bronze bust was then removed from the Cameron Gallery. Y.I.K.

213

A Passion for
Antiquities

"The most perfect Beauty..."

ANNA TROFIMOVA,
VALERY SHCHEVCHENKO

Bust of Lucius Verus
[Cat. 219]

Johann Winckelmann applied these words to one particular Ancient bust of Athena,[1] but it can aptly be used to describe contemporaries' attitude to Antique monuments, so avidly collected by wealthy Europeans in the 18th century. Catherine II was no exception: she corresponded with leading Europeans writers and philosophers, men acquainted with the ideas of Winckelmann and Anton Raphael Mengs, with translations of Vitruvius. Moreover, she set out to build an "Antique palace" in St Petersburg, filled with original Antique works.

Catherine bought wholesale quantities of albums of prints and drawings with views of Graeco-Roman structures ("I am passionately interested in books on architecture; they fill my room, but even that is not enough for me," she wrote to Melchior Grimm in August 1776), including numerous gouaches by Charles-Louis Clérisseau. The story of her complicated relations with Clérisseau is a fascinating one, documented in detail in her correspondence with Grimm and presenting a mine of information about the Empress's attitude to collecting. We learn, for instance, that Catherine's drawings formed part of her personal collection and were kept in the library, often lying unsorted after their acquisition until she should find time to look them over. She appointed viewing sessions for groups of works, which were often used to decorate the walls of palace apartments: "Clérisseau's pictures have come in very handy, for I use these drawings to decorate my boudoir in Petersburg," she wrote. The collection was also put to the use of two leading architects working in Russia, both described by Catherine as "great admirers of Clérisseau": Giacomo Quarenghi and Charles Cameron (whose designs in turn form today an important part of the Hermitage collection).

Cameron had made a careful study of Antique monuments in Italy, and it was he who realised Catherine's dream of an "Antique palace", building the Baths at her summer residence in Tsarskoye Selo. His open arched Gallery, standing high above the park, was decorated around the perimeter with copies and casts of Antique busts, while in a nearby grotto stood a whole collection of Classical sculptures acquired in England from John Lyde Brown.

We first find reference to Catherine's desire to compile a collection of antiquities in the mid-1760s. Maruzzi, Catherine's Russian diplomatic agent, reported back that "as regards ancient statues, only in Rome can one find anything worthy of H.I.H. [Her Imperial Highness] but export from there is forbidden under threat of the severest punishment. There have been several incidences whereby some royal courts managed to receive papal permission to export after

Portrait of an Elderly Roman
[Cat. 220]

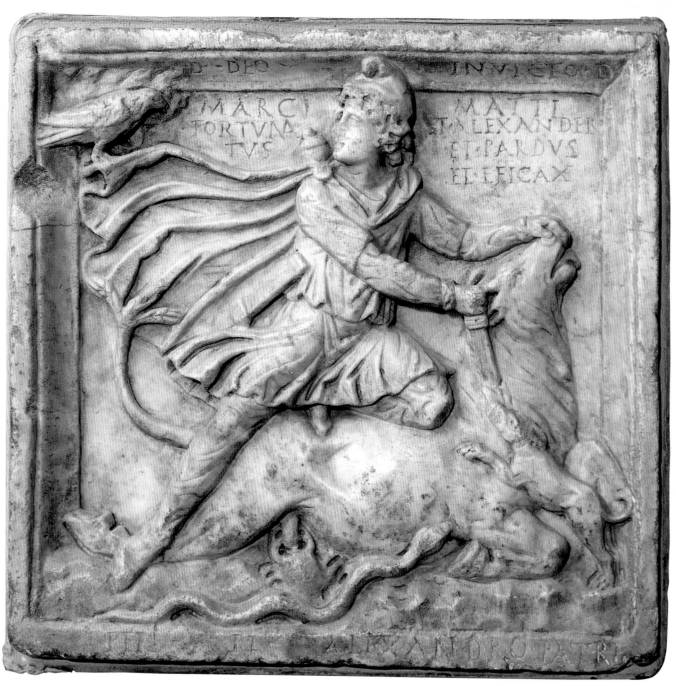

Relief: *Mithras Slaying the Bull*
[Cat. 215]

conclusion of a sale." Maruzzi failed to buy any works, thanks to the ban on exports of antiquities from Rome and to some very strong competition from other would-be purchasers. In response to the agent's enquiries, "a cavalier, with a good understanding of painting and sculpture" replied: "I can only repeat to you again the impossibility of acquiring Antique statues and marble bas-reliefs. It would be possible only to have very mediocre pieces, as the rare objects are in the Capitoline and in the houses of the nobility, who do not sell them, and if they should wish to part with them, the Pope himself is always ready to purchase them in order to increase his own collection in the Capitoline."[2]

Charles-Louis Clérisseau: *Architectural Fantasy with Bathers* [Cat. 227]

Considerable success, however, was achieved by Ivan Shuvalov, statesman, patron and founder of the Academy of Arts, who in 1767 settled in Rome, where he actively collected Antique objects for both himself and Catherine, also carrying out commissions for the Academy. Shuvalov received papal permission both to export antiquities and to take casts from Antique sculptures, and in 1769 plaster forms were made from famous originals in the Capitoline, the Vatican Belvedere, the Palazzo Farnese, the Villa Medici and the Villa Ludovisi, and from collections in Florence. Back in St Petersburg, casts were made of them for the Academy of Arts, and in the 1780s bronze casts were made for Catherine's residence at Tsarskoye Selo.

Archive documents record the arrival of Antique originals in the capital in 1769: Ivan Shuvalov had acquired in Cività Vecchia 25 Antique statues, busts, heads and bas-reliefs, seven new marble copies from the Antique, and a number of stone vases.[3] According to the invoices, the antiquities cost 32,736 écus, the greater part paid by the Cabinet, i.e. by order of Catherine herself. But when they arrived in St Petersburg, the works were largely forgotten, spending seven years stored away in the Academy of Arts, until they were at last moved in 1786.[4] Acquisition of Antique marbles seems to have continued into the 1770s, for we know that Shuvalov sent Catherine another group in 1779.[5]

Charles-Louis Clérisseau: *Temple of Bacchus in the Palace of Diocletian in Dalmatia* [Cat. 236]

Compared to Catherine's acquisitions of engraved gems and of paintings for her Picture Gallery, her purchases of Antique sculpture appear very modest. In Russia, Antique statues were still not truly perceived as collectable objects and served mainly as decoration in parks and palaces. By the time Catherine took the Russian throne, however, the fashion for antiquities which engulfed all Europe from the 1730s onwards had reached its height: Antique sculpture was being acquired by Gustav III of Sweden, by the Prussian King Frederick II, by the Spanish, French and Polish royal courts, while in Rome itself the major collections of Antique sculpture – the Capitoline Museum and the collection of Cardinal Albani – also took shape over the course of the 18th century. In private collecting the English led the way: Antique sculptures flowed apace into English palaces and in the 1740s and 1750s alone the largest and most important English aristocratic collections were formed: those of the Marquess of Landsdowne, Charles Townley and Lyde Brown, and those at Marbury Hall, Ince Blundell Hall and Petworth House.

English antiquarians were in close contact with the Roman artistic elite, with Winckelmann and Mengs, with the engraver Giovanni Battista Piranesi and the restorer Bartolomeo Cavaceppi. Not surprisingly, two British artists and collectors, Gavin Hamilton and Thomas Jenkins, played a decisive role in forming Catherine's collection of Antique sculpture. They had arrived in Rome as history painters, although Jenkins soon switched to banking, being appointed British Consul in Rome in the 1770s. Trading in antiquities, Hamilton and Jenkins became the main suppliers to the papal court. Hamilton even organised a series of excavations himself in his search for new sculptures, compiling a catalogue of Antique marbles found at Hadrian's Villa, and recording the names of their purchasers. According to Dallaway, who published part of this catalogue, Shuvalov acquired three Antique pieces from Hamilton: a head of Antinous, a head of a Sabine woman, and a life-size bust of a youth.[6]

Shuvalov also purchased five Antique pieces from Cavaceppi, a talented restorer and imitator of Antique sculptures whose catalogue of monuments which passed through his hands includes reproductions of busts now in the Hermitage.[7]

In the 1780s, Catherine – with typical decisiveness – took steps to bring her collection of antiquities onto a par with the main European collections. She seems not merely to have been influenced by European fashion, but driven by a personal passion, partly linked with the Neoclassical building works under way at Tsarskoye Selo. It was to Tsarskoye Selo that in 1785 she sent Shuvalov's collection of Antiquities, bought for 24,440 roubles. In choosing sculptures, the Empress sought to invite comparison between her own achievements and those of the heroes of Antiquity.

Her next important acquisition, in 1785-7, was an outstanding monument to the golden age of British amateur collecting: the sculpture collection of John Lyde Browne, a director of the Bank of England. Dallaway described Catherine's purchase,[8] thanks to which we know that the sale was concluded and the works delivered through the offices of a St Petersburg merchant, Ständer, and that one of the masterpieces, a portrait of Lucius Verus, had been purchased from Jenkins. Dallaway also states that Catherine paid £23,000 for the collection, of which the owner received only £10,000, as the intermediary went bankrupt. Lyde Brown himself died in 1787, shortly after the sale.

Lyde Browne's collection was already renowned in the 18th century and its owner – a member of the London Society of Antiquaries, and from 1780 a member of the Society of Dilettanti – was known to contemporaries as the "virtuoso". He began collecting in the 1740s, and by 1779 he had 236 sculptures,[9] most of them acquired via Hamilton and Jenkins from old family collections (Barberini, Massimi, Verospi, Albani and Giustiniani) in Rome, as well as some from Hamilton's excavations at Hadrian's Villa. The sculptures were kept at Lyde Brown's country residence at Wimbledon.

Two catalogues were published during his lifetime,[10] manuscript copies of which were discovered in the mid-19th century by the first Director of the Hermitage, Stepan Gedeonov. A comparison with old Hermitage inventories has enabled scholars to identify the nucleus of the Lyde Browne collection. Further identification was made possible by the drawings of Jenkins, who sent records of monuments and archaeological finds to the Society of Antiquaries, and others by Giovanni Cipriani (British Museum), probably intended for a third publication of the catalogue.[11]

In composition and state of conservation, the Lyde Brown collection was typical of the 18th century, although on a far more impressive scale and of much higher quality than other British collections. Portraits, then the most prestigious Antique sculptures, occupied a key place; many of the Lyde Brown portraits are even today central to the Hermitage collection – amongst them busts of Philip the Arab, Lucius Verus, Salonin and Tiberius. But Lyde Brown also acquired new works created by Cavaceppi, such as the bust of Faustina the Elder and a basalt portrait of Agrippina. Cavaceppi's workshop would seem to have been responsible for the restoration of a statue of Heracles, whereby the head of a hellenistic work was placed on a torso from the classical era. (Such composite sculptures were typical of Cavaceppi, who always sought to please the client: Jenkins reported Cavaceppi's annoyance at the English virtuosi, who saw no value in headless statues, while Lord Tavistock would not give even one guinea for the most marvellous torso ever found.[12]) Lyde Brown's collection was complemented by urns and altars from the Giustiniani collection, from the Villa Mattei and the Villa Negroni, as well as vast 18th-century marble vases copying the famous Medici and Borghese vases.

On their arrival in Russia, the sculptures were housed in the Grotto (Morning Hall) at Tsarskoye Selo. Various descriptions of its appearance survive today: in 1788 an *Inventory of Bronze and Marble Statues* there was compiled and in 1793 the Tsarskoye Selo museum was described by Koehler.[13] Johann Georgi wrote in his description of St Petersburg (1794): "Nearby the arcade, in a separately built single-storey stone house, is a gallery of statues. This truly imperial cabinet contains numerous rare and marvellous statues, busts, vases, vessels, instruments, tombstones, inscriptions and other antiquities and tasteful works by the Egyptians, Etruscans, Greeks, Romans etc."[14] Filled with outstanding examples of Antique works, the Grotto was Russia's first museum of Antique sculpture, a prototype for the sculpture galleries at country palaces at Pavlovsk and Gatchina, at the Mikhail Castle and the New Hermitage.

During the reign of Catherine's son Paul, most of the sculpture was removed to Pavlovsk and to the Tauride Palace, where it remained until 1850. But with the opening of the Imperial Hermitage Public Museum in 1852, the best pieces came into the Antiquities Department, and were set into interiors specially designed by Leo von Klenze.

NOTES

1 J. Winckelmann: *Opere*, Prato, 1832, vol. 10, p. 125. The bust was acquired by Catherine with the Lyde Brown collection and is now in the Hermitage.

2 Levinson-Lessing 1986, pp. 93, 268.

3 P. N. Petrov: *Sbornik materialov dlya istorii Imperatorskoy Sanktpeterburgskoy Akademii khudozhestv* [Anthology of Material for the History of the Imperial St Petersburg Academy of Arts], St Petersburg, 1864, vol. 1, pp. 727-30.

4 State Historical Archive, Moscow, Fund 789, *opis* 1, *chast* 1, *delo* 367, f. 70.

5 SbRIO vol. XLIV 1885, p. 35.

6 J. Dallaway: *Anecdotes of the Arts in England*, London, 1800, p. 369.

7 B. Cavaceppi: *Raccòlta d'antiche statue, busti, bassirelievi ed altre sculture, restaurate da Bartolomeo Cavaceppi*, 3 vols, Rome, 1768-72.

8 Dallaway: *Op. cit.*, p. 389.

9 See: O. Ya. Neverov: "Kollektsiya Layda Brouna" [The Lyde Browne Collection], *Trudy Gosudarstvennogo Ermitazha* [Papers of the Hermitage Museum], XXIV, Leningrad, 1984; O. Neverov: "The Lyde Brown Collection and the History of Ancient Sculpture in the Hermitage Museum", *American Journal of Archaeology*, vol. 88 (1), 1984, pp. 33-42.

10 *Catalogus veteris aevi varii generis monumentorum quae Cimelliarchio Lyde Browne arm. ant. soc. soc. apud Wimbledon asservantur*, 1768; *Catalogo dei piu Scelti e Preciosi Marmi che si conservano nella Galleria del Sigr Lyde Browne Cavaliere Inglese a Wimbledon, nella contea di Surry*, London, 1779.

11 See note 9.

12 *Bartolomeo Cavaceppi. Eighteenth-Century Restorations of Ancient Marble Sculpture from English Private Collections*, catalogue and introduction by Carlos A. Picon, London, 1983, p. 11.

13 H. K. E. Koehler: *Gesammelte Schriften*, Band VI, St Petersburg, 1853.

14 Georgi 1794, p. 499 (para 788 in French and German editions).

Classical Sculpture

214
Relief: Three Nymphs. 1st century AD

Roman

Inscription: *Folia. Herois. Nymphis. / Nitrodiaes. D.D. Curavit. M.V.D. / Diomedes*

Marble. 43 × 41

Inv. No. A 34

Provenance: 1787, collection of John Lyde Brown, Wimbledon.

An important work in Catherine's collection, this piece was found on the island of Ischia near Naples. A small collection of similar reliefs, most showing Apollo and three nymphs with vessels, is in the Museo Archeologico Nazionale, Naples.

They are devoted to the Nitrodiae Nymphs, whose cult was linked with the thermal springs on the island (their healing properties were mentioned by Pliny and Ovid).

No figure of Apollo appears on the Hermitage relief, while the nymphs are half-naked, their hair arranged in complex hellenistic styles tied with a bow. The middle nymph holds a shell, those to the sides rest on hydras on low pedestals, with water flowing from the vessels. Low pylons indicate that the relief once adorned a fountain and indeed the image of the nymph with a shell was common on fountains. This figure is not a Roman copy of a Greek original as has traditionally been thought, but possibly represents the conflation of depictions of nymphs with the anthropomorphical figures holding a bowl of water for purification which stood at the entrance to Greek temples and holy sites. A.K.

215
Relief: Mithras Slaying the Bull. 2nd century AD

Roman

Inscription: *Deo. Invicto. D / Marci / Matti / Fortuna / tus / Et. Alexander / Et. Pardus / Et. Eficax / Per Fl. Alexandro. Patre*

Marble. 37 × 39

Inv. No. A 33

Provenance: 1787, collection of John Lyde Brown, Wimbledon; heirs of Cardinal Valenti, papal secretary; in the 16th century in the house of Andrea Cinquina, Rome.

(Illus. see p. 136)

Mithras, the Indo-Persian sun god, wears oriental attire (trousers, a long waisted tunic and narrow sleeves, a phrygian hat and short boots). Thrusting his sword into the bull's throat, he is a symbol of the eternal battle between Good and Evil and the victory of heavenly forces over earthly ones. This is one of numerous such images devoted to Mithras, all of which feature dogs and snakes and the drinking of blood from the wound in the speared bull (symbolising fertility and nature's nutritious force). A scorpion clasps tightly onto the bull's genitals, although its tail is not raised, i.e. it is not biting, indicating an astrological significance (the opposition of the star signs Scorpio and Taurus).

The cult of Mithras was from the 1st century BC assimilated into the cult of Helios and Apollo, becoming widespread throughout the Roman Empire. It was particularly popular amongst soldiers as a symbol of force and masculinity (women were excluded from taking part in Mithraic rituals).

A drawing by Pirro Ligorio confirms that the relief was already known in the 16th century, when it was in the house of Andrea Cinquina. A.K.

216
Portrait of a Child with Beads on its Head. Mid-1st century AD

Roman

Small-grain Carrara marble. Height 38 (head 18)

Inv. No. A 79

Provenance: 1787, collection of John Lyde Brown, Wimbledon.

Head of a (?female) child of six or seven, the soft, ornamental locks treated as in portraits of women and girls of the time of the Julio-Claudians. Jewellery on the heads of children is often seen in hellenistic and Roman sculpture

214

216

217

Bust of Julia, Daughter of Titus. Last quarter of the 1st century AD

Roman

Marble. Height 40 (head 18)

Inv. No. A. 119

Provenance: 1850, from Tsarskoye Selo; 1787, collection of John Lyde Brown, Wimbledon.

The portrait has been variously identified as showing Julia, daughter of the Emperor Titus, or an unknown Roman woman of the 80s AD. No proven sculptural portrait of Julia or Domitia Longina – Roman women from the imperial Flavian family – has survived which repeats fully the documented images of Julia on coins. It is therefore often difficult to differentiate between their official portraits and portraits of other Roman women which include elements of the same iconography.

A portrait of Julia in the Museo Nazionale Romano is closest to the image on coins. The Hermitage head repeats the broad, full face and the large bulging eyes but differs strongly in details – the narrow brow, small almond-shaped eyes, and small mouth. Although the hair is typical for portraits of Julia in the 80s, it lacks the important diadem seen from the time she received the title "Augusta". We cannot exclude, therefore, that this work shows a noble Roman woman and merely imitates official portraits of the imperial family.

Second daughter of Titus, Julia was born in 63. Official portraits were made of her, and her portrait was chased on coins with Titus. Domitian, Titus's heir, treated Julia as Empress although he had an official wife. Statues of Julia were erected in Rome and in the provinces and coins continued to be minted with her portrait. A.T.

but although most scholars recognise its religious and ritual nature they interpret its significance differently. Undoubtedly, the attribute derives from Greek religious rites, which became widespread in Rome and in numerous provinces. Statuettes of children with jewellery or plaits on their forehead are found as far apart as Egypt, Sicily, Africa, Fasos and Britain; in Italy they have been found at Ostia and Rome. It has been suggested that the jewellery was worn as an amulet to protect the child from evil forces, or that children devoted to particular gods wore them. There has also been detailed discussion of a ritual specifically for minors, by which they dedicated to a god a lock of hair on their forehead. Certainly, both locks of hair and jewellery on the forehead of children seem in all cases to have been linked to the cult of one of the gods. A.T.

217

218

Bust of Artemis. *Second quarter of the 2nd century*

Roman

Marble. 41

Inv. No. A 107

Provenance: 1850, from Tsarskoye Selo; 1787, collection of John Lyde Brown, Wimbledon.

Once part of a statuette, the head was reset onto another bust, a manner of assembling fragments from different sculptures common to 18th-century Italian restorers.

There is a whole group of such archaistic female heads and judging by the numerous copies, each with only slight variations in the hair and the form of the diadem, there was a common prototype, possibly a Roman work of the 1st century BC. This in turn may have been based on a Greek archaic (6th-5th century BC) statuette of Artemis in wood, bronze or gold and ivory: scholars suggest that the Roman copies show signs of being taken from a model in such materials. Surviving statuettes of Artemis indicate the figure would have been robed in a chiton and peplos, holding one of a number of attributes – a bow, arrows, flowers or small figures of animals. A.T.

219

Bust of Lucius Verus. *Third quarter of the 2nd century*

Roman

Small-grain marble. Height 48 (head 27)

Inv. No. A 316

Provenance: 1787, collection of John Lyde Brown, Wimbledon.

(Illus see p. 134)

One of the finest portrait busts in the Hermitage collection, revealing the skill in conveying texture and the illusionism characteristic of sculpture during the rule of the Antonines, this bust shows Lucius Verus in his youth. Not of the widespread type of Lucius Verus (over 90 known replicas), it finds analogy in a similar work in the Vatican, dated to around 155 AD.

The original for statues of the young Lucius Verus may have been created to mark his elevation to the rank of Consul in 154. Born in 130, in 138 he was adopted by Antoninus Pius. Nine years younger than Marcus Aurelius, direct heir to Antoninus, he was less honoured than his adopted brother and there are few portraits of him as a child or youth. In 161, however, he became co-ruler with Marcus Aurelius and from this moment many official portraits appeared. Unlike portraits of Marcus Aurelius, however, those of Lucius Verus are not philosophical or bombastic, but reveal a desire for external effects, and for the elegance of the time of Hadrian. The luxurious locks and soft skin recall Antinous – Hadrian's favourite and the embodiment of youthful beauty. Suetonius noted that Lucius Verus scattered gold dust in his pale hair, recalling the golden hair of the heroes of the Iliad. A.T.

218

220

Portrait of an Elderly Roman. Second quarter of the 3rd century

Roman

Marble. Height 35 (head 26)

Inv. No. A 2

Provenance: purchased from Bartolomeo Cavaceppi, Rome.

(Illus see p. 135)

This head can easily be identified from Cavaceppi's catalogue of restored sculpture, which records: "Unknown Head. Now in Petersburg." Cavaceppi added missing fragments and reinforced the head. According to 18th-century practice, he overcleaned the surface by mechanical means, and we have totally lost the Antique finish, while the modelling of the face and hair has suffered severely.

A bust at Castle Howard, originally thought to show either Antoninus Pius or an unknown Roman of the time of Gordian Pius, is of similar facial type. Later it was identified as Gordian the Elder for its likeness to a statue of Gordian the Younger in the Palazzo dei Conservatori. Scholars have suggested it is a copy of a famous statue of Gordian. Nonetheless, the sitter's age, the individuality and drama of this portrait, suggest that it shows a private individual, for official portraits of rulers had to accord to a stricter canon. A.T.

221

Bust of a Boy. Mid-3rd century AD

Roman

Marble. Height 42 (head 26)

Inv. No. A 319

Provenance: 1787, collection of John Lyde Brown, Wimbledon.

This elongated bust is typical of the middle of the 3rd century, while the hairstyle is characteristic of Roman portraits during the reign of Gallienus. Related to a series of portraits of children of that era, its execution and iconographical type reveal the orientation towards monuments of the Julio-Claudian era found in art under Gallienus (from 253 co-ruler with Valerian; sole emperor 260-8). It was at that time official policy to make imperial portraits recall the art of a period of stability and prosperity, of great military campaigns: initially portraits of Gallienus recall the iconography of

Octavian Augustus, later that of Alexander the Great. Depictions of children from the imperial family were also intended to confirm the dynasty's legitimacy and longevity: they too accentuated family features and official style.

Here we see a young ruler (or son of a ruler) of the time of Gallienus, in style and feature related to images of Gallienus's family. There are no known analogies for the portrait; those closest to it are identified as Gordian (138-44), Alexander Severus (222-35) and Salonin (258-9; son of Gallienus). This portrait probably shows Salonin. Since the boy is naked we might suggest that this is a posthumous heroicised image. A.T.

222

Bust of Athena. Late 16th – early 17th century

Italy

Small-grain marble, bust of Oriental alabaster.

Height 39

Inv. No. A 61

Provenance: 1859, from the Tauride Palace; 1787, collection of John Lyde Brown, Wimbledon; previously collection of Cardinal Albani.

The catalogue of the Lyde Browne collection notes that this piece came from the Villa Albani. Restored whilst in the collection of Cardinal Albani, the female marble head was set on an

221

alabaster bust to make it a pendant to a portrait of Commodus (also Lyde Brown collection; Hermitage). Both pieces are interesting examples of 17th to 18th-century restoration, illustrating a purely decorative approach to sculptural reconstruction. The busts were deliberately selected for their size and the turn of their heads and they seem to have been specifically restored for placement on a console or mantelpiece.

The top hair is barely worked up and the statue possibly once wore a helmet. Scholars have considered the head of Athena to be Antique but today it seems that, like the portrait of Commodus, the head is in fact an imitation. The unnatural bend of the neck, the elongated proportions and Mannerist forms indicate the work of an Italian sculptor of the late 16th or early 17th century. A.T.

223
Column. 18th century
Italy
Marble. Height 102
Inv. No. A 42
Provenance: 1787, collection of John Lyde Brown, Wimbledon.

An extremely decorative work in which only the middle of the column is fluted, while the upper and lower parts are richly ornamented with vegetable patterns, including palmettes, acanthus leaves and flowers. Such a column may have served as a pedestal for an urn or small bust. A.K.

223

Charles-Louis Clérisseau. 1721-1820

After winning the Grand Prix d'Architecture in 1746, Clérisseau set off for Italy, where he remained for a number of years studying Ancient monuments in and around Rome. A chance acquaintance with Robert Adam led to employment as the architect's tutor in antiquities and to collaboration on Adam's various projects in Italy. Numerous drawings from life made during his travels were used back in France as a source for endless compositions which moved increasingly further away from the depiction of specific monuments to the creation of *capricci*, finally arriving at a kind of universal "ruin in itself". He gained great fame for his finished large format gouaches composed of various combinations of his favourite elements. These were produced specifically for sale as independent works,

It was Falconet who told Catherine of Clérisseau when she was seeking an architect for her Roman palace, and in 1773 she commissioned a series of drawings from him. Clérisseau enraged her by sending a vast quantity of drawings and a huge bill. Nonetheless, she eventually purchased over 1,000 drawings, some of which were on display in her rooms.

November 2000 - March 2001

224
Arch of Titus in Rome

Signed bottom left in pen and brown ink: *Clerisseau 1781*
Gouache, pen and brown ink on paper; border in black ink. 60.9 × 47.5
Inv. No. OR 16925
Provenance: 1924, transferred from the Winter Palace; 1781, acquired from the author by Catherine II.

Elements and forms from this arch, erected in 81 AD in honour of the taking of Jerusalem by the Emperor Titus Flavius Vespasian, recur more frequently than any other in Clérisseau's work (17 times in Hermitage works alone). His careful studies of the arch led to its appearance in various contexts: as a background for initials on the title pages of albums of his works, as an independent monument or sometimes simply as part of a general architectural setting. He returned to interpretations of the arch in later years, creating striking large gouaches for the art market, such as a composition showing the Arch of Titus with numerous figures on foot and horseback, now in the Sir John Soane Museum.

This gouache, produced in 1781, employs the restrained colour scheme of the works created specifically for Catherine the Great. V.S.

225
Arch of Constantine in Rome

Signed bottom left in pen and brown ink: *Clerisseau 1781*
Gouache, pen and brown ink on paper; border in black ink. 61 × 36.8
Inv. No. OR 16916
Provenance: 1924, transferred from the Winter Palace; 1781, acquired from the author by Catherine II.

Another of Clérisseau's favourite motifs in Rome was the Arch of Constantine. This gouache is one of a series of early views of Roman monuments which the 60-year-old master went on to rework between 1781 and 1784 for Catherine II. It was clearly produced in two

224

phases: first the Arch was depicted in Clérisseau's usual style and given the then fashionable broad black border; some time later, having been informed by Baron Grimm of Catherine's great admiration of his pictures, Clérisseau saw fit to please the Empress with "new" works ostensibly produced specially for her, in fact large quantities of reworked early sheets, as here.

Some stylistic features in the "ruins" which Clérisseau sent Catherine between 1781 and 1784 suggest that he employed assistants. V.S.

226

Architectural Fantasy with A Traveller

Signed bottom left in pen and brown ink: *Clerisseau 1781*
Gouache, pen and brown ink on paper; border in black ink. 61 × 47.3
Inv. No. OR 16924
Provenance: 1924, transferred from the Winter Palace; 1781, acquired from the author by Catherine II.

Clérisseau's gouaches clearly reveal the experience of a 60-year-old master, fully aware of both his strengths and his weaknesses. He used scattered fragments of marble and half-destroyed cornices cutting across the picture to cover any errors in perspective or proportion, while imprecise illumination allowed him to place highlights where he wished: the angle at which the sun falls is different everywhere, and shadows can be made to disappear where the artist has no need of them. A soft combination of cold and warm earthy ochre-green creates the illusion of weathered and faded stones which have lost their original sharpness. A landscape with some distant building enveloped in a haze is visible through the colonnade – a feature from the mature artist's arsenal of favoured devices. V.S.

226

227

Architectural Fantasy with Bathers

Signed bottom left in pen and brown ink: *Clerisseau 1781*
Gouache, pen and brown ink on paper; border in black ink. 61 × 47.1
Inv. No. OR 16923
Provenance: 1924, transferred from the Winter Palace; 1781, acquired from the author by Catherine II.
(Illus. see p. 137)

One of those works which elicited high praise from Catherine II, this gouache hung for many years under glass on the wall of her apartments.

Clérisseau repeatedly turned to this striking motif and the Hermitage has five of eleven known drawings showing how a single architectural composition evolved over three decades, revealing the master's changing preferences and his increasingly decorative approach to architecture. In this work the mood is emphatically nostalgic. V.S.

228

Architectural Fantasy with Statue of a Seated Consul

Signed bottom left in pen and brown ink: *Clerisseau 1781*
Gouache, pen and brown ink on paper; border in black
ink. 61.2 × 46.8
Inv. No. OR 16927
Provenance: 1924, transferred from the Winter Palace;
1781, acquired from the author by Catherine II.

On the basis of his early sketches, Clérisseau
produced a number of fantasies with statues of
seated Romans set amidst ruins. The Hermitage
has four such pieces, the two earliest probably
produced in Italy and the others (including this
example) part of a series of signed and dated
gouaches which the artist sent to St Petersburg
between 1781 and 1784. V.S.

229

Architectural Fantasy with Statue of a Seated Consul

Signed bottom left in pen and brown ink: *Clerisseau 1782*
Gouache, pen and brown ink on paper. 60.5 × 47.1
Inv. No. OR 43672
Provenance: 1924, transferred from the Winter Palace;
1782, acquired from the author by Catherine II.

This sheet is interesting in the details it reveals of
how the artist used reverse images to create
variations of the same composition. On the back
is a reverse outline sketch of one version of an
often-repeated gouache with a Roman fountain.
Judging by the nature of the sketch, it was made
by holding the clean paper over the original
against back-lit glass. For some reason the sketch
was ignored when the sheet was worked up. V.S.

230

Architectural Fantasy with an Artist

Signed bottom left in pen and brown ink: *Clerisseau 1782*
Gouache, pen and brown ink on paper; border in black
ink. 60.6 × 47.2
Inv. No. OR 16926
Provenance: 1924, transferred from the Winter Palace;
1782, acquired from the author by Catherine II.

The culmination of Clérisseau's works on this
theme, the sheet is yet another work in praise of
Roman Antiquity, revealing the artist's love in
later years for the fussier, less clean lines of the
Corinthian order, even within such a balanced

and soft-toned work. The group of figures in
front of the sarcophagus appears in another of
his works, showing a tower at Nîmes. V.S.

231

Architectural Fantasy with Revealed Construction

Signed bottom left in pen and brown ink: *Clerisseau 1782*
Gouache, pen and brown ink on paper; border in black
ink. 61 × 47
Inv. No. OR 16915
Provenance: 1924, transferred from the Winter Palace;
1782, acquired from the author by Catherine II.

In such architectural *capricci*, Clérisseau would
seem to have set himself the sole purpose of
demonstrating his knowledge of Antique
constructions and building techniques. He
removes to the background the more striking
"composed" architectural effects and allows the
constructional carcass to dominate the sheet. It
was a desire to portray different Roman building
techniques which led him to produce varied
compositions showing side walls, revealing
different arches set within the walls, picking out
the diagonal Roman brickwork (*opus reticulatum*),
consoles and other structural articulation and
engineering details. V.S.

March 2001 - June 2001

232

Interior of a Mausoleum at Campagna near Pozzuoli, Naples

Signed on the back: *Intérieur d'un Sepulchre à Campane
proche de Poussoles dans le royaume de Naples*
Pen, brown and grey wash, white, over a black chalk
drawing, on paper; border in black ink. Lined. 42 × 59.1
Inv. No. OR 11488
Provenance: 1924, transferred from the Winter Palace;
1782, acquired from the author by Catherine II.

This interior was produced from sketches made
during Clérisseau's journey through Italy with
Robert Adam's brother James in 1761. It is simply
constructed according to a quite ordinary
compositional scheme, but the artist makes
good use of light falling through a hole in the
vault to pick out decoration on the pilasters and
to accentuate the dominance of the portico in
the interior. We should also note the influence

of an engraving by Piranesi, *La camera sepolcrale di
via Appia* (F. 238), published in his *Antichità romane*
of 1756.

Figures were added to enliven the
composition after the completion of the
architectural drawing, but a sense of
disorientation is created by their exceedingly
small scale (at least half the size they should be),
which distorts the proportions. V.S.

233

Ruins of the Temple of Poseidon at Paestum

Inscription on the back in pen and ink: *Vue de débris d'une
bazilique à Pestum*
Pen, black and brown ink, brown and grey wash,
gouache, white, over black chalk sketch, on paper;
border in black ink. Lined. 43.1 × 59.9
Inv. No. OR 16921
Provenance: 1924, transferred from the Winter Palace;
5 May 1780, acquired from the author by Catherine II.

Like its pair (Museum of the Academy of Arts, St
Petersburg; until 1931 also in the Hermitage), this
work was probably produced from sketches
made during Clérisseau's journey through
southern Italy in December 1761. Nonetheless,
neither finished gouache goes beyond a simple
fixation of the appearance of the monuments
and it is the charming little genre scenes which
set them apart from a mass of other works.
Possibly it was these scenes which made the
drawings so attractive that they hung for many
years in apartments in the Winter Palace, clear
evidence for which is found in the pencil
inscription on the back, "glass broken", and the
severely faded surface. It is also possible that the
unusual colour of the sheet was a deliberate
device on the part of the artist, seeking to echo
the golden tones of the Roman Travertine stone
of which the temple is built. V.S.

234

Grotto of Tiberius on the Island of Capri

Inscription on the back in black ink: *Grotte de Tibere a
l'isle de Capray dans le royaume de Naples*
Gouache, pen and black and brown ink on paper;
border in black ink. Lined. 42 × 59
Inv. No. OR 11478
Provenance: 1852-5, transferred from the Winter Palace;
5 May 1780, acquired from the author by Catherine II.

Usually perfectly capable of clearly depicting any architectural form, Clérisseau seems to have found himself helpless before such massive, formless vaults: famous for his carefully arranged ruins, he was thrown by the depiction of disorganised nature. Yet the sheet makes excellent use of groups of figures added over the original drawing in grey and black, and of white wash. Sketched directly onto the sheet without previous underdrawing, the figures are set freely and expressively into the amorphous "interior". The groups are linked by a whole system of poses and gestures, by turns and twists, but differ in the tempo and rhythm of the conversation and the varied reactions of the listeners.

The figures in this and other works produced after the tour around southern Italy were possibly painted by Antonio Zuccho, who was employed by the Adam brothers for this purpose.　　V.S.

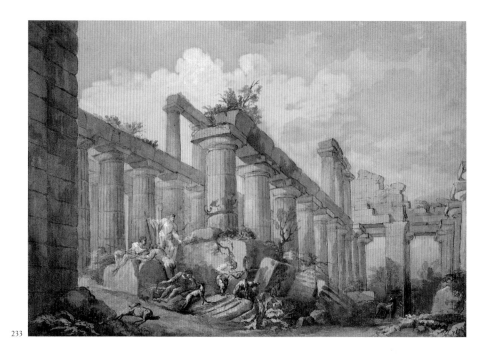

233

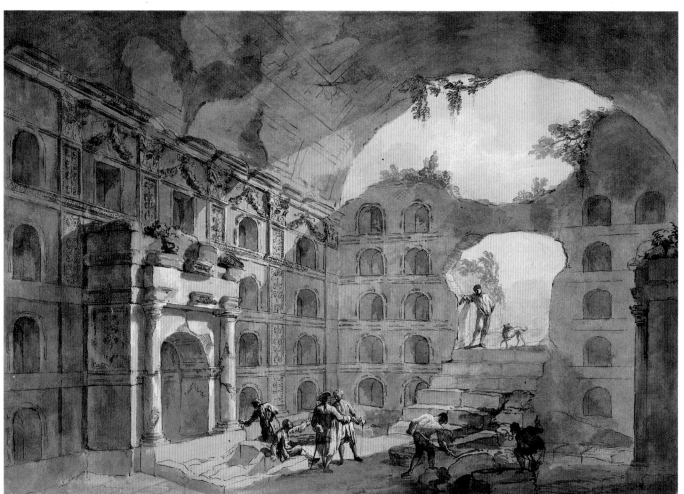

232

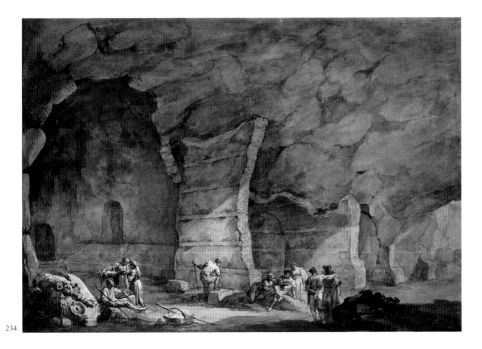

234

235
Colosseum

Inscription on the back in pen and brown ink: *Vue d'une
partie de l'Exterieur du Colisée à Rome*
Gouache, pen and brown ink, over pencil sketch, on
paper; border in black ink. 43.2 × 60
Inv. No. OR 2571
Provenance: before 1797, transferred from the Library in
the Winter Palace; 5 May 1780, acquired from the author
by Catherine II.

Clérisseau depicted the Colosseum repeatedly
during his stay in Rome, and these images are to
be found in many collections. Apart from the
young artist's natural interest in such a famous
monument, his efforts were inspired by his
active participation in Robert Adam's unrealised
project, begun in 1755, to produce a new version
of A. Desgodetz's *Les Edifices antiques de Rome
dessinés et mesurés trés exactement* (Paris, 1682). As
usual in Clérisseau's drawings, the figures would
seem to have been produced by a colleague.

The Hermitage also has a large series of
drawings by Clérisseau showing the interior
galleries of the Colosseum. V.S.

236
Temple of Bacchus in the Palace of Diocletian in Dalmatia

Signed bottom left in pen and brown ink: *Clerisseau. 1783*
Pen, brown and grey wash, over black chalk sketch, on
paper; border in black ink. Lined. 43.1 × 59.4
Inv. No. OR 16920
Provenance: 1924, transferred from the Winter Palace;
5 May 1780, acquired from the author by Catherine II.
(Illus. see p. 138)

References are found to this drawing in the
correspondence of the Adam brothers, who
expressed doubt regarding the number of steps
and the use of brickwork in a structure
otherwise entirely built of stone. A comparison
of this work (also entitled "The Temple of
Jupiter", although Robert Adam identifies it as
"The Temple of Aesculapium") with an earlier
drawing produced in Spalato in 1757 (Hermitage)
reveals the author's changing approach. The later
piece puts more emphasis on the Ancient
monument itself and its ruined state, stressing
the moss covering the steps, the broken state of
the stones, the rough boards over the doorway,
and the vegetation above the cornice.

The Hermitage has three more fantasies on
the subject of the Temple of Bacchus, perhaps
produced in Spalato, and there are two *capricci* on
the same theme in the Fitzwilliam Museum,
Cambridge. V.S.

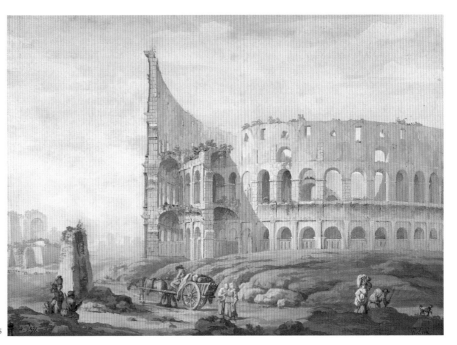

235

237

Arch of Septimus Severus in Rome

Signed bottom left in pen and brown ink: *Clerisseau. 1783*
Gouache, pen and brown ink on paper; border in black
ink. 46 × 59.3
Inv. No. OR 11485
Provenance: 1924, transferred from the Winter Palace;
1782, acquired from the author by Catherine II.

This arch was of much less interest to Clérisseau
than his beloved Arch of Titus, and on the few
occasions when he took up the subject the arch
appears in the background or at the edge of the
composition. It was only in later years, when his
works became more decorative, that the artist
produced for Catherine II this large gouache with
the Arch of Severus as the main object. The
figures, possibly the work of an assistant, are out
of proportion and reduce the sense of the arch's
monumentality. V.S.

238

Architectural Fantasy with Portico and Sarcophagus

Gouache, pen and brown ink on paper; border in black
ink. Lined. 47.5 × 60.5
Inv. No. OR 16922
Provenance: 1924, transferred from the Winter Palace;
1782, acquired from the author by Catherine II.

In his architectural fantasies Clérisseau juggled
with architectural elements and sculptures to
create a free interpretation whilst still remaining
within the bounds of reality. One such standard
scheme is represented here, involving a variation
on different compositional planes. In the
foreground to left and right are dark, half-buried
architectural fragments with figures leaning
against them in relaxed poses. The right half of
such compositions is usually more lively, with
the major monument – a sarcophagus or vast

pedestal – rising up in the foreground and just
behind it the ruins of some massive structure,
often overgrown with weeds.

This is one of the framed works sent to
Catherine between 1781 and 1784. V.S.

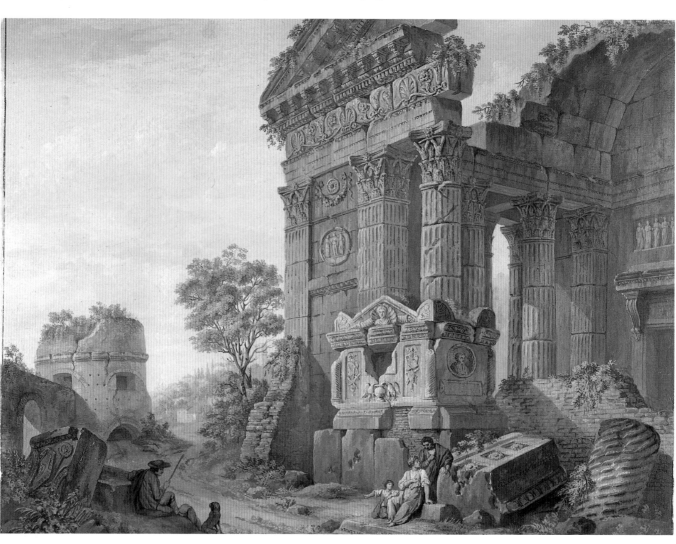

238

239

Architectural Fantasy with Roman Fountain

Signed bottom left in pen and brown ink: *Clérisseau. 1782*
Gouache, pen and brown ink on paper: border in black
ink. Lined. 47.1 × 60.5
Inv. No. OR 16919
Provenance: 1924, transferred from the Winter Palace;
1782, acquired from the author by Catherine II.

Numerous versions of this motif are known,
including an early drawing of 1759 (Hermitage).
Clérisseau used a generalised version without
figures in his *Museum* project, which he added to
18 portfolios of drawings acquired from him by
Catherine in 1780. V.S.

June 2001 - September 2001

240

Arch of Titus in Rome

Inscription on the back in black ink: *Vue de L'arc de Titus*
Pen and ink, brown and grey wash, white, over a black
chalk sketch, on paper; border of black ink. Lined.
42.7 × 59.5
Inv. No. OR 2568
Provenance: before 1797, transferred from the Library in
the Winter Palace; 5 May 1780, acquired from the author
by Catherine II.

In this depiction of his favourite monument,
Clérisseau placed the emphasis on the Arch
itself, ignoring the later structures which
surrounded it. He particularly noted the
decaying details and brick supports. V.S.

241

Vestibule of the Palace of Diocletian in Spalato

Inscription on the back: *Cour du palais de l'Empereur
Diocletian en Dalmatie*
Pen, brown and grey wash, white, on paper coloured
with wash; border of black ink. Lined. 42.6 × 59.9;
40.5 × 49.1 (drawing). Enlarged with additions to left and
at top
Inv. No. OR 2566
Provenance: before 1797, transferred from the Library in
the Winter Palace; 5 May 1780, acquired from the author
by Catherine II.

Clérisseau worked with Robert Adam on a
number of projects, for instance from 22 July to
28 August 1757, together with two other
draughtsmen, they took measurements and
produced drawings for an engraved publication

on the Palace of Diocletian at Spalato. His
drawings formed the most important part of
the resulting work.

Here Clérisseau chose a simple angle,
consciously removing later architectural
accretions seen in drawings by other artists.
Nonetheless, on Adam's instructions, these were
inserted when the work was engraved by Santini
for *The Ruins of the Palace of Diocletian at Spalato in
Dalmatia* (London, 1764, Pl. XX), possibly on the
basis of another (unknown) drawing by
Clérisseau.

The figures were the work of F. Bartolozzi, as
is confirmed by an inscription on the back of his
drawing in Cambridge, which shows not only
the same traders in the foreground, but also
another group beneath an awning which Santini
included in the final version. V.S.

242

Temple of the Sibyl at Tivoli

Inscription on the back: *Vue du Temple de la Sibylle
Tiburtine proche de Tivoly*
Pen and black and brown ink, grey and brown wash,
over a black chalk sketch, on paper; border in black ink.
43.5 × 59.4
Inv. No. OR 2567
Provenance: before 1797, transferred from the Library in
the Winter Palace; 5 May 1780, acquired from the author
by Catherine II.

Tivoli, with its slender Temple of the Sibyl, drew
many artists. True to his principles, Clérisseau
turned repeatedly to the subject, including it in a
number of small *capricci* and in the initials for
albums of his works (Hermitage). Whilst noting
the specific nature of the Temple's construction,
with its doors widening towards the bottom and
the remains of brickwork between the columns,
Clérisseau made the proportions of the
entablature much heavier, a feature which he
repeated in all later versions of the motif. V.S.

243

Colosseum

Inscription on the back in brown ink: *Exterieur du
Colisée à Rome*, and a rough pencil sketch showing an
unknown plan
Pen and ink, brown and grey wash, gouache, over
indications of black chalk, on paper; border in black
ink. Lined. 43.4 × 60.2
Inv. No. OR 2570
Provenance: before 1797, transferred from the Library in
the Winter Palace; 5 May 1780, acquired from the author
by Catherine II.

The artist intended to continue work on this
drawing, as we can see from the foreground and
the unfinished figures to the right. As in other
works by Clérisseau, these figures were added by
one of his colleagues employed by Adam.

This sheet may have been the model for a
more finished and compact drawing of 1765

241

(Ralph Edwards Collection, London), where the road leading to the Colosseum and the figures of different scales reinforce the sense of depth and accentuate the building's size. V.S.

244

Grotto at Baia

Inscription on the back: *Interieur d'un temple à Baja*
Pen and ink, brown and grey wash, gouache, on paper; border in black ink. 42.3 × 59.2
Inv. No. OR 11491
Provenance: before 1797, transferred from the Library in the Winter Palace; 5 May 1780, acquired from the author by Catherine II.

McCormick dates this sheet to the autumn of 1761, when Clérisseau accompanied James Adam to Naples, but it can be suggested that the Hermitage drawing was produced later, from a small format gouache on the same subject, *Travellers in the Interior of the "Temple of Mercury" at Baia* (Pierpont Morgan Library, New York; in the 18th century the ancient baths near Naples were known as the Temple of Mercury). V.S.

244

245

View of the Crater of Mount Vesuvius

Inscription on the back: *Vue de l'interieur du Vesuve après une irruption*
Grey and brown wash, gouache, white on paper; border in black ink. Lined. 42.6 × 60.2
Inv. No. OR 2561
Provenance: before 1797, transferred from the Library in the Winter Palace; 5 May 1780, acquired from the author by Catherine II.

Clérisseau could not but note the more exotic manifestations of nature, as in this gouache where he sought to capture the danger and the massive scale of Vesuvius by placing tiny figures at the very edge of the crater against a background of sulphurous smoke. He did not feel easy with the subject, however, and was unable to avoid his usual desire for equilibrium and harmony, placing the column of smoke directly in the centre.

The right hand side of the sheet has been damaged and repainted. V.S.

242

245

246

Grotto of the Nymph Egeria

Inscription on the back: *Vue de l'interieur de la grotte de la nimphe Egerie à Rome*

Pen and ink, brown and grey wash, gouache, on paper; border in black ink. Lined. 43.2 × 60.2

Inv. No. OR 2569

Provenance: before 1797, transferred from the Library in the Winter Palace; 5 May 1780, acquired from the author by Catherine II.

Egeria, nymph of the spring, was, according to legend, wife of the Emperor Numa. This grotto dedicated to her appears on two sheets in the Hermitage. Like many other works, the drawing was considerably "improved" in 1779 before being sent to St Petersburg, greenish-ochre gouache and white being used to reinforce the foreground details. V.S.

246

247

Arch of the Argentari in Rome

Inscription on the back in brown ink: *Vue de l'arc des orphèvres à Rome*

Pen and ink, brown and grey wash, watercolour, on paper; border in black ink. Lined. 43.2 × 60.4

Inv. No. OR 2565

Provenance: before 1797, transferred from the Library in the Winter Palace; 5 May 1780, acquired from the author by Catherine II.

Erected in 204 in honour of Septimus Severus and his wife Julia Domna, the arch stands near the Church of San Giorgio in Velabro, Rome. Once again, Clérisseau based his enlarged gouache on an earlier drawing from life (Hermitage) and although it is more faithful in its depiction of details and the modern structures around, the large sheet has lost the convincing vividness of the sketch. V.S.

247

Patron of the Arts and Crafts

"Catherine II Rewarding Art and Protecting Commerce"

NATALYA GUSEVA

The Reverend William Coxe was struck by what he saw when he visited Russia in the late 18th century: "The houses of the nobility are furnished with great elegance, and the suite of apartments in which they receive company is uncommonly splendid. They are fitted up in the style of London and Paris, and the new fashions make their appearance as soon as in those two capitals."[1] Above all, Coxe was describing St Petersburg, transformed during the 34-year reign of Catherine II into a majestic city with orderly stone buildings, dominated by the spirit of Neoclassicism. Inside, the decoration of the apartments accorded with the rational harmony of their façades: noble proportions, the natural beauty of rich materials and smooth polished surfaces replaced the glitter of Baroque gilding and fanciful forms of earlier years.

For all its apparent simplicity, this new decorative language required from its proponents great professional skill and taste and a good education. Extremely conscious of this, Catherine – a passionate admirer of Neoclassicism – issued decrees reforming artistic production at the very start of her reign. In 1764, a "statute of crafts" reorganised classes at the Academy of Arts for the training of artist-craftsmen. She stimulated an increase of activity at the Academy of Sciences, the Imperial Porcelain and Glass Factories and the Tapestry Manufactory; the Treasury Bronze Factory began production. Numerous contemporary images of Catherine as Minerva – including the Wedgwood plaque with the inscription "Catherine II Rewarding Art and Protecting Commerce" [see Cat. 209] – truly reflect perceptions of Catherine's contribution to the development of learning, the crafts, and style in Russian applied and decorative art.

Coloured stones became a common

Obelisks with Coats-of-arms of Russian Provinces [Cats 292–310]

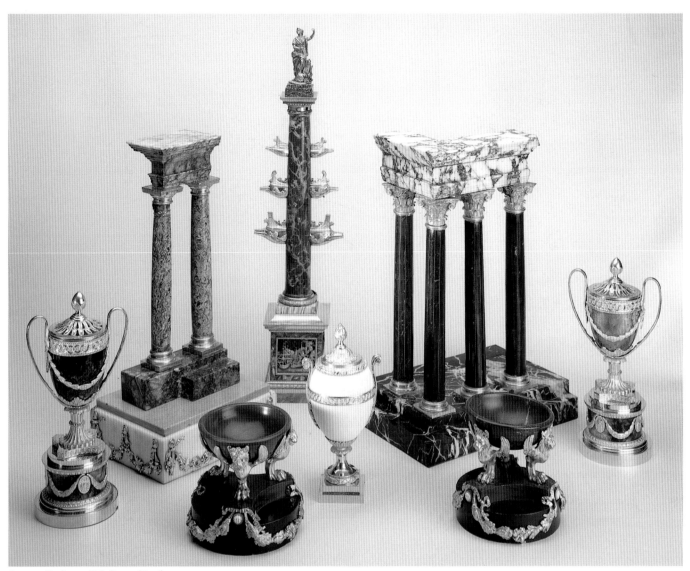

European Hardstones: Valadier and Boulton
[Cats 311-15]

element in the new architecture and were central to the history of Russian interior design. Their decorative potential was brilliantly exploited in Charles Cameron's Baths at Tsarskoye Selo, that same "Graeco-Roman rhapsody" of which the Empress wrote with such enthusiasm to her foreign correspondents. In the Agate and Jasper Rooms, walls, columns, pilasters, niches and doors are decorated with natural jasper, different shades of green, red and brown, with coloured veins and stripes running through them. All unite into a single, natural design, yet a design which is carefully crafted: on close inspection, the pattern proves to be composed of thousands of tiny pieces of stone set together in a technique known, in honour of its most talented exponents, as "Russian mosaic".

Stone for the Agate Rooms came from the Peterhof Lapidary Works, founded not far from St Petersburg by Peter I in 1723, initially for the working of glass and then for coloured stone. Carvers there specialised mainly in creating small pieces of jewellery, above all snuffboxes, for the raw material had to be brought over long distances. As architects made increasingly skilful use of hardstones, the need arose to re-orient

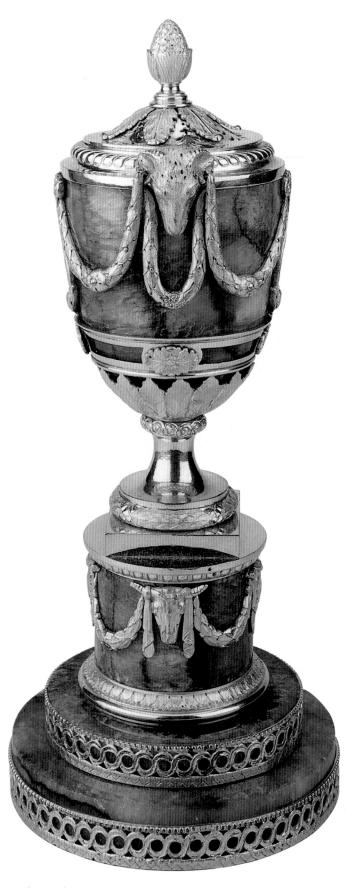

Matthew Boulton: *Vase Censer* [Cat. 316]

production towards more monumental pieces. It was Joseph Bottom, son of an English sailor in the Russian service and head of the Peterhof Works for 30 years, who was largely responsible for revolutionising its work.

Success at Peterhof stimulated the search for new sources of stone and the setting up of more manufactories. Technical inventions made it more advantageous to work the raw material on site, rather than transport unworked stone over long distances. Existing production in the Urals was reorganised in the 1760s and activities took off at the Yekaterinburg Lapidary Works; in 1786, in the far off Altai Region, a new works was founded at the Loktev Copper Smelting Factory (transferred in 1802 to Kolyvan, known today as the Kolyvan Works).

Catherine herself studied each new piece keenly when it arrived. Elegant works by anonymous Russian craftsmen pleased her no less than the marvellous stone and bronze table decorations of famous masters such as Valadier and Matthew Boulton. In his description of the Imperial Hermitage, Johann Georgi (1794) noted, amongst other things, a unique "pyramid of Urals stones", the pedestal made of "white marble and reddish porphyry, on which is a plaque composed of small coloured stones. On each side of it are images of rapids from very brilliant Siberian aquamarine, which most excellently represents falling water. Beneath the rapids is a bowl like a shell of alliance [composed of fine granite with white quartz veins]. Four pilasters are made of different coloured jasper, and the most quadrangular pyramid is of pale green Orsk jasper. It has the inscription: *Don précieux de la nature.*"[2]

Such a detailed commentary on a single piece by Russian masters, when the Empress's collection included hundreds of unique works by foreign craftsmen, was quite deliberate: Georgi's attention was particularly drawn to objects which bore witness to local achievements, objects which could successfully compete with the masterpieces of European work displayed nearby.

Catherine's patronage and support did much to expand and improve production at a number of existing centres, such as the Imperial Porcelain Factory. Said to have been founded in 1744, when masters were able to make their first pieces from "hard" porcelain, the factory now began to work mainly for the imperial court. Growing demands for large decorative

Gardner Factory:
Service of the Order of St George
Leaf-shaped Compotier
[Cat. 334]

pieces and ceremonial dinner services (often including allegorical compositions glorifying the ruler) stimulated technical and creative experimentation.

Decoration on porcelain tended to be carefully chosen according to a set programme: the Cabinet Service, commissioned by Catherine, has views of Rome and its environs taken from engravings by Giuseppe Vasi and Giovanni Battista Piranesi: Catherine particularly admired Piranesi, and she spent hours leafing through her copies of his albums. Such porcelain might also represent a political or social statement, as with the Order Services, used only for receptions of knights of the four highest Russian Orders of chivalry. Commissioned from the Moscow factory (founded 1766) of English merchant Francis Gardner,[3] each set, equal in size to the number of knights of the relevant Order, was painted with the ribbon and symbols of that Order. All of the forms were strongly influenced by the Berlin Service presented to Catherine II in 1772 by Frederick of Prussia.

Ceremonial tableware by leading European firms arrived at the Russian court not only as diplomatic gifts, however, but also via the Empress's personal commissions – she never scrimped on decorating her own residences. One example is the service she commissioned from Wedgwood for her Gothic Chesme Palace, built on a site with the Finnish name Kekerekeksinen (frogmarsh): each of its 944 pieces bears the humorous emblem of a green frog, as well as views of English palaces, castles and abbeys set against natural landscapes. These views served as a "model book" for contemporaries, both in the development of landscape gardening (confirming once more the dominance of "anglomania") and in the decoration of porcelain.

St Petersburg in the 1790s had many English, French, German and Dutch shops, but it was only the English merchants ("28 households") which enjoyed customs privileges, forming "a separate block apart from other foreign merchants".[4] Indeed, throughout the whole of the 18th century, the Russian nobility's interest in English culture was as consistent as its permanent admiration for French art. Whilst France dictated the fashion in the more luxurious sphere of palace interior decoration, the English feel for rational comfort was keenly applied to everyday life.[5] Even back at the start of the century, that most practical of rulers, Peter the Great, notably sent young men to study crafts (at state expense) in England and Holland rather than France.

Wedgwood: *Green Frog Service, Square Compotier with a View of Stowe* [Cat. 329]

Pedestal Table with the Arms of Tula [Cat. 281]

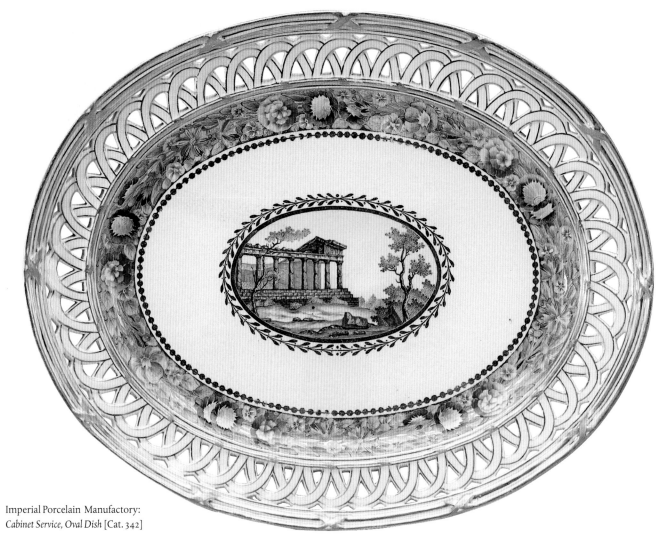

Imperial Porcelain Manufactory:
Cabinet Service, Oval Dish [Cat. 342]

Under Catherine, however, state-sponsored study trips were available only to graduates of the Academy of Arts, who were sent to Italy. In all other cases, the Empress's permission had to be individually sought. In 1785, for instance, she sent two experienced steelworkers from the Tula Armoury Factory, Alexey Surnin and Andrey Leontyev, to England. Already masters of the finer points of working metal, they were to study local products and broaden their creative outlook. This must surely have been the first time that Russian craftsmen associated with their foreign colleagues as equals. Alexey Surnin even received an offer to remain and work in England on highly preferential terms, but refused in order to return to his native Tula.

With its fortress kremlin, Tula had long been a defensive centre in southern Muscovy. The city was mainly inhabited by blacksmiths who produced arquebuses and other weaponry for the Russian army from the 16th century, passing on their skills, like their patriotism, from generation to generation. From 1712, when the Tula Armoury was officially founded by decree of Peter I, its masters regularly enjoyed the patronage of the royal court, producing both large government commissions and individual items as diplomatic gifts.

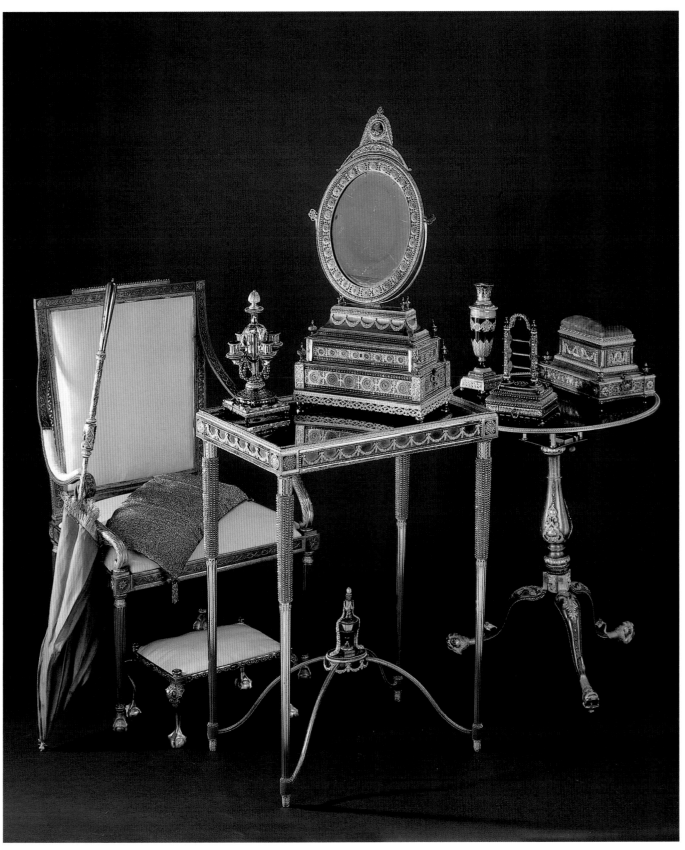

Tula Furniture and Decorative Art

Tula Swords [Cats 249, 251 and 267]

To earn the right to be called "master", an armourer had to produce a work with "faceted stones" and inlaid gold and silver. "Faceted stones" describes a technique whereby the spherical head of a steel nail was carefully polished and faceted like a diamond. Dozens, even hundreds, of such brilliant "diamonds" were attached to an object, while hollows and channels were made in the surface and then filled with coloured metals, forming a kind of inlay. Another technique involved applying copper, silver and gold mixed with mercury to the steel surface and heating it to evaporate the mercury, leaving a fanciful ornament. This process was repeated several times. When such a pattern was produced on a burnished ground, the effect was reversed: the ornament looked paler than the background. An even more complex process involved removing the background from the design, leaving the ornament proud above the surface. Endless devices were used by masters to create extremely varied and original weapons, and in their free time often to make everyday items: ink stands, boxes, pin-cases, candlesticks, bracelets, beads etc. "We dined with Count Potemkin," wrote the French chargé d'affaires, Chevalier de Corberon in his diary for 7 November 1775. "He showed us works in steel from Tula, of great beauty for the steely blue, the gilding and the fine ornament."[6]

From the 1740s, Tula craftsmen received frequent commissions to produce for the imperial court a new kind of furniture and works of applied art. Armchairs and tables of the Baroque era were richly adorned with wrought openwork details, while later

pieces made maximum use of the material's strength, achieving elegant silhouettes on ultra-thin supports.

In 1785, the Englishman Ferdinand Davieh (thus his name is recorded) arrived in Tula at the invitation of Prince Potemkin, to set up a workshop producing mathematical and physical instruments. Three of his pupils later opened their own manufactories, considerably extending the assortment of Tula products.

Catherine visited the Armoury personally in 1775 and 1787. Both times, according to the Ceremonial Journal chronicling court life, masters presented her with "bread and salt [a traditional Russian welcome – N.G.] and various items of their own working". The sovereign "deigned to look over all the works… and to purchase both weapons and hilts and other objects which Her Highness wished".[7] She also acquired pieces for herself and her family at the annual May fair in Sofia, not far from Tsarskoye Selo: steel tables, toilet services, umbrellas, various small items, and some craftsmen were permitted to present their goods to her personally in the palace. Petersburg's rich were keen to follow the court's example, acquiring Tula steel for presents and prizes.

The Victoria & Albert Museum in London has a steel fireplace and openwork screen decorated with burnishing, gold and silver inlay and bronze details. Charles Oman was the first to establish that the fireplace was not in fact English but from Tula ("Though traces of the Adam style can be found in the design, it does not look like a product of the Birmingham workshops of Matthew Boulton") and was presented by Catherine Dashkova, President of the Russian Academy of Sciences, to Martha Wilmot, who "may have provided the Tula craftsmen with sketches showing what was wanted".[8]

By the end of the 18th century, Russian craftsmen had truly won international recognition. Catherine left behind her a country in which the crafts flourished, and "the fruits of a European education", as the diarist Filipp Vigel expressed it, had penetrated to the "very womb of Russia", giving birth to "taste" and "an attachment to the merits of the Russian name".[9] Catherine prepared the way for that last, brilliant outpouring of the patriotic Empire style which emerged – reinforced by the war against Napoleon – in the early 19th century.

NOTES

1 Coxe 1784, vol. 1, p. 505.

2 Georgi 1794, p. 341.

3 On Gardner see Anthony Cross: *By the Banks of the Neva. Chapters from the Lives and Careers of the British in Eighteenth-Century Russia*, Cambridge, 1997, pp. 73-4.

4 Georgi 1794, p. 185.

5 Martha Wilmot visited Princess Vorontsova in 1808 at her estate near Moscow, where she settled shortly after the death of Catherine I: "When I went to the Countess's Apartments I found them brilliant with lights and a blazing fire in the Chimney. The House is very much in the Style of an elegant English House" (see Charles Oman: "The Romance of a Fireplace", *Apollo*, June 1961, p. 180).

6 M. D. B. de Corberon: *Un diplomat français à la Cour de Catherine II…*, Paris, 1901, vol. 1, p. 106.

7 S. Troynitsky: "Zametki o tulskom zavode" [Notes on the Tula Factory], *Staryye gody* [Days of Yore], October-December 1916, p. 87.

8 Oman: *Op. cit.*, p. 180.

9 F. F. Vigel: "Zapiski" [Notes], *Russkiy arkhiv* [Russian Archive], 1892, part 1, p. 73.

Tula Weapons

In the 18th century, Tula was Russia's main centre for the production of hunting and army weapons. Combining the experience of Western Europe's leading craftsmen, notably the Germans and the French, with national traditions in applied art, armourers took the working of metal to new technical and artistic heights.

During the reign of Peter the Great, Tula produced weapons for the developing Russian army. The sole requirement then was technical perfection, but by the 1720s they had moved on to apply their skills to the production of richly decorated hunting weapons, both firearms and daggers, for private individuals. As the wealth of the Russian aristocracy grew, they demanded that their arms combine technical efficiency with the very latest in fashionable ornament.

From the 1730s, armourers had official permission to supplement their income outside working hours and output of pistols and daggers, rifles and sabres of all descriptions grew rapidly in the 1740s and 1750s.

Much of their work was richly finished, the metal parts - barrels and locks, the hilts of swords and daggers - were decorated with deep carving, the background gilded, while wooden parts were often incrusted with silver wire. Over the next decades the nature of the decoration changed: from the 1760s to 1790s wire was still used to adorn wooden parts but metal was now incrusted with steel, silver and gold, with ornamental compositions made up of stylised vegetable and floral ornament, birds and beasts, and figures of hunters. From the 1770s armourers used marcasite, a material which was particularly popular in England.

Many of the pieces included here were commissioned by high-ranking individuals, while others were intended as presents for members of the imperial family.

Perhaps the greatest interest attaches to a hunting set [Cats. 268-70] made for Catherine II by Ivan Lyalin, an outstanding master who produced many commissions for the court between the 1770s and the 1800s. The set consists of two rifles (single and double-barrelled) and two pistols, the butts, handles and rods of which are of ivory covered with very fine vegetable carving. Gold and silver incrustation of flowers, leaves and garlands covers the burnished barrels, while the pistol handles end in eagles' heads.

Of the side arms, we should particularly note the hunting daggers, their handles and mounts decorated with marcasite and incrusted with silver and gold. Apart from the blade itself, a dagger might often also have a spoon and fork hidden inside the sheath.

A masterpiece of virtuoso skill is the child's sabre decorated with gold incrustation on a burnished background, which once belonged to Grand Duke Alexander (future Alexander I) and bears his monogram beneath a crown. Alexander, Catherine's favourite grandchild, was also the owner of an elegant court dress sword, with its openwork steel hilt, while the model pistols (Cats 254-90) belonged to his brother Constantine. Y.Y.

248
Hunting Rifle. 1760s-1770s
Gunsmith: A. Leontev
Steel, wood; incrusted, burnished, gilded, carved, engraved, inlaid with gold and silver. Length 120.5; calibre 17.9mm
Inv. No. ZO 5632
Provenance: 1925, from the Bachmanov collection.

248

249
Sword in a Scabbard. 1769
Steel, leather; engraved, polished and gilded. Length 94
Inv. No. ZO 6801
Provenance: 1938, from the Western European Department; formerly Gallery of Objets de Vertu.
(Illus. see p. 168)

250
Sword. 1765-75
Steel; polished, burnished, gilded and engraved. Length 97.3
Inv. No. ZO 6800
Provenance: 1938, from the Western European Department; formerly Gallery of Objets de Vertu.

251
Sword in a Scabbard. 1770s-1780s
Steel, leather; polished, burnished, silver-plated and engraved. Length 96.3
Inv. No. ZO 6802
Provenance: 1938, from the Western European Department; formerly Gallery of Objets de Vertu.
(Illus. see p. 168)

252
Child's Hunting Rifle. c. 1780
Steel, wood; silver-plated, gilded, burnished, incrusted with silver wire. Length 69.7; calibre 9.8mm
Inv. No. ZO 5429
Provenance: 1885-6, from the Tsarskoye Selo Arsenal.

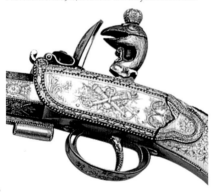

252

253
Child's Sabre in a Scabbard. c. 1780
Steel; burnished, gilded. Length 45
Inv. No. ZO 4661
Provenance: 1885-6, from the Tsarskoye Selo Arsenal; belonged to Grand Duke Alexander.

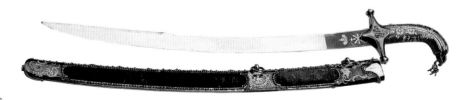

253

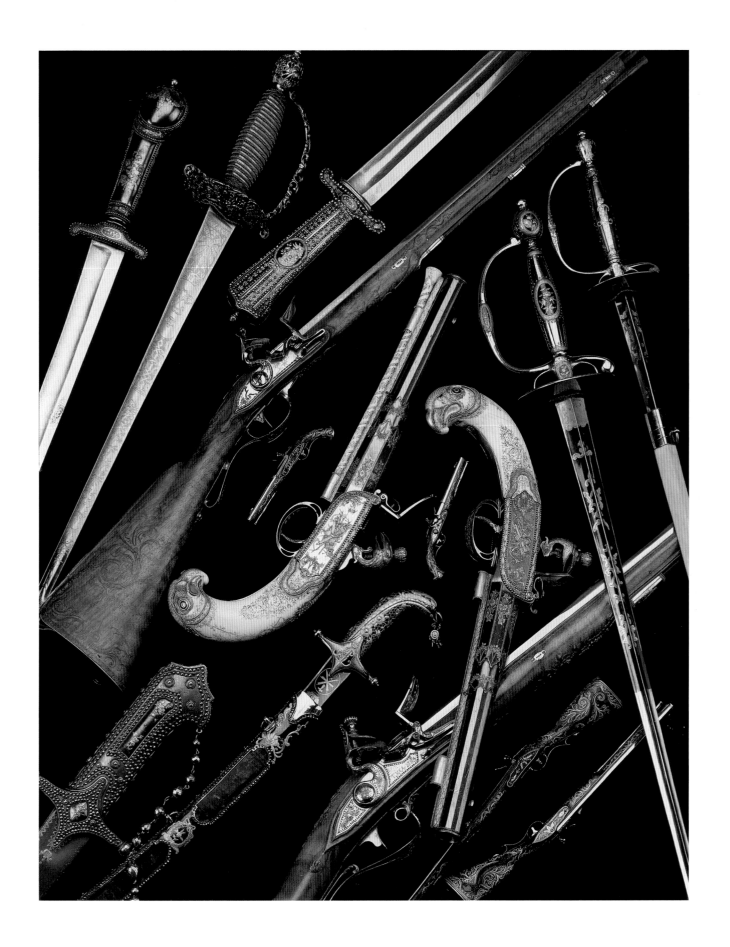

254-59
Model Firearms
Gunsmith: I Makarishchev
Provenance: 1885-6, from the Tsarskoye Selo Arsenal;
belonged to Grand Duke Constantine.

254
Model Flint-Lock Rifle. 1780s
Steel, wood; inlaid with gold and silver wire. Total
length 22.5; length of barrel 13.5; calibre 4mm
Inv. No. ZO 5435

255
Model Flint-Lock Rifle. 1782
Steel, wood; inlaid with gold and silver wire, burnished
and incrusted. Total length 27; length of barrel 18.5;
calibre 4mm
Inv. No. ZO 5438

256
Model Flint-Lock Rifle (Blunderbuss).
Early 1780s
Steel, wood; inlaid and incrusted with gold and silver
wire. Total length 22; length of barrel 13; calibre 10 by
6mm
Inv. No. ZO 5437

257
Model Flint-Lock Pistol. Early 1780s
Steel, wood; inlaid with gold and silver wire, incrusted
and burnished. Total length 10; length of barrel 6;
calibre 3mm
Inv. No. ZO 5443

258
Model Flint-Lock Pistol. Early 1780s
Steel, wood; incrusted, inlaid with gold and silver wire
and burnished. Total length 10; length of barrel 6;
calibre 3mm
Inv. No. ZO 5444

259
Case for Model Weapons. 1780s
Wood, polished and incrusted; braid; key of steel and
bronze, gilded. 6 × 17 × 32
Inv. No. ZO 5435(a)

259

260
Six-cartridge Rifle. Late 1780s - early 1790s
Steel, wood, silver wire, gilded bronze; incrusted,
engraved, gilded, silver-plated and carved. Length 125.8;
calibre 13.5mm
Inv. No. ZO 5135
Provenance: 1885-6, from the Tsarskoye Selo Arsenal.

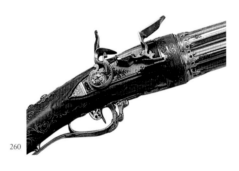

260

261
Carbine. 1785
Steel, wood; inlaid, polished and gilded. Length 94.5;
calibre 11.8 mm
Inv. No. ZO 731
Provenance: 1885-6, from the Tsarskoye Selo Arsenal.

262
Carbine. 1785
Steel, wood, ivory; burnished, gilded and engraved.
Length 91
Inv. No. ZO 5578
Provenance: 1885-6, from the Tsarskoye Selo Arsenal.

263
Six-barrel Rifle. c. 1785
Steel, wood, bronze; carved, gilded, silver-plated,
engraved, incrusted with gold and silver wire. Length
118.3; calibre 14.4mm
Inv. No. ZO 55
Provenance: 1885-6, from the Tsarskoye Selo Arsenal.

264
Sabre. c. 1785
Steel; gilded, engraved and burnished. Length 97
Inv. No. ZO 7798
Provenance: 1885-6, from the Tsarskoye Selo Arsenal.

265
Hunting Dagger in a Scabbard. 1780s-1790s
Steel, leather; polished, gilded, silver-plated and
burnished. Length 71.3
Inv. No. ZO 1363
Provenance: 1885-6, from the Tsarskoye Selo Arsenal.

266
Hunting Dagger in a Scabbard. 1780-1790
Steel, leather; gilded and silver-plated. Length 73.5
Inv. No. ZO 1364
Provenance: 1885-6, from the Tsarskoye Selo Arsenal.

267
Sword in a Scabbard. c. 1790
Steel, leather; burnished, engraved and gilded.
Length 89.5
Inv. No. ZO 6803
Provenance: 1938, from the Western European
Department; formerly Gallery of Objets de Vertu;
belonged to Grand Duke Alexander.
(Illus. see p. 168)

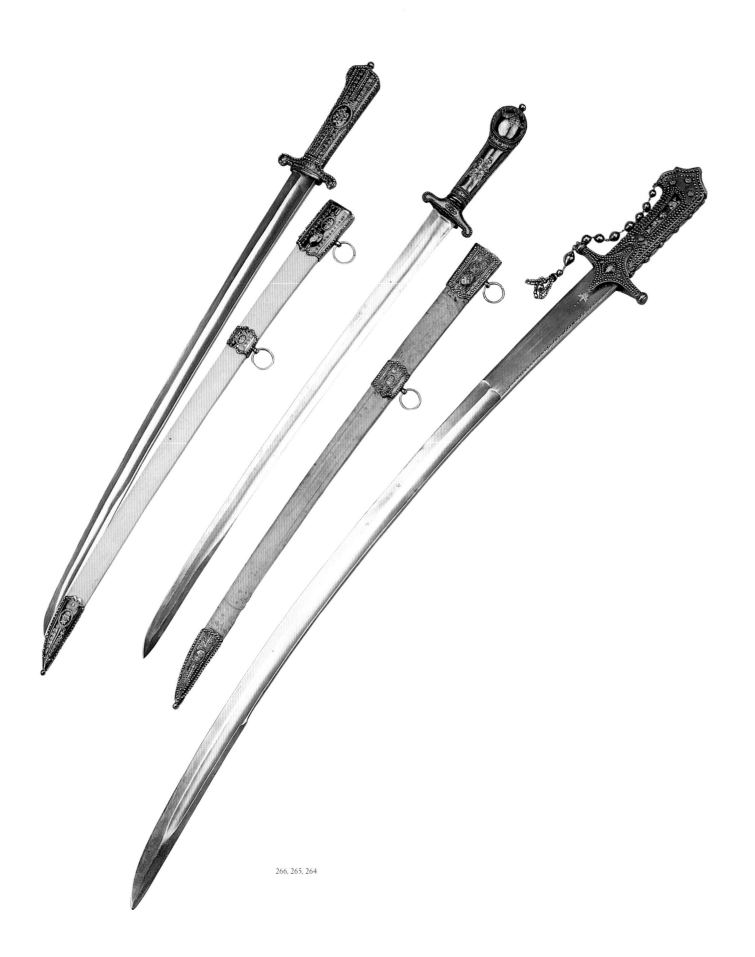

266, 265, 264

268-270

Hunting Set

Gunsmith: Ivan Lyalin

1885-6, from the Tsarskoye Selo Arsenal; made for
Catherine II

268

Pair of Pistols. c. 1790

Steel, bronze, ivory, gilded bronze; polished, burnished,
engraved, inlaid with gold and silver. Total length 35.2;
length of barrel 20.1; calibre 18mm

Inv. No. ZO 6619

269

Hunting Rifle (with Ivory Butt). c. 1790

Steel, ivory; polished, engraved, burnished, gilded and
silver-plated. Total length 119.6; length of barrel: 74.8;
calibre 14mm

Inv. No. ZO 6654

270

Hunting Rifle (with Leather Butt). c. 1790

Steel, ivory, gilded bronze; polished and engraved.
Total length 112; length of barrel 74.1; calibre 19mm

Inv. No. ZO 6655

Y.Y.

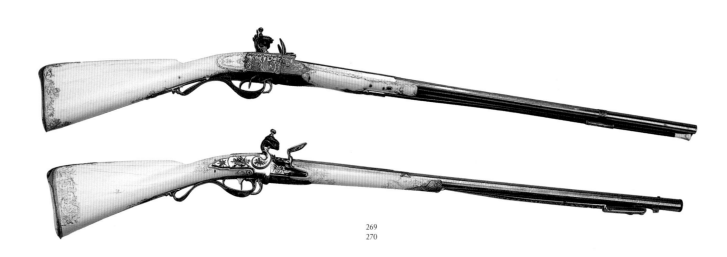

269
270

Tula Domestic and Decorative Objects

271

Rectangular Casket with Velvet Cushion. Late 18th century

Monogram: *EA*

Steel, gilded bronze, velvet; polished, inlaid and chased.

17 × 26 × 17.5

Inv. No. ERM 7503

Provenance: Main Hermitage Collection.

This box was acquired by Catherine II at the Sofia Fair (near Tsarskoye Selo) for Grand Duchess Yelizaveta Alexeyevna, wife of her grandson Alexander. It is decorated with garlands of roses, palmettes and pearls. M.K.

272

Casket in the Form of a Sarcophagus. Late 18th century

Master Rodion Leontyev

Inscription: *Тула М. Радіонъ Леонтьевъ* [Tula. Master Radion Leontyev]

Steel, gilded steel, velvet; burnished, faceted and carved.

18.5 × 27.5 × 19.2

Inv. No. ERM 2170

Provenance: Main Hermitage Collection

Decorated with garlands of roses, horns of plenty, laurel, acanthus and a network of steel beads. Such works were rarely signed in the 18th century, making this piece all the more rare. M.K.

273

Pair of Candlesticks. 1780s

Steel, bronze; chased, gilded, polished and inlaid.

33 × 14 × 14

Inv. Nos ERM 2147, ERM 2148

Provenance: Main Hermitage Collection. M.K.

274

Pair of Four-branched Candelabra. Last quarter of the 18th century

Steel, gilded bronze; polished, burnished and faceted.

26.5 × 12 × 12

Inv. Nos ERM 980, ERM 981.

Provenance: 1950, via the Hermitage Purchasing Commission.

These candelabra are in the form of fluted columns with branches, decorated with faceted beads. M.K.

275

Vase-Candlestick. First quarter of the 19th century

Steel, gilded bronze; polished and burnished.

26.2 × 9.3 × 9.3

Inv. No. ERM 2165

Provenance: Main Hermitage Collection. M.K.

276

Writing Set in the Form of a Globe. Early 19th century

Steel; polished, engraved and inlaid. 23.5 × 11.5 × 11.8

Inv. No. ERM 2129

Provenance: 1941, From the Museum of Ethnography.

A button mechanism opens the doors of the spherical lid. The days of the week are engraved on the foot. M.K.

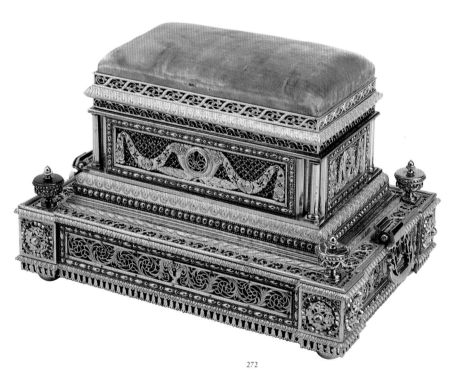

272

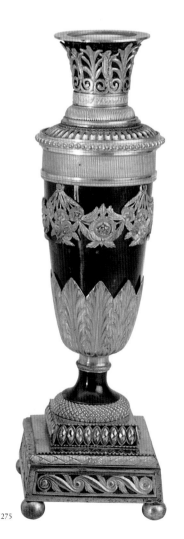

275

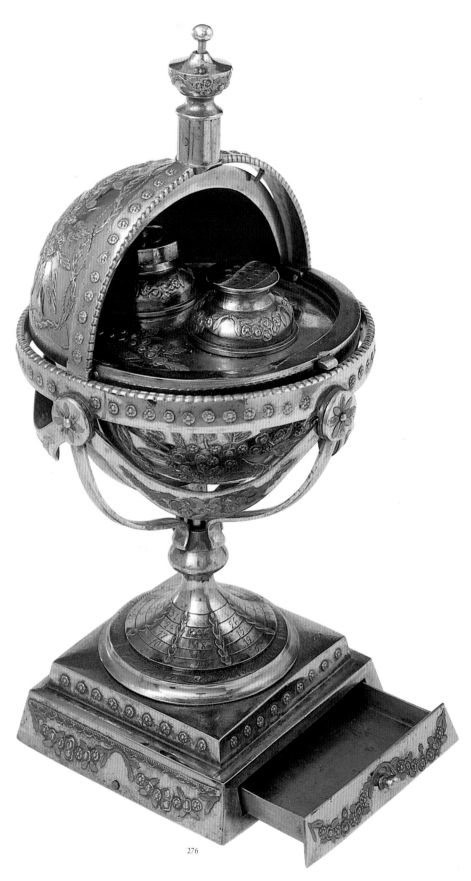

276

277

Writing Set with Ink-Pot, Pounce-box and Candlestick on an Oval Base. Late 18th century

Steel, bronze; polished, burnished, inlaid. 16 × 20 × 17.3
Inv. No. ERM 7701
Provenance: 1969, Hermitage Purchasing Commission.

M.K.

278

Thread Winding Reel in the Form of an Arch. Late 18th century

Steel, bronze; polished, burnished, faceted and carved.
25 × 17 × 10.7
Inv. No. ERM 2183
Provenance: Main Hermitage Collection; formerly Bachmanov collection.

The arch stands on a rectangular base with a festooned edge and a drawer.　　M.K.

279

Toilet Set. c. 1801

Monogram: IMF
Steel; polished, burnished, faceted and carved.
70 × 32 × 18
Inv. No. ERM 7498
Provenance: Main Hermitage Collection.

The base is in the form of a casket with an oval mirror, on the top of which is a medallion with the monogram. The whole is decorated with rosettes and a band of steel "diamonds", combined with garlands of flowers, vignettes and laurel.　　M.K.

280

Pedestal Table. 1780s

Steel, bronze; faceted, chased, inlaid and burnished.
67 × 57
Inv. No. ERM 2308
Provenance: 1941, From the Museum of Ethnography.

The folding top is set in a gilded bronze frame, the central leg decorated with vignettes in gilded bronze with Rococo ornament and masks, oval medallions with roses, and three figures of dolphins.　　M.K.

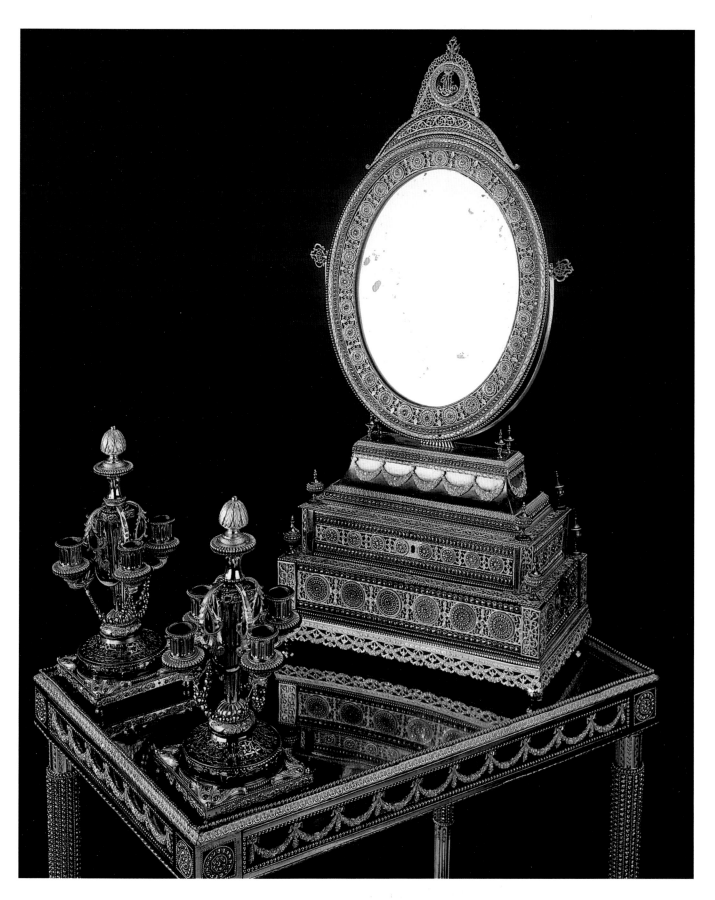

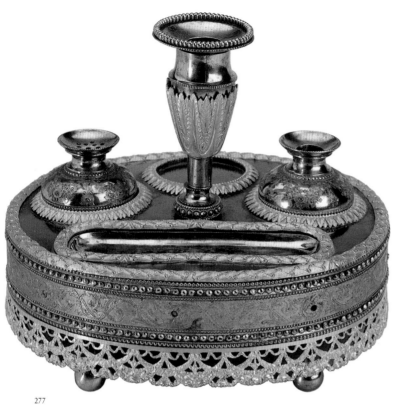

277

283
High-backed Armchair. 1790s
Steel, bronze, silk; cast, inlaid, burnished and carved.
92 × 58.5 × 47.5
Inv. No. ERM 2185
Provenance: Main Hermitage Collection.

Decorated with acanthus, gilded bronze, and
fine curved arms, while the legs end in birds'
claws resting on spheres. M.K.

281
Pedestal Table with the Arms of Tula. 1785
Steel, copper; gilded, faceted, inlaid and ground. 66 × 66
Inscription: *Тула 1785 ГОДУ* [Tula 1785]
Inv. No. ERM 2307
Provenance: Main Hermitage Collection.
(illus. see p. 165)

In the centre of the copper table top is a star of one
of the Orders and the arms of Tula. The legs are
decorated with figures of dolphins, garlands, and
oval medallions with bouquets of roses. M.K.

282
Dressing Table. c. 1801
Steel, gilded bronze; cast, inlaid, burnished and ground.
77 × 55.5 × 38
Inv. No. ERM 7497
Provenance: Main Hermitage Collection.

The table has a gilded bronze balustrade, and is
decorated with laurel garlands, rosettes with
steel "diamonds" at the corners, and feet in the
form of fluted columns. M.K.

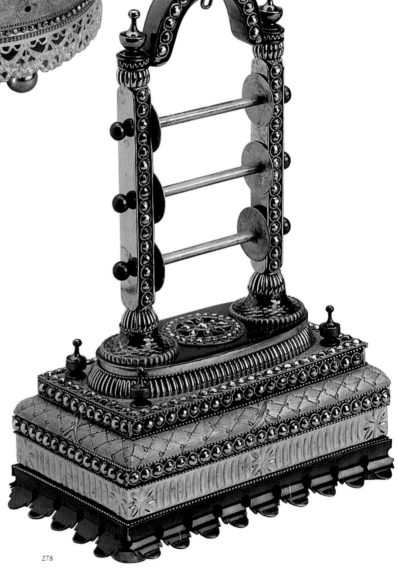

278

281

284

Small Rectangular Bench. Late 18th century

Steel, gilded bronze, silk; cast, chased, inlaid and faceted. Late 18th century.

17 × 34.5 × 25.5

Inv. No. ERM 7535

Provenance: Main Hermitage Collection; formerly Bachmanov collection.

The legs rest on birds' claws on spheres, and the whole is decorated with applied flower ornament and faceted steel beads.　　　M.K.

285

Cushion Studded with Faceted Steel Beads with Steel "Diamond" Tassels.
Late 18th century

Steel, velvet; faceted and polished. 41 × 22.5

Inv. No. ERM 2336

Provenance: Main Hermitage Collection; formerly Bachmanov collection.　　　M.K.

286

Cylindrical Openwork Incense Burner.
Late 18th century

Steel; polished, burnished, chased, carved and inlaid.

12.5 × 25.5 × 9

Inv. No. ERM 2330

Provenance: Main Hermitage Collection.　　　M.K.

287

Green Silk Parasol. 1780s

Steel, bronze, silk, glass; polished, carved, inlaid and faceted. 105.5 × 12 × 10

Inv. No. ERM 2164

Provenance: Main Hermitage Collection.

The steel handle bears the monogram of Catherine II, a bouquet of forget-me-nots and a flaming heart beneath glass insets, as well as bands of steel faceted beads and applied garlands of flowers.　　　M.K.

288

Set of Miniature Weapons: Pair of Pistols, Rifle and Sword in a Red Morocco Case.
First half of the 19th century

Steel, wood, leather; polished and carved

Rifle: 13 × 3.5 × 1.7. Inv. No. ERM 5112

Pair of pistols: 5.8 × 2.5 × 1.3. Inv. Nos ERM 5113, ERM 5114

Sabre: 8 × 1.5 × 0.8. Inv. No. ERM 5115

Provenance: 1941, From the Museum of Ethnography.

Tula armourers also showed off their skill and their virtuoso technique in tiny copies of their work, produced as souvenirs and gifts; these were particularly common in the second half of the 19th century. Most of the fine, jewellery-like pieces were working models, complete with cartridges, although the bullets would only pierce a single sheet of cardboard.　　　M.K.

286

Chess Set. 1780s
Provenance: Main Hermitage Collection.

This chess set was presented to Catherine II, who kept it in her Cabinet of Curiosities. In the 19th century it moved to the Gallery of Objets de Vertu, which was established to house commemorative and extremely precious objects. On the lid and sides of the casket are applied reliefs with designs of 1778 for the Tula manufactory, by the local architect K. S. Sokolnikov (famous for a number of buildings in Tula). On the spire of the central tower is a figure of Glory blowing her horn, with Catherine's monogram "EA", and there is a figure of Athena on the entrance gates. Over the dome is the figure of an armourer with a hammer and tongs. Although this design was approved in 1782 it was never put into effect.

The set originally consisted of 80 figures, or five half-sets: "four-handed" chess was very popular in Russia, involving four players at any one time. M.K.

289
Casket for Chess Set
Master Andrian Sukhanov
Steel, gilded bronze; burnished, polished, faceted and inlaid. 70 × 50 × 31
Inv. No. ERM 4578

290
Chess Pieces
Steel, bronze; burnished, polished, faceted and inlaid
Kings: 10.5 × 3.4 × 33. Inv. Nos ERM 4591, ERM 4579
Queens: 9.5 × 3.3 × 3.3. Inv. Nos ERM 4592, ERM 4580
Pawns: 5 × 2.1 × 2.1. Inv. Nos ERM 4584, ERM 4585, ERM 4586, ERM 4587, ERM 4588, ERM 4594, ERM 4596, ERM 4598, ERM 4604, ERM 4612, ERM 4613
Knights: 5.8 × 2.5 × 2.5. Inv. Nos ERM 4590, 4609
Rook: 4 × 3.7 × 2.5. Inv. No. ERM 4607
Bishops: 7.9 × 2.7 × 2.7. Inv. Nos ERM 4581, ERM 4593

Russian Hardstones

291

Obelisk of Dark Red Jasper on a Pedestal of Greyish-yellow Granite, on Bronze Legs. 1780s

Peterhof Lapidary Works, Russia

Jasper, granite; cut and polished; gilded bronze.

35.5 × 10.2 × 10

Inv. No. ERKm 499

Provenance: Main Hermitage Collection

The obelisk is crowned with a figure of an owl on a sphere and has applied gilded bronze plaques with trophies and the arms of Russia and Perm Province. A. E. Fersman, a leading scholar of Russian hardstones, wrote: "Amidst the wide variety of objects from our lapidary works were many of the obelisks on tables and fireplaces which were so fashionable at the end of the 18th century." E.T.

292-310

Obelisks of Smoky Quartz ("rauchtopaz") with Gilded Bronze Coats-of-arms of the Russian Provinces, on Coloured Stone Pedestals. C. 1875

Peterhof Lapidary Works, Russia

Smoky quartz, lazurite, white Altai quartz, black marble, jasper of different colours

Provenance: Main Hermitage Collection.

(Illus. see p. 158)

Between 1777 and 1785 a new three-storey stone building by Yury Velten was erected to house the Imperial Peterhof Lapidary Works, not far from the summer palace of Oranienbaum. A bronze bust of Catherine II, encircled by topaz obelisks, was placed in the lobby and her monogram, "E II" was above the main entrance. To mark the opening of the new building, the Works produced a rectangular malachite pedestal with columns of Siberian jasper, and cast bronze base, capital and bust of Catherine II. Arranged around the column were 40 topaz pyramids on hardstone pedestals with the bronze coats-of-arms of Russian provinces and important towns, all on a square slab of red Siberian jasper. The whole stood on a grey granite pedestal with a bronze inscription reading "Established by Catherine the Great 1785". The pedestal is still at the factory today, but all the other parts were transferred to the Hermitage by order of Emperor Nicholas I. A selection of the obelisks are on display in the exhibition. E.T.

292

Obelisk with the Arms of Vladimir Province

Smoky topaz, quartz, jasper, bronze. 11.8 × 4.1 × 4.1

Inv. No. ERKm 502

293

Obelisk with the Arms of Kharkov Province

Smoky topaz, quartz, jasper, bronze. 11.8 × 4.1 × 4.1

Inv. No. ERKm 506

294

Obelisk with the Arms of Polotsk

Smoky topaz, quartz, jasper, bronze. 11.3 × 4.1 × 4.1

Inv. No. ERKm 507

295

Obelisk with the Arms of Kursk Province

Smoky topaz, quartz, jasper, bronze. 11.7 × 4.1 × 4.1

Inv. No. ERKm 508

296

Obelisk with the Arms of Astrakhan Province

Smoky topaz, quartz, jasper, bronze. 11.6 × 4.1 × 4.1

Inv. No. ERKm 509

297

Obelisk with the Arms of Tula Province

Smoky topaz, quartz, lazurite, bronze. 11.7 × 4.2 × 4.2

Inv. No. ERKm 510

298

Obelisk with the Arms of Vologda Province

Smoky topaz, jasper, lazurite, bronze. 11.7 × 4.2 × 4.2

Inv. No. ERKm 513

299

Obelisk with the Arms of Vyborg Province

Smoky topaz, jasper, lazurite, bronze. 12 × 4.2 × 4.2

Inv. No. ERKm 515

300

Obelisk with the Arms of Tauris Province

Smoky topaz, jasper, bronze. 11.7 × 4.2 × 4.2

Inv. No. ERKm 517

301

Obelisk with the Arms of Olonetsk Province

Smoky topaz, jasper, bronze. 11.6 × 4.1 × 4.1

Inv. No. ERKm 520

302

Obelisk with the Arms of Siberia

Smoky topaz, jasper, bronze. 11.6 × 4.1 × 4

Inv. No. ERKm 522

303

Obelisk with the Arms of Novgorod-Seversk

Smoky topaz, lazurite, jasper, bronze. 11.6 × 4.1 × 4.1

Inv. No. ERKm 525

304

Obelisk with the Arms of Nizhny Novgorod Province

Smoky topaz, jasper, bronze. 11.7 × 4.1 × 4.1

Inv. No. ERKm 528

305

Obelisk with the Arms of Kostroma Province

Smoky topaz, jasper, lazurite, bronze. 11.6 × 4.1 × 4.1

Inv. No. ERKm 529

306

Obelisk with the Arms of Ufa Province

Smoky topaz, lazurite, bronze. 11.5 × 4.1 × 4.1

Inv. No. ERKm 531

307

Obelisk with the Arms of Riga Province

Smoky topaz, quartz, lazurite, bronze. 11.6 × 4.2 × 4.2

Inv. No. ERKm 532

308

Obelisk with the Arms of Archangel Province

Smoky topaz, quartz, jasper, bronze. 11.6 × 4.2 × 4.2

Inv. No. ERKm 533

309

Obelisk with the Arms of Tobolsk Province

Smoky topaz, quartz, lazurite, bronze. 11.7 × 4.2 × 4.2

Inv. No. ERKm 534

310

Obelisk with the Arms of Penza Province

Smoky topaz, jasper, bronze. 11.6 × 4.3 × 4.1

Inv. No. ERKm 535

European Hardstones

311-14

Pieces from the de Bréteuil Surtout-de-table.
1770s

Giuseppe Valadier. 1762-1839

Provenance: 1785, from the heirs of Alexander Lanskoy,
St Petersburg.

(illus. see p. 159)

This large table decoration *(surtout-de-table)* was acquired by the Empress Catherine II in 1777. On 29 October she declared to Grimm, "The surtout, the surtout, I have told you more than once that it has happily arrived and that it pleases me…"

Each item recalls some monument of Antiquity, for instance a miniature replica of the Arch of Titus and the Temple of Antoninus Pius in Rome, or a rostral column "like that found on the Capitoline", porticos, urns, vases and statuettes.

Made in Rome, the *surtout-de-table* was designed by a young Italian artist, Giuseppe Valadier, son of the jeweller Luigi Valadier. The artist's sketchbook (Hermitage) includes over 70 drawings of architectural ruins, chalices, columns, vases, urns, statuettes, and knives with stone handles for this set. All the objects were arranged on a large plateau (lost) around a centrepiece imitating the fountain at the Villa Albani; the objects could be moved to create different compositions each time. In the introduction to his sketchbook, Valadier wrote, "One can choose as one wishes from the objects large or small which make up the set; moreover there is a sufficient quantity of them to be combined in different ways."

The whole almost perished in strong floods which swept through the capital on 10 December 1777. Catherine wrote to Grimm: "The dessert service of the Bailli de Bréteuil, which arrived some time ago and which is resting from its risks and fatigues in its entirety, without being cracked or broken, either entirely or in part, in the last room in the Hermitage, thought this night to have its part in the wind's revels, for a large cross

smashed nose down into the floor beside the solid table where it was exhibited; this meant that the wind tore back the cloth covering it, but the dessert service is still safe and sound."

Catherine went on to present the table decoration to her favourite, Count Alexander Lanskoy, after whose early death it returned to the Hermitage.

The table decoration takes its name from Baron Louis-Auguste le Tonnelier de Bréteuil (1730-1807), French Ambassador to St Petersburg, who facilitated Catherine's acquisition of the piece. N.M.

311
Portico-ruin of Four Columns on a Two-Tiered Base
Lazurite, white marble with grey spots, bronze; carved, ground, polished, cast, chased and gilded.
Height 36.8; base 25 × 18
Inv. No. ZI 779

312
Portico-Ruin with Two Columns
Shell, pink, reddish-brown and white marbles, bronze; carved, ground, polished, cast, chased and gilded.
Height 36.5; base 19.2 × 14.5
Inv. No. ZI 764

313
Two Chalices on Three-Winged Lions
Red and black marble, bronze; carved, ground, polished, cast, chased and gilded. Height 11; diameter of base 12.3
Inv. Nos ZI 3435, ZI 3436

314
Rostral Column
Spotted red jasper, green marble, silver, gilded bronze; carved, ground, polished, cast, chased and gilded.
Height 48.5; base 8.6 × 8.6
Inv. No. ZI 3496

315
Pair of Vase Censers. 1770s
Matthew Boulton. 1728-1809
Fluorite and bronze; carved, ground, polished, cast, chased and gilded. 23 × 11.5
Inv. Nos E6480, E7549
Provenance: Main Hermitage Collection.
(Illus. see p. 161)

Matthew Boulton was the owner of a well known factory in Soho, Birmingham, which between 1768 and 1782 produced stone and bronze vases, candelabra, obelisks, clock-cases, decorative bronzes for furniture, ceramics, and objects of marble and Derby fluorite. Together with his partner John Fothergill, Boulton received orders via embassies and sold his work to various European countries. Amongst his clients was Catherine II, to whom he was recommended by Baron Grimm. In 1771, the Russian Ambassador to the Court of St James, Alexey Musin-Pushkin, visited his factory specifically to acquire pieces for the Empress.

Boulton sent the vases for the Imperial Court via Lord Cathcart, British Ambassador in St Petersburg. In 1771, tripods were sent to St Petersburg and approved of by the Empress, who in 1772 bought a set of vases, making subsequent orders in 1774 and 1776. The Russian Empress said of Boulton's vases that they were "...in all aspects better than the French". It is possible that these vase-censers were part of the group acquired in 1771 or shortly after.

A similar pair of vases is in the collection of the Earl of Bradford, Weston Park, Shropshire. N.M.

316
Vase-Censer. 1770s
Matthew Boulton, 1728-1809
Fluorite and bronze; carved, ground, polished, cast, chased and gilded. 31 × 11.4
Inv. No. ZI 12614
Provenance: Main Hermitage Collection.
(Illus. see p. 162)

During the 1770s, the style of Robert Adam dominated the decorative arts in England, and this is reflected in the Antique forms and motifs of this vase-censer. Vases of this type were filled with pot-pourri and they differ from ordinary vases in having openings in the neck (in this case in the cover), which allowed the fragrance to spread freely into the room.

Boulton and Fothergill's Book of Patterns I describes this piece as a "lyre" vase. N.M.

317
Vase-candlestick. 1770s
Matthew Boulton. 1728-1809
White marble and bronze; carved, ground, polished, cast, chased and gilded. Height 18.5 with lid (20 with candle-holder), width 9
Inv. No. E1675
Provenance: 1931, from the Museum of Everyday Life (Sheremetev Palace).

One of a pair, this vase has a lid decorated with inverted acanthus leaves and crowning flames which can be upturned to convert the vase into a candlestick. Vase-candelabra and vase-candlesticks were, with censers, amongst the most popular objects produced at Boulton's Soho works. They were usually richly decorated with ornamental (sometimes sculptural) gilded bronze. This vase-candlestick appears in Boulton and Fothergill's Book of Patterns I under the letter "e". N.M.

318
Pair of Wine-Coolers. 1770s
Matthew Boulton. 1728-1809
Birmingham
Gilded bronze; cast, chased, ormulu gilding; ice liner of
white metal. 38.5 × 17 × 14.8
Inv. Nos E 1573, E 1574.
Provenance: 1925, from the Yusupov House Museum,
formerly Yusupov collection.

These wine-coolers may have been purchased by
Nikolay Yusupov during a visit he made to
London in 1776. England was then dominated by
the Neoclassical style, of which the Adam
brothers were the most outstanding
representatives. Robert Adam, architect,
published the antiquities of Rome, while his
brothers James and John designed not only
mansions for the British aristocracy but also the
objects which filled them, often imitating
Antique forms. The Yusupov wine-coolers are
modelled on an ancient amphora and are divided
into three by horizontal articulations: an upper
relief frieze with palmettes; a broad middle band
filled with two relief ram's heads, two medallions
with a scene of sacrifice and four draped festoons
of laurel garlands; a fine third band with fluting
filled with tiny leaves. The smooth shoulders and
lip of the vase (removable) are crowned with a
lid, while the foot of the vase rests on a square
plinth. This model can be seen in designs by
Robert Adam for Neoclassical interiors.

Matthew Boulton was strongly influenced by
the work of the Adam brothers, and often
created bronze pieces to their designs. The
amphora form is common in his work, these
wine-coolers being a superb example on
which the gilded bronze is extremely skilfully
worked. Y.Z.

319
Tapestry: Portrait of Catherine II. 1782-3
Imperial Tapestry Manufactory, St Petersburg
Wool, silk, metal threads. 82 × 62 (oval)
Inv. No. 16192
Provenance: Main Hermitage Collection

From the time of its foundation by Peter I, the
Imperial Tapestry Manufactory regularly
produced woven and tapestry portraits of
reigning monarchs, their family and favourites.
One of the most frequently produced pieces

during the second half of the 18th century was a
portrait of Catherine II after the painted original
by Fyodor Rokotov of 1779 (copies of which were
ordered from various artists for use at the
manufactory). Such skillfully woven portraits
were used as diplomatic gifts or could be presented
to high-ranking guests to the manufactory itself.
Examples are to be found, for instance, in the
royal collections of Sweden and Belgium. T.T.K.

Porcelain

320-33
Pieces from the Green Frog Service. 1773-4
Wedgwood, Etruria Manufactory. England
Queen's Ware, enamel painted
Provenance:
a) Inv. Nos GCh 8443 – GCh 9175: 1912, to the porcelain
gallery of the Hermitage; from 1830 at the English
Palace, Peterhof; from 1777 at Kekerekeksinen Palace
(from 1790 Chesme Palace); purchased 1774.
b) Inv. Nos 20833 – 20866: 1921; from 1879 at the Cottage
Palace, Peterhof; from 1830 at the English Palace,
Peterhof; from 1777 at Kekerekeksinen Palace (from 1790
Chesme Palace); purchased 1774.

The unusual name of the service derives from a
small green frog in a shield which appears on
each of its original 944 pieces. It was
commissioned for Catherine's wayside palace,
built by Yury Velten in 1774–7 on the road from
St Petersburg to Catherine's favourite summer
residence at Tsarskoye Selo, in an area known as
Kekerekeksinen – from the Finnish word for a
frogmarsh. There are now 767 pieces from the
Green Frog Service in the Hermitage.

Catherine ordered the service from
Wedgwood in 1773, via the Russian consul in
London, Alexander Baxter. With covers for 50
persons, and 944 pieces in all (680 piece dinner
service and 264 piece dessert service), the service
presented a tour of the sights of England, each
item decorated with one or more topographical
views: castles, abbeys, palaces and parks, with
none of the 1,222 landscape images repeated.
Such a commission was partly inspired by the
Russian Empress's passion for English
landscaping, and partly by an increasing interest
at the Russian court in the Gothic style, which
was brought to Russia by British architects and
designers. The client specifically requested that
images of Gothic ruins be included. Wedgwood's

partner, Thomas Bentley, drew up a handwritten
catalogue for Catherine in French, listing the
names of all the views according to numbers
which are marked in brown enamel on the back
of each piece.

Wedgwood used a new ceramic material for
the Green Frog Service, created by perfecting
traditional English creamware. In 1766
Wedgwood gave the material the name Queen's
Ware, in honour of his patron Queen Charlotte.
Most of the pieces reproduce the Royal Shape, so
named after Wedgwood used the model in a
service for George III, but some forms, notably
those for the compotiers, cream bowls and ice
pails, were created specially for the Green Frog
Service. This modified version of the Royal
Shape hence became the "Catherine Shape".

The dinner service was decorated with a
border of oak branches, the dessert service with
a border of ivy. When work was nearing
completion, a large part of the service was
exhibited to the British public in London: Queen
Charlotte herself attended the exhibition. L.L.

320
*Oval Dish Decorated with a View of Etruria
Hall, Staffordshire*
38.5 x 29
Mark: *WEDGWOOD; 1129* in brown enamel
Inv. No. Gch 8641

321
*Round Dish Decorated with a View of the
Lodge at Windsor*
Diameter 33
Mark: *460* in brown enamel
Inv. No. GCh 8710

322
*Soup Plate Decorated with a View of
Somerset House*
Diameter 24.25
Mark: *1179* in brown enamel
Inv. No. GCh 9016
(Illus. see p. 8)

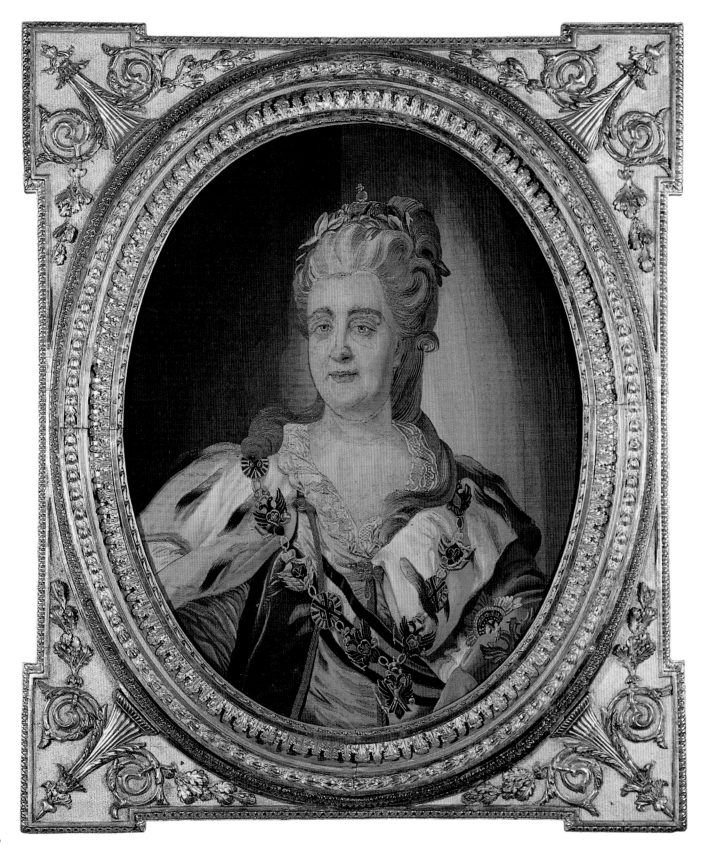

319

320

323

321

326

323

Large Compotier Decorated with a View of Westminster Hall

31.5 × 18

Mark: *WEDGWOOD*; *1267* in brown enamel

Inv. No. GCh 8554

324

Large Compotier Decorated with a View of St James' Palace

31.5 × 18

Mark: *WEDGWOOD*; *1268* in brown enamel

Inv. No. GCh 8553

325

Large Compotier Decorated with a View of the Royal Exchange

31.5 × 18

Mark: *WEDGWOOD*; *1269* in brown enamel

Inv. No. GCh 8482

326

Flat Plate Decorated with a View of Appleby Castle

Diameter 24.5

Mark: *23* in brown enamel

Inv. No. GCh 8799

327

Flat Plate Decorated with a View of the Gardens of Chiswick

Diameter 24.5

Mark: *179* in brown enamel

Inv. No. Gch 8834

328

Square Compotier Decorated with a View of Chiswick House

Length 20

Mark: *966* in brown enamel

Inv. No. 20850

329

Square Compotier Decorated with a View of Stowe

Length 20

Mark: *960* in brown enamel

Inv. No. GCh 8600

(illus. see p. 164)

336

328

330

332

333

330

Oval Compotier Decorated with a View of Northumberland House

22 X 17

Mark: *WEDGWOOD; 1003* in brown enamel

Inv. No. GCh 8588

331

Oval Compotier Decorated with a View of Ingestre Park

22 X 17

Mark: *1008* in brown enamel

Inv. No. GCh 8487

332

Triangular Dish Decorated with a View of the Gothic Tower at Whitton

Length 28.5

Mark: *WEDGWOOD; 646* in brown enamel

Inv. No. GCh 8501

333

Triangular Dish Decorated with a View of Alnwick Castle

Length 28.5

Mark: *WEDGWOOD; 644* in brown enamel

Inv. No. GCh 8503

Catherine's Order Services

The Gardner Factory

One of the first Russian private porcelain factories, founded in 1766 by the English merchant Francis Gardner in the village of Verbilki, Dmitrov District, Moscow Province. Production was established with the aid of a talented Russian ceramicist, A. Grebenshchikov, and a chemist, Franz Gattenberger. From Saxony came the production manager, J. Meisner, and the painter J. Kästner, while design was under the control of Gavriil Kozlov. Employing 70 people in 1771, ten years later this number had grown to nearly 150.

The Gardner Factory soon gained a reputation as the best private porcelain manufactory in Russia, and was commissioned by Catherine to produce four Order Services between 1777 and 1785. These were to be used for receptions in the Winter Palace in honour of the Knights of the four highest Orders in Russia: of St George, St Alexander Nevsky, St Andrew and St Vladimir. In form and decoration, the Order Services were inspired by the Berlin Service presented to Catherine by Frederick II in 1772.

In the 19th century the Gardner Factory's reputation grew, thanks to a series of sculptures of Russian artisans, traders and other folk types, and to its high quality individual pieces. In 1892, the factory was acquired by the firm of M. S. Kuznetsov and is still active today as the Dmitrov Porcelain Factory. T.K.

334-6
Three Pieces from the Service of the Order of St George. 1778

Gardner Factory, Moscow Province.
Design by Gavriil Kozlov
Provenance: Main Hermitage Collection.

The Service of the Order of St George (Georgiyevsky Service) was commissioned together with other Order Services in 1777. The Order of St George the Bringer of Victory was established 26 November 1769 to reward officers and generals for military feats and it had four classes, the highest only for those who had already received the three previous classes, for

335

outstanding military achievements. Only 25 people received the highest award, including the famous commanders Alexander Suvorov, Mikhail Kutuzov, Prince Grigory Potemkin and Pyotr Rumyantsev-Zadunaysky.

The symbols of the first two classes included a gold rectangular star with the device "For Service and Bravery" and the initials "SG" (for St George), and a white enamel cross with the arms of Moscow in the centre, showing St George on a horse defeating the dragon. The ribbon of the Order was orange with black stripes.

With 80 covers (places for 80 people), this service was completed in 1778, at a cost of 6,000 roubles. Its forms include the sculptured figure of a squirrel nibbling at a nut, an allegory borrowed from a book of symbols and emblems, where it was accompanied by the didactic explanation "without labour it cannot be gained"- a direct reference to the award of the Order of St George. The service was first used to serve a ceremonial dinner in the Winter Palace on 26 November 1778, on the ninth anniversary of the foundation of the Order, and was used thenceforth at all later anniversaries. T.K.

334
Leaf-shaped Compotier, with Ribbon, Cross and Star of the Order of St George

6.5 × 25.2 × 25
Marks in cobalt underglaze: G
Inv. No. ERF 6871
(illus. see p. 163)

335
Elongated Leaf-shaped Compotier, with Ribbon, Cross and Star of the Order of St George

6.7 x 30 x 24
Marks in cobalt underglaze: G
Inv. No. ERF 318

336
Flat Plate with Festooned Edge, with Ribbon, Cross and Star of the Order of St George

3.5 × 23.5
Inv. No. ERF 302
Marks in cobalt underglaze: G
Mark stamped in the mass: 1

336

337

337-8

Two Pieces from the Service of the Order of St Andrew. 1778

Gardner Factory, Moscow Province. Design by Gavriil Kozlov

Provenance: Main Hermitage Collection.

The Order of St Andrew – Russia's first such Order – was founded c. 1698 by Peter I: all newborn male children of the House of Romanov were to become Knights of the Order. The Order's anniversary, 28 November, was marked with great ceremony at court and originally the table was laid with the gold service and the Meissen porcelain service with symbols of the Order presented to Empress Elizabeth in 1745 by the Elector of Saxony, Augustus III. In 1777, Catherine II commissioned this Service of the Order of St Andrew (Andreyevsky Service), the smallest of all four Russian Order Services, with covers for only 30 people: in the 18th century the number of Knights of this most honourable Russian Order never exceeded 30. The service was completed and sent to St Petersburg in 1780.

 Running around the edges of the dessert plates and openwork baskets is the colourful chain of the Order of St Andrew. The cream cups, dishes, rosettes and handles in the dinner service were decorated with the pale blue ribbon and cross of the Order. T.K.

337

Leaf-shaped Dish, with Ribbon, Star and Symbol of the Order of St Andrew

4.5 × 19.7 × 11

Mark in cobalt underglaze: *G*

Inv. No. ERF 295

338

Flat Plate

3.5 × 24

Mark in cobalt underglaze: *G*

Mark stamped into the mass: *

Inv. No. ERF 289

338

339

Plate from the Service of the Order of St Alexander Nevsky. 1777-80

Gardner Factory, Moscow Province. Design by Gavriil Kozlov

3.2 × 23

Mark in cobalt underglaze: *G*

Mark stamped into the mass: *

Inv. No. ERF 273

Provenance: Main Hermitage Collection.

The Order of St Alexander Nevsky was founded by Empress Catherine I in 1725. The service for Knights of the Order, with 40 covers, was made between 1777 and 1780. Like the other Order Services in form and decoration, it bears the eight-pointed star of the Order with the device "For Labours and for the Fatherland". The edges of the plates and compotiers have a red moiré ribbon with the cross of the Order of St Alexander Nevsky and his monogram, "SA". T.K.

340-1

Two Pieces from the Service of the Order of St Vladimir. 1783-5

Gardner Factory, Moscow Province. Design by Gavriil Kozlov

Provenance: Main Hermitage Collection.

Catherine founded the Order of St Vladimir on 22 September 1782 to mark the 20th anniversary of her reign. The service for the Order (largest of all the Order Services, with covers for 140 people) was therefore commissioned later than the others, in 1783. Its cost, at 15,000 roubles, was almost equal to that of the three other services put together (16,000 roubles). T.K.

340

Leaf-shaped Compotier, with Ribbon, Star and Symbol of the Order of St Vladimir

6.5 × 25.5 × 25

Inv. No. ERF 268

341

Flat Dish, with Star of the Order of St Vladimir

3.5 × 22.3

Mark in cobalt underglaze: *G*

Mark stamped into the mass: °°

Inv. No. ERF 7048

339

340

341

342-4
Pieces from the Cabinet Service. 1793-1801
Imperial Porcelain Manufactory, St Petersburg
Porcelain, overglaze painting, gilding
Provenance: Main Hermitage Collection.

The Cabinet Service played a unique role in the further design of Russian dinner services during the late 18th century. Originally it was named after its owner, Count Alexander Bezborodko (1747-99), for whom on 18 February 1793, Catherine ordered "a table and dessert service with biscuit and coffee pieces…", which was, in its composition and richness, to match the Arabesque Service. The latter had been made at the Imperial Porcelain Factory and presented to the Empress in 1784; it had amazed courtiers with the beauty of its decoration and its variety of forms – over 50 in all.

Bezborodko's service was just as rich in composition, including table decorations of nine white allegorical sculptures in biscuit. All the pieces are decorated with gilded edges with rich garlands of wild flowers and views of Rome and its surroundings. The models for these landscape miniatures were the compositions of Giuseppe Vasi, Piranesi and others in illustrated 18th-century publications with engraved views of Roman antiquities, such as *Delle Magnificenze di Roma antika e moderna. Da Giuseppe Vasi da Corleoné* (10 books, Rome, 1764) and *Le Antichità romane, opera di Giambattista Piranesi* (4 vols, Rome, 1756).

The dining service, which included a *surtout-de-table*, was made in 1794 and additions continued to be made right up to the death of Prince Bezborodko in 1799. Around one thousand pieces were made in all.

Due the perfection of its forms and the harmony between form and rich decoration, allowing for endless variations, this service became the standard for many later commissions and gave rise to numerous imitations well into the late 19th century. T.K.

342
Oval Dish with Openwork Border
View of the Temple of Concordia, Rome, in an oval medallion
Handwritten inscription on the bottom, black overglaze: *Temple Concorde*
4 × 34.6 × 27.5
Marks in cobalt overglaze: *II* beneath a crown
Figures handwritten in the porcelain mass: 26
Inv. No. ERF 8916 a
(Illus. see p. 164)

343
Flat Plate
View of the Street near the Church of Sant'Andrea, Rome, in a round medallion
Handwritten inscription on the bottom, black overglaze: *Rue qui est aupré l'église de s: André*
3.5 × 24.1
Mark in cobalt overglaze: *E II*
Inv. No. ERF 6833

344
Flat Plate
View of the Palazzo Stoppani, Rome, in a round medallion
Handwritten inscription on the bottom, black overglaze: *Palais Stoppani*
3.5 × 24.3
Mark in cobalt overglaze: *E II*. Figures handwritten in the porcelain mass: *70*; in gold: *
Inv. No. ERF 6852

345
Dish from the Mecklenburg-Schwerin Service of Grand Duchess Yelena Pavlovna. 1797-9
Imperial Porcelain Manufactory, St Petersburg
Handwritten inscription on the bottom in back: *Civita Castellana*
Porcelain, overglaze painting, gilding. 3.2 × 25.2 × 18.2
Mark in cobalt overglaze: *II* beneath a crown
Inv. No. ERF 7704
Provenance: Main Hermitage Collection.

During the last years of her reign, Catherine II began putting together a trousseau for the elder daughters of her son Paul, Alexandra and Yelena. Each sister had made for her porcelain dinner and dessert services, coffee and tea sets, a table decoration of biscuit figures on mirror platters,

343

344

finished with glass and bronze, plus a bronze table with a porcelain top and a déjeuner service of seven items. Porcelain was used in many parts of the toilet set, which included a mahogany dressing table decorated with biscuit bas-reliefs, a toilet mirror in a bronze frame on a porcelain pedestal, two candelabra with biscuit figures, small porcelain vases, baskets, powder cases, small containers, brushes, a washing bowl and ewer, and two déjeuner services of five and four pieces. The whole was complemented by two clocks and two candelabras decorated with porcelain, bronze and marble.

Based on the Cabinet Service in form and type of decoration, these services differed in the use of rose borders in place of wild flowers. Each of the princess's services had over 1,100 dinner and dessert pieces and an ensemble of 28 biscuit sculptures on marble and bronze pedestals decorated with "arabesque bas-reliefs" to models by Jacques-Dominique Rachette. T.K.

346

Dish from the Imperial Service, with Views of English Castles. 1793-6

Black handwritten inscription. *Vue des Ruines du château du Comté de Burligton, à Knaresborough, dans la province d'York.*

Porcelain, monochrome overglaze painting, gilding

5.5 × 38.7 × 28.7

Mark in cobalt underglaze: *E II*

Mark stamped into the mass by hand: 2

Inv. No ERF 76 a

Provenance: Main Hermitage Collection.

This service would seem to have been influenced by Catherine's faience Green Frog Service, from which the subjects and their arrangement on the surface, surrounded by a frame of branches and leaves, were directly borrowed. In place of the shield with a green frog, however, the Russian service has the gilded monogram "*E II*". Its forms are also stricter and more classical than Wedgwood's service, and were based on those of the Cabinet Service.

The dish shows the castle at Burlington, Knaresborough, Yorkshire; on the lid (not exhibited) are views of the castle at Conisborough, Doncaster, Yorkshire, and a view of Woburn, Surrey. T.K.

345

346

347, 348
Plates from a Dinner Service with Grisaille Landscapes. 1793-1810s

Imperial Porcelain Manufactory, St Petersburg

Porcelain, overglaze painting, gilding

Provenance: Main Hermitage Collection.

One of many court ensembles modelled on the Cabinet Service, this dinner service repeats the forms and the overall scheme of decoration, but reveals great differences in the type of ornament and the colour scheme. The wild flowers of the Cabinet Service are here replaced by grey meander against a gold ground and garlands of laurel leaves and there are monochrome architectural landscapes in medallions. Different pieces of the service bear the marks of three reigns, Catherine II, Paul I and Alexander I, indicating that items continued to be added to it throughout these years. T.K.

348

347
Soup Plate with an Italian Landscape with Houses and Border of Grey Meander and Gilded Garlands of Leaves

Mark in cobalt underglaze: *E II*

Mark stamped into the mass by hand: *4*

347

348
Soup Plate with an Italian Landscape with Ruins of a Fortress on a Hill and Border of Grey Meander and Gilded Garlands of Leaves

Mark in cobalt underglaze: *II* beneath a crown

Cobalt mark: *и*

5.5 x 23.7

Inv. No. ERF 336 T.K.

349
Console. 1800s

St Petersburg

Wood, marble; carved, tinted and gilded. 86 x 118 x 52

Inv. No. 167/1

Provenance: 1941, from the Museum of Ethnography; previously in the Bobrinsky Palace Museum.

One of a pair of consoles formerly kept in a building on Palace Embankment used in the early 19th century as a "reserve" for the reception of guests and for various ceremonies. They probably relate to the building's redecoration in 1807 by the architect Andrey Voronikhin, for they are typical of the early Russian Empire style. T.S.

China and Chinoiserie

Oriental Rooms and Catherine's Chinese Collections

MARIA MENSHIKOVA

Architecture, parks and landscape pavilions, the collecting of Oriental curiosities and philosophical thought, all reflected the European interest in the East – particularly China – which lasted throughout the 18th century. St Petersburg could not remain untouched by the fashion and costly Oriental objects occupied a notable place in palace interiors and collections from the very foundation of the city – along with "chinoiserie" imitations and the creation of stylised settings for genuine Oriental works. "Lacquered rooms" were created at Peter I's Great Palace at Peterhof; other palaces, such as Monplaisir and Catherine I's Yekaterinhof, were decorated with Chinese, Japanese and Persian ornament; palace rooms were decorated with Chinese silks and wallpapers. Peter gathered in his Kunstkammer Chinese rarities and precious items, sending envoys to Persia and China to bring back whole caravans of goods – rolls of silk, porcelain, silver, tea and a wealth of other objects. Such trading links were further reinforced during the reigns of Anna Ioannovna and Elizabeth, many of the goods brought by traders being taken for the treasury – i.e. the imperial court – and the rest sold at auction.

Yury Velten: *Chinese Pavilion* [Cat. 421]

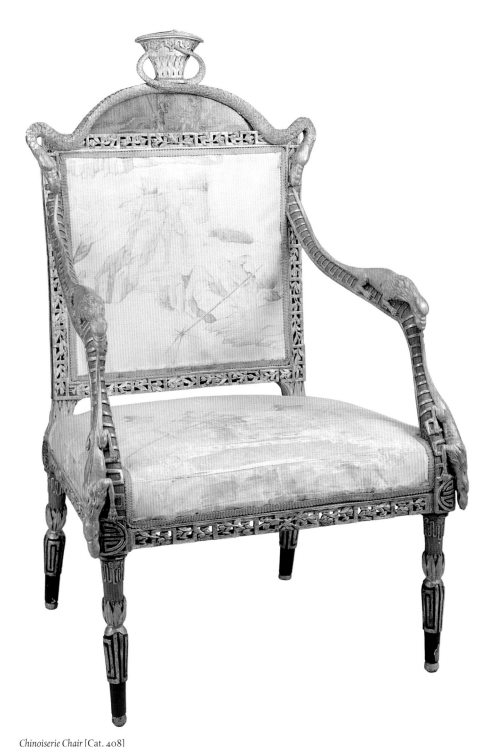

Chinoiserie Chair [Cat. 408]

When Catherine II came to the throne, the imperial collections thus already contained many Oriental works, but it was she who was to take the Russian interest in China and chinoiserie to new heights.[1]

Like many educated people of her time, she was much absorbed by the concept of the enlightened ruler, of a type thought to be found in China. One of Catherine's regular and most influential correspondents was Voltaire, with whose writings on China she was familiar: he praised the Celestial Kingdom, its monarchs and men of wisdom; only in China, he thought, were man's life, honour and property truly protected by the law. Such a clear link between Catherine's desire for justice and order in Russia (as reflected in her "Instruction") and general perceptions of good Chinese government, taken with the fashion for "curios" of all kinds, led in the 1770s to a great surge of interest in China. Alexey Leontyev, one of Russia's earliest sinologists, produced the first ever translations into any European language of several Chinese treatises, including *The Chinese Teachings of Yongzheng to His Son*, *The Chinese Code*, the laws of Chinese government and much more. Most of the translations were carried out by imperial order and were "printed at the expense of the Cabinet".

Catherine built on a vast scale, paying particular attention to her country residences, where she ordered the creation of rich interiors and park structures in the chinoiserie style. At Oranienbaum, for instance, where she had spent much of her time as Grand Duchess, a small building was erected, in a transitional style somewhere between Rococo and Neoclassicism, with Large and Small "Chinese Rooms". This came to be known as the Dutch or Chinese Palace (1762-8; architect Antonio Rinaldi) and until the early 19th century the park and gardens still had Chinese pavilions and plants. Genuine Oriental pieces were used in the decoration, as well as chinoiserie items already at

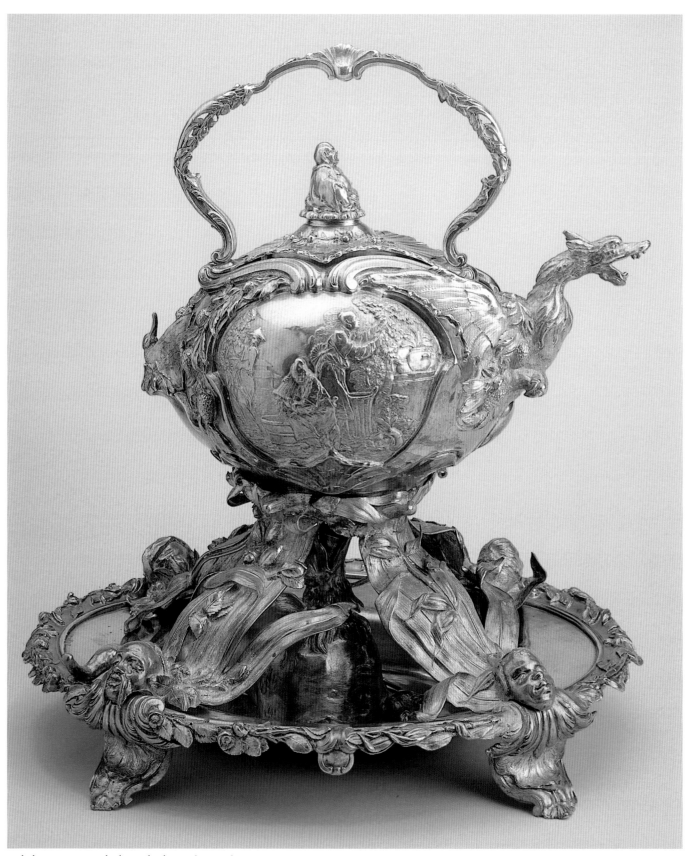

Nicholas Sprimont: *Tea-kettle, Stand and Burner* [Cat. 405]

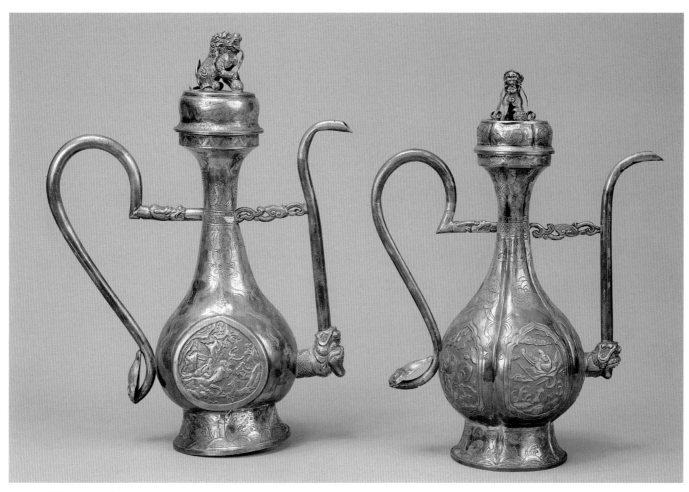

Wine Vessels [Cats 380, 381]

Oranienbaum, but these proved insufficient and caravans sent to China in the 1760s and 1770s were ordered to bring back more. Lacquered tables, chairs, commodes, textiles, wallpaper, ivory dolls, books and many other pieces were delivered in 1772 and 1775.[2]

Today the Chinese Palace has St Petersburg's only chinoiserie interiors to survive essentially unchanged since the late 18th century. Many of the chinoiserie objects kept there were, however, in 1792 transferred to the Hermitage (such as the silver Oranienbaum Service).

But it was Tsarskoye Selo which truly occupied the Empress's "improving" tendency, and once more the influence of the Orient was brought to bear. The Great Palace had Oriental rooms, most importantly the Chinese Room designed by Charles Cameron: although it has not survived, we know it was decorated with Chinese porcelain and lacquer, and such interiors must undoubtedly have been influenced by English examples of chinoiserie style, such as Claydon House, which Cameron would surely have seen in his native Britain.

The English tradition – as represented by Stowe – also came to play in the park, where Catherine had built a Chinese Theatre, a Chinese Village, Chinese Pavilions, Turkish Baths, a pyramid and much more. A large surviving body of designs for such buildings and their interiors by Yury Velten and the Neyelov brothers provides much information about the extent of the planned "Chinese" works. The Neyelovs travelled to

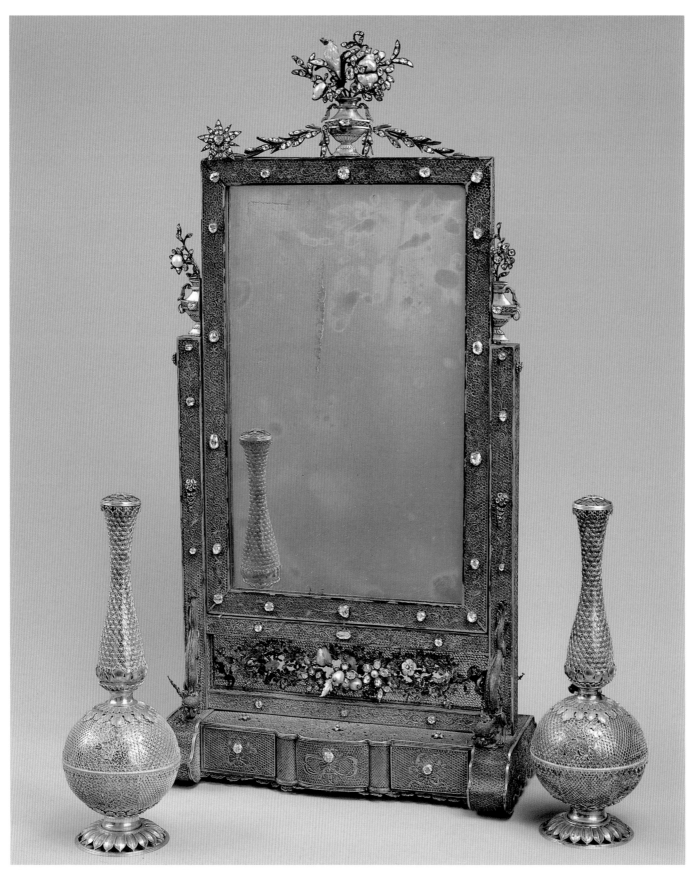

Table Mirror [Cat. 354] and *Rose-Water Sprinklers* [Cat. 362]

England, perhaps visiting the gardens at Stowe and Kew; on their return they worked with Cameron on chinoiserie designs. Some were apparently never used, or these buildings were later reworked, but several such structures survive today, among them the Chinese Village.

Inside Petersburg's palaces were numerous examples of chinoiserie applied art: textiles, jewellery and personal items, silver cutlery and vessels, even furniture, such as a cylindrical marquetry bureau by David Roentgen of 1785 (Hermitage; transferred from Peterhof in 1932). Court interest in chinoiserie was reinforced during a visit to St Petersburg in 1777 by the Swedish King Gustav III, who had recently completed a Chinese Pavilion at Drottningholm (1753-77). Gustav attended sessions at the Academy of Sciences, where he heard reports of journeys to China and looked over the Kunstkammer, the small museum founded by Peter the Great. Knowing of the King's interest, Catherine ordered for him at the Imperial Porcelain Factory a "Chinese" stove, now at Drottningholm.[3]

The Winter Palace – main imperial residence – was caught up in the whirl of interest in "exotica". Inside Catherine's "imperial museum"... " everything breathed Asia". Catherine wrote to Melchior Grimm in October 1777 of her rooms decorated in Oriental style: "this museum forms a haven, which one reaches via China, China via Turkey, Turkey via Persia."[4]. Contemporaries wrote that "the Sovereign's mezzanine apartments are decorated with taste and most richly and there are many curiosities particularly of the type of Chinese objects."[5] In her Lantern Study, the interiors included Chinese porcelain, "barrel chairs" and textiles; here Catherine loved to play cards, inviting her closest friends – Stroganov, Orlov, Betskoy – people who shared her interests and who often had their own by no means insignificant Chinese collections.

In the 1770s, silver, filigree, mirrors and engraved gems were transferred to the Hermitage and a new inventory of precious items was begun in 1789, an inventory which is today a key document in the study of Catherine's collections.[6] It includes Chinese objects, although when and how they entered the museum remains unclear: they may have been transferred from other parts of the palace or from stores; they may have been recently acquired or received as gifts. Certainly, however, these collections were more accessible in the Hermitage than they had been before. They were seen by visitors to the imperial museum, such as Johann Georgi (1794), who mentioned Chinese curiosities in cabinets near the Raphael Loggia, including tableware, silver filigree tea sets, toilet sets with mirrors painted with brightly coloured birds, gilded "Tibetan" idols and stone works, "evidence of the art of the Chinese in carving".[7]

Late 18th-century descriptions record Chinese lacquered chairs, cupboards, textiles and porcelain, much of which has presumably since been lost or is now outside the Hermitage. Worthy of particular note are the "various mirrors, for dressing tables and on stands, and sets to them",[8] recently identified in the Hermitage. Made for export in China and India, in the middle of the 18th century, their forms are mainly European (many were long considered to be of European make), but some are very Chinese in appearance, and it was these pieces which provided the key to the attribution. Technical devices – filigree, enamel and paint – reveal the hand of an Oriental master in the fineness and complexity of the work, while the pomegranates, flowering branches and spirals in the decoration all

Six Ornaments in the Form of Phoenixes [Cat. 383]

come from the accepted repertoire of traditional Chinese benevolent images. The Indian pieces can be distinguished since all have the same 'weave' of silver wire while several imitate Near Eastern forms. The filigree is woven of such fine wires that in 18th century Russia the same word was used as for the finest of gold and silver thread.

Several Chinese mirrors survive with reverse painting on glass, for instance a pair with pictures of Chinese figures and landscapes, set in Russian carved and gilded wooden frames. One of these is on display in the exhibition. Such mirrors were a common export to Europe, frequently found in England; some clearly made their way to Russia. Another mirror, recorded in the Winter Palace since the 18th century, comes from a toilet service. It has a silver filigree frame and is painted with a pair of pheasants and flower ornament: this would seem to be the mirror mentioned by Georgi. One mirror in the form of a table screen, of gilded silver with fine filigree, was considered insufficiently decorative in Russia, where many pearls and diamonds were added.

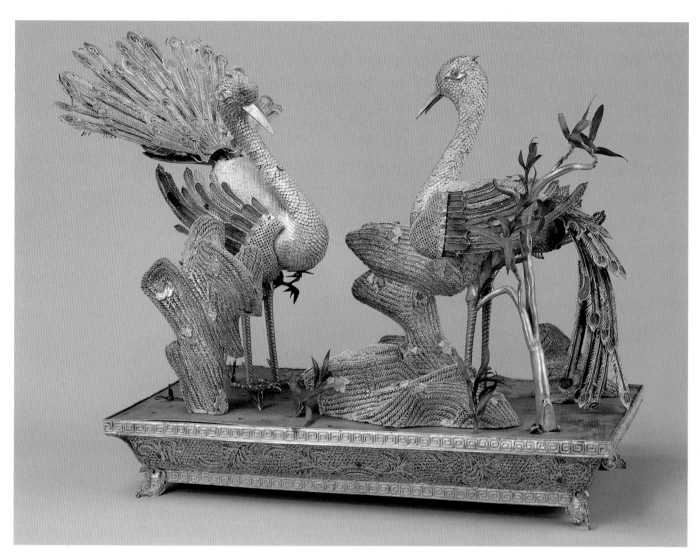

Table Decoration [Cat. 363]

Catherine's collections included much tableware. Coffee was her favourite drink: "After her morning toilet the Empress went to her study, where she was brought strong coffee with thick cream and toast. The coffee was made for her using one pound to five cups [of water], after which the lackeys added water, then the cooks boiled it again... In old age the Empress was forbidden coffee because of her plethora, but she nonetheless continued to drink and on the day of her death had two cups of it."[9]

Her passion for coffee might explain the number of silver Chinese vessels she owned, with gilding, enamel and filigree. China began exporting silver to Europe no later than the 17th century and some pieces must have arrived in St Petersburg even during the reign of Peter I. Chinese jugs (intended for wine) with a high neck and long spout were used in 17th- and 18th-century Russia as coffee pots, known by the Turkish word *kulgan* (*kumgan*). Although many of the teapots and coffee pots in the Hermitage use forms which are traditional to this day in Europe and Russia, their Chinese subjects and decoration leave no doubt as to their Oriental origins.

Chinese gold was much less common than silver in European collections. Catherine's inventory begun in 1789 mentions the first gold jewellery only after 1790: here we find

mention of a "table with a Chinese female head-dress of gold filigree" (the phoenixes forming part of the Chinese Empress's crown). It was perhaps only at this late date that Catherine handed the gold items (including the phoenixes) over to the Hermitage; they may have been kept before this near the Throne Room in the Winter Palace, where the regalia, crowns and precious objects were on show.[10] Or they may only have arrived in St Petersburg around 1790, perhaps as diplomatic gifts.

Catherine's collections included several sculptures of gold and gilded silver, described as "idols" and "little statues". Some survive today, although they do not come originally from the Winter Palace. They were kept in different imperial palaces in the middle of the 18th century, and they bear a variety of old inventory numbers.

Chinese gold and silver jewellery, Chinese curiosities and books all served as models for chinoiserie objects, as in the Russian card table of the 1770s included here, one of a pair with a marquetry top showing a Chinese woman seated at a table. It may have been influenced by objects in circulation in St Petersburg: certainly we can see the likeness between the objects depicted and the silver cups and teapots, the artificial pot with flowers made of semi-precious stones, the pile of books and the hair ornament, all illustrated nearby.

Chinese pieces from Catherine's collection were kept in the 19th and early 20th century in the Gallery of Objets de Vertu,[11] but later they were passed from one department to another or were even given to other museums. Many pieces had the wrong attribution: the hairpins were sometimes described as Japanese and the silver filigree toilet boxes were thought to be of Western manufacture, possibly because of the European forms or the Russian silver marks. Today, research is making it possible to establish once more the full scale of Catherine's Oriental collection.

Only a small quantity of the Hermitage's gold hairpins and ornaments, gold sculpture and silver gathered by Catherine in the 18th century, a collection unique in both quality and quantity, can be included here. Never previously exhibited outside Russia, it is published here for the first time.

NOTES

1 Voltaire mentions China in a number of his works: *Essai sur les moeurs et l'esprit des nations*, chapter 195; *Le siècle de Louis XIV*, chapter 39; *Dictionnaire philosophique de la Chine*, "L'or de la Chine".

2 Central State Archive of Ancient Documents, *opis* 14.1, delo 213, 1764-72.

3 *Catherine the Great & Gustav III*, Stockholm, 1999, p. 159.

4 SbRIO vol. XLIV 1885.

5 P. B. Sheremetyev: *Otgoloski 18v.* [Echoes of the 18th Century], St Petersburg, 1889, issue 6, p. 43.

6 Hermitage Archives, Fund 1, *opis* VI, 3N9, vol. 1.

7 Georgi 1794, pp. 342, 386-9.

8 Russian State History Archive, Fund 470, *opis* 106/540(2), documents 93, 165.

9 Pylyayev 1990, p. 183.

10 G. Lieven: *Putevoditel' po Kabinetu Petra Velikogo i Galereye dragotsennostey* [Guide to the Cabinet of Peter the Great and the Gallery of Objets de Vertu], St Petersburg, 1902.

11 G. N. Komelova: *Zimniy dvorets* [The Winter Palace], St Petersburg, 2000.

Toilet Sets

Toilet sets were used as wedding gifts in both Russia and Europe, and those in the Russian imperial collection were often passed from generation to generation down the female line. Mostly made of silver, more rarely of gold, toilet sets – in which the mirror was usually the central feature – were an attribute of the life of rich Europeans in the 17th and 18th centuries.

With the development of the East India Companies, silver items were sometimes purchased ready made in the Orient, where labour was cheaper. "Chinoiserie" jewellery was most popular from the last quarter of the 17th to the middle of the 18th century, influenced by the fashion for exotica. Even Goethe noted the passion for Oriental fripperies, and in his *Triumph of Sensibility* he mocked the domination of chinoiserie objects, mentioning specifically lacquer trays, toilet boxes and tea trays.

Commissions were often executed in China according to European designs and thus many objects employ a European form to which the Chinese decoration is subordinated, leading to problems with identification of their origin.

Filigree toilet sets are an extreme rarity, the technique having been used only infrequently in silver and many such sets having clearly been divided or melted down. We know of only one full filigree toilet set, perhaps of late 17th-century European make (Burghley House), and several individual pieces from the second half of the 18th century in private collections in Britain (Powis Castle, Knole House).

All the more interesting, therefore, is a comparison of Catherine's 1789 inventory and surviving pieces in the Hermitage, which make it clear that she had two silver filigree toilet services composed of mirrors with other objects (caskets, boxes, trays and bottles) of high-grade silver (higher than sterling, about 96-7) grouped around them. Many of the items were fully or partially gilded.

Before the inventory was compiled, however, some objects from one set were added to the other and thus the pieces became confused. These have now been divided and it becomes clear that one set is of Chinese and the other of Indian workmanship. Both were produced in the middle of the 18th century and are extremely rare: no other such large sets are known anywhere. We cannot say when or how they arrived in Russia and the issue is confused as most of the pieces were considered to be of European make and they were split between separate museum departments.

The Indian pieces, with a lobed mirror and 19 objects, are of identical intertwined filigree, and are very simple in decoration. The mirror to the second, Chinese, set of 32 pieces was mentioned in Georgi's 1794 description of the Hermitage: it represents a rectangular screen on a stand, decorated with reverse painting of birds on glass, with peacock and kingfisher feathers, mother-of-pearl and semi-precious stones. The boxes and sprinklers in this set employ both European and Oriental forms, while the decoration is made up of traditional Chinese devices and symbols. Objects are mainly paired, and these pairs would have been grouped symmetrically around the mirror, with one box in the centre.

Today we continue to be amazed by the elegance and lightness of these works, particularly those of openwork filigree without a more solid frame beneath. Such openwork boxes and baskets were presumably intended purely for decoration, to hold gloves and other trinkets, and must once have had a silk lining. Their extreme fragility would explain why so few have survived.

A study of a Christie's list of the sale of property formerly belonging to the late Queen Charlotte, consort of King George III of England (1760-1810), held 17-19 May 1819, would seem to suggest that she owned similar Oriental (Indian and Chinese) filigree pieces. One mirror, for instance, listed under No. 90, is described as "A frame for a toilet glass, of silver filligree". Unfortunately the items were dispersed and their fate is unknown. M.M.

350-3
Toilet Set. Mid-18th century
India, Karimnagar, Deccan (?)
Provenance: Main Hermitage Collection.
First publication.

It cannot be excluded that such fine filigree appeared in India in the late 17th and early 18th centuries under the influence of Chinese silver, which the East India Company imported in some quantity from China to Europe via India. Europeans were able to commission additional silver from India to add to ready made sets. Such influence has been suggested by several authors, albeit with some caution, and certainly many 18th-century Indian pieces have been mistakenly identified as Chinese on the basis of their style and technique.

In the 1789 inventory mention is made of a "mirror in silver filigree frame" with a set of "silver filigree items". All the pieces which make up this toilet set have identical lace filigree in the form of "commas" combined to form scroll or flower ornament. M.M.

350
Toilet Mirror
Frame: silver, filigree: base of Swietenia Meliaceae wood. Height 74
Inv. No. E 3205.
Table mirror with S-shaped sides, on short legs with a flap leg at the back. At the top a small rhomboid crown-mirror which could be removed for use as a hand mirror. The mirror is set in a fine silver filigree frame with spiral scroll ornament, the ends winding into carnations – a feature typical of Indian metalwork.

A mirror of similar form in a filigree frame is at Burghley House, and was listed there in the inventory of the 1690s; it came from Chatsworth (Burghley House, Silver Exhibition, 1984, pl. 19). An even closer analogy in terms of the filigree style and execution is a mirror from a toilet set at Knole House, Kent. There are pieces with the same filigree work and pattern at Powis Castle, listed in the inventory of 1774 (Clive Collection 1987, No. 188). M.M.

350

351

351

351

Pair of Candlesticks

Silver, filigree. Height 28

Inv. Nos E 2556, E 2557

The candlesticks are of European form with
trumpet-shaped foot. They are made totally of
silver filigree, the ornament arranged in fluted
vertical bands narrowing towards the top. M.M.

352

Box with Lid

Silver, filigree. 12 x 9.7

Inv. Nos LS 17

Small box in the form of a cloud, recalling the
top of the *ruyi* sceptre. Made of the same fine
silver filigree as the mirror and candlesticks, in
the centre of the box, on the lid and bottom are
multi-petal flower rosettes of wire. M.M.

353

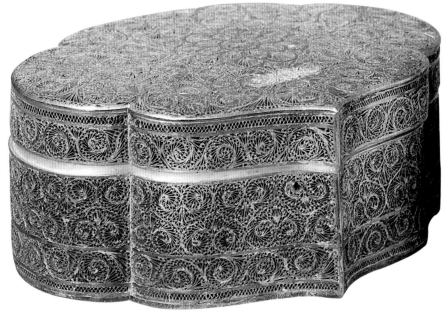

353

*Perfume Bottle in the Form of a Vase with
Bouquet, on a Stand*

Silver, silver filigree, glass. Height 15.5

Inv. No. LS 34 a-g

This is an *attardan* (a perfume or lavender water
bottle) of Indian form. It stands on a tray
shaped like a five-petal flower. The upper part of
the bouquet opens to reveal inside a faceted
glass bottle with an openwork silver container
and silver lid, which would have held incense
or perfume.

 Also in the Hermitage is a pair to the perfume
bottle and they were listed in the inventory of
1789 as "two pieces like glasses, with flowers at
the top, inside each a phial, beneath the pieces
trays, each with five feet." M.M.

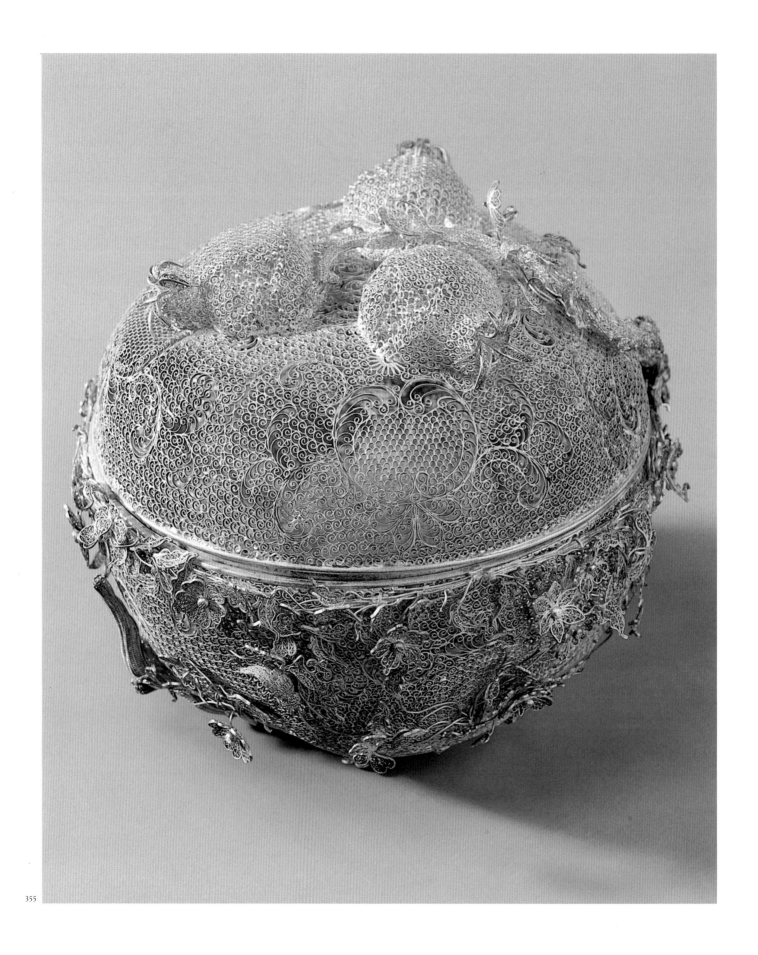

355

354

Table Mirror. Mid-18th century

China, made for export to Europe; additional decoration in Europe

Silver, silver filigree, enamel, wood, silk brocade, diamonds, pearls, mother-of-pearl. 58.5 × 27.5

Inv. No. LS 578

Provenance: Main Hermitage Collection.

First publication.

(Illus. see p. 206)

In the form of a Chinese rectangular table screen, this mirror revolves on its stand and can be adjusted to a convenient angle. Set in a gilded silver frame with additional airy silver filigree of different diaper patterns on the front, like the design on the boxes [Cat. 364].

The stand is of traditional Chinese form: the mirror is supported on two bars which rest on broad perpendicular supports, on each side of which there were originally four gilded silver filigree dragons, of which only three have survived (two in front and one behind). Between the supports on the base is a filigree ornament with massy flowers and leaves, partly covered with blue and green enamel and with three pearl flowers on spiral springs. In the lower part of the pedestal are three drawers, their insides gilded and the handles in the form of rosettes with rings.

At some point in the 18th century, when the mirror arrived in Europe or Russia, the decoration was found to be insufficiently luxurious and the mirror was given additional vases, garlands and flowers, using diamonds, pearls and mother-of-pearl. Attached to the upper bar is a bouquet of roses made from a large Baroque pearl with leaves of diamonds, in a vase decorated with horizontal bands of diamonds and with handles made of silver garlands. The side vases have rings with garlands of leaves decorated with diamonds. On one side the garland ends in a star with rays, again decorated with diamonds, and according to the Hermitage inventory of 1859 the other side had a sickle moon, also covered with diamonds. The frame has 18 rosettes with diamonds.

Removable half-vases now rest on the side columns probably once occupied by Chinese figures of lions; one contains a bouquet with a flower made of a large Baroque pearl and diamond leaves; the other has a branch and a flower with diamonds. Diamonds also adorn many other details.

Listed in the inventory of 1789 as having been

moved from the mezzanine apartments, it is described as "mirror in silver filigree frame with gilding in places set with rose diamonds with pearls, with three drawers, each drawer with one... rose diamond pendant, with four dragon's heads, two of which have one small pendant each and a little garden at the top, in which are flowers of rose diamonds and pearls." Unfortunately, not all the details have survived. The 1789 inventory mentioned no toilet service to this mirror.

Although the mirror was made in China for export, in type it may reflect a style used by Chinese women in the 18th century. M.M.

355

Globular Box with Cover. Mid-18th century

China

Silver filigree. Height 10

Inv. No. LS 4a, b

Provenance: Main Hermitage Collection.

First publication.

Made completely from lace filigree, this box is shaped as a pomegranate on a gnarled branch which serves also as the base. The handle is composed of three small convex pomegranates and on the sides of the box are flowers, branches, butterflies and other ornaments attached to springs and wires. Several patterns can be picked out in the weave of the filigree – scrolls, net and some pomegranates as on the basket box [Cat. 357].

In China the pomegranate was a symbol of the desire for numerous male offspring, in accordance with the saying "may you have as many sons as there are seeds in a pomegranate".

There are two such boxes from the toilet-set of Catherine the Great, both of which would have stood on leaf trays [Cat. 356]. They appear in the inventory of 1789 as "two round little boxes with flowers and lids; on the lids fruits; set on leaves of filigree work".

Christie's list of the sale of Queen Charlotte's collection on 17-19 May 1819 mentions several Chinese filigree pieces, among them lot 43, "globular baskets and lids with leaf shaped stands to match". M.M.

356

Pair of Trays. Mid-18th century

China

Silver, silver filigree. Length 20

Inv. Nos LS 41, LS 42

Provenance: Main Hermitage Collection.

First publication.

Two leaf trays to the pomegranate boxes [Cat. 355], of identical weave fine silver openwork filigree, the veins picked out with filigree bands. Along the edges are small leaves and flowers like the decoration on another tray [Cat. 359] but without the gilding. These trays stand on round feet.

Listed in the inventory of 1789 as "two small leaves on low round bases", they formed part of Catherine's toilet service. M.M.

357

Basket Box with Lid. Mid-18th century

China

Silver, gilding, enamel, paint; filigree, granulation.

19.5 × 23

Inv. No. LS 2a, b

Provenance: Main Hermitage Collection.

First publication.

Octagonal box of openwork silver filigree; along its curving sides are branches on wires with flowers and leaves, partly gilded, partly decorated with blue and green paint and enamel. The lid handle is composed of massy filigree burst pomegranates (symbol of numerous male offspring), the seeds made using the granulation technique. The filigree net includes details woven to form leaves, flowers and pomegranates, as on the globular box [Cat. 355].

Also in the Hermitage is a pair to this box; both formed part of Catherine's toilet service. They are listed in the inventory of 1789 as "two tall little boxes with projections in places with gilded flowers, octagonal, on the top a lid with fruits".

No. 42 in Christie's sale of Queen Charlotte's collection on 17-19 May 1819 was "an octagonal scalloped basket and cover, with handle covered with fruit, flowers and insects in relief, of the most delicate workmanship". M.M.

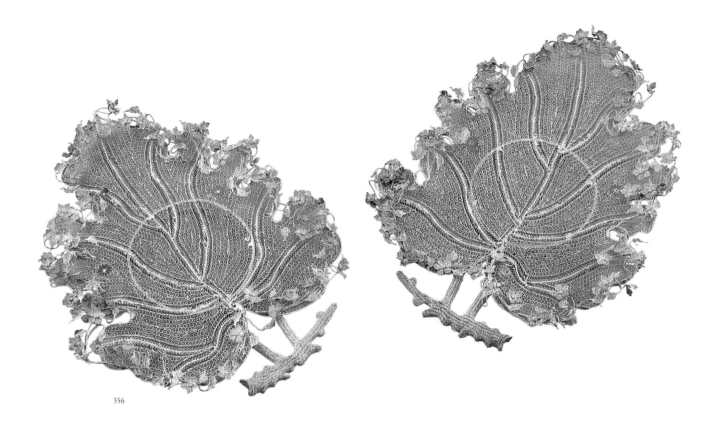

356

358
Crab-shaped Box. Mid-18th century

China

Silver, silver filigree, gilding. Height 3.5

Inv. No. LS 10a

Provenance: Main Hermitage Collection.

First publication.

The crab holds a water plant in its openwork filigree claw. Its eyes serve as a lock for the box, which is gilded inside. This box stood on a leaf tray [Cat. 359] and the Hermitage has another crab and leaf which must have formed a pair with these pieces. Both were part of Catherine's toilet set and may have been used for rouge or other cosmetics.

In the Hermitage inventory of 1789, the crabs are listed with their trays – "two saucers like small leaves with flowers gilded along the edge on the leaves" – and it was this description which served as the key in uniting the various pieces of the set scattered throughout the museum.

Crabs were popular motifs in Chinese art during the second half of the 18th century, for they were thought to ward off evil spirits as they looked like tiger's heads. Crabs were also used for medicinal purposes

Lots 49 and 53 at Christie's 1819 sale of the collection of Queen Charlotte were crabs on leaf shaped stands: "53. Three leaf shaped dishes bearing crabs of old fillagree."　　　M.M.

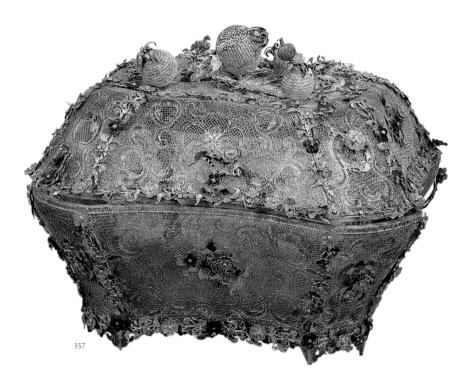

357

359

Leaf Tray. Mid-18th century

China

Silver, gilding; silver filigree. Length 20

Inv. No. LS 10b

Provenance: Main Hermitage Collection.

First publication.

Stand for the crab box [Cat. 358] in the form of a silver filigree leaf, to the edge of which are attached small twigs with leaves and flowers, partly gilded. Each twig is set into a small tube soldered to the back of the leaf. The stand has a round foot. M.M.

360

Pair of Rose-water Sprinklers. Mid-18th century

China

Silver, gilding, silver filigree, enamel. Height 29.5

Inv. Nos 105a, b; 106a, b

Provenance: Main Hermitage Collection.

First publication.

The form of these vessels derives from Persian flasks of the 13th and 14th centuries, which became common in the Near East, India and China, where they were made of various precious materials. They were often exported to Europe in the 17th and 18th centuries. .

Applied over the gilded silver base is an openwork net of silver filigree composed of three kinds of pattern, with branches, flowers and leaves (partly gilded or with blue and green enamel) attached. The neck has a spiral branch with leaves and flowers. The mouth is corked and there are several openings for spraying scented water.

Catherine's toilet service included four such flasks [see also Cats 361, 362]: the inventory of 1789 lists "Four little bottles in places gilded, two with green and blue flowers".

Flasks of similar form and style are at Powis Castle; they were mentioned in the inventory of 1774 (Clive Collection 1987, Nos 187, 189). M.M.

361

Rose-water Sprinkler. Mid-18th century

China

Silver, silver filigree; silver gilt. Height 23

Inv. No. LS 103a, b

Provenance: Main Hermitage Collection.

First publication.

Covered with a network of silver filigree, along the lip this sprinkler has a spiral twist of flowers and leaves of silver filigree. Inside the removable lid is a hole for spraying water. This piece formed part of Catherine's toilet set. M.M.

362

Rose-water Sprinkler. Mid-18th century

China

Silver, silver filigree, enamel; gilded. Height 24

Inv. No. LS 107a, b

Provenance: Main Hermitage Collection.

First publication.

(Illus. see p. 206)

Covered with a network of three kinds of silver filigree, one of them with intertwined lotus flower ornament, this sprinkler has a removable, screw-on lid. It has a pair in the Hermitage.

There is a similar pair of sprinklers at Powis Castle (Clive Collection 1987, No. 189).

The Queen Charlotte sale at Christie's in 1819 included lots 37 and 44: "a pair of taper necked essence bottles, covered with the most delicate lace-work of filligree of different patterns, with gilt wreath and flowers, incrusted, one of them enamelled." M.M.

363

Table Decoration. Mid-18th century

China, for export to Europe

Silver, copper, paint; silver filigree, gilding, paint.

Height 26

Inv. No. LS 26

Provenance: Main Hermitage Collection.

First publication.

(Illus. see p. 209)

Group of two peacocks, male and female, standing by a rock with small leafy bushes and two trees, attached to a stand on four feet. The birds and rock are of silver filigree, some of the details painted in blue and green. Smooth sheet silver forms the top of the base, with holes into which the bushes are fitted (many are missing), while the sides have a net of filigree with flower patterns. The trees are of gilded copper, their leaves of green painted copper; the leaves of some of the bushes, however, are simply made of waxed and painted paper. It is interesting to note how easily the Chinese combined precious and cheap materials, differing very strongly from Europeans in their concept of relative values.

This is a very rare example of a table (toilet) decoration in the form of a filigree sculpture. Its pair is also in the Hermitage, and these two amusing groups formed part of Catherine's toilet set with a large painted mirror. They were entered in the inventory of 1789 as "Two low pedestals, elongated rectangles, on gilded feet, on which are placed trees with green leaves, also little green bushes, many of which are missing, and two peacocks each".

Both sculptures were made in Canton for export to Europe. Such large filigree sculptures are very rare and no other examples are known to the author. M.M.

364

Two Boxes. Mid-18th-century

China, for export to Europe

Silver, silver filigree, gilding. 13 × 11; 17 × 13

Inv. Nos E 2113, E 2080

Provenance: Main Hermitage Collection.

First publication.

Two boxes with slightly festooned sides, a flat bottom and lid, made of sheets of silver gilded inside and out, with a network of silver filigree attached mechanically to the outside of the hinged lid and walls. This filigree incorporates several patterns: in the centre of the lid is a rosette with long petals, to the sides are diaper patterns; beneath the handles on the sides are woven flower and lotus patterns. The same type of pattern can be seen on the table mirror and on the rose-water sprinklers. The box closes with a lock and key.

As a result of its European form, this box – which was produced in Canton for export – was for many years considered to be of European origin. In fact it belonged with a large mirror with reverse painting on glass with pheasants, mentioned by Johann Georgi in his description of the Hermitage (1794). Catherine's toilet service included seven boxes of this form, in different sizes, and all are still extant.

A box of similar form but with additional branches and flowers with enamel was published by A. Marlowe (Chinese Export Silver, 1990, No. 103). M.M.

364

364

Chinese Altar Sculpture

Catherine had five Chinese sculptures in gold and silver, listed in the 1789 inventory of her collection as "Chinese gold figures" or "idols". These were mainly Daoist immortals, which in China were thought to ensure longevity and ward off evil spirits, the most popular being Shouxing, Star God of Longevity, and groups of the eight Daoist immortals. Such small but expensive sculptures could be presented to imperial Daoist temples or set on domestic altars.

These sculptures are extremely rare examples of Chinese votive figures in precious metals of the Kangxi period (1662-1722). M.M.

365
Daoist God of Longevity. 17th century
China
Number punched into the base: АД – 1
Gold; cast, embossed, chased, engraved, pounced.
Height 15.5
Inv. No. LS 285
Provenance: Main Hermitage Collection.
First publication.

This standing figure is of Shouxing, identifiable by his prominent bald skull with its wrinkles upon the brow. He wears a long robe with cloud pattern and round medallions imitating embroidery with flying cranes – symbol of longevity and one of Shouxing's companions and "means of transportation". Such medallions are to be seen on Daoist robes. In his right hand, Shouxing holds a staff, in his left the healing mushroom *lingzhi fungus*, symbol of longevity. The figure is attached to a double stepped hexagonal pedestal with engraved wave ornament.

There are holes in the eyes and the sculpture may have been used as an incense (fragrance) container.

The figure appears in the 1789 inventory under "D 1", recorded as being kept with many other Chinese objects in the dinner service stores. M.M.

365

366
*Daoist God of Longevity. Late 17th –
early 18th century*
China
Old number pounced into the base: 136
Silver; cast, embossed, gilded, engraved, chased,
pounced. Height 16.5
Inv. No. LS 95
Provenance: Main Hermitage Collection.
First publication.

Shouxing is seated on a tree stump with rocks
beneath his feet. He wears a long waisted robe
with both punched and gilded cloud pattern.
Front and back on the robe is an engraved square
containing a flying crane, indicating the *bufang* –
the embroidered mandarin badge of a civil
official of the first rank. Shouxing's hands lie on
the knees, in the right a *ruyi* sceptre ("all you
desire") and in the left a scroll. A branch grows
from the stump on which lies a cup in the form
of half a peach (symbol of longevity); in the
bottom of the cup is a cast figure of a bat
(homonym to the word *fu* – meaning happiness).

Listed in the 1789 inventory under "D 64", which
describes it as "Silver statue of a seated Chinese
male, gilded in places, with a cup, a flower in the
hand, and a bird. 87 carat weight one pound five
and a half *zolotniki* [one *zolotnik* = 4.26 grams]."
From this description we can conclude that there
was also a crane (now lost) by the tree stump.

Possibly used in China as an incense container.
M.M.

367

366

367
*Standing Figure of a Daoist Immortal.
Late 17th – early 18th century*
China
Old number pounced into the base: АД – 3
Silver; cast, chased, engraved. Height 18.5
Inv. No. LS 287
Provenance: Main Hermitage Collection.
First publication.

Lu Dongbin, one of the eight Daoist immortals,
wears a waisted robe with engraved stylised *shou*
characters indicating longevity; on his head is a
hat like an ancient crown with a flat top. In his
raised right hand he holds a fan which he uses to
ward off evil spirits; the left hand hangs down
and is covered by the sleeve. The figure stands on
a hexagonal pedestal decorated with engraved
cloud ornament.
M.M.

Drinking Vessels

Catherine's collection already included a large number of Chinese silver vessels in the 18th century. Many of these would originally have been used for wine, being of traditional shape with a narrow high neck, long spout, handle and lid (this form derives from Near Eastern prototypes). In Europe, however, these vessels were used for coffee and chocolate in the late 17th and early 18th centuries. The 1789 inventory describes them as "coffee pots", using the Turkish words "*kumgan*" or "*kulgan*".

Some are more spherical or drawn out towards the top, occasionally with a handle on top and these were probably made in Canton (Guangzhou) for export to Europe, where tea and coffee were recent introductions and were very popular. Such objects served as prototypes for European teapots and kettles, many of which were produced in the "chinoiserie" style in the late 17th to mid-18th century [Cat. 405].

Various types of cups are to be found in the Hermitage collection, many of them in the familiar form of a small drinking vessel, although the lids to these have often been lost. Of greatest interest are little traditional Chinese cups (archaistic bronze ritual vessels) in the form of the symbol of benevolence, the peach. All such vessels were used for wine in China and they are now extremely rare.

The earliest pieces date to the last quarter of the 17th and very beginning of the 18th century. For a long time the provenance of many of them was considered dubious, since much Chinese silver made for export has been melted down and surviving pieces are often incorrectly attributed. A number of items have been published in recent years and works in the Hermitage collection may contribute to the correct identification of other pieces.

The Russian imperial collection is notable for the number of surviving pieces it contains, sometimes still in sets or pairs. Several of them bear Russian fineness marks and numbers from early 18th-century inventories which allow us to fix the latest date by which they could have been acquired. Chinese characters are extremely rarely found.

Surviving "tea and coffee" silver can be divided into several groups: those with cast relief details soldered onto the body and with partial mercury gilding; silver with engraved and gilded ornament; silver with enamel. M.M.

368
Teapot and Lid. Last quarter of the 17th century

China, made for export to Europe
Silver; some parts gilded, chased, engraved, cast.
Height 18.5
Old inventory number punched into the teapot: *АД* 190
Russian fineness mark: 87 (each figure in a square)
Inv. No. LS 87 a, b
Provenance: Main Hermitage Collection.
First publication.

This four-lobed teapot, almost ovoid in form, has a smooth spout and handle, a knob on the lid in the form of a branch with plum flowers, and a flat base. It has two ornate panels and is cast and chased with symbolic landscapes. On one side is a river bank with a bridge on which stand two figures; on the bank are a pagoda, buildings, a flowering plum with birds, and a pomegranate tree with fruit. On the other is a similar river bank with a boat and two figures, buildings, a pine, weeping willow and pomegranate tree. Four small horizontal panels with flowering branches decorate the neck. The lid has a lobed panel with a landscape including flowering plum and birds.

The teapot and its matching cups with lids [Cat. 369] are among the collection's earliest examples of Chinese export silver, traditionally thought to have been made in Canton (Guangzhou). They come from a group of similarly decorated silver pieces with landscapes, plum blossom, trees, birds and figures, scattered amongst various collections (Forbes 1975, pp.52-4; Christie's New York, 18 April 1989, lot 589). A late 17th-century coffee pot from the collection of the Queen Mother has similar designs (John Cornforth: *Queen Elizabeth, the Queen Mother at Clarence House*, London, 1996, ill. 48). Some of these bear London hallmarks dating back to 1680-90 which have for many years led scholars to think that the silver was produced in England under Chinese influence. The Chinese origin of such items is now accepted.

Interestingly, the Hermitage silver bears no European marks and has only those in use in Russia in the middle of the 18th century, from around 1732. This possibly indicates that it was brought directly from China in trading caravans, which we know from documentary sources came to St Petersburg, and that it was marked when they arrived in the palace. M.M.

368

369
Two Cups with Lids. Last quarter of the 17th century

China
Silver; partly gilded, chased, engraved, cast. Height 8
Old inventory numbers punched into the cups and lids: *АД* 205, 207
Russian fineness mark on both cups: 87 (each figure in a square)
Inv. Nos LS 162 a, b; LS 163 a, b
Provenance: Main Hermitage Collection.
First publication.

Round, almost cylindrical cups, lidded with three identical lobed panels containing landscapes. One panel shows a man crossing a bridge carrying a musical instrument (*qin*), with weeping willow and pines on the bank. The second panel has a pagoda, buildings, plum blossom and a pine. The third contains two figures on a bank in the foreground, a pagoda, buildings, pomegranate tree and bamboo.

Six cups form a set with the teapot [Cat. 368]. Such surviving sets are extremely rare. No other Chinese export silver cups of this form are known, probably because silver cups were too hot to handle when drinking tea. Generally, the form was used for porcelain teacups in Europe at the turn of the 17th and 18th centuries, and these were also ordered from China. Sometimes such cups had a silver stand.

Larger versions of this form are still used in China to brew individual cups of tea. M.M.

willow, lotus, begonia and birds. The background is chased.

By the spout are symmetrically arranged reliefs with a pair of gilded phoenixes, and beneath the handle a squirrel or gerbil on a vine with bunches of grapes. The lip is decorated with a chased scroll with peony flowers; around the opening is an engraved key-fret border. M.M.

370
Teapot with Lid. Late 17th – early 18th century
China
Silver; mercury gilding, chased, engraved, cast, soldered. Height 21
Old inventory number punched into the bottom: 110
Russian fineness mark: 87 (each figure in a square)
Inv. No. LS 83 a, b
Provenance: Main Hermitage Collection.
First publication.

Such silver was produced in Amoy and Canton, and was exported to Europe in the late 17th and early 18th centuries. A large number of details were cast and chased separately and then applied to the body, this high relief creating a massy, heavy effect, which was sometimes emphasised by the use of gilding.

The teapot is round, almost spherical, with a low cylindrical neck and a knob on the lid in the form of a seated lion. It has a fixed rectangular handle. Two panels with landscapes are set into the sides of the teapot. One has two figures beneath a flowering plum tree, with a peony bush and two birds, while a large phoenix descends in the centre of the composition; the other shows a river bank with a boat and two figures, one fishing, the other punting, while on the bank stand a pagoda and buildings, with a

370

371

Two Wine Goblets.
Late 17th – early 18th century

China

Silver; mercury gilding, chased, engraved, cast,
soldered. Height 8.5

One bears the Russian fineness mark: 86 (each figure in
a square) and an old punched inventory number: 148

Inv. Nos 50, 52

Provenance: Main Hermitage Collection.

First publication.

Formed like ancient bronze ritual altar vessels of
the *ding* type, these goblets are rounded bowls on
three legs with two vertical handles. The body is
divided into four sections with horizontal bands,
each containing a landscape with plants, trees,
birds and animals. One cup has a lion and a
peony; plums and a bird; a branch with peaches,
monkey and bird; a pine, deer and bird. The
second has two deer, plums and a bird; flying
crane and lotus; pine, horse and birds; peony and
flying phoenix.

Made of a large number of cast pieces soldered
together, with engraved and chased ornament,
these goblets employ the same technique and
style as another teapot in the Hermitage [Cat.
373], and they may have formed part of the same
set. There are also similar goblets. M.M.

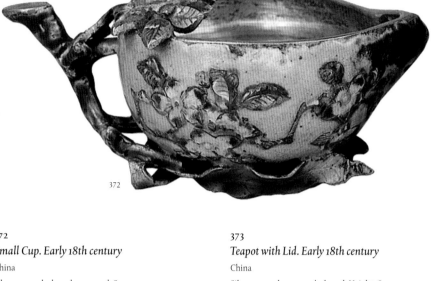

372

372

Small Cup. Early 18th century

China

Silver, enamel; chased, engraved. 8.5 × 3.5

Pounced inside: *камеру*. [probably Kamerzalmeister
Office – in charge of palace table silver in the 18th
century]

Inv. No. LS 131

Provenance: Main Hermitage Collection.

First publication.

The cup in the form of half a peach, its handle a
branch, stands on leaf-shaped feet. The peach is
covered outside with pale green and lilac enamel,
the sides decorated with flowering branches,
engraved and chased leaves. Enamel in pale
green, turquoise-green, blue, white and lilac.

Produced for the Chinese market, such cups
were symbols of a long life. M.M.

373

Teapot with Lid. Early 18th century

China

Silver, enamel; engraved, chased. Height 18

Old inventory number punched into the bottom: 118

Inv. No. LS 80 a, b

Provenance: Main Hermitage Collection.

First publication.

One of several such pieces in the Hermitage, this
square teapot has a lid, an elongated vertical
arched handle fixed to two cores, and four small
feet. Some details are picked out with chasing
and engraving, or with green, turquoise, lilac,
yellow and white enamel. The background is of
smooth plain silver.

Garden scenes decorate the sides. On one
facet sits a scholar raising a cup to his lips, about
to drink wine; nearby stands a jug and a servant
brings him a drink in a ewer; to the left is a large
plantain. On the opposite side is another scholar,
seated with a scroll in his right hand, and a
servant kneeling presenting him a ewer with
wine. The other two sides show servants cooking
and one of the servants playing the *qin* (musical
instrument).

The knob on the lid is in the form of a lotus,
and beneath it is petal ornament with coloured
enamel. On the handle is pounced spiral scroll,
on the neck a key-fret border, and flower rosettes
adorn the end of the spout.

Together, the whole scheme would seem to
represent an expression of congratulations on
success in official exams and the vessel must
have been made for the Chinese market, where it
would have been used for wine. M.M.

371

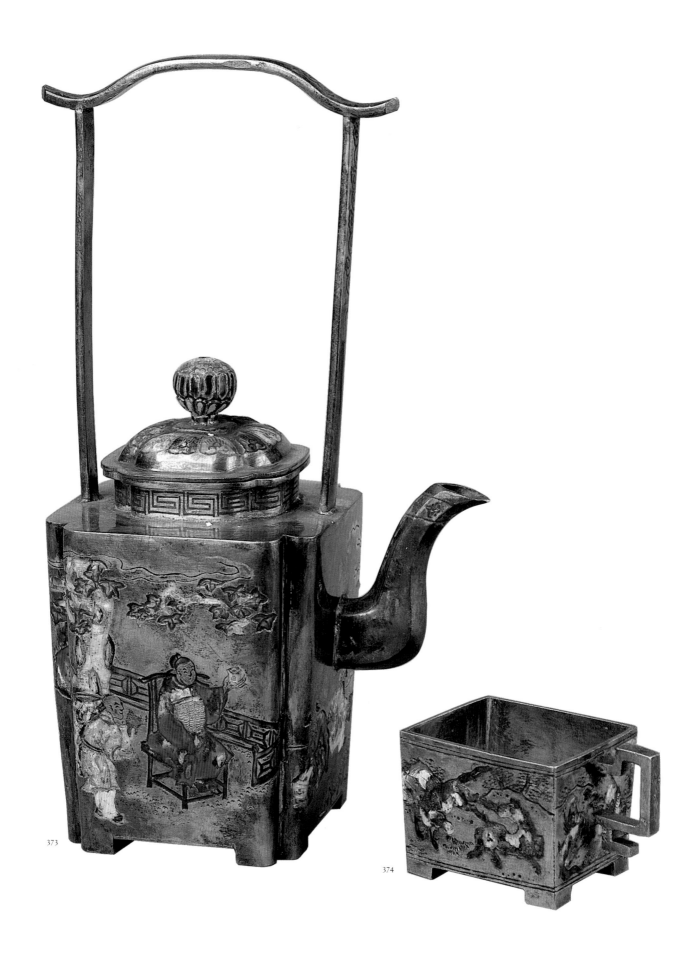

373

374

374

Cup. First half of the 18th century

China

Silver, enamel; engraved, chased. Height 3.8

On the bottom severely rubbed Chinese characters and the words: *камерц: № 87* [probably Kamerzalmeister Office – in charge of palace table silver in the 18th century]

Inv. No. LS 142

Provenance: Main Hermitage Collection.

First publication.

Almost square in form, its handle in the form of a key fret, this cup stands on four small feet. It is decorated with eight horses, two on each side, and plants. Details are picked out in dark blue, turquoise, lilac and white enamel; scroll ornament is engraved on the handle.

Such decoration is linked with the eight famous horses of Mu Wang – one of the ancient rulers of China – and was a popular motif in Chinese art.

Made for the Chinese market, the cup would have been used for wine.　　M.M.

375

Two Saucers. Late 17th – early 18th century

China

Silver, enamel; engraved, chased. 11 x 11

Inv. Nos LS 255, LS 260

On the reverse the Russian fineness mark: 87 (each figure in a square)

On the back edge of each saucer: *камерц: № 78* [probably Kamerzalmeister Office – in charge of palace table silver in the 18th century]

Provenance: Main Hermitage Collection.

First publication.

Two saucers with curved horizontal edges and festooned corners, decorated with landscapes. One shows a bird standing on one leg on a rock, with another flying towards it and to the left two plantain trees. On the other is a pool with a lotus flower and a heron standing on one leg; another heron flies up into the sky. Engraved along the edge is a spiral scroll. Flowers, trees and birds are all enamelled in white, blue, lilac, turquoise-green and yellow.

Each of the eight such saucers in the Hermitage bears a different landscape and these scenes would seem to represent phonetic homonym puns, indicating good wishes. Herons

375

(*lu* – homonym to the word for "path") and lotus (*lian* – homonym to the word for "always"), for instance, might be read as "May your path be always upwards". They might also be illustrations to poems.　　M.M.

376

Teapot with Lid. Late 17th – early 18th century

China

Silver; chased, engraved, cast. Height 17.5

Russian fineness mark: 77 (each figure in a square); old inventory number punched into the surface: 112

Inv. No. LS 84 a, b

Provenance: Main Hermitage Collection.

First publication.

Ovoid teapot with a lid on a chain, its spout in the form of a pine trunk, the handle a bamboo cane with soldered relief leaves. Sculptured plum blossom branches are soldered onto the lid. The neck bears bands of triangular leaf ornament. The programme of plants – pine, bamboo and flowering plum – symbolises the "three friends of winter" and is linked with Chinese New Year.

Produced for the Chinese market, where it would have been used for wine, the teapot has two engraved symbols on the bottom, possibly the Russian letters FI, indicating the initials and mark of the assay master Ivan Frolov, who worked in St Petersburg during the period 1738-79. [See also Cat. 404]

The Hermitage has a pair to this teapot.　M.M.

377

Small Cup. First half of the 18th century

China

Silver, enamel; engraved, chased. Length (with handles) 8

Inv. No. LS 143

On the bottom two Chinese characters meaning "pure silver"

Provenance: Main Hermitage Collection.

First publication.

This cup has two arched handles in the form of fish and stands on a round foot. Its body is engraved and chased with ornament filled with enamel in white, lilac, blue, turquoise and yellow, on one side showing orchids and lotuses, on the other branches of plum blossom. Such decoration was probably linked with flowers of the different seasons.

These cups were used in China for wine and it is possible that they formed a set with a wine vessel or teapot in the Hermitage [Cat. 402].

　　M.M.

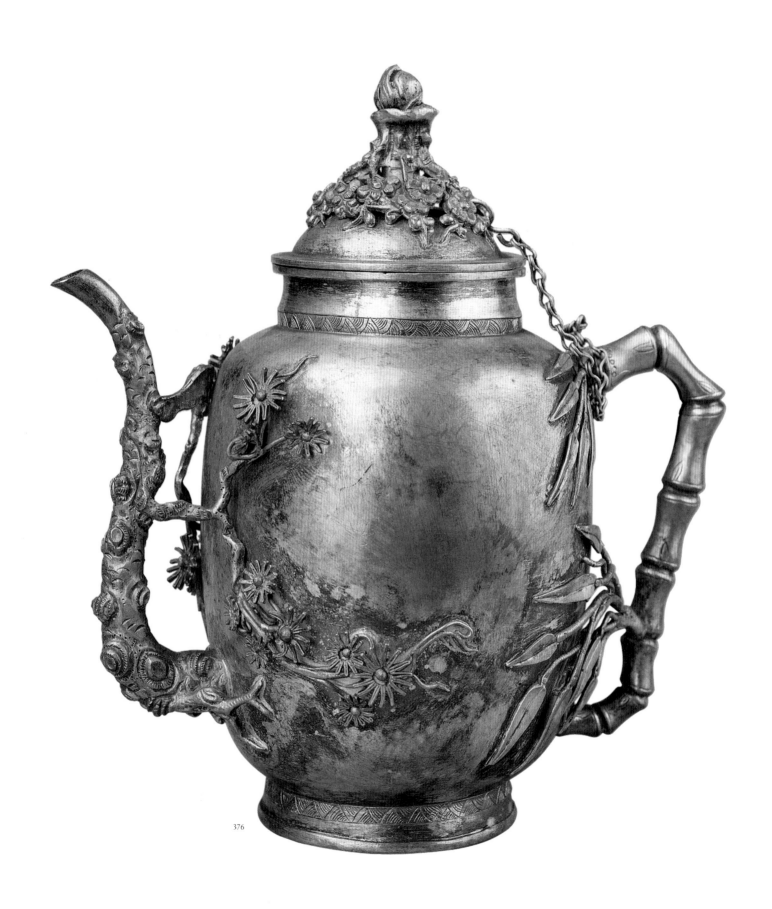

376

377

378
Wine Vessels. Late 17th – first quarter of the 18th century
China

Silver, enamel; chased, engraved, partially gilded.

32.5 x 31.5

Old inventory numbers on the base and lid:

LS 119 = 160; LS 118 = 156

Inv. Nos LS 119a, b; LS 118a, b

Provenance: Main Hermitage Collection.

First publication.

Pair of wine vessels, with lid, each vessel pear shaped with a high narrow neck, faceted, standing on a hexagonal foot. The handle emerges from a dragon's mouth, while the curved spout is attached to the body by a bridge in the form of a spiral scroll intertwined with the head of a deer. On its five convex surfaces the body has landscapes with civil officials or literary figures. The foot is chased with wave ornament, showing a horse and deer leaping in the waves; the neck has a band of ornament with flying cranes below spirals and lotus flowers. By the opening on the lid are archaic *tao-te* monster masks. The knob is in the shape of a lion with a brocade ball beneath its paw.

All of the chased decoration has blue and green enamel and partial gilding.

The ewers or wine vessels were all entered in the 1789 inventory under the letter D as "silver *kulgan* (with enamelling) with lid, on the lid a little lion", the weight given in *zolotniki*. M.M.

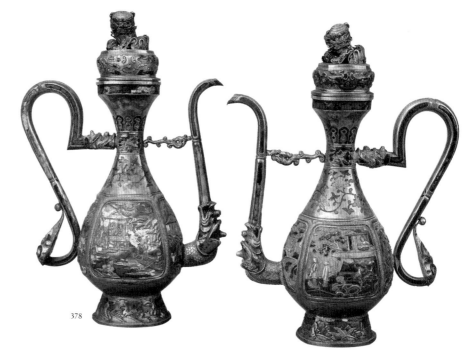

378

379
Wine Vessel. Late 17th – first quarter of the 18th century
China

Silver, enamel; chased, engraved, partially gilded.

Height 31

On the bottom two severely rubbed Chinese characters

Old inventory numbers on the bottom and lid: 155

Inv. No. LS 124a, b

Provenance: Main Hermitage Collection.

First publication.

Pear shaped wine vessel with lid, in five parts; it has a high narrow neck and faceted trumpet, and stands on a hexagonal foot. The handle emerges from a dragon's mouth while the curved spout is attached to the body by a bridge in the form of a spiral scroll with an intertwined *lingzhi fungus* mushroom. Each of the vessel's five convex sides has a landscape with Shouxing and old men. On one panel two star gods are playing *wei-qi* – a Chinese board game; on another is an old man with a staff; a third shows Fuxing ("Star of Happiness") and his servant on the terrace; a fourth Luxing ("Star of Career") with a stag (*lu* – homonym to the word "career") lying near him.

Chased wave ornament and *shou* characters indicating longevity decorate the foot. The lid has depictions of precious items and the knob is in the shape of the seated Shouxing, holding a sceptre in his right hand and a scroll in his left.

The chased decoration also has blue and green enamel and partial gilding. There is a pair to this item in the Hermitage.

Numbers D 33, 34 in the 1789 inventory read: "Silver *kulgan* with enamel and with a lid, on which is a small male Chinese statue."

The figure of Shouxing is similar in style and treatment to a large silver gilt sculpture of the kind which would have served as a model for the decoration and forms on silver chinoiserie items such as the Sprimont kettle [Cat. 405]. M.M.

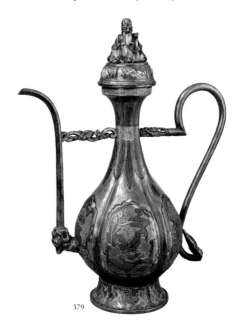

379

380

Wine Vessel. Late 17th – early 18th century

China

Silver; chased, engraved, partially gilded. Height 32

Old inventory number on the bottom: 163

Inv. No. LS 126a, b

Provenance: Main Hermitage Collection.

First publication.

(Illus. see p. 205)

Pear-shaped wine vessel with lid, in five parts, with a high narrow neck and faceted trumpet, on a hexagonal foot, the handle emerging from a dragon's mouth. The curved spout is attached to the body by a bridge in the form of a spiral scroll with an intertwined *lingzhi fungus* mushroom. The body has two panels with chased and gilded images: one shows Shouxing, Star God of Longevity, sitting by a pine and a rock, watching a stag and a flying bat (all symbols of longevity and success or omnipotence); on the other a scholar official stands on a terrace with a banana tree, pointing out the sun to his servant. The foot is decorated with rocks emerging from waves and flying bats. Chased onto the neck is a band of diaper pattern from which descend chased and gilded burst pomegranates suspended on ribbons and strings of beads. On the spout by the opening is a scroll with the *lingzhi fungus*. Bands of triangular petals run around the joints on the lid and neck.

Along the edge of the lid are objects from a scholar's study – scrolls, books and a musical stone. The knob is in the shape of a lion with a brocade ball beneath its paw, sitting on a diaper surface.

Such a scheme symbolises wishes for good luck in exams and in one's official career, for a long life and many sons.

The Hermitage also has the pair to this vessel, showing the divinities of happiness and career (Fu, Lu-xing) and a crane. M.M.

381

Wine Vessel. Late 17th – early 18th century

China

Silver; chased, engraved and partially gilded. Height 30

Old inventory number on the bottom: 162

On the bottom two severely rubbed Chinese character

Inv. No. LS 129a, b

Provenance: Main Hermitage Collection.

First publication.

(Illus. see p. 205)

Pear shaped wine vessel with lid, in five parts, with a high narrow neck and faceted trumpet, standing on a hexagonal foot. The handle emerges from a dragon's mouth. The curved spout is attached to the body by a bridge in the form of a spiral scroll with an intertwined *lingzhi fungus* mushroom. There are five images of Shouxing and linked scenes in panels.
1) Shouxing descends on a crane; 2) two civil officials point at the divinity; 3) he is awaited by a deer and servant; 4) one old man holds a peach in his hands, another bows to Shouxing;
5) a landscape (beneath the handle).

The foot is decorated with rocks emerging from waves and flying bats. Chased onto the neck is diaper pattern, from which hang chased and gilded burst pomegranate fruits on ribbons and strings of beads. On the spout by the opening is a scroll with the *lingzhi fungus*. The joints in lid and neck have bands of triangular petals.

Along the edge of the lid are items from a scholar's study: scrolls, books, a *qin* stringed instrument, a shell and coins. The knob is in the shape of a lion with a brocade ball beneath its paw, sitting on a diaper surface.

The symbolism of this scheme is the wish for long life and numerous male offspring. M.M.

382

Small Cup. First half of the 18th century

China

Silver, gold, silver filigree, enamel. 4.3 × 5.5

Punched into the bottom: *Бир.* [Bir.] (?)

Inv. No. LS 153

Provenance: Main Hermitage Collection.

First publication.

This lobed cup narrows towards the bottom and sits on a low foot with a band of openwork filigree. The outside of the cup is gilded and the top is decorated with an airy network of filigree in four sections. In the centre of each side is a small tree by a rock with three plums (?), the leaves and fruits covered with lilac and green enamel. There is blue and yellow enamel on the ribbons with spiral scroll and on other details.

The word on the bottom may imply that the cup once belonged to Ernst Johann Biron, favourite of the Empress Anna Ioannovna, who was exiled and whose property was sequestered by the state in the 1740s. M.M.

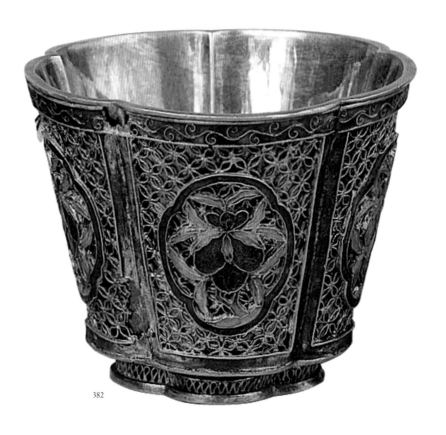

382

Chinese Gold Jewellery

At the heart of the Hermitage Oriental collection is a large body of Chinese gold jewellery from the end of the Ming dynasty (1368-1644) to the start of the Qing dynasty (1644-1911). The only comparable collection is in the Gugong Museum, Taiwan (gold from the treasury of the Qing dynasty; Catalogue 1986).

The first decorations and hairpins were brought to Russia as diplomatic gifts from China during negotiations regarding establishment of a border in the late 17th century. Some ornaments were kept in Petersburg collections or the Kunstkammer, but most are mentioned in the later pages of the inventory of Catherine's property begun in 1789, before the entries for 1792, indicating an arrival date of 1790-1. The Hermitage inventory of 1859 also mentions that the Chinese jewellery belonged to Catherine II.

Most of the objects are hairpins and ornaments from ceremonial head-dresses. Hairpins were the most common form of female adornment in China, with a developed language of hairpins which could be used to indicate status and rank. Such pins usually came in pairs and were placed symmetrically on either side of the chignon, while at the centre was a single, flat, elongated hairpin. Small decorations could be attached to little silk hats and forehead bands. The phoenix ornaments in this exhibition possibly decorated the crown-like hat which was the Chinese Empress's ceremonial headwear (Catalogue 1986, pls 2, 3), and certainly only women from very rich families would have had gold jewellery. Male attire also included jewellery accessories, stitched to the front of headwear as hat buckles or suspended on strings of pearls or woven silk coloured ribbons from the back of the hat, perhaps attached to the front collar of the robe. Gold pins might also have served as the equivalent of money.

A Russian description of 1800 records contemporary perceptions of how Chinese noble women did their hair. It specifically relates to the ethnographic collections in the Kunstkammer, but the author was undoubtedly aware of the palace collection of Chinese gold: "The usual head-dress for Chinese ladies consists of dividing the hair into many locks, and the weaving into them of gold and silver flowers and precious stones. Often to these are added an artificial bird, whose wings fall over the temples, while the bent tail forms a feather in the middle of the head. The body lies over the forehead itself. The neck and beak over the nose, the legs entwined in the hair, supporting the whole construction, which is however worn only by noble Ladies. Sometimes they have several such birds, interwoven to form the likeness of a garland on the head. Young girls wear paper caps wound round with a silk ribbon, decorated with precious stones, forming an angle over the forehead. The crown of the head is decorated with flowers between which diamond pins are stuck. Aged women and those of mean station wrap their heads several times with silk cloths" (Belyayev 1800, section 2, p. 161).

In China, the Emperors repeatedly sought to regulate the wearing of gold, silver and precious stones and materials, and the form of decorations, although they were not always successful. Under the Emperor Qianlong (1736-95) a summary of laws was published in 1759 regulating the wearing of precious items in accordance with rank (*Huang ch'ao li-ch'i t'u-shih / Illustrated Precedents for Ritual Paraphernalia of the Imperial Court....*).

Gold with red stones (*hung bao shi* – rubies or spinels), sapphires, large pearls and images of phoenixes were permitted only to the Empress and imperial concubines. Diamonds and emeralds were not used.

All the gold jewellery in this exhibition is made of the finest filigree, difficult to see with the naked eye. Thanks to the ductility of gold, a single gram of high carat metal could be drawn out to several metres of wire. The filigree technique was mastered in China no later than the Western Han Dynasty (206 BC – 9 AD). During the last two dynasties, the late Ming (1368-1644) and Qing (1644-1911), filigree was popular and widely used in items for the imperial court. Some details were screwed on with thin wire, allowing them to tremble when moved or touched. Stones were fixed using natural glue or lacquer, or sometimes set in clasps; they could have drilled holes for threading onto gold wire. All the stones were polished as cabochons, but never faceted.

Jewellery was often seen as a talisman, incorporating Chinese symbols for longevity, happiness and wealth. M.M.

383

Six Ornaments in the Form of Phoenixes. 17th-18th century

China

Gold, gold filigree, rubies, spinels, sapphires, pearls, paint. Length of birds: 3.5 (4 items); 6.5; 8.5

Inv. Nos LS 351, LS 352, LS 356, LS 359, LS 379, LS 382

Provenance: Main Hermitage Collection.

First publication.

(Illus. see p. 208)

The phoenixes themselves are of thin filigree reinforced with thicker wire; small leaves, flowers and clouds are attached on wires to their bodies. Some of the birds are decorated with touches of green and dark blue paint, while on the crowns and backs are polished pierced rubies, sapphires and pearls – stones which according to the rules of the Qing Empire could only be worn by Empresses and the imperial concubines. Several figures have flat cloud-shaped sheets of gold at the bottom. Small holes in the feathers indicate that the phoenixes were attached to a crown or hat by thread passed through fine tubes (some small tubes survive). The smaller phoenixes are male (*feng*), larger ones female (*huang*).

In China the phoenix came to be seen as the symbol of the Empress and the highest of all birds. There are 36 male and female phoenixes of different sizes (between 1.5cm and 9cm) in the Hermitage collection and these elaborate, fragile birds once decorated a crown or hat belonging to a Chinese Empress. This was possibly the crown mentioned in the inventory of 1789, which was dismantled in the early 19th century.

Similar birds with pearls decorate the summer hat of an imperial concubine in the Gugong Museum (Catalogue 1986, pl. 2). M.M.

384

Three Hairpins with Phoenixes. 17th-18th century

China

Gold, gold filigree, rubies, spinels, pink quartz, pearls, paint, silver. Length 15.5; 10.5; 13. Birds: 10-11

Inv. Nos. LS 339, LS 340, LS 454

Provenance: Main Hermitage Collection.

First publication.

Each hairpin has a single tooth onto which the phoenix is attached with wire. One bird is male (*feng*), two are female (*huang*). The birds are of

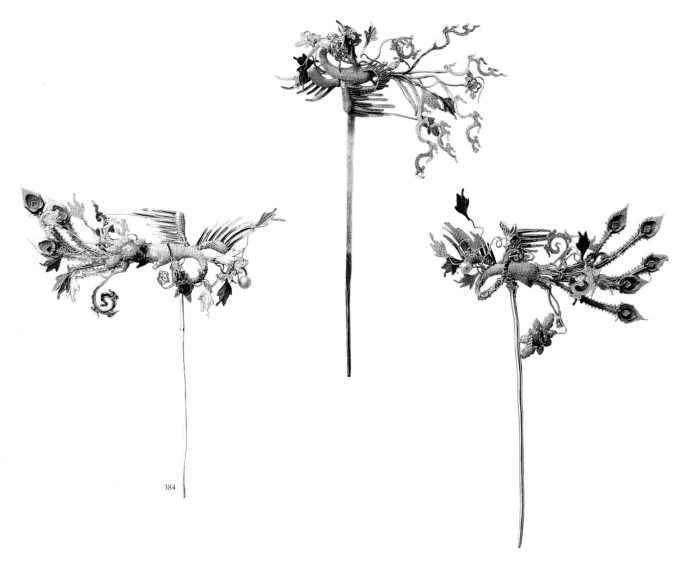

384

filigree, in places reinforced with stronger wire, which is also used for the wings. Bodies and crowns are decorated with flowers and red stones; lotus flowers and leaves are incorporated into the birds' five tail feathers and fixed on fine wires. The phoenixes hold small gold pearls in their beaks, while two cloud shaped wires represent their breath. Strings of pearls or other pendants may have been suspended from the beaks. Green paint is visible on some parts of the feathers.

Hairpins with male and female phoenixes were usually arranged in symmetrical pairs. Phoenix hairpins were popular, but only court ladies were allowed to wear gold and red stones in their hair. Phoenixes of cheaper materials were sometimes worn in the hair by brides ("Empress for a night").

Like the previous ornaments, these probably formed part of the crown mentioned in the inventory of 1789.

A crown from the tomb of the consort of the Emperor Wanli (1573-1619) includes phoenixes of gold, pearls, red stones and kingfisher feathers.

Such gold hairpins are represented in several collections (Singer 1972, pl. 100; Gullensvard 1953, pls 54-6) and are attributed to different dynasties from the Tang (617-906) to late Ming – early Qing. As this type of decoration is traditional, it is very difficult to date such items precisely. M.M.

385
Hat Ornament in the Shape of a Vase with Flowers. 18th century
China
Gold, gold filigree, spinel, paint. Length 7.5
Inv. No. LS 303
Provenance: Main Hermitage Collection.
First publication.

Relief vase or basket with flowers, buds and petals of the mudan peony, which probably once adorned a hat. It may have had gold decorations stitched to either side. The flowers are attached to movable wires and the centre of the plant is decorated with a large spinel, but similar stones which once formed the heart of the bud and the basket are now lost (they survive on the pair to this item, also in the Hermitage).

Baskets of peonies indicate wishes for prosperity, a successful career and wealth.

Baskets of similar form, with kingfisher feathers, adorn a hat in the Gugong Museum (Catalogue 1986, pls 85, 86). M.M.

385

(*lu* – career). Also attached to wires are bamboo, a banana, a *lingzhi fungus*, cloud stones, all indicating wishes for longevity, happiness and success.

Such an ornament may have been suspended from a man's hat on strings of pearls or woven ribbons, or stitched onto the front of the hat.

M.M.

388
Hairpin. 17th-18th century
China
Gold, gold filigree, rubies, tourmaline, paint.
Length 16.5
Inv. No. LS 313
Provenance: Main Hermitage Collection.
First publication.

Hairpin on two gold teeth, the top with a *ruyi* sceptre and the character *shou*, symbolising longevity, below. Between the teeth is the *yin-yang* sign, emerging from which on wires are two stylised dragon clouds, a flower and a large tourmaline. It symbolises longevity and the fulfilment of the owner's wishes.

A symmetrical pair to this hairpin is also in the Hermitage and a comparable *ruyi* ornament (but with a single tooth) is in the Gugong Museum (Catalogue 1986, pl. 131). M.M.

386
Pair of Earrings. 17th-18th century
China
Gold, gold filigree, paint. 2.3
Inv. Nos LS 422 a, b
Provenance: Main Hermitage Collection.
First publication.

Each of these coloured gold earrings has on the rim a small filigree phoenix, its feathers painted green. There are several pairs of such earrings in the Hermitage: portraits of Empresses of the Qing dynasty reveal that three pairs of earrings could be worn at one time, with several holes in each ear. Most importantly, they had to be arranged symmetrically. M.M.

387
Pendant Ornament. 17th-18th century
China
Gold, gold filigree, ruby, sapphire, pearl, paint.
Length 8.5
Inv. No. LS 436
Provenance: Main Hermitage Collection.
First publication.

Attached to the centre of this ornament of intertwined six-petal flowers is a figure of Shouxing, Star God of Longevity, with his prominent forehead and beard. Wearing a robe, in one hand he holds a staff, in the other a double gourd. He is accompanied by flying bats (*fu* – happiness), two cranes (for longevity) and a deer

386

387

389
Hairpin. 17th-18th century
China
Gold, gold filigree, spinel, pearls, paint. Length 12
Inv. No. LS 322
Provenance: Main Hermitage Collection.
First publication.

Hairpin with a single tooth shaped like a knotty
stick; the top in the form of a *ruyi* sceptre or the
mushroom *lingzhi fungus*. In the centre is a large
red stone from which emerge a branch with
leaves and a small pearl. There are traces of paint
and mastic in places where stones have been lost.
The hairpin symbolises the wish for "all you
desire" and longevity. M.M.

390
Rings. 18th century
China
Gold; cast, chased, enamelled. Diameter 2
Inv. Nos LS 419, LS 460, LS 464
Provenance: Main Hermitage Collection.
First publication.

Such rings were usually worn symmetrically in
pairs (one on each hand). Rings were not of fixed
size but were adjustable. Most of the examples in
the Hermitage are gold, with a cast rectangular
panel bearing chased ornament. One of the rings
shown here has figures in a landscape, the
second has a branch with a leaf and two five-
petal flowers, the third shows a stylised *shou*
character on a round panel decorated with
blue enamel. M.M.

391
Pendant Ornament: Boy on a Qilin.
17th-18th century
China
Gold, gold filigree, paint. Length 5
Inv. No. LS 437
Provenance: Main Hermitage Collection.
First publication.

The boy sits on the back of the mythical beast
known as a *qilin*, its body covered with scales and
with a twisting fluffy tail, hoofs, a dragon's head
and two horns on its head. Both legs swung over
to one side, the boy wears the waisted robe of a
civil official. In his left hand he holds a scroll, but
the attribute which was once in the right hand
has been lost; it was probably a lotus or
the *ruyi* sceptre. Attached to the *qilin* with wires
are a rhinoceros horn and an ingot, with ribbons
of clouds.

 On the back are loops which were probably
used to attach the ornament to a necklace or a

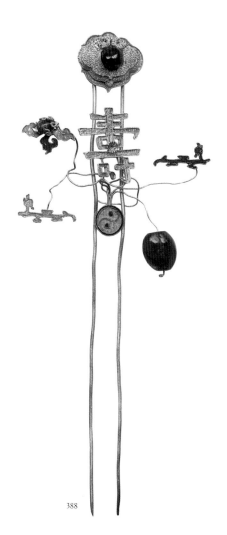

388

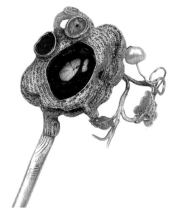

389

390

391

brooch which fastened at the neck, of the kind worn by Chinese women hoping for the birth of a male child who would go on to have a successful official career and a happy and wealthy life. The *qilin* brings sons and is a symbol of good wishes. A boy on a *qilin* in the clouds is a frequent feature of Chinese decorative art and textiles. M.M.

392
Hairpin with Flowers and Frog.
17th-18th century
China
Gold, gold filigree, rubies, sapphire, paint. Length 11
Inv. No. 299
Provenance: Main Hermitage Collection.
First publication.

A composition of lotus flowers and buds, peonies, orchids and water plants, with a little panel attached to a branch over which flies a crane. The ornament also includes ribbons of clouds and bamboo and at the base of the composition a large lotus leaf with a frog seated upon it. All the details are in fine openwork filigree, the heart of the flowers decorated with polished precious stones of red and blue, and some details are painted blue and green.

In China, the frog had several symbolic meanings, one being a protection against evil. This hairpin with its frog, flowers and crane may have served as a talisman and at the same time have implied wishes for numerous male offspring, for well-being and longevity. M.M.

393
Hair Ornament. 17th-18th century
China
Gold, gold filigree, almandine, paint. Length 4.5
Inv. No. LS 348
Provenance: Main Hermitage Collection.
First publication.

Top of a hairpin, in the form of a gold filigree crab holding water plants in its claws, its shell adorned with a large almandine (*hung bao shi*). In

China the crab was thought to remove curses and ward off evil charms. Crab was used for medical purposes and as an aphrodisiac. The crab form was also used for boxes in the toilet set [Cat 358].

There is a hairpin with similar ornament in Taiwan (Catalogue 1986, pl. 130). M.M.

394
Hairpin. 18th century
China
Gold, gold filigree, almandine, paint. Length 10
Inv. No. LS 324
Provenance: Main Hermitage Collection.
First publication.

Single-tooth hairpin, the top in the form of a flower with an almandine at the centre, from which is suspended a perch. An oriole is attached by its foot to a chain, and has at the sides two little cups for food and drink. Songbirds, particularly orioles, were often kept in China, and birds on perches are an extremely popular motif in Chinese art.

The Hermitage has a number of such hairpins. M.M.

393

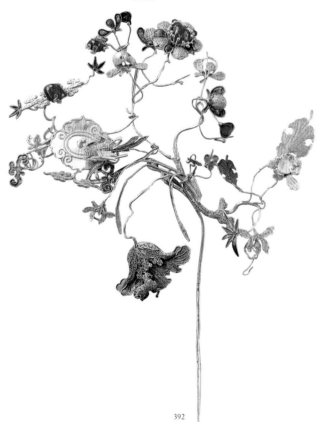

392

395
Ornament. 17th-18th century
China
Gold, gold filigree, spinel, paint. Length 8.5
Inv. No. LS 433
Provenance: Main Hermitage Collection.
First publication.

Three structures stand on the deck of a dragon-boat: gates by the prow, in the centre a pavilion, and on the bridge a tent. Also on deck are two officials and an oarsman. The dragon's body has three empty nests which once contained stones indicating the location of portholes. Beneath the boat is an ornament of waves with a red stone in the middle and on the bottom are several loops used for strings of pearls.

May have decorated a man's collar or have been part of a hairpin. M.M.

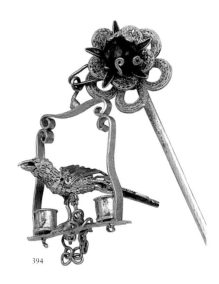

394

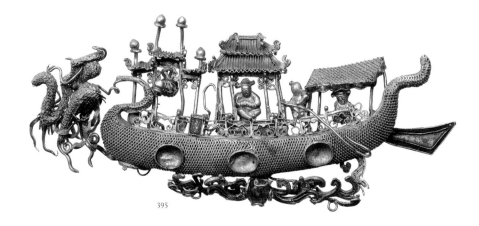

395

396
Pair of Hairpins. 18th century
China
Gold, silver, paint, pearls; filigree. Length 17.5; width of
top 5.5
Inv. Nos LS 312, LS 450
Provenance: Main Hermitage Collection.
First publication.

Hairpins were usually arranged symmetrically in
pairs in the hair. Here each pin consists of two
parts, the silver pin and the gold filigree top,
attached to each other with wire. The top is made
up of four elements from a scholar's study. Over
the hairpin is a vase in the form of an archaic
ancient vessel of the *gu* type, with ribbons of
clouds along the edges; set into it are peacock
feathers and three coral branches. On one side of
the vase is a globular incense-burner on three
legs of the *ding* type, from which rises smoke
twisting to form the character *shou* (meaning
longevity). There is a surviving pearl on one of
the pins at the top of the character. On the other
side of the vase are a round container for incense
and a small vase with two sticks and a spatula for
putting incense into the burner. All the vessels
are on a gold ribbon from which grow bamboo
shoots on wires. M.M.

397
Hair Ornament. 17th–18th century
China
Gold, gold filigree, ruby, paint. 9.5 × 7
Inv. No. LS 300
Provenance: Main Hermitage Collection.
First publication.

Made of fine filigree, painted with blue and
green, this ornament has one surviving ruby. It
would have been attached to a hairpin with wire.
The Russian imperial collection probably
included another such piece to form a pair.
 On a branch with lotuses and other water
plants are a *ruyi* sceptre, a Chinese mouth organ
(*sheng*), brush and ingot, a round box for ink, a
hat in the shape of the ancient imperial crown,
and bamboo shoots. The incorporation of
phonetic rebuses and symbolic items might
indicate that this piece was intended to wish the
owner a successful career – promotion within
the service (the *sheng* and the brush), wealth
(the ingot), rank (the hat), firmness (bamboo),
and the general fulfilment of the owner's
desires (*ruyi*).
 There is an ornament with similar symbolic
items in the Gugong Museum (Catalogue 1986,
pl. 141). M.M.

396

397

398
Ornaments from a Pair of Hairpins.
17th-18th century
China
Gold, gold filigree, pearls, rubies, paint. 9 × 10
Inv. Nos LS 305, 306
Provenance: Main Hermitage Collection.
First publication.

Tops of two symmetrical hairpins, woven of fine
gold filigree and decorated with blue and green
paint. One has a surviving ruby, the other a ruby
and a pearl. These ornaments were attached
mechanically to the pin with gold wires.

In the centre of each ornament is a stringed
instrument or *qin* (Chinese lute), shown wrapped
in cloth and tied with a ribbon with fluttering
ends. Attached to the *qin* with wires are
chequered boards for playing *wei-qi*, a kind of
Chinese chess, with a round box for the pieces;
an unfurled scroll with the *yin-yang* sign; a pile of
books, and ornaments in the form of spiral
tendrils and stones. The *qin*, *wei-qi* board, scroll
and pile of books are the symbols of the four
scholarly arts in China. M.M.

398

Chinoiserie

In producing chinoiserie items European masters may have been inspired by prints or by real Chinese objects they had seen. The Russian chinoiserie marquetry table in this exhibition incorporates a number of readily identifiable Chinese items, examples of which are displayed nearby.

399
Card Table. 1770s-1780s

St Petersburg

Amaranth, walnut, rosewood, pearwood, lemonwood, palm, maple, ebony, mother-of-pearl, ivory; marquetry, etching, engraving, scorching. 76 × 110.5 × 53.5

Inv. No. ERMb 1350

Provenance: formerly in the Great Palace at Peterhof.

An early example of Russian Neoclassical furniture, this table combines strict rectangular forms with marquetry ornament, employing a typical Rococo combination of stylised shell motifs, winding branches, exotic birds and chinoiserie subjects. Most striking is the Oriental tea-ceremony scene on the top, which is reversed on the pair to this table (also in the Hermitage). It is possible that the master worked from prints to produce this composition, as was common European practice. N.G.

400
Box for Writing Instruments. 18th century

China

Red lacquer, wood, ivory, jade; carved. 22 × 18.5 × 22

Inv. Nos LN 124 a, b, v, g; LN 122

Provenance: 1930s, from the Ethnographical Department of the Russian Museum; 1898, transferred from the Hermitage to the Russian Museum; formerly Main Hermitage Collection.

First publication.

On a carved red lacquer stand with diaper and meander pattern, this box has removable lids placed one on top of the other to form rectangular boxes. It imitates a pile of Chinese books lying one upon another, their bindings indicated by silk brocade fabric with a pattern of circles and vegetable motifs made of carved relief cinnabar lacquer. The sides where the pages should be visible are incrusted with carved ivory. On the top lid are jade plaques in the form of clasps and title plates. The inside is of smooth black lacquer.

Chinese books appeared in Russia in the early 18th century, during the reign of Peter the Great. Under Anna Ioannovna, in the 1730s, manuscripts arrived at the Academy of Sciences from China, and more came in the middle of the 18th century. During Catherine's reign, Chinese books and manuscripts and translations from Chinese were all studied by decree of the Empress herself. Russian perceptions of the Chinese as an educated people were much influenced by philosophers and by representatives of the Russian Orthodox Mission to China (founded 1711), who sent dictionaries and manuscripts back to St Petersburg. Books came to be a symbol and attribute of the Chinese educated elite – including women.

This may explain why chinoiserie objects such as the Russian card table often incorporate the same attributes, which Europeans perceived as essential to the life of an educated Chinese woman. The table shows a woman seated at a table with a pile of books (probably including the works of Confucius) nearby. She has broken off her reading and sits in thought, looking at a miniature tree in a pot which reminds her of a garden, drinking tea from a small cup. The band in her hair has a Chinese flower decoration of the kind by rich women. M.M.

399

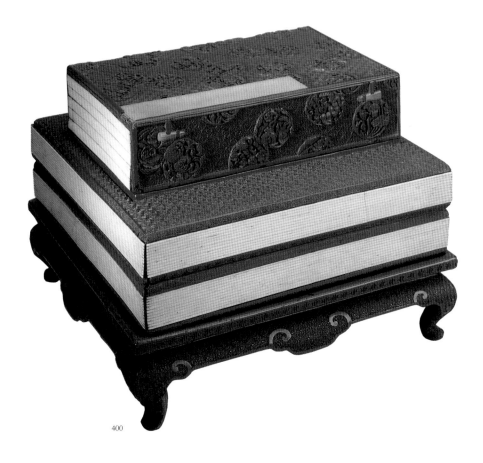

400

Imitation gardens in precious materials decorated palaces in China, particularly during the Qianlong period (1736-95). Such pieces were made in Guangzhou and were popular export items to Europe. The Queen Charlotte sale at Christie's, 17-19 May 1819, included "35. A pair of single light candelabra of beautiful filligree, each representing a dwarf Chinese fruit tree, in leaf and fruit, in a garden pot, with a parrot, on silver gilt circular stands." M.M.

402

Teapot with Lid. First half of the 18th century

China

Silver, enamel; engraved, chased. Height 14

Inv. Nos LS 65a, b

On the bottom two severely rubbed Chinese characters and the Russian fineness mark: 88 (each figure in a square)

Old punched inventory number: 130

Provenance: Main Hermitage Collection.

First publication.

Spherical teapot with rounded handle and bent spout emerging from the head and mouth of a dragon. The smooth walls are chased and enamelled to show rocks out of which grow orchids with flowers and long thin leaves; flying over the orchids are butterflies, and below is the mushroom *lingzhi fungus*. On the lid are dragons with the *lingzhi fungus* in their claws and a spiral scroll around them. The handle and shoulders are decorated with chased spiral scroll with blue enamel. On the spout by the hole is key fret border. The enamel is turquoise, blue, lilac, white and yellow.

401

Candlestick-Flowerpot. Second half of the 18th century

China

Silver, silver filigree, enamel, copper, carved soapstone, mineral paints, glass jewels; gilded. Height 28

Inv. No. LS 91

Provenance: 1918, from the Yusupov collection.

First publication.

Single candlestick in the form of a pot with a small pomegranate tree having painted soapstone fruits, the leaves of fine gilded copper covered with green mineral paint. By the trunk is a small filigree silver lion (*fo*) and a small rock. The edge of the pot is marked with a row of faceted red glass jewels imitating precious stones. An airy network of silver filigree decorates the outside walls of the pot and the candlestick, with blue enamel flower patterns on the sides of the pot.

The Hermitage also has a pair of candlestick-flowerpots with a star-fruit tree and a bird.

Real flowers or small trees in pots (*penjing* – tray landscapes) were very popular in China. They facilitated meditation, imagined walks around a garden creating a poetic atmosphere. Such pots usually contained a miniature tree associated with blessings, in this case a pomegranate with fruit, symbol of the desire for numerous male offspring.

402

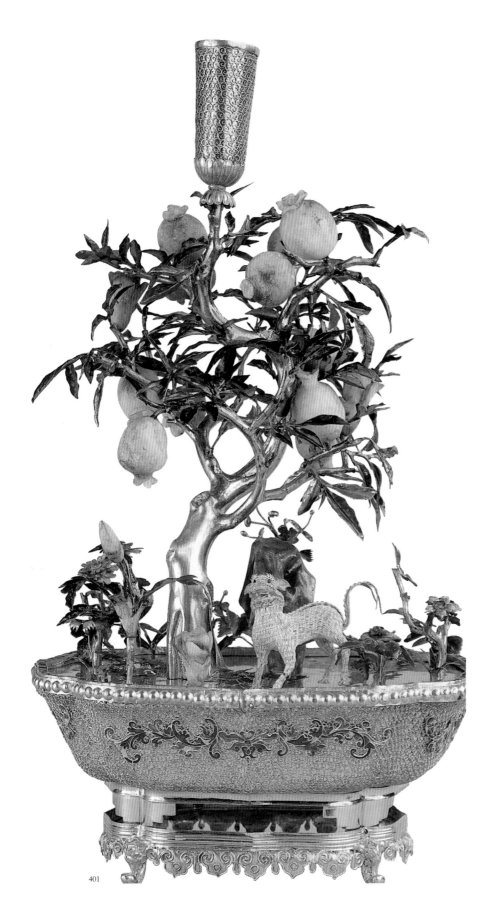

401

The Hermitage has a pair to this teapot as well as several similar teapots with slightly different decoration.

Such vessels were used in China for wine but in Europe the form served as the basis for teapots. One such vessel may have provided the model for the marquetry composition on the Russian card table. M.M.

403
Hair Ornament. 17th-18th century
China
Gold, gold filigree; ruby. Height 4
Inv. No. LS 332
Provenance: Main Hermitage Collection.
First publication

Hair ornament in the shape of a lotus, with double filigree petals and a large protruding central gold jewelled crown with six round petals supporting a polished cabochon ruby fixed with gold claws.

The Hermitage has several similar pieces, but of different sizes. Some have pine needles around the centre of the flower, some have five petals. These may have been used to decorate the silk band which supported the hair above the forehead, as seen in portraits of Chinese palace ladies of the Qing Dynasty in the 18th century.

The large ruby is characteristic of such decoration. Stones were usually not specified according to modern geological divisions but were identified by colours. This kind – a red precious stone – would have been a *hung bao shi*, and the rules dictated that such stones be worn only by members of the imperial family or the highest officials and their wives.

Such a hair ornament may have served as the prototype for the gold flower decoration on the silk head band worn by the woman on the chinoiserie table. M.M.

404
Small Cup. Mid-18th century
China
Silver; engraved and gilded. 4.1 × 5.5
Inv. No. LS 160
Provenance: Main Hermitage Collection.
First publication.

Four-lobed cup, rounded towards the bottom, on a low stand. Decorated with engraved stylised lotus flowers, one on each side, the tops of which are gilded. Spiral scroll runs along the edge. One of a pair in the Hermitage.

On the bottom are two engraved symbols, possibly the Russian letters FI, indicating the initials and mark of the assay master Ivan Frolov, who worked in St Petersburg during the period 1738-79.

Such pieces may have served as the prototype for the cup in the woman's hand on the marquetry table. M.M.

405
Tea-Kettle, Stand and Burner. 1750
Nicholas Sprimont. 1716-71
London
Silver; cast, chased and gilded. Height 39.5
Marks: on the kettle: sterling standard mark, hallmark for London, date letter for 1750-1, maker's mark of Nicholas Sprimont; control mark for St Petersburg and the year 1792 (?); assay-master mark of Nikifor Moshchalkin (fl. 1772-1800); Russian fineness mark 88 [English equivalent 916]; on the burner: sterling standard mark; hallmark for London; date letter for 1745 – 6; maker's mark of Nicholas Sprimont.
Inv. Nos E7125, E7125a
Provenance: from 1792 in the Winter Palace; in the imperial household from the mid-18th century.
(Illus. see p. 204)

Seven items survive from the Oranienbaum service, made by the London craftsmen Nicholas Sprimont, Thomas Heming and Fuller White in the 1750s. The service took its name from its original home at Oranienbaum, favourite residence of Catherine's husband Peter.

The whole of this outstandingly original service is in the chinoiserie style. Chased scenes of Chinese life, undoubtedly borrowed from engravings, decorate the reserved areas on the kettle. Dragon motifs dominate – the spout and burner are executed in the form of a dragon – and even the mascarons at the base of the leaves have Oriental features. Nonetheless, the vegetable motifs reflect a degree of naturalism characteristic of Rococo style. Although at first sight it perhaps seems heavy and overloaded, its composition complex, its silhouette fussy, the tea-kettle skilfully incorporates all the wealth of the artist's powers of invention. Nicholas Sprimont undoubtedly has much in common with Paul de Lamerie and Paul Crespin – the leading silversmiths of the 18th century – and their influence is clearly visible in his work. M.L.

403

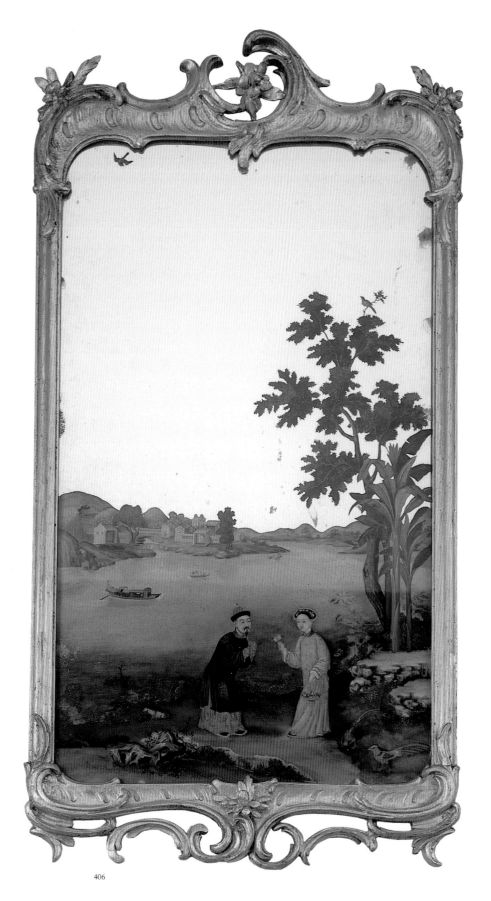

406

406

Framed Mirror. Mid-18th century

Mirror: China. Frame: Russia.

Enamel painted mirror; carved and gilded wood.

80 × 44

Inv. No. ERMb 597

Provenance: 1954, from the Museum of Ethnography.

An example of the vast number of goods produced in 18th-century China for export to Europe. Frames for such mirrors were usually produced in the country of destination; in this case the carved and gilded frame is typical of Russian work of the middle of the 18th century, as we can tell from the complex interweaving of dynamic relief Baroque forms and elegant Rococo motifs.　　　　　N.G.

407

Folding Fan

Screen: China. Frame: England, 1750s – no later than 1762

Paper, leather, ivory; painted, carved and gilded.

Length 27.5

Inv. No. ERT 15082

Provenance: 1951, from the Western European Department; 1920, from the Fabergé collection.

On the third and tenth shafts of the carved openwork ivory frame, this fan bears the monogram "EA" beneath a Grand Ducal crown, evidence that it belonged to Catherine before she became Empress in 1762. Painted scenes from Chinese life decorate both sides of the screen.

Physical analysis by Hermitage specialists has shown that the screen is made of two layers, the upper being of thin leather, so called "chicken-skin", the lower or reverse side of an inner layer of hide. The screen is edged with a gilded paper ribbon in which are layers of mulberry tree and Chinese nettle (*rami*). Mulberry bast and *rami* threads were traditional Chinese raw materials for the making of paper.

Analogies for the carved decoration of the frame, particularly the openwork, can be found in English fans of the 1750s and 1760s.　　　　　Y.P.

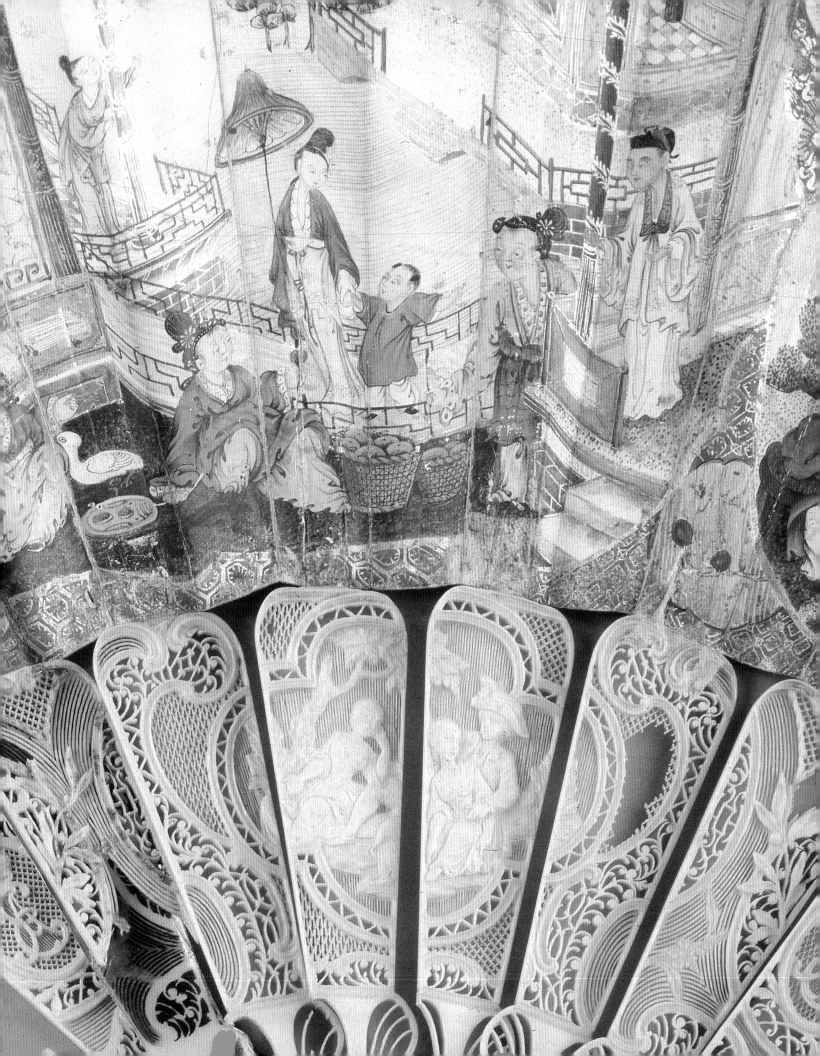

407

408
Chair. 1784

Workshop of Jean-Baptiste Charlemagne, St Petersburg.
To a design by Charles Cameron
Wood, silk, metal; carved, gilded, painted and tinted.
119 × 72 × 72
Inv. No. ERMb 1193
Label: Tsarskoye Selo Palace Administration
Provenance: 1930s, from the Shuvalov Palace Museum,
formerly Shuvalov collection.
(Illus. see p. 203)

The walls of the two-tiered Chinese Room at the
Catherine Palace in Tsarskoye Selo were hung
with genuine Chinese lacquered panels in black
frames and enamel ornament. After a careful
study of the rich array of Oriental pieces at the
palace, Cameron drew up a detailed design for
the interior: the whole of the room, including the
ceiling, was then decorated with stylised
"Oriental" compositions and ornaments, the
stylisation extending to all the furniture.

Cameron's furniture and applied art present
an apparently natural combination of the latest
European artistic trends and chinoiserie
elements. The carved intertwining snakes and
creeping lizards on this chair were echoed in the
painting on the walls and the carved frame over
the fireplace. This was probably the first example
of the use in Russian furniture, alongside
decorative painting and tinting, of different
shades of gold for the gilding. Archive
documents relating to Charlemagne's workshop
mention yellow, red and green gold with various
admixtures to create various effects.

The silk painted upholstery dates to the
second half of the 19th century. N.G.

409
Hexagonal Chinoiserie Chandelier. 1780s/1830s

St Petersburg
Tin, metal alloy, brass, glass; gilded and painted.
72 × 41 × 41
Inv. No. ERRz 3172
Provenance: 1941, Museum of Ethnography; formerly
Russian Museum.

Reminiscent in form of a Chinese pagoda, this
chandelier is decorated with gilded figures of
winged dragons and numerous little bells, while
the glass panels have excellent little humorous
scenes of Chinese men and women dancing. It
must have hung in a "Chinese" room in one of St
Petersburg's numerous imperial palaces, and
was probably inspired by similar pieces which
once decorated Catherine's private apartments
in the Winter Palace.

In 1777-8 the library in the mezzanine of the
Winter Palace was reworked to create "Turkish",
"Persian" and "Chinese" rooms. A chandelier was
made for each room by Johann Reiners, a
Petersburg bronzeworker, possibly to designs by
the architect Antonio Rinaldi. Ten "Turkish"
pieces were made in gilded copper with crystal
figures, copper sickle moons, stars and crystal
drops. Six chandeliers "in the Persian manner"
were adorned with coloured glass, while the
"Chinese" pieces had mirror polished glass and
small copper bells (State Russian History
Archive, Fund 468, *opis* 1, part 2, *delo* 3895, ff.75-
6v.). We know from the archives that most of
these were destroyed during the terrible fire
which raged through the Winter Palace in 1837,
and only two Chinese pieces survived, but with

all the glass smashed (State Russian History
Archive, Fund 470, *opis* 2 (106/540), *delo* 92,
f.926v.).

The metal construction was probably made
some time soon after the 1780s, but the glass
dates to the 1830s. I.S.

410-15
Series of Designs for Park Pavilions in Chinese Style. 1770s
Ilya Neyelov. 1745-93

Pencil, pen, brush, ink, watercolour on paper
Provenance: Main Hermitage Collection.

All the works in this series are identically
finished. Cats 410 and 411 both bear the signature
of Ilya Neyelov on the basis of which the whole
series is attributed to him.

These drawings are proof that the author was
familiar with popular engraved albums of
Chinese motifs – *Rural Architecture with Chinese
Taste, Being Designed Entirely New for the Decoration
of Gardens, Parks, Forrest, Inside of Houses, by Will'm
and Jn'n Halfpenny Architects*, London, 1750-2;
*Designs of Chinese Buildings, Furniture, Dresses,
Machines and Utensils*, by William Chambers,
London, 1757 – from which he often reworked
motifs or images.

Neyelov graduated from the St Petersburg
Academy of Arts in 1770 and was sent to study in
Italy for four years, being elected member of the
Bologna Academy in 1774. He was well
acquainted with the latest trends in art and on
his return to Russia became involved in the
extensive works being carried out at Catherine's
favourite country residence at Tsarskoye Selo.
Major work was done here in the 1770s,
transforming part of the regular park into an
English landscaped park. Buildings in Chinese
style were an obligatory part of such landscapes
and at Tsarskoye Selo they were designed by
Antonio Rinaldi, Yury Velten and Charles
Cameron. The Chinese Village, still partly
preserved today, was by Rinaldi and Cameron,
but Neyelov would seem to have been also
involved in the construction. M.F.K.

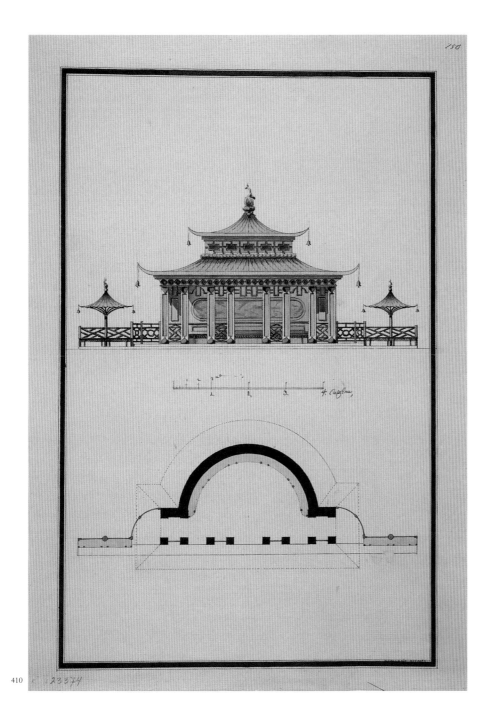

November 2000 – March 2001

410

Design for a Chinese Pavilion: Façade and Plan

Bottom right corner above the frame: *арки: Илья Нееловъ* [arch. Ilya Neyelov]. 48.3 × 43

Inv. No. OR 23374

411

Design for a Round Chinese Pavilion: Façade and Plan

Signed bottom right corner: *ар: Илья Нееловъ* [ar: Ilya Neyelov] 48 × 33.7

Inv. No. OR 23373

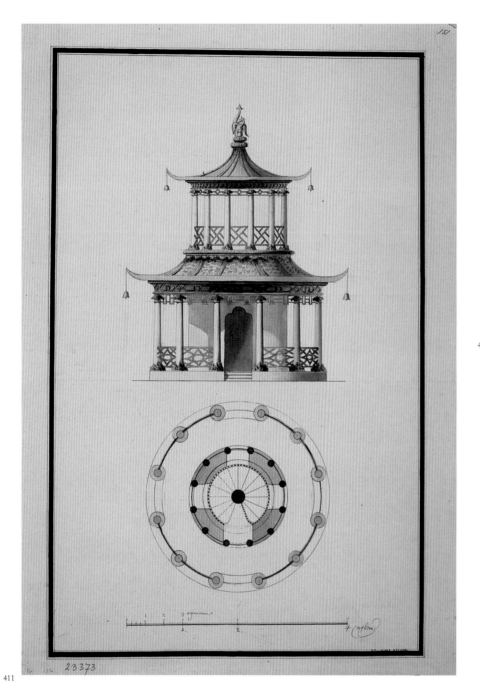

411

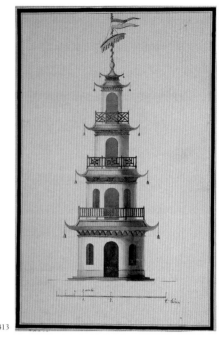

413

March 2001 - June 2001

412
Design for a Chinese Pavilion: Façade and Plan. 1770s
32.2 × 22.3
Inv. No. OR 23368

413
Design for a Pagoda
35.5 × 23.5
Inv. No. OR 23369

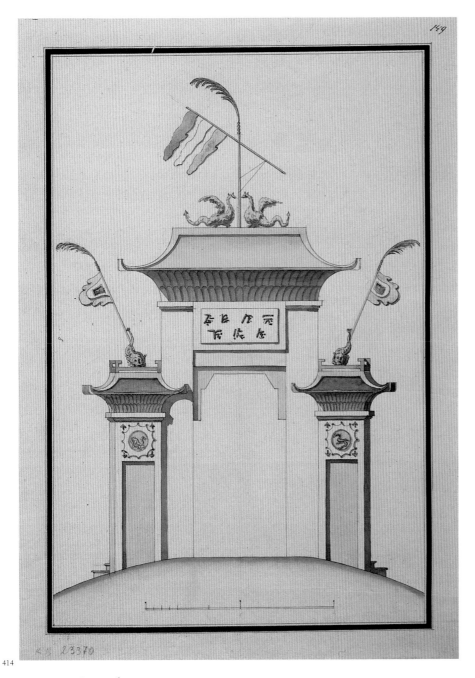

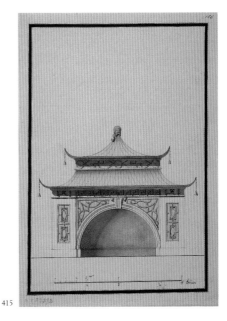

415

June 2001 - September 2001

414
Design for Gates in Chinese Style
35.8 × 25.5
Inv. No. OR 23370

415
Design for a Pavilion in Chinese Style
35 × 25.5
Inv. No. OR 23372

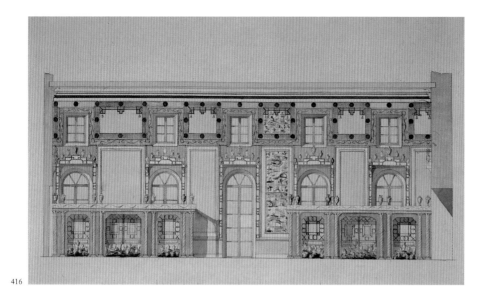

416

November 2000 - March 2001

416

44.5 x 53.6

Inv. No. OR 11036

March 2001 - June 2001

417

44.5 x 71

Inv. No. OR 11029

November 2000 - March 2001

418

Room in a Rural House. 1770s
Unknown Architect

Inscription along the upper edge: *Chambre de Companie, Développée*

Pen, brush, ink and watercolour on paper. 25 × 46.2

Inv. No. OR 11062

Provenance: 1822, from Cameron's heirs, London.

An interesting variation on an interior combining the elegance of European Rococo with elements of Chinese decoration (note the coloured decoration of the walls and the use of Chinese motifs). The sheet was amongst papers acquired from Cameron's heirs, which included materials by other architects who worked alongside the Neoclassical architect at Tsarskoye Selo. M.F.K.

416, 417
Designs for Wall Decoration in the Chinese Room of the Palace at Tsarskoye Selo. 1780s
Charles Cameron. 1745-1812

Pencil, pen, brush, ink and watercolour on paper

Provenance: 1822, from Cameron's heirs, London.

A large collection of Chinese and Japanese porcelain, carved and painted lacquers, ivories and silks was kept at Tsarskoye Selo, much of it acquired during the reign of Peter I. As the fashion for Chinese style raged in the second half of the century, Catherine entrusted the reworking of the Baroque interiors to the Scottish architect Charles Cameron, one of his tasks being to create a fitting setting for original Oriental objects. This Chinese Room was to form the centre of the palace. Cameron arranged the original works – porcelain, lacquers and silk – picturesquely on the stylised walls.

Although the basis of these designs may have been prepared in Cameron's workshop, Cat. 416 nonetheless reveals the free drawing of details which was characteristic of the architect himself.

These works were among 114 plans and drafts acquired from the architect's heirs in London in 1822 by the Russian ambassador to London, Count Khristofor Lieven. The acquisition was prompted by restoration undertaken at Tsarskoye Selo after a fire in 1820. M.F.K.

417

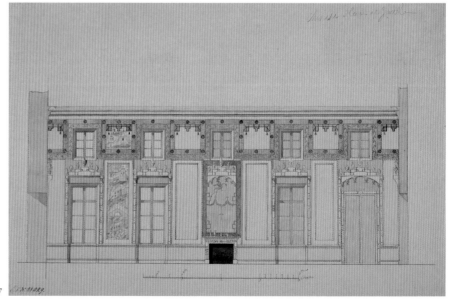

419-21

Designs for Chinese Pavilions. 1760s

Yury (Georg) Velten. 1730-1801

Pencil, pen, brush and ink on paper.
Provenance: Main Hermitage Collection.

Part of a series of designs for park structures
which Velten produced in the late 1760s, possibly
to be engraved. Some of the 12 varied subjects
include Chinese decorative motifs. Typically,
small bridges and summer houses employed the
external features of exotic architecture and such
buildings, with their striking silhouettes and
fanciful forms, were often an integral part of the
English landscaped park.

Undoubtedly this series should be related to
the decorative Chinese structures erected in the
park at Tsarskoye Selo. Velten was directly
involved in work there, his contribution included
the Creaking Bridge and the Chinese Bridges,
still standing today. M.F.K.

420

March 2001 - June 2001

419
Chinese Pavilion
37.3 × 53.2
Inv. No. OR 8751

June 2001 - September 2001

420
Chinese Pavilion on a Rock
37.4 × 53.6
Inv. No. OR 8753

421
Chinese Pavilion with Spiral Top, on a Rock
37.3 x 53.8
Inv. No. OR 8752
(Illus. see p. 202)

419

422

View of the Cameron Gallery, Tsarskoye Selo.
1793

Johann Christophor de Meyr [Mayr, Mair].
1764-1812

Bottom right: *Gravé par c. De Mayr 1793*; bottom centre:
Vue de la Collonade de Czarskoie Selo

Aquatint, printed in sanguine. 43.1 x 63.5 (image)

Inv. No. ERG 27297

Provenance: Main Hermitage Collection.

Catherine's elegant colonnaded gallery (1783-7) is
named in honour of its architect, the Scot
Charles Cameron. This print also shows to the
right the Catherine Palace (1756-78) by Rastrelli
and Cameron's Agate Pavilion (1780). Migdal
sees this engraving as a joint work by the two de
Meyr brothers on the basis of a comparison with
their other works. We know that they frequently
worked together.

In 1782 Catherine wrote to Grimm: "The
garden at Tsarskoye Selo, in the words of the
English, various travellers from all countries and
our own travellers who have visited other parts,
is become unique of its kind." Nine years later, in
May 1791, she again described her favourite
residence as she sat under the colonnade: "This
colonnade is all the more pleasant in that when it
is cold there is always one side where it is less to
be felt. The middle of my colonnade is glazed and
is 39 *sazehn* [approximately 39 metres] long;
below and around is a flower garden... In my
colonnade stand bronze busts of the greatest
men of Antiquity, of Homer, Demosthenes, Plato
and others. There are several other statues. The
Farnese *Hercules* and *Flora* adorn the colonnade
staircase leading from the terrace to the lake...
I return from the colonnade, where I have
walked between the bronze busts standing there.
You cannot imagine what wonderful thoughts
are inspired by such company, I like to be in this
society." G.K.

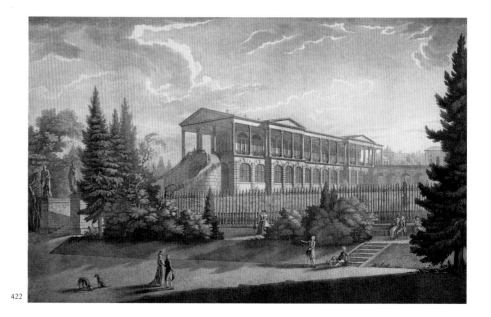

422

423

View of the Park at Tsarskoye Selo. 1790s
Johann Christophor de Meyr [Mayr, Mair].
1764-1812

Aquatint, printed in sanguine. 43.5 × 61.7 (image)

Inv. No. ERG 31874

Provenance: Main Hermitage Collection.

Pair to Cat. 422. To the left is the Kagul
(Rumyantsev) Obelisk (1771; Antonio Rinaldi),
erected in honour of the Russian victory over the
Turks in Moldavia on the River Kagul. The
Russian troops were under the command of
Count Pyotr Rumyantsev. To the left is the Great
Caprice, a pseudo-Gothic pavilion of 1772-4 by
Vasily Neyelov. This print is taken from the
artist's own drawing. G.K.

423

Bibliography

This basic bibliography is divided into sections. The first, "Catherine, St Petersburg and the Hermitage", includes general publications and exhibition catalogues relating to many different objects mentioned in different chapters of this publication. Later sections provide references to particular objects or groups of objects mentioned in specific chapters of the book. In many cases, the recent publications listed can provide fuller bibliographies for individual objects.

Entries are arranged chronologically.

A few abbreviations have been used in the text. These are entered here in chronological order, with full details.

Catherine, St Petersburg and the Hermitage

Coxe 1784
William Coxe: *Travels into Poland, Russia, Sweden, and Denmark. Interspersed with historical relations and political inquiries, illustrated with charts and engravings*, 2 vols, London 1784

Georgi 1794
I. G. Georgi: *Opisaniye rossiysko-imperatorskogo stolichnogo goroda Sankt-Peterburga i dostopamyatnostey v okrestnostyakh onogo, 1794-1796* [A Description of the Russian Imperial Capital City of St Petersburg and the Sights in its Environs, 1794-1796], St Petersburg, 1794; all references are to the reprint of 1996 (St Petersburg). This book was originally published in German and translated into French: *Versuch einer Beschreibung der Rußisch Kaiserl. Residentzstadt St. Petersburg und der Merkwürdigkeiten der Gegend, von Johann Gottlieb Georgi*, Riga, 1793; *Description de la Ville de St. Pétersbourg et de ses environs, traduite de l'allemand de Mr. Georgi*, St Petersburg, 1793. Only the Russian edition, however, includes the text on the Hermitage.

Svin'in 1821
P. P. Svin'in: *Dostopamyatnosti Sankt Peterburga i yego okrestnostey* [The Sights of St Petersburg and its Environs], parallel Russian and French texts; 5 books, St Petersburg, 1816-28; book IV, 1821, deals with the Hermitage; all page references are to the Russian language reprint of 1997, St Petersburg

Zapiski Dashkovoy [The Notes of Dashkova], London, 1859; reprinted Moscow, 1990; a slightly abbreviated version is available in English: *The Memoirs of Princess Dashkova*, translated and edited by Kyrill Fitzlyon, Durham and London, 1995

F. Gille: *Musée de l'Hermitage Impérial*, St Petersburg, 1860; revised edition 1863

Khrapovitsky Diaries 1990
A. V. Khrapovitsky: *Pamyatnyye zapiski A. V. Khrapovitskogo, stats-sekretarya imperatritsy Yekateriny Vtoroy* [Memorable Notes of A. V. Khrapovitsky, Secretary to the Empress Catherine the Great], Moscow, 1862; reprint Moscow, 1990

Catherine's Correspondence with Melchior Grimm
SbRIO - *Sbornik Rossiykogo Imperatorskogo istoricheskogo obshchestva* [Anthology of the Russian Imperial Historical Society], vol. XVII, 1876; vol. XXIII, 1878; vol. XXXIII, 1881; vol. XLIV, 1885. Published in abbreviated form: Ya. K. Grot: *Yekaterina v perepiske s Grimmon* [Catherine II in Correspondence with Grimm], St Petersburg, 1984; "Correspondance Artistique de Grimm avec Catherine II", published by Louis Réau, *Archives de l'Art Français*, N.P., vol. 17, 1932

Pylyayev 1990
M. I. Pylyayev: *Staryy Peterburg* [Old St Petersburg], St Petersburg, 1889; reprint Moscow, 1990

Maurice Tourneaux: *Diderot et Catherine II*, Paris, 1899

M. D. B. de Corberon: *Un diplomat français à la cour de Catherine II. Journal intime du Chevalier de Corberon, chargé d'affaires de France en Russie*, Paris, 1901

Khudozhestvennyye sokrovishcha Rossii [Art Treasures of Russia], 1904

Corréspondance de Falconet avec Catherine II, Paris, 1921

Catherine the Great: Memoirs, ed. D. Maroger, New York, 1957

Pierre Descargues: *The Hermitage Museum*, Leningrad and New York, 1961

Series of 16 articles on the Hermitage collections in *Apollo*, December 1974; June 1975

A. Vasilyeva: "Velikaya knyaginya Mariya Fyodorovna - khudozhnitsa" [Grand Duchess Maria Fyodorovna as an Artist], Pavlovsk, Imperatorskiy dvorets. Stranitsy istorii [Pavlovsk. Imperial Palace. Pages From its History], St Petersburg, 1977

L. A. Dukelskaya: *The Hermitage. English Art Sixteenth to Nineteenth Century*, Leningrad, 1979

Lawrence Kelly: *St Petersburg. A Traveller's Companion*, London, 1981

Isabel de Madariaga: *Russia in the Age of Catherine the Great*, London, 1981

Anthony Cross: "The Great Patroness of the North. Catherine the Great's Role in Fashioning Anglo-Russian Contacts", *Oxford Slavonic Papers*, vol. 18, 1985, pp. 67-82

Levinson-Lessing 1986
V. V. Levinson-Lessing: *Istoriya kartinnoy galerei Ermitazha (1784-1917)* [The History of the Hermitage Picture Gallery (1784-1917)], Leningrad, 1986 (2nd ed., with index)

Rossiya-Frantsiya. Vek prosveshcheniya [Russia-France. The Century of Enlightenment], Leningrad, 1987

John Alexander: *Catherine the Great, Life and Legend*, Oxford, 1989

E. Dimsdale: *An English Lady at the Court of Catherine the Great. The Journal of Baroness Elizabeth Dimsdale 1781*, Cambridge, 1989

Ermitazh: Istoriya stroitel'stva i arkhitektura zdaniy [The Hermitage. The History of the Construction and the Architecture of the Buildings], Leningrad, 1989

Isabel de Madariaga: *Catherine the Great. A Short History*, New Haven and London, 1990

St. Petersburg um 1800, exh. cat., Essen, 1990

Treasures of Imperial Russia. Catherine the Great. From the State Hermitage Museum, Leningrad, exh. cat., Memphis, Los Angeles, Dallas, 1990-2

Yakob Shtelin [Jacob Stählin]: *Zapiski Yakoba Stelina ob izyashchnykh iskusstvakh v Rossi* [Jacob Stählin's Notes on the Fine Arts in Russia], 2 vols, Moscow, 1990

San Pietroburgo 1703-1825. Arte di corte dal Museo dell' Ermitage, exh. cat., Turin, 1991

Gosudarstvennyy Ermitazh. Yekaterina Velikaya. Russkaya kul'tura vtoroy poloviny XVIII veka [The State Hermitage. Catherine the Great. Russian Culture in the Second Half of the 18th Century], exh. cat., Hermitage, St Petersburg, 1993

Zur Tafel im Winterpalast. Russische und westeuropäische Porzellan- und Fayencearbeiten aus der Zweiten Halfte des 18. Jahrhunderts, exh. cat., Kolding, 1994

Emmanuel Decamp, ed.: The Winter Palace, St Petersburg-Paris, 1995

Solomon Volkhov: St Petersburg: A Cultural History, London, 1996

British Art Treasures from Russian Imperial Collections in the Hermitage, exh. cat., New Haven, CT; Toledo, OH; Saint Louis, MI; 1996-7

Catharina, de keizerin en de kunsten. Uit de schatkamers van de Hermitage, exh. cat., Amsterdam, 1996-7

G. Norman: The Hermitage. The Biography of a Great Museum, London, 1997

M. Piotrovsky, O. Neverov: The Hermitage: The History of the Collections, St Petersburg, 1997

Katharina die Grosse, exh. cat., Kassel, 1997-8

Caterina di Russia. L'imperatrice e le Arti, exh. cat., Florence, 1998

Catherine the Great & Gustav III, exh. cat., Stockholm, 1998-9

Ot voyny k miru. Rossiya-shvetsiya XVIII vek [From War to Peace. Russia and Sweden in the 18th Century], exh. cat., 5 vols, St Petersburg, 1999

Biography of an Empress - Gallery 2

Portraits

Katalog istoriko-khudozhestvennoy vystavki russkikh portretov, ustraivayemoy v Tavricheskom dvortse v polzu vdov i sirot pavshikh v boyu voinov [Catalogue of a Historical and Artistic Exhibition of Russian Portraits Organised in the Tauride Palace in Aid of the Widows and Orphans of Soldiers Fallen in Battle], St Petersburg, 1905

Portraits Russes, 3 vols, Moscow, 1905-7

Russkiye portrety XVIII i XIX stoletiy [Russian Portraits of the 18th and 19th Centuries], published by Grand Duke Nikolay Mikhailovich, 5 vols, St Petersburg, 1905-9

Baron N. Wrangell: "Inostrantsy v Rossii" [Foreigners in Russia], Staryye gody [Days of Yore], 1911, pp. 45-9

S. P. Ernst: "Staryye portrety" [Old Portraits], Staryye gody [Days of Yore], April-June 1916

K. A. Agafonova: "Ogyusten Ritt. Portret A. L. Naryshkina" [Augustin Ritt. Portrait of A. L. Naryshkin], in Sokrovishcha Ermitazha [The Treasures of the Hermitage], Moscow – Leningrad, 1949, pp. 331-2

Pamyatniki russkoy kultury pervoy chetverti XVIII veka v sobranii Gosudarstvennogo ordena Lenina Ermitazha [Monuments of Russian Culture of the First Quarter of the 18th Century in the Collection of the State Order of Lenin Hermitage], exh. cat. , Moscow, 1966

G. N. Komelova: "Pervyy russkiy miniatyurist G. S. Musikiyskiy" [G. S. Musikiysky, First Russian Miniaturist], in Russkoye iskusstvo pervoy chetverti XVIII veka. Materialy i issledovaniya [Russian Art of the First Quarter of the 18th Century. Materials and Research], Moscow, 1974

G. N. Komelova: "A. G. Ovsov – miniatyurist petrovskogo vremeni" [A. G. Ovsov – Miniaturist of the Time of Peter I], Pamyatniki kultury. Novyye otkrytiya. Yezhegodnik 1975 [Cultural Monuments. New Discoveries. Annual for 1975], Moscow 1976

G. N. Komelova: "Miniatyury A. I. Chernova" [The Miniatures of A. I. Chernov], in

Pamyatniki kultury. Novyye otkrytiya. Yezhegodnik 1976 [Cultural Monuments. New Discoveries. Annual for 1976], Moscow 1977

G. N. Komelova: "D. I. Yevreinov – Russkiy miniatyurist na emali" [D. I. Yevreinov – Russian Miniaturist on Enamel], Pamyatniki kultury. Novyye otkrytiya. Yezhegodnik 1979 [Cultural Monuments. New Discoveries. Annual for 1979], Leningrad, 1980

L. A. Markina: "Izucheniye tvorcheskogo naslediya G. Kh. Groota" [A Study of the Creative Heritage of G. C. Groot], Khudozhestvennoye naslediye. Khraneniye, issledovaniye, restavratsiya [Artistic Heritage. Preservation, Study and Restoration], issue 8, 1983

G. A. Printseva, G. N. Komelova: Portretnaya miniatura v Rossii XVIII - nachala XX veka. Iz sobraniya Gosudarstvennogo Ermitazha [Portrait Miniatures in Russia in the 18th to Early 20th Century. From the Collection of the State Hermitage], Leningrad, 1986

G. N. Komelova: Russkaya miniatura na emali XVIII – nachala XIX veka [Russian Miniatures on Enamel of the 18th to Early 19th Century], St Petersburg, 1995

Maltiyskiy orden v Rossii [The Order of Malta in Russia], exh. cat., Hermitage, St Petersburg, 1998

Prints

D. A. Rovinsky: Podrobnyy slovar russkikh gravirovannykh portretov [Detailed Dictionary of Russian Engraved Portraits], 4 vols, St Petersburg, 1886-9

D. A. Rovinsky: Podrobnyy slovar russkikh gravyorov XVI-XIX vekov [Detailed Dictionary of Russian Engravers of the 16th to 19th Centuries], 2 vols, St Petersburg, 1895

Gravirovalnaya palata Akademii nauk XVIII veka. Sbornik dokumentov [The Engraving Department of the Academy of Sciences in the 18th Century. Anthology of Documents], Leningrad, 1985

Eriksen

T. Andersen: "Vigilus Eriksen in Russia", Artes I, Copenhagen, October 1965

T. Andersen: Vigilius Eriksen, List of Paintings 1757-1772, Copenhagen, 1970

E. Renne: "Catherine II Through the Eyes of Vigilius Eriksen and Alexander Roslin", Catherine the Great & Gustav III, exh. cat., Nationalmuseum, Stockholm, 1998-9, pp. 97-106

French Sculpture

Zh. Matsulevich: Frantsuzskaya portretnaya skulptura XV-XVIII vv. v Ermitazhe [French Portrait Sculpture of the 15th to 18th Centuries in the Hermitage], Leningrad – Moscow, 1940

Gosudarstvennyy Russkiy muzey. Zhak-Dominik Rashett. 1744-1809 [The State Russian Museum. Jacques-Dominique Rachette. 1744-1809], exh. cat., Russian Museum, St Petersburg, 2000

European Porcelain

K. Berling: Festschrift zur 200 jährigen Jubelfeier der ältesten europäischen Porzellanmanufactur Meissen, 1910, Leipzig, 1911

G. Lenz: Berliner Porzellan. Die Manufactur Freidrichs des Großen 1763-1786, Bd. I, Berlin, 1913

K. Berling: Die Meissner Porzellangruppen der Kaißerin Katharina II in Oranienbaum, Dresden, 1914

Von Sanssouci nach Europa. Geschenke Friedrichs des Großen an europäische Höfe, exh. cat., Stiftung Schlösser und Gärten Potsdam-Sanssouci, 1994

Objets de Vertu

G. Lieven: *Putevoditel' po kabinetu Petra Velikogo i Galereye Dragotsennostey* [Guide to the Cabinet of Peter the Great and the Gallery of Objets de Vertu], St Petersburg, 1902

Ori e Argenti dall'Ermitage, exh. cat., Lugano, 1986

Der Zarenschatz der Romanov. Meisterwerke aus der Eremitage St. Petersburg, exh. cat., Speyer, 1994

Zarengold. 100 Kostbarkeiten der Goldschmiedkunst aus der Staatlichen Eremitage, St Petersburg, exh. cat., Pforzheim, 1995

Cameo Fever - Gallery 3

Cameos

P. J. Mariette: *Description sommaire des pierres gravées du Cabinet de feu M. Crozat*, Paris, 1741

La Chau, Le Blond: *Description des principales pierres gravées du Cabinet de S. A. M. le Duc d'Orléans, premier Prince du sang*, Paris, 1780-4

[Belley]: *Catalogue des pierres gravées du Cabinet... de feu M. le Duc d'Orléans*, Paris, 1786

A. Miliotti: *Description d'une Collection de pierres Gravées qui se trouvent au Cabinet Impérial de St. Pétersbourg*, vol. I, Vienna, 1803

D. F. Kobeko: "Imperatritsa Mariya Fyodorovna kak khudozhnitsa" [Empress Maria Fyodorovna as an Artist], *Vestnik izyashchnykh iskusstv* [Fine Arts Bulletin], 1884, col. 2

S. N. Troinitsky: "Georg Genrikh Kyonig" [Georg Heinrich König], *Sbornik Gosudarstvennogo Ermitazha* [Anthology of the State Hermitage], issue 1, 1920

M. I. Maximova: "Imperatritsa Yekaterina Vtoraya i sobraniye reznykh kamney Ermitazha" [Empress Catherine II and the Hermitage Collection of Engraved Gems], *Sbornik Gosudarstvennogo Ermitazha* [Anthology of the State Hermitage], Petrograd, 1921

J. Wirenius-Matzoulewitch: "Quelques camées inédits du Musée de l'Ermitage", *Aretuse*, No. 2, 3-e trimestre, 1928

N. B. Krasnova: "Ital'yanskiye reznyye portrety XV – nachala XVI veka v sobranii Ermitazha" [Italian Carved Portraits of the 15th to Early 16th Century in the Hermitage Collection], *Trudy Gosudarstvennogo Ermitazha* [Papers of the State Hermitage], VIII, 1965

Y. O. Etkind [Kagan]: "Reznyye kamni Uil'yama i Charl'za Braunov v Ermitazhe. Istoriya kollektsii" [Engraved Gems by William and Charles Brown in the Hermitage. The History of the Collection], *Trudy Gosudarstvennogo Ermitazha* [Papers of the State Hermitage], VIII, Leningrad, 1965

Y. Etkind [Kagan]: "Russian Themes in the Work of the English Gem Cutters William and Charles Brown", *The Burlington Magazine*, August 1965

O. Y. Neverov: "Concordia Augustorum – dinasticheskaya tema v rimskoy gliptike" [Concordia Augustorum - The Dynastic Theme in Roman Glyptics], *Wissenschaftliche Zeitschrift der Universitet Rostock*, XIX, 1970

O. Neverov: *Antique Cameos in the Hermitage Collection*, Leningrad, 1971

Ju. Kagan: *Western European Cameos in the Hermitage Collection*, Leningrad, 1973

Y. O. Kagan: "Kabinet slepkov Dzheymsa Tassi v Ermitazhe" [James Tassie's Cabinet of Casts in the Hermitage], *Trudy Gosudarstvennogo Ermitazha* [Papers of the State Hermitage], XIV, Leningrad, 1973

Y. O. Kagan: *Reznyye kamni Uil'yama i Charl'za Braunov*, exh. cat., Hermitage Museum, Leningrad, 1976

O. Neverov: *Antique Intaglios in the Hermitage Collection*, Leningrad, 1976

Y. O. Kagan, O. Y. Neverov: "Sud'ba Petrovskoy relikvii" [The Fate of a Petrine Reliquary], *Soobshcheniya Gosudarstvennogo Ermitazha* [Reports of the State Hermitage], issue 47, Leningrad, 1982

O. Neverov: *Antichnyye kamei v sobranii Ermitazha* [Antique Cameos in the Hermitage Collection], catalogue, Leningrad, 1988

O. Neverov: "Gems from the Collection of Princess Dashkov", *Journal of the History of Collections*, 1990, No. 1

J. Kagan: "Zarin Katharina II. als Auftraggeberin und Sammlerin geschnittener Steine des 18. Jahrhunderts", *Zeitschrift für Kunstgeschichte*, Bd. 59, Hf. 2, 1996

Furniture

P. Macquoid: *A History of English Furniture*, London, 1904

H. Huth: *Abraham und David Roentgen und ihre Neuwieder Möbelwerkstatt*, Berlin, 1928

R. Edwards, M. Jourdain: *Georgian Cabinet-makers*, London, 1955

H. Huth: *Roentgen und Gluck. Intuition und Kunstwissenschaft. Festschrift für H. Swarzenski*, Berlin, 1973

Yu. Kagan: "O vozmozhnom avtore reznogo kamnya 'Lot s docher'mi'" [On the Possible Author of the Engraved Gem 'Lot and his Daughters'], *Soobshcheniya Gosudarstvennogo Ermitazha* [Reports of the State Hermitage], issue 38, Leningrad, 1974

J. M. Robinson: *The Wyatts. An Architectural Dynasty*, Oxford, 1979

C. Baulez: "David Roentgen et François Remond", *L'Objet de l'Art*, No. 305, 1996

Cameo service

G. Lechevallier-Chevignard: *La Manufacture de Porcelaine de Sèvres*, Paris, 1908

S. N. Troinitsky: *Galereya farfora Imperatorskogo Ermitazha* [The Porcelain Gallery of the Imperial Hermitage], St Petersburg, 1911

T. Gautier: *Les porcelaniers du XVIII s. français*, Paris, 1964

K. Butler: "Sèvres from the Imperial Court", *Apollo*, 1975, pp. 452-7

M. Brune, T. Préaud: *Sèvres. Des origines à nos jours*, Fribourg, Switzerland, 1978

La porcelaine de Sèvres, Paris, 1982

R. Saville: "Cameo Fever: Six Pieces from the Sèvres Porcelain Dinner Service made for Catherine II of Russia", *Apollo*, 1982, pp. 304-11

S. Eriksen, G. de Bellaigne: *Sèvres Porcelain. Vincennes and Sèvres 1740-1800*, London – Boston, 1987

N. I. Kazakevich: "Serviz s kameyami. Istoriya sozdaniya i bytovaniya" [The Cameo Service. A History of its Making and Existence], *Pamyatniki kul'tury 1994* [Cultural Monuments 1994], Moscow 1996, pp. 462-7

Nollekens

P. Ettinger: "Portraits of Charles Fox at the Hermitage", *The Burlington Magazine*, vol. XLV, December 1924

J. T. Smith: *Nollekens and His Times*, abridged edition, London 1929

A Passion for Antiquities – Corridor

Classical Sculpture

Raccoltà d'antiche statue, busti, bassirrelievi ed altre sculture restaurate da Bartolomeo Cavaceppi, 3 vols, Rome, 1768-72

Catalogus veteris aevi varii generis monumentorum quae Cimelliarchio Lyde Browne arm. ant. soc. soc. apud Wimbledon asservantur, 1768

Catalogo dei piu Scelti e Preciosi Marmi che si conservanno nella Galleria del Sigr Lyde Brown Cavaliere Inglese a Wimbledon, nella contea di Surry, London, 1779

O. F. Waldhauer [Valdgauer]: *Rimskaya portretnaya skul'ptura v Ermitazhe* [Roman Portrait Sculpture in the Hermitage], Petrograd, 1923

O. Waldhauer: *Die Antiken Skulpturen der Ermitage*, 3 vols, Berlin-Leipzig, 1928-36

A. I. Voshchinina: *Rimskiy portret. Kollektsiya Gosudarstvennogo Ermitazha* [The Roman Portrait. Collection of the State Hermitage], Leningrad, 1974

Clérisseau

J. Lejeaux: "Charles-Louis Clérisseau. Architecte et peintre de ruines (1721-1820)", *Revue de l'Art*, No. 299, September - October 1928, pp. 125-37

T. J. McCormick: *Charles-Louis Clérisseau and the Genesis of Neo-Classicism*, Cambridge (MA) – London, 1990

Charles-Louis Clérisseau. (1721-1820) Dessins du Musée de l'Ermitage. Saint-Pétersbourg, Musée du Louvre, Paris, 1995

Sharl-Lui Klerisso – arkhitektor Yekateriny Velikoy. Risunki iz sobraniya Gosudarstvennogo Ermitazha [Charles-Louis Clérisseau – Architect to Catherine the Great. Drawings from the Collection of the State Hermitage], Hermitage, St Petersburg, 1997

V. G. Shevchenko: "Triumfal'nyye arki v risunkakh Klerisso" [Triumphal Arches in the Drawings of Clérisseau], *Trudy Gosudarstvennogo Ermitazha* [Papers of the State Hermitage], XXIX, St Petersburg, 2000

Patron of the Arts and Crafts – Gallery 4

Tula

E. Lenz: "Zametki o tulskom oruzheynom zavode v XVIII veke" [Notes on the Tula Armoury Factory in the 18th Century], *Staryye gody* [Days of Yore], July - September 1907

M. Malchenko: *Tulskiye 'zlatokuznetsy'* [Tula Goldworkers], Leningrad, 1974

M. Malchenko: "Khudozhestvennyye raboty tul'skikh masterov XVIII veka" [Artistic Works by 18th-century Tula Masters], *Trudy Gosudarstvennogo Ermitazha* [Papers of the State Hermitage], XV, 1974, pp. 161-76

Khudozhestvennyy metall v Rossii [Artistic Metal in Russia], Leningrad, 1981

Russische Schützkunste aus dem Moskauer Kreml und der Leningrader Eremitage, Cologne, 1981

Hardstones

B. V. Pavlovsky: *Kamnereznoye iskusstvo Urala* [Stonecutting Art of the Urals], Sverdlovsk, 1953

Ye. M. Yefimova: *Russkiy reznoy kamen v Ermitazhe* [Russian Cut Stones in the Hermitage], Leningrad, 1961

Nicholas Goodison: *Ormolu: The Work of Matthew Boulton*, London, 1974

B. V. Pavlovsky: *Dekorativno-prikladnoye iskusstvo promyshlennogo Urala* [Decorative Applied Arts of the Industrial Urals], Moscow, 1975

Khudozhestvennyy metall v Rossii XVII – nachala XX veka [Artisitic Metal in Russia From the 17th to Early 20th Century], Leningrad, 1981

Matthew Boulton and the Toymakers. Silver from the Birmingham Assay Office, exh. cat., Goldsmiths Hall, Foster Lane, London, 1982

V. B. Semyonov, I. M. Shakinko: *Ural'skiye samotsvety. Iz istorii kamnereznogo i granil'nogo dela na Urale* [Semi-precious Stones of the Urals. From the History of Stonecutting and Lapidary Work in the Urals], Sverdlovsk, 1982

Prikladnoye iskusstvo Italii v sobranii Ermitazha [Italian Applied Arts in the Hermitage Collection], Leningrad, 1985

N. M. Mavrodina: *Raboty kamnerezov Kolyvani v Ermitazhe* [Works of Kolyvan Stonecutters in the Hermitage], Leningrad, 1990

Omaggio al Nuovo Ermitage, exh. cat., Palazzo Ducale, Massa, 1998

Tapestries

T. T. Korshunova: *Russkiye shpalery. Peterburgskaya shpalernaya manufaktura* [Russian Tapestries. The St Petersburg Tapestry Manufactory], Leningrad, 1975

Green Frog Service

V. Harriman: "Wedgwood and Royalty", *The Fifth Wedgwood International Seminar*, Royal Ontario Museum, Toronto, 1960

R. Reilly, G. Savage: *The Dictionary of Wedgwood*, New York, 1980

The Genius of Wedgwood, exh. cat., Victoria & Albert Museum, London, 1995

M. Raeburn, L. N. Voronikhina, A. Nurnberg, eds: *The Green Frog Service*, London, 1995

R. Reilly: *Wedgwood. The New Illustrated Dictionary*, Antique Collectors' Club, 1995

Russian Porcelain

La France et la Russie au siècle des lumières, exh. cat., Grand Palais, Paris, 1986; Hermitage, Leningrad, 1987

An Imperial Fascination: Porcelain. Dining with Czars, Peterhof. An Exhibition of Services from Russian Imperial Palaces, exh. cat., texts by N. Vernova, V. Znamenov and T. Nosovitch, New York, 1991

Le Porcellane Imperiali Russe dal 1744 al 1917, exh. cat., texts by N. Vernova, V. Znamenov and T. Nosovic, Faenza, 1993

Treasures from the Hermitage, St Petersburg, exh. cat., Maastricht MEEC, 1994

China and Chinoiserie - Gallery 5

Chinese Objects

Belyayev 1800
O. Belyayev: *Kabinet Petra Velikogo* [The Cabinet of Peter the Great], St Petersburg, 1800

B. Gullensvard: *Chinese Gold and Silver in the Carl Kempe Collection*, Stockholm, 1953

O. L. Fishman: "Kitay i yevropeyskoye Prosveshcheniye" [China and the European Enlightenment], in *Kitayskiy satiricheskiy roman* [The Chinese Satirical Novel], Moscow, 1966, chapter 5, pp. 139-69

Paul Singer: *Chinese Gold and Silver in the Carl Kempe Collection, Stockholm*, China Institute in America, 1972

Forbes 1975
H. A. Forbes, Devereux John Kernan, Ruth Wilkins: *Chinese Export Silver. 1785 to 1885*, Museum of American China Trade, 1975.

H. A. Forbes, C. Crosby: *Chinese Export Silver. A Legacy of Luxury*, 1984, Milton, MA

Catalogue 1986
Catalogue of the Exhibition of Ch'ing Dynasty Costume Accessories, National Palace Museum, Taipei, 1986

Clive Collection 1987
M. Archer, C. Rowell, R. Skelton et al: *Treasures from India. The Clive Collection at Powis Castle*, National Trust, 1987

A. J. Marlowe: *Chinese Export Silver*, London, 1990

Julia White, Emma Bunker: *Adornment for Eternity. Status and Rank in Chinese Ornament*, catalogue, Denver Art Museum, 1994

D. A. Howard: *A Tale of Three Cities: Canton, Shanghai & Hong Kong*, Sotheby's, London, 1997

R. Sackville-West: *Knole. Kent*, National Trust, 1999

Mark Zebrovsky: *Gold, Silver and Bronze from Mughal India*, London, 1999, pp. 46-9

G. N. Komelova: "Appartamenty Yektariny II v Zimnem dvortse", [The Apartments of Catherine II in the Winter Palace], in *Zimniy Dvorets* [The Winter Palace], St Petersburg, 2000, pp. 44-73

Chinoiserie

M. F. Korshunova: *Arkhitektor Yury Fel'ten* [The Architect Yury Velten], exh. cat., Leningrad, 1982

V. N. Taleporovsky: *Sharl'z Kameron* [Charles Cameron], Moscow, 1939

D. M. Migdal: "Iogann Georg Mayr i yego vidy Peterburga" [Johann Georg Meyr and His Views of St Petersburg], *Soobshcheniya Gosudarstvennogo Russkogo muzeya* [Bulletin of the State Russian Museum], issue VI, Leningrad, 1959, pp. 26-8

Produced and printed in England
By Christie's International Media Division
21-25 South Lambeth Road, London SW8 1SX Tel: 44 (0)20 7582 1188